Advanced Photoshop Elements 5.0 For Digital Photographers

Philip Andrews

AMSTERDAM • BOSTON • HEIDELBERG • LONDON • NEW YORK • OXFORD PARIS • SAN DIEGO • SAN FRANCISCO • SINGAPORE • SYDNEY • TOKYO Focal Press is an imprint of Elsevier

Focal Press An imprint of Elsevier Linacre House, Jordan Hill, Oxford OX2 8DP, UK 30 Corporate Drive, Suite 400, Burlington, MA 01803, USA

First edition 2007

Copyright © 2007, Philip Andrews. Published by Elsevier Ltd. All rights reserved

The right of Philip Andrews to be identified as the author of this work has been asserted in accordance with the Copyright, Designs and Patents Act 1988

No part of this publication may be reproduced, stored in a retrieval system or transmitted in any form or by any means electronic, mechanical, photocopying, recording or otherwise without the prior written permission of the publisher

Permissions may be sought directly from Elsevier's Science & Technology Rights Department in Oxford, UK: phone (+44) (0) 1865 843830; fax (+44) (0) 1865 853333; email: permissions@elsevier.com. Alternatively you can submit your request online by visiting the Elsevier web site at http://elsevier.com/locate/permissions, and selecting *Obtaining permission to use Elsevier material*

Notice: No responsibility is assumed by the publisher for any injury and/or damage to persons or property as a matter of products liability, negligence or otherwise, or from any use or operation of any methods, products, instructions or ideas contained in the material herein. Because of rapid advances in the medical sciences, in particular, independent verification of diagnoses and drug dosages should be made

British Library Cataloguing in Publication Data

A catalogue record for this book is available from the British Library

Library of Congress Cataloging-in-Publication Data

A catalog record for this book is available from the Library of Congress

ISBN-13: 978-0-240-52057-5 ISBN-10: 0-240-52057-2

For information on all Focal Press publications visit our website at www.focalpress.com

Printed and bound in Canada

Layout and design by Karen and Philip Andrews in Adobe InDesign CS2

 $07\ 08\ 09\ 10\ 11\ 11\ 10\ 9\ 8\ 7\ 6\ 5\ 4\ 3\ 2\ 1$

Acknowledgements

Karen for your support, love and patience always and Adrian and Ellena for keeping me balanced. And as always, my thanks goes to the great team at Focal Press, especially Marie Hooper, Emma Baxter, Stephanie Barrett, Debbie Clark and Margaret Denley – you always make me look good. Cheers to Richard Coencas and Don Day for their technical comments and direction and to the supportive staff at Adobe in the UK, Australia and USA offices. Much appreciation to Mike Leavy, Adobe Engineering Manager for Elements products and Nigel Atherton, editor *What Digital Camera* and *Better Digital Photography* magazines for your kind words of introduction to this text.

Picture credits

With thanks to the great guys at www.ablestock.com for their generous support in supplying the cover picture and the tutorial images for this text. Copyright © 2007 Hamera and its licensors. All rights reserved. All other images and illustrations by Karen and Philip Andrews © 2007. All rights reserved.

1

vi

viii

13

Contents

Foreword Introduction

The Next Level

The comprehensive Photoshop Elements workflow
Elements basics
Basic Elements workflow

Scanner and Camera Techniques

The basics – resolution	14
2.01 How many pixels do I need?	16
The basics – color depth	18
2.02 More colors equal better quality	20
Digital shooting technique	22
2.03 Exposure compensation	24
Frame-by-frame control	25
2.04 Contrast	26
2.05 Color saturation	27
2.06 Image sharpness	28
2.07 White balance control	29
2.08 Applying fine-tuning automatically	33
2.09 Customizing your white balance	34
2.10 Shooting RAW for ultimate control	35
So what is in a RAW file?	37
The RAW advantage	39
2.11 Shooting workflows	40
Film and print scanners	41
2.12 Scanning resolution – 'Know where you are going	
before you start the journey'	42
2.13 Color depth	43
2.14 Multi-sample	44
2.15 Highlight and shadow capture	45
2.16 Color cast correction	46
2.17 Dust and scratches	47
2.18 Noise Reduction technologies	48
,	49
5	50
Fixing common shooting problems	51
Fixing common scanning problems	53

22

Processing Raw files	55
3.01 Enabling your raw camera	57
3.02 Modifying your capture workflow for raw	59
3.03 Using the Adobe Photo Downloader	61
3.04 The Adobe Camera Raw interface	64
3.05 The Conversion process	72
3.06 Keeping ACR up to date	76
3.07 Other Raw plug-ins	76

Photo Organization and Manageme	nt 77
Organizing your photos with Photoshop Elements	78
4.01 Add picture details in-camera	78
4.02 Organize photos whilst downloading	78
Organizing using Photo Browser	80
4.03 Captioning	80
4.04 Naming and renaming	80
4.05 Tagging your photos	81
4.06 Auto Face Tagging	82
4.07 Collections and how to group photos	83
4.08 Changing your view	84
4.09 Locating files	86
Protecting your assets	88
4.10 Creating a backup	89
Back up regularly	90
Store the duplicates securely	90
4.11 Versioning your edits	91
Versions and Photoshop Elements	91
4.12 Creating Image Stacks	93

Pathways to Editing in Elements	95
Automatic editing	96
Auto editing summary:	96
5.01 Auto Smart Fix	97
5.02 Adjust Smart Fix	97
5.03 Auto Red Eye Fix	97
Automating editing of several pictures at once	98
5.04 Processing multiple files	98
5.05 Multi-selection editing	99
5.06 Bulk Red Eye fixing	99
Semi-automatic editing	100
Semi-auto editing summary	100
5.07 Using the Quick Fix editor	100
5.08 Semi-auto Full Edit features	101
Manual editing	103
5.09 The Full Edit workspace	103

Image Changes – Beyond the Basics	105
Advanced selection techniques	106
6.01 Adding to and subtracting from selections	106
6.02 Using the Selection Brush	106
6.03 Magical selections	108
6.04 Saving and loading selections	109
6.05 Modifying selections	110
6.06 Transforming a selection	111
6.07 Precise control of selection size	113
Understanding layers	114
Masking techniques	118
6.08 Painting masks with the Selection Brush	118
6.09 Fill and adjustment layer masks	119
6.10 Using selections with layer masks	120
6.11 'Group with Previous' masks	120
Converting color to black and white	121
6.12 Changing the mode to grayscale	121

iii

CONTENTS

6.13 Desaturate the color file	122
6.14 A more sophisticated approach	124
6.15 The new Convert to Black and White feature	125
Advanced dodging and burning-in	127
6.16 Using selections to change tone	127
6.17 Erase back through tonal layers	129
6.18 Paint on dodging and burning-in	131
Enhance your poorly exposed pictures	132
6.19 Screening image layers to enhance tones	132
6.20 Adding detail to highlights and shadows	135
Tinted monochromes	136
6.21 Using Hue and Saturation to tone your pictures	137
Split toning	139
6.22 Select and tone	139
6.23 Two-layer erase	141
Black and white and color	142
6.24 Layer mask and gradient map	142
Border techniques	143
6.25 Simple borders	143
6.26 Sophisticated edges using grayscale masks	144
6.27 Creating frames with Frame Layers	145
Adding texture	147
6.28 Add Noise filter	147
6.29 Grain filter	148
6.30 Non-destructive textures	149
Advanced sharpening secrets	150
6.31 Unsharp Masking to the rescue	151
6.32 Adjust Sharpness for the ultimate control	153
6.33 Another approach	154
and and a second of the second s	

Z	Darkroom Techniques on the Desktop	155
	7.01 Diffusion printing	156
	7.02 Instant film transfer effect	158
	7.03 Using the Unsharp Mask filter to add contrast	162
	7.04 Lith printing technique	164
	7.05 Correcting perspective problems	166
	7.06 Add emphasis with saturation	168
	7.07 Restoring color to faded images	170
	7.08 Cross-processing effects	172
	7.09 Digital hand coloring	174
	7.10 Realistic depth of field effects	177
	7.11 Beyond the humble drop shadow	181
	7.12 Ring flash shadow	185
	7.13 New Curves features	186
	7.14 Dust and scratches be gone	189
	7.15 Combining images seamlessly	191
	7.16 Believable montages – a step further	193
	7.17 Producing high-key pictures	196
	7.18 Correcting lens problems	198
	7.19 Change to old	200
	7.20 Painterly photos	202

Professional Retouching	205
Visual surgery without a hint of anything plastic	207
8.01 Adding a dreamy effect	208
8.02 Softening freckles	209
8.03 Eliminating blemishes	210
Clone Stamp tool	210
Healing Brush tool	210
Spot Healing Brush	211
Clone Stamp tool step-by-step	212
Healing Brush tool step-by-step	213
Spot Healing Brush tool step-by-step	213
8.04 Brighten Eyes	214
8.05 Tone down skin highlights and shadows	215
8.06 Retouching non-destructively	216
Sample all layers	216
Retouch duplicate layer	216
Mask editing adjustments	216
Use Adjustment layers	216

Making Better Panoramas	217
Advanced shooting techniques	221
9.01 Positioning the camera	221
9.02 Camera support	222
9.03 Exposure	225
9.04 Focus and zoom	226
9.05 Depth of field	226
9.06 White balance	228
9.07 Timing	229
9.08 Ensuring consistent overlap	230
9.09 Dealing with the moving subject	231
9.10 Fixing misaligned picture parts	233
9.11 Coping with extremes of brightness	233
9.12 Creating artificially increased DOF	236
9.13 Correcting exposure differences	237
9.14 Adjusting for changes in color balance	238
9.15 Vertical panoramas	240
9.16 High-resolution mosaics	241
9.17 Panoramic printing	242
9.18 Spinning panorama movies	244
9.19 Panorama workflow	248

Extending Your Web Abilities	249
Building websites – the basics	251
10.01 Elements' Photo Galleries websites	253
Creating individual web assets using Photoshop Elements	256
10.02 Optimizing photos for the web	257
10.03 Button creation	259
10.04 Effective headings	261
10.05 Making seamless backgrounds	261
10.06 Using background matting	262
10.07 Creating downloadable slide shows	263
10.08 Assembling the site	264
10.09 Uploading the site	266

10

Producing Effective Graphics
Revisiting painting and drawing basics
11.01 Controlling brush characteristics
The More Options palette
11.02 Changing an existing brush
11.03 Creating a new brush
11.04 Text
11.05 Adding styles to text layers
11.06 Customizing shapes
11.07 Adding pictures to shapes
11.08 Using shapes as borders
11.09 Customizing the shapes you use
Text and pictures
11.10 Images in text
11.11 Text in images
11.12 Realistic text and image montages
11.13 Hand drawn logos
11.14 Reducing your picture's colors
11.15 Posterized pictures
11.16 Kaleidoscopic images
11.17 Presentation backgrounds

Free Form Photo Layouts	307
Before you start – edit then layout	309
12.01 Basic steps for layout creation	310
12.02 Editing existing Photo Layouts	312
12.03 Adding, removing and replacing photos	314
12.04 Adding, moving and deleting pages	316
12.05 Using the Artwork and Effects palette	318
12.06 Align, arrange and distribute your frames	322
12.07 Printing your Photo Layouts	324
Print Preview	325
Print Photos	325
Order a Kodak Photo Book	325
12.08 Adding your own backgrounds and graphics	326

Photo Creations The Photo Creations options 13.01 Multimedia slide shows The version 5.0 slide show Editor in action 13.02 Producing a VCD with a menu 13.03 Creating pages for printing and publishing 13.04 Publish a photo book 13.05 Book publishing without using Photo Creations 13.06 On-line publishing options 13.07 Creating a greeting card 13.08 Making a CD or DVD Jacket 13.09 VCD/DVD with Menu 13.10 Flipbooks 13.11 Your pictures month by month

Finely Crafted Output	347
Printing basics	348
The inkjet printer	350
Laser	352
Dye Sublimation	352
Other printing processes	353
Image resolution vs printer resolution	354
14.01 Basic steps	355
14.02 Creating contact sheets	358
14.03 Multiple prints on a page	359
Ensuring color consistency between devices	360
14.04 Setting up a color-managed workflow	363
14.05 Calibrating your screen – Adobe Gamma	368
14.06 Calibrating your screen – ColorVision Spyder	370
Getting intimate with your printer	372
14.07 Calibrating your printer – resolution, color, ton	ie
and sharpness tests	372
14.08 Calibrating your printer – ColorVision PrintFIX	376
14.09 Making great black and white prints	378
14.10 What about permanence?	381
14.11 Preparing your images for professional outsour	cing
	385
14.12 Shoot small print big	387
14.13 Printing workflow	390

391
392
394
396
398
403
406

Index

v

Foreword

Nearly without exception, human beings the world over are fascinated by the photograph. A photograph is a timeless, compelling, emotive and honest representation of our world; of the places we've been, the events we've witnessed, the people we've met and loved. The photograph is a reflection of our world and ourselves; our mind's eye projected onto cotton vellum or computer screen. The persistence of vision *ex machina*. Indeed, the photographic image is the true iconography of the modern world.

For the photography enthusiast, these are very exciting times. In the span of less than 10 years, we have witnessed the evolution of photography from a mostly silver halide film-based process to a completely digital process. The individual photographer now has the capability to shoot, 'develop', and create prints using an entirely digital workflow, and completely within the comfortable confines of his or her own study.

This new-found freedom from film and the complicated processing thereof is largely due (of course) to the ready availability of affordable digital cameras and photo-quality printers; but it is due also, in no small part, to the efforts of the people at Adobe Systems. Adobe is committed to empowering the digital photographer by providing the most powerful and excellent tools available for rendering, manipulating and printing digital images. Among the most popular and successful of these tools is Adobe Photoshop Elements.

Although one of the original design intents behind Photoshop Elements was to make many of the most common image enhancement tools more readily available and noticeable to the novice user, there is still much depth behind this initial surface. Fortunately for both Adobe and its customers, talented writers such as Philip Andrews have resolved to explore this depth and, in easy-to-understand language and step-by-step guidance, provide access to you, the reader.

FOREWORD

Advanced Photoshop Elements for Digital Photographers is a beautifully rendered and compellingly written exploration of the advanced features and techniques that can be accomplished with Photoshop Elements. Through the use of many sample photographs, screen shots and clearly illustrated examples, Mr Andrews provides us with the tools to turn our images into exciting and compelling works of art.

From careful and thoughtful descriptions of the basics of tonal adjustments and camera and scanner settings to detailed explanations for creating traditional photographic effects such as lith print style reproductions, *Advanced Photoshop Elements 5.0 for Digital Photographers* will provide you with an entire arsenal of tools for adding emphasis, detail, and clarity to your images and for exposing and enhancing their inherent beauty.

If you love photography as much as I do, you are in luck with this book.

Enjoy.

Mike Leavy Engineering Manager for Elements products Adobe Systems, Inc. FOREWORD

Introduction

When Photoshop Elements came out it was assumed by many that, because it was so inexpensive, it would be the sort of program that you could master in a couple of hours – it certainly wouldn't require a huge learning curve and probably, let's face it, a chunky manual to get to grips with it, as its professional sibling, Photoshop, does. But how wrong we were. Budget certainly doesn't mean basic in this case, and Adobe has packed so much into Photoshop's little brother that you really do need an expert guide to get the best out of it, to lead you through all those nooks and crannies and show you all the cool tricks that are not obvious to the casual user.

But who to choose to be that guide? Well for me there's only one person, and luckily for you it's the one whose name is on the cover of this book. Philip Andrews is an enigma. As editor of the UK's leading digital photography magazine I require two main qualities from my contributors: they have to be real experts who possess a truly in-depth knowledge of their subject, and they have to be able to communicate that knowledge in simple layman's terms that anyone can understand. (They also have to be reliable and hand their copy in on time, but that's another story!) Well there are plenty of experts and plenty of communicators, but you'd be amazed at how rare it is to find someone who is both, as Philip is.

Philip Andrews knows Elements better than anyone else I know. He also writes in a friendly, entertaining and non-academic style – despite the fact that he is a senior lecturer in photography. He has a great understanding of the needs of the end user and his knowledge and enthusiasm for digital imaging (and photography in general) shine from every sentence. He's an accomplished photographer too, so he not only talks the talk but walks the walk, and uses many of his own excellent images to illustrate his points.

Having already covered the fundamentals of Elements in his last book Philip now moves on to more complex themes and ideas, things which you might (wrongly) have considered a bit ambitious for Elements. As before he puts the software into the wider context of digital imaging in general and explains the why as well as the how. Once again there's a great linked website that allows you to download some of the images used in the book and try the techniques out for yourself.

With Philip as your guide you'll be using Elements like a pro and making great images in no time.

Good luck.

Nigel Atherton Editor What Digital Camera

The Next Level

ADVANCED PHOTOSHOP ELEMENTS 5.0 FOR DIGITAL PHOTOGRAPHERS

There is no doubt that when Adobe decided to release Photoshop Elements photographers the world over rejoiced. Not content with their offerings for entry and intermediate users in the past and ever conscious of the growing digital camera user base, the Adobe boffins created the new package with you, the digital photographer, firmly in their mind. Despite the rumors spread by the 'Photoshop Snobs' that the product was just a cut down version of Adobe's professional package and that any serious editing will need to be completed in Photoshop, users the world over are realizing just how well Photoshop Elements fits their needs.

A true photographer's tool

Adobe had finally heard the cries of the mortals and produced an image manipulation package that has the strength of Photoshop with the price tag more equal to most budgets. Elements gives desktop image-makers top quality image editing and management tools that can be easily used for preparing pictures for printing or sharing via the web or CD. Features like the panoramic stitching option, called Photomerge, and the Photo Browser are firm favorites and were featured in this package before they ever appeared in Photoshop. The color management and vector text and shape tools are the same robust technology that drives Photoshop itself, but Adobe has cleverly simplified the learning process by providing an easier-to-use interface and options like step-by-step interactive recipes for common image manipulation tasks. These, coupled with features like Magic Selection Brush tool, Adjust Color Curves and the Convert to Black and White feature, make the package a digital photographer's delight.

Beyond the companion introduction title >> This book is the result of many requests to provide a 'next step' that will take Elements users beyond the basic concepts and skills outlined in the introductory text, Adobe Photoshop Elements – A visual introduction to digital imaging. (a) Edition 1. (b) Edition 2. (c) Edition 3. (d) Edition 4. (e) Edition 5.

Book resources at: www.adv-elements.com

As a photographer, teacher and author I was captivated by the simplicity and strength that Adobe has crammed into the package and knew that this was just the sort of image editing program that would satisfy the demands of the digital camera users I met every day. So to accompany Elements version 1.0, I released a new book which was an introduction to the package and digital imaging in general. Titled *Adobe Photoshop Elements – A visual introduction to digital imaging* it quickly became a best-seller and was followed up with a series of new and revised editions to accompany ongoing versions of the program.

As Elements users became more familiar with the concepts and tools used in the program it wasn't long before I started to receive requests for more advanced techniques than those presented in this introductory text. These were quickly followed by queries about how to position Elements as the key 'image editing component' in a high quality photographic workflow that encompassed capture, management, manipulation and output activities.

3

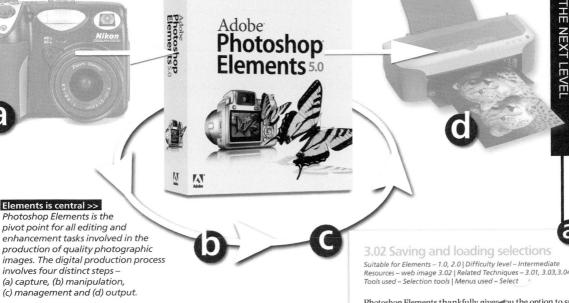

This book is my answer to these requests. With well over 140 new techniques it provides professional tips aimed at advancing your Elements skills beyond the basics. It is presented in a series of highly illustrated step-by-step color tutorials that show you what can be achieved. The techniques are discussed in the greater context of professional quality workflows that cover camera and scanner capture, raw processing, picture management, panorama production and quality print and web production.

Each technique is cross-referenced with related skills and ideas in the book and there are on-line resources at the book's website -

www.adv-elements.com

Here you can download and practise with many of the example images, video tutorials and resources used in the production of the book. Key settings for important dialog boxes are presented along with the illustrated steps needed for you to complete each technique. By working side by side with this text, your favorite image editing program and the associated web resources, you will quickly build both your Elements skills and your general understanding of the processes involved in creating quality photographic images.

Resources – web image 3.02 [Related Techniques – 3.01, 3.03, 3.04, 3.05 Tools used – Selection tools | Menus used – Select

Photoshop Elements thankfully gives fou the option to save all your hard electing work an be used again later. With ction

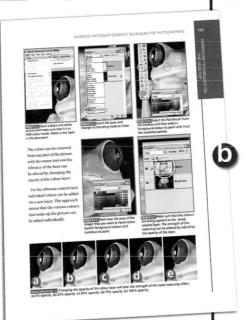

Step-by-step >> The techniques in the book are presented in a highly illustrated step-by-step fashion that will progressively build your Elements skills. (a) Cross-referenced techniques. (b) Step-by-step illustrations.

The comprehensive Photoshop Elements workflow

Adobe made massive changes to the way that users worked in Elements between versions 2.0 and 3.0 of the program. These changes converted Photoshop Elements from simply being a photo editing program into a complete digital photography system.

Now in its fifth revision, Elements provides a total workflow solution from the moment you download your files from camera, scanner or the net, through organization and manipulation phases and then onto printing or outputting the pictures electronically (photo gallery, email attachments) or as print. Understanding how the various components in the system fit together will help you make the most of the software and its powerful features.

The Adobe Photo Downloader feature and **Get Photos** command allow you to preview, select and download files from a variety of different sources.

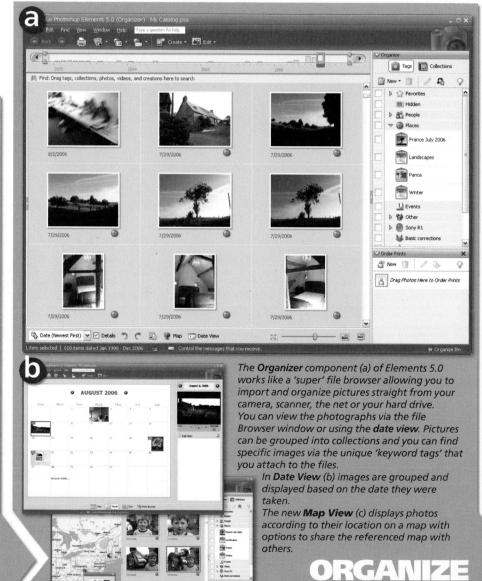

4

THE NEXT LEVEL

The **Full** editor contains all the familiar editing and enhancement tools that Elements users have come to expect. It is here that you can take full control over the manipulation and fine-tuning of your pictures. You can also add text, play with layers, create multi-picture composites and combine all manner of special effects with your original photo.

EDIT & ENHANCE

The **Quick Fix** editor provides a series of one-click or semiautomatic fixes for common problems with lighting, contrast, color and sharpness. All the controls are contained in the one screen for speed and you can configure the display to show before and after versions of the photo.

QUICK EDITS

The **Print** options in Elements 5.0 are different from earlier versions of the program. Now you can choose to print individual photos or multiple pictures on a single sheet of paper. You can also preview and print individual pages of the new multi-page .PSE document. As an added bonus decorative frames can be added to the images right from the Print Multiple Photos dialog box.

The **Photo Creations** projects are the way that special output options are grouped in Elements. In this workspace a step-by-step approach is used to create slide shows, VCD presentations, photo album pages, and greeting cards, calenders and photo galleries.

5

Elements basics

Most digital image-makers find that there are several enhancing steps that they always perform on a newly acquired picture. These changes are often among the first skills that the new Elements user learns. Despite the fact that this book is designed to build upon such basic techniques I thought that it would be best to revisit them briefly to ensure that we are all working from the same game plan.

For the most part these changes follow a predictable sequence:

Import, Organize, Orientate or Straighten, Crop, Adjust Tones, Alter Color, Apply Sharpness and Save.

These basic alterations take an image captured by a camera or scanner and tweak the pixels so that the resultant picture is cast-free, sharp and displays a good spread of tones.

Importing photos

When opening Elements the user is confronted with the Quick Start or Welcome screen containing a variety of options. From this screen you can choose to organize, fix, edit or make a new Photo Creation from your pictures. The first step for most Elements users is to import their photos from a digital camera or scanner. This task is generally handled by the Adobe Photo Downloader which will automatically start when a camera or card reader is attached to the computer. The files are downloaded and cataloged in Elements with the utility.

Alternatively you can import files from other sources or activate the downloader manually from inside the Organizer workspace, which is accessed via the View and Organize selection in the Welcome screen. See Step 1. This feature provides a visual index of your pictures and can be customized to display the images in Browser, Date or Folder mode and thumbnails can be sorted by keyword tags, title, media, metadata or collection.

To start your first catalog simply select the Organizer: File > Get Photos menu option. Choose one of the listed Book resources at: **www.adv-elements.com**

Step 1 The Quick Start screen provides simple and easy access to different parts of the Photoshop Elements system .

Step 2 >>> Choose the location of the files to import from the list in the File > Get Photos menu or shortcut.

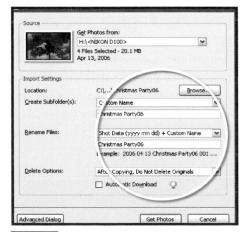

Step 3 Add naming, destination folder and deletion details for the transferred files in the Downloader dialog.

6

sources of pictures provided and follow the steps and prompts in the dialogs that follow. See Step 2.

Basic organization

When using the Photo Downloader you can add naming, destination folder and deletion details and in the Advanced dialog you can also apply metadata, auto stack, fix red eye and add group tags to photos automatically. See Step 3. After downloading, or importing, the files are previewed as thumbnails in the Organizer workspace. At this time it is a good idea to make use of some of Elements' brilliant organizational features to help manage the files before jumping into editing and enhancement activities. Add keywords - Tags - in Elements' terminology, to you photos by click-dragging existing entries from the Tags pane onto vour photos. See Step 4. Alternatively, add your own Tag entries or Catagories using the New option at the top of the pane. See Step 5. Adding Tags to your photos means that you can search for and locate individual files based on this association.

Changing a picture's orientation

Turning your camera to shoot images in Portrait mode will generally produce pictures that need to be rotated to be viewed correctly. Elements provides a series of dedicated rotate options that are available from inside the Photo Browser workspace. Simply right-click the thumbnail and select an option from the pop-up list. See Step 6. Whilst organizational tasks and simple automatic enhancement changes are handled in the Photo Browser workspace, more complex and controllable picture edits are applied in either the Quick Fix or Full Edit workspaces. So for the next set of changes the picture is passed to the Standard Editing workspace. Do this by selecting the Go to Standard Edit option from the right-click thumbnail menu. See Step 7.

Cropping and straightening

Most editing programs provide tools that enable the user to crop the size and shape of their images. Elements provides two such methods. The first is to select the Rectangular Marquee tool and draw a selection on the image the size

Step 5 >> Add a different Tag entry by clicking the New button and adding details in the Create Tag dialog.

Book resources at: www.adv-elements.com

THE NEXT LEVE

and shape of the required crop. Next choose Image > Crop from the menu bar. The area outside of the marquee is removed and the area inside becomes the new image. The second method uses the dedicated Crop tool that is located just below the Magic Selection Brush in the tool box. Just as with the Marquee tool, a rectangle is drawn around the section of the image that you want to retain. The selection area can be resized at any time by click-dragging any of the handles positioned in the corners of the box. To crop the image click the Tick button at the bottom of the crop marquee or double-click inside the selected area. See Step 8.

An added benefit to using the Crop tool is the ability to rotate the selection by click-dragging the mouse when it is positioned outside the box. To complete the crop click the Tick button at the bottom of the crop marquee, but this time the image is also straightened based on the amount that the selection area was rotated.

Spreading your image tones

When photographers produce their own monochrome prints they aim to spread the image tones between maximum black and white. So too should the digital image-maker ensure that their pixels are spread across the whole of the possible tonal range. In a 24-bit image (8 bits per color channel – red, green and blue), this means from a value of 0 (black) to 255 (white). Elements provides both manual and automatic techniques for adjusting tones.

The Auto Contrast and Auto Levels options are both positioned under the Enhance menu. Both features will spread the tones of your image automatically, the difference being that the Auto Levels function adjusts the tones of each of the color channels individually whereas the Auto Contrast command ignores differences between the spread of the red, green and blue components. If your image has a dominant cast then using Auto Levels can sometimes neutralize this problem. The results can be unpredictable though, so if after using the feature the colors in your image are still a little wayward, undo the

Step 7 >> Pass the photo to one of the editing spaces by selecting the option from the right-click menu.

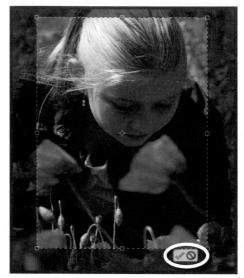

Step 8 >>> The Crop tool gives the user the ability to crop and straighten selected areas of the image.

Step 9 >>> The Auto Levels and Auto Contrast functions spread the tones of your image automatically.

the

8

changes and use the Auto Contrast feature instead. See Step 9.

If you want a little more control over the placement of your pixel tones then Adobe has also included the sliderbased Contrast/Brightness and Levels features used in Photoshop in their entry-level software. Both these features, plus the new Adjust Color Curves feature, take back the control for the adjustment from the program and place it squarely in the hands of the user. See Step 10. Jump to the end of the chapter for more details on manual control of tones.

Ridding your pictures of unwanted color casts

Despite the quality of modern digital camera's White Balance systems, images shot under mixed lighting conditions often contain strange color casts. The regularity of this problem led Adobe to include the specialized Color Cast tool (Enhance > Adjust Color > Remove Color Cast) in Elements. Simply click the eyedropper on a section of your image that is meant to be gray (an area that contains equal amounts of red, green and blue) and the program will adjust all the colors accordingly. See Step 11. This process is very easy and accurate, if you have a gray section in your picture. For those images without the convenience of this reference, the Variations feature (Enhance > Adjust Color > Variations) provides a visual 'ring around' guide to cast removal. See Step 12.

Applying some sharpening

The nature of the capture or scan process means that most digital images can profit from a little careful sharpening. I say careful, because the overuse of this tool can cause image errors, or artifacts, that are very difficult to remove. Elements provides several sharpening choices, most automatic, and one with a degree of manual control.

The Auto Sharpen feature found in the Enhance menu provides automatic techniques for improving the clarity of your images. The effect is achieved by altering the contrast

Step 10 >>> The Levels feature provides manual control of the position of white, mid and black tones in your image.

Step 11 >> The Color Cast tool uses an Eyedropper feature to neutralize color casts in your images.

Step 12 >>> The Variations control provides a 'ring around' approach to cast removal.

THE NEXT LEVE

of adjacent pixels and pixel groups. Elements also includes the Unsharp Mask filter and the Adjust Sharpness feature, which provides the user with manual control over which pixels will be changed and how strong the effect will be. The key to using these features is to make sure that the changes made by the filter are previewed in both the thumbnail and full image at 100 percent magnification. This will help to ensure that your pictures will not be noticeably over-sharpened. See Step 13.

Saving your images

The final step in the process is to save all your hard work. The format you choose determines a lot of the functionality of the file. If you are unsure of your needs always use the native PSD or Photoshop format. These files maintain layers and features such as editable text and saved selections, and do not lose any picture details due to compression. If space is a premium, and you want to maintain the best quality in your pictures, then you may decide to use a compressed version of TIF or Tagged Image File Format. JPEG and GIF should only be used for web work or when you need to squeeze you files down to the smallest possible size. Both these formats lose image quality in the reduction process, so keep a PSD or TIF version as a quality backup. See Step 14.

CK Cancel Proves Anount: 13 9% Backus: 10 powels Remoge: Lens Blur Angle: -Demodel More Refined Charles Sharpess

Step 13 >>> Adjust Sharpness improves the overall appearance of sharpness in the image by increasing the contrast of adjacent pixels.

Step 14 >> Elements provides a range of file formats that can be used to save your images.

Basic Elements workflow

These steps should be the first changes and enhancements you make to new digital photographs. It is upon these basics that the rest of the book will build. So make sure that the sequence and skills included here are second nature before moving on to extending your Elements knowledge.

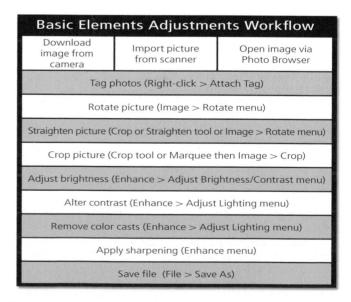

Take manual control of your tones >>

One of the most basic, yet critical, tasks for any digital photographer involves adjusting the contrast and brightness of their images. This action is often one of the first undertaken by novices and professionals alike when enhancing newly shot pictures. Well-executed contrast and brightness adjustments can take an 'okay' image and turn it into a dramatic picture.

Though at first glance making these changes seems like a simple task, don't be too eager to play with the Brightness/Contrast sliders. These controls are far too coarse for quality work. Careful manipulation of the pixels is the key to making quality images and these features don't allow the subtlety of adjustment that is necessary to achieve good results. Instead, employ the aid of either the Levels feature (Enhance > Adjust Lighting > Levels) or the new Adjust Color Curves feature (Enhance > Adjust Color > Adjust Color Curves) when making these changes.

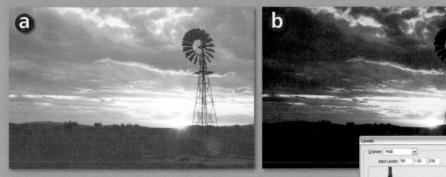

Levels adjustments >>> The Levels and Adjust Color Curves features provide fine manual control over the contrast and brightness of your pictures. (a) Before. (b) After. (c) The Levels adjustment used to correct contrast and brightness.

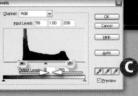

Advanced tonal control

The first step in taking charge of your pixels is to become aware of where they are situated in your image and how they are distributed between black and white points. The Histogram palette (Window > Histogram) displays the same graph of your picture's pixels as the Levels feature. Viewing the histogram can be one of the quickest ways to diagnose the source of brightness and contrast problems in your pictures.

The left-hand side represents the black values, the right the white end of the spectrum and the center area the mid tones (see Levels feature illustrations on page 12). As you may be already aware, in a 24-bit image (8 bits per color channel) there are a total of 256 levels of tone possible from black to white – each of these values are represented on the graph. The number of pixels in the image with a particular brightness or tone value is displayed on the graph by height. Where the graph is high there are many pixels of this tone present in the image. In contrast, low areas of the graph mean that few pixels of this tone can be found in the picture.

Knowing your images

After a little while of viewing the histograms of your images you will begin to see a pattern in the way that certain styles of photographs are represented. Overexposed pictures will display a large grouping of pixels to the right end of the graph, whereas underexposure will be represented by most pixels bunched to the left. Flat images or those taken on an overcast day will show all pixels grouped around the middle tones and contrasty pictures will display many pixels at the pure white and black ends of the spectrum.

These tonal problems can be fixed automatically by applying one of the standard correction features, such as Auto Contrast or Auto Levels, found in Elements. Both these commands re-map the pixels so that they sit more evenly across the whole of the tonal range of the picture. Viewing the histogram of a corrected picture will show you how the pixels have been redistributed. If you want to take more control of the process than is possible with the auto solutions, open the Levels dialog.

Using the Levels control

Looking very similar to the histogram this feature allows you to interact directly with the pixels in your image. As well as a graph, the dialog contains two slider bars. The one directly beneath the graph has three triangle controls for black, mid tones and white and represents the input values of the picture. The slider at the bottom of the box shows output settings and contains black and white controls only.

To adjust the tones, drag the input shadow and highlight controls until they meet the first set of pixels at either end of the graph. When you click OK the pixels in the original image are redistributed using the new white and black points. Be careful though as moving the black point slider 11

beyond the first pixels in the graph will convert these tones to straight black, losing any shadow detail that was present. Similarly, dragging the white point too far towards the middle will change delicate highlight details to pure white. Moving the mid tone slider will change the brightness of the middle values of the image without changing the black and white points in the image. Altering the output black and white points will flatten, or decrease, the picture's contrast.

Pro's Tip: Hold down the Alt key whilst moving the black or white input slider and you will see a reversed version of the image showing the pixels that are being converted to black or white by the action.

Basic changes >>

(a) To add contrast drag white and black input sliders inwards.
(b) To reduce contrast drag white and black output sliders inwards.
(c) To darken mid tones drag mid input slider to the right.
(d) To lighten mid tones drag mid input slider to the left.

The Adjust Color Curves control

The Adjust Color Curves option provides another way that you can alter brightness and contrast in your photo. Unlike the very basic Brightness/Contrast control, Adjust Color Curves provides separate controls for altering the brightness of highlights, shadows and midtones as well as a single slide for changing midtone contrast.

The feature is divided into two different sections – Samples and Advanced Options. Each section can be opened or closed by clicking the small triangle next to the section heading in the dialog.

The Samples area contains six thumbnail previews of your photo with standard enhancement changes applied. Clicking on a thumbnail will apply the adjustment to your photo. With the Preview option selected you will be able to see the tonal changes on the full image.

The Advanced Options section contains four slider controls plus a curves graph that plots the tonal relationships in the picture. Whereas the Samples thumbnails provided a one-click adjustment the controls contained here allow multiple, additive, fine-tuning changes.

The best approach is to apply a thumbnail version of the change that you are requiring first, e.g. Lighten Shadows, and then fine-tune the results with the sliders in the Advanced Options section.

Pressing the Reset button restores the dialog's control to the default 'Increase Midtones' values.

Scanner and Camera Techniques

ADVANCED PHOTOSHOP ELEMENTS 5.0 FOR DIGITAL PHOTOGRAPHERS

There is no way to get around the fact that the quality of your final digital pictures is dependent on how well they were captured initially. Poorly photographed or badly scanned images take their problems with them throughout the whole production process and end up as poor quality prints. One of the best ways to increase the level of your work is to ensure that you have the skills and knowledge necessary to create the best digital file possible at the time of capture. This is true for the majority of you who now shoot with a digital camera as well as those who are converting existing photographic images to digital with a scanner.

To help gain this level of control let's go back to the basics and see how factors like resolution and numbers of colours affect the quality of image capture.

The basics – resolution

Most of us, no matter how new to digital photography, are aware that resolution has a direct link with picture quality. It is true that this factor, along with the numbers of colors (bit depth) saved in the file, or captured by the camera, helps determine the overall quality of the image.

The rule of thumb that most new users adhere to goes something like this – 'the higher the resolution and the greater the bit depth the better the image will be' – and to a large extent this is true. High-resolution images with lots of colors are generally better quality than those with a limited color range and fewer pixels, but to understand how integral resolution is to making great digital images we must look a little deeper.

Digital photography basics All digital photographs are constructed of a grid of colored pixels which when seen at a distance combine to form the appearance of a continuous color and tone picture.

Image capture - input resolution

Computers can only work with digital files. The world as we view it, and as we capture it in silver-based photographs, is not in a digital format. Tones and colors merge gradually from one extreme to another. For the computer to be able to work with such images they must be changed from this 'analog' or continuous tone format to a digital one. Scanners and digital cameras make this change as part of the capturing process.

The scene or print is tested, or sampled, at regular intervals and a specific color and brightness allocated for each sample area. The testing continues in a grid pattern all over the scene, gradually building a pattern of the image which is made up of discrete areas of specific color/ brightness. Each of these areas, or samples, becomes a pixel in the resultant digital file.

Resolution at this capturing stage refers to the frequency that samples are made of the image. Generally this measurement is represented as the number of samples taken in a one inch space; for this reason it is sometimes called Samples Per Inch or spi. Unfortunately most scanner software does not use this terminology but prefers to refer to this setting as 'Dots Per Inch' (dpi). This is a hangover from language used in the printing industry and does more to confuse than clarify the situation.

If you are using a digital camera to capture your image then the resolution will be determined by the sensor, which has a specific number of CCDs set into a grid that is used to digitize the image. Scanner users, on the other hand, are able to control the sampling rate by changing the settings in the scanner's dialog box.

A high sampling rate will result in a higher quality image with a much greater file size. A low SPI will provide a smaller file of less quality. These facts lead a lot of new users to a situation where all images are scanned at the highest resolution possible. Do this and your hard drive will soon be completely used up. High-resolution scans require huge amounts of storage space.

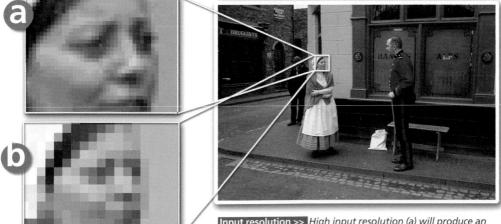

Input resolution >>> High input resolution (a) will produce an image with finer detail than a picture with low resolution (b).

15

Input resolutions should be decided on the basis of what the image's final use will be. If the image is to be printed the size of a postage stamp then there is no point scanning at a resolution that will result in a file large enough to print an A2 poster. Remember the end usage determines the scanning resolution, or to put it in a way more easily remembered, 'Know where you are going before you start the journey'.

2.01 How many pixels do I need?

Suitable for Elements – 5.0, 4.0, 3.0, 2.0, 1.0 | Difficulty level – Intermediate Related techniques – 2.02, 2.12, 2.13, 13.07

The trick to knowing how many pixels you require is to think carefully about the end product you want to create. As an example, if you want to produce a 10 x 8 inch photographic quality print and you know that the lab you will use to output the image suggests a resolution of 250 dpi, then you have all the information to determine the number of pixels you will need to capture. Essentially the lab is saying that to produce photographic quality they need 250 pixels for every inch of the print. For the photograph to be 10 inches high then your file must contain a minimum of 2500 pixels for this dimension and to ensure the 8 inch width, you will need 2000 pixels. With this knowledge you can adjust the settings on you scanner so that you will end up with a picture file that contains the minimum pixel dimensions of 2500 x 2000.

For digital camera shooters understanding this concept will not only give you an indication of the maximum print size available from your camera's sensor, but will also allow you to accurately select the correct resolution, or more precisely the correct pixel dimension, setting on your camera for specific tasks. The table below will give you a good starting point.

Chip pixel dimensions:	Chip resolution: (1 million = 1 megapixel)	Print size at 200 dpi: (e.g. photo print)	Image size at 72 dpi: (e.g. web use)
640 x 480 pixels	0.30 million	3.2 x 2.4 inches	8.8 x 6.6 inches
1440 x 960 pixels	1.38 million	7.4 x 4.8 inches	20.0 x 13.2 inches
1600 x 1200 pixels	1.90 million	8.0 x 6.0 inches	22.0 x 16.0 inches
2048 x 1536 pixels	3.15 million	10.2 x .7.6 inches	28.4 x 21.3 inches
2304 x 1536 pixels	3.40 million	11.5 x 7.5 inches	32.0 x 21.3 inches
2560 x 1920 pixels	4.92 million	12.8 x 9.6 inches	35.5 x 26.6 inches
2000 x 3000 pixels	6.0 million	10 x 15 inches	27.7 x 41.6 inches
2336 x 3504 pixels	8.2 million	11.6 x 17.5 inches	32.4 x 48.6 inches
2592 x 3888 pixels	10.2 million	12.9 x 19.44 inches	36 x 54 inches

Proposed use	Suggested image resolution
Screen or web use	72 dpi
Draft quality inkjet	150 dpi
Photo-quality inkjet	200-300 dpi
Photo lab output (min)	250 dpi
Photo lab output (max)	400 dpi
Offset printing (good quality)	300 dpi

The suggested output resolution changes for different end uses. For you to accurately capture enough pixels for the end result you desire, you will need to be aware of the resolution requirements for different end products. The table to the left indicates some of the resolution requirements for different uses.

Spreading the pixels >>> In the example, the digital file has dimensions of 800 x 1200 pixels. Though the number of pixels remains the same, each of the prints ranges in size because of the numbers of pixels used to print each inch.

(a) 16 x 24 inch printed at 50 pixels per inch (ppi).
(b) 8 x 12 inch printed at 100 ppi.
(c) 4 x 6 inch printed at 200 ppi.
(d) 2 x 3 inch printed at 400 ppi.

Pro's Tips:

• Know where you are going before you start the journey – your scanner resolution should be based on the end use of the digital file. A poster will need a higher resolution initial scan, and a bigger file, than a postcard.

• **Balance print quality with practical file sizes** – test your printer to see at what image resolution increases in print quality cease to be perceived. Make this your base image resolution and scan your files according to this setting.

Once you know the image resolution needed for the printer, the final size of the print and the size of your original you can easily calculate the scanning resolution and the total pixel dimensions you need for your digital file. Use the formula in the table below to give yourself an indication of the number of pixels you need for any size print job.

	Pro's Scanning Resolution Formulae				
1.	Final image dimensions (pixels)	=	Original image dimensions (inches)	X	Scanning resolution (samples per inch)
	3000 x 2400 pixels	=	10 x 8 inch print	x	300 samples per inch
	6000 x 4000 pixels	=	1.5 x 1 inch (135 mm film)	Х	4000 samples per inch
2.	Print size (inches)	=	Image dimensions (pixels)	/	Image resolution (pixels per inch)
	15 x 12 inches	=	3000 x 2400 pixels	/	200 pixels per inch
	20 x 13.33 inches	=	6000 x 4000 pixels	1	300 pixels per inch

3

Book resources at: www.adv-elements.com

CAMERA TECHNIQUES

SCANNER AND

The basics – color depth

This growing understanding of how important resolution is to high quality imaging underpins the continual push by digital consumers for higher pixel output from their cameras. In the last couple of years sensor sizes have pole-vaulted from the diminutive 1.5 megapixels to the more commonplace 8.0 and even 10.0 megapixel models that now fill the shelves of many photographic suppliers. The power to create truly photographic quality output up to A3 size is well within our grasp.

But high resolution is only half the 'image quality' story. The number of colors in an image is also a factor that contributes to the overall quality of the photograph.

Discrete colors (or levels)

Photographs in either print or negative (or slide) form contain a range of subtle tones and colors that blend smoothly into each other. These are referred to as 'continuous tone images'. For instance, in a traditional black and white print it is difficult to see where one shade of gray starts and another one finishes. The effect is a smooth transition from the deepest shadows through to the most delicate highlights.

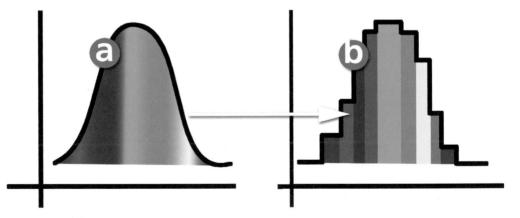

In contrast, a digital image is made up of discrete tones and colors. When a scene or a print is captured by a device such as a camera or scanner the continuous original is converted into a digital file. The file describes the image as a series of numbers representing these discrete colors and tones. When we scan a negative or slide, or photograph a scene, we make this conversion by sampling the picture at regular intervals. At each sample point, a specific color is chosen to represent the hue found in the original. In this way, a grid of colors is put together to form a digital version of the continuous tone original.

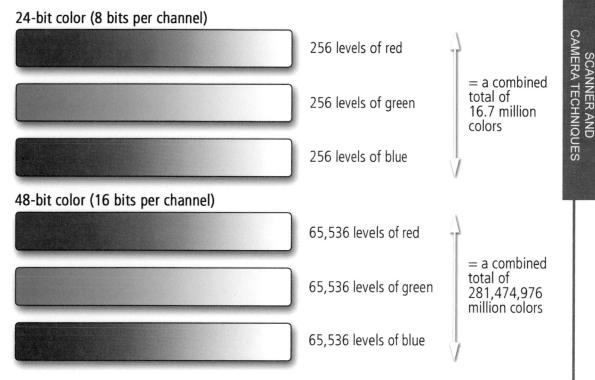

8-bit versus 16-bit >> Digital photographs captured in 16-bit per channel mode contain a greater number of colors than those captured with 8 bits.

Comparing bits

Each digital file you create (capture or scan) is capable of representing a specific number of colors. This capability, usually referred to as the 'mode' or 'color depth' of the picture, is expressed in terms of the number of 'bits'. Most images these days are created in 24-bit mode. This means that each of the three color channels (red, green and blue) is capable of displaying 256 levels of color (or 8 bits) each. When the three channels are combined, a 24-bit image (8 + 8 + 8) can contain a staggering 16.7 million discrete tones/hues.

This is a vast amount of colors and would be seemingly more than we could ever need, see, or print, but many modern cameras and scanners are now capable of capturing 16 bits per channel or 'high-bit' capture. This means that each of the three colors can have 65,536 different levels and the image itself a whooping 281,474,976 million colors (last time I counted!). But why would we need to capture so many colors?

12-bit capture

Many cameras capture 12 rather than 16 bits per channel. These files contain 4096 tones per channel. as opposed to the 65,536 possible with 16-bit capture. Generally these 12-bit files are captured as raw files and when converted with the Adobe Camera Raw feature, you can choose between producing a 16- or 8-bit converted file.

19

2.02 More colors equal better quality

Suitable for Elements – 5.0, 4.0, 3.0, 2.0, 1.0 | Difficulty level – Intermediate Related techniques – 2.13

Most readers would already have a vague feeling that a high-bit file is 'better' than a low-bit alternative, but understanding why is critical for ensuring the best quality in your own work. The main advantage is that capturing images in high-bit mode provides a larger number of colors for your camera or scanner to construct your image with. This in turn leads to better color and tone in the digital version of the continuous tone original or scene.

'Fantastic!' you say, 'No more 8-bit capture for me, I'm a 16-bit fanatic from here on in'. But there is a catch (you knew there had to be).

Despite the power and sophistication of Photoshop Elements the program only contains a limited range of editing options when it comes to 16-bits per channel files. Along with Raw file conversion, 16-bit support commenced in version 3.0 of the program. Previously when opening a 16-bit picture the program displayed a dialog warning that it didn't support the high-bit mode and then asked if you wanted to change the picture to an 8-bit form.

In these recent versions of the program the Rectangular and Elliptical Marquee and Lasso, Eyedropper, Move and Zoom tools all function in 16-bit mode. In addition, you can rotate, resize, apply auto levels, auto contrast or auto color correct, or use more manual controls such as Levels, Shadow/Highlights and Brightness/Contrast features. The Sharpen, Noise, Blur and Adjustment filter groups also work here as well.

Does this mean that making enhancement changes in 16-bit mode is unworkable? No, you just need to use a different approach. Read on.

Global versus local enhancement

Capture commandment >> If you want the

best quality pictures always make sure that your scanner or camera captures in 16-bit

On most cameras this is referred to as the 'Tiff' or 'Raw' setting. See technique 2.10

per channel or 48-bit mode.

for more details on Raw files.

Because of the limitations when working with a 16-bits per channel file in Elements some digital photographers break their enhancement tasks into two different sections – global and local.

Global, or those changes that are applied at the beginning of the process to the whole picture. These include general brightness and contrast changes, some color correction and the application of a little sharpening.

Local changes are those that are more specific and are sometimes only applied to certain sections of the picture. They may include dodging and burning in, removal of unwanted dust and scratches, the addition of some text and the application of special effects filters.

This separation of enhancement tasks fits neatly with the way that the 16-bit support works in Photoshop Elements. Global changes can be applied to the photograph whilst it is still in 16-bit mode; the file can then be converted to 8 bits per channel (Image > Mode > 8 Bits/channel) and the local alterations applied. This is the process that the professionals have been using for years and now Elements gives you the power to follow suit.

The advantages of 16-bit or high-bit capture

Here are the main advantages in a nutshell:

- 1. Capturing images in high-bit mode provides a larger number of colors for your camera or scanner to construct your image with. This in turn leads to better color and tone in the digital version of the continuous tone original or scene.
- 2. Global editing and enhancement changes made to a high-bit file will always yield a better quality result than when the same changes are applied to a low-bit image.
- 3. Major enhancement of the shadow and highlight areas in a high-bit image is less likely to produce posterized tones than if the same actions were applied to a low-bit version.
- 4. More gradual changes and subtle variations are possible when adjusting the tones of a high-bit photograph using tools like Levels than is possible with low-bit images.

Common high-bit misconceptions

- 1. Elements can't handle high-bit images. Not true. Previous versions of the program couldn't handle high-bit pictures, but since Elements 3.0 the program has contained a reduced feature set that can be used with 16-bits per channel images. And even with this limitation there are enough tools available to ensure quality enhancement of your images.
- 2. High-bit images are too big for me to handle and store. Yes, high-bit images are twice the file size of 8-bit images and this does slow down machines with limited resources, but if this is

16-bit We	orkflow		
Set camera or scanner to 16 bits per channel or 48-bit mode	Set camera to Raw file format		
Photograph scene			
Download or import file to the Elements' Organizer workspace with Adobe Photo Downloader			
	Open photo in the Adobe Camera Raw feature		
Open photo in the Standard Editor	Adjust settings to 16-bit PSD file		
workspace	Convert and pass photo from Camera Raw to the Full Edit workspace		
Perform basic cropping and orientation changes with the Crop tool			
Alter contrast with the Levels or Shadows/Highlights features			
Adjust brightness using the Levels or Shadows/Highlights features			
Remove color casts by adjusting Levels settings in individual color channels			
Apply basic sharpening using the Unsharp Mask filter			
Save a 16-bit archive version of the file			
Convert to 8 bit	s per channel		
Remove dust and scratches with Spot Healing Brush			
Dodge and burn specific picture parts			
Apply filter changes			
Add text			
Add image or adjustment layers			
Save a finished 8-bit working version of the file			

21

a concern put up with the inconvenience of a slow machine whilst you make tonal and color changes then convert to a speedier 8-bit file for local changes.

3. I can't use my favorite tools and features in high-bit mode so I don't use high-bit images at all. You are loosing quality in your images needlessly. Perform your global edits in 16-bit mode and then convert to 8-bit mode for the application of your favorite low-bit techniques.

Ensure quality capture and enhancement with 16-bit and Raw files

- 1. Unless space is an issue capture all images in the highest color depth possible. This will help to ensure the best possible detail, tone and color in your pictures.
- 2. If you have a camera that can capture Raw files then ensure that this feature is activated as well, as it provides the best quality files to work with.

Digital shooting technique

With the basics out of the way let's now look at how to manipulate some of your camera's technology in order to create the best digital files possible.

Exposure

Good exposure is one of the cornerstones of great imaging. Whether it be traditional silver-based photography, or the new pixel-centered picture making, getting your exposure right will ensure that you capture the most information possible.

Photographs that result from the sensor receiving too much light are said to be 'overexposed'. They typically have little or no details in the highlight portions of the image and the mid tone regions are far too bright. In contrast, pictures that have been captured with too little light are referred to as being 'underexposed'. In these images it is the shadow areas that lose details and in this scenario the mid tones are too dark.

The perfect exposure will produce a picture that contains:

- A good spread of tones from light to dark,
- Details in the shadow areas, and
- Details in the highlight areas.

For most shooters, exposure is something that the camera does automatically. You frame the image in the viewfinder, or via the preview screen, push the button down halfway and the camera focuses and adjusts the exposure for the scene. Push the button down fully and the image is captured using the exposure settings selected by the camera.

22

Generally speaking, letting the camera do the work produces great results, but in some circumstances where the lighting is a little tricky, the 'auto' exposure route can result in images that are either 'under' or 'over' exposed. It's here that the photographer needs to 'step in' and make some adjustments to the exposure settings. Modern cameras have a range of features designed to override the camera's auto exposure settings.

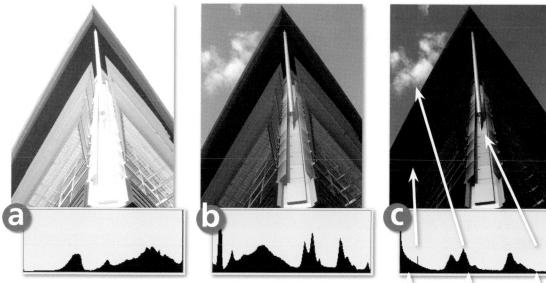

Over- and underexposure >> The cornerstone of all good photography is accurate exposure. (a) Overexposed images are too light and lose details in the highlights and mid tone areas. (b) Well-exposed pictures have a good distribution of tones over a range from dark to light. (c) Underexposed images have little or no shadow detail as these areas are converted to pure black.

Shadows Highlights Mid tones

Exposure control

Two devices – the **shutter** and the **aperture** – control the amount of light that hits your camera's sensor.

The shutter is either an electrical or mechanical device that controls the length of time that the light falls upon the sensor. The longer the shutter is 'open' the more exposure the sensor will receive and, conversely, the shorter the shutter speed the less exposure is received. Shutter speeds have traditionally been measured in fractions of a second and are represented by a number sequence of halves and doubles. With some cameras, one step either way in the sequence is referred to as a change of a 'full stop', other modes step in 1/2 or 1/3 stops, and so multiple steps will be needed to make a full stop change in exposure.

The aperture works in a similar way to the iris in your eyes. The amount of light hitting the sensor, or entering your eye, is controlled by the size of the aperture, or iris, hole. Using a large hole will transmit more light than when a small aperture is in place. Again a series of numbers represent a doubling or halving of the amount of light entering through a given aperture.

Book resources at: www.adv-elements.com

CAMERA TECHNIQUES

SCANNER AND

This sequence is called F-stops and causes some confusion with new camera users as the scale equates the biggest aperture hole with the smallest F-stop number.

By varying the combination of aperture and shutter speed the camera, or photographer, can adjust the amount of light entering the camera to suit the sensitivity of the sensor. In bright conditions it is normal to use a fast shutter speed coupled with a large aperture number (small hole). Conversely, in low light situations a slow shutter speed and small aperture number (large hole) would be selected.

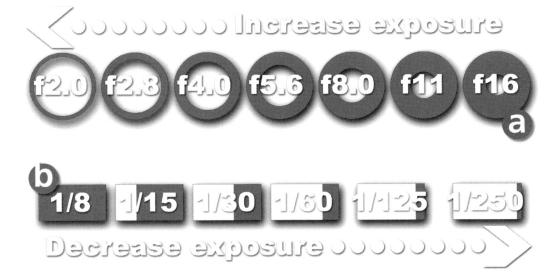

Mechanics of exposure >>> Aperture and shutter in combination control the amount of light that hits the sensor. (a) The aperture opens to allow more light into the camera and closes to reduce exposure. (b) The length of time the shutter is opened is displayed in fractions of a second. In addition to these mechanisms controlling exposure they also change the way that the photo looks. The aperture also controls the depth of field or zone of focus in the photo and the shutter manipulates how motion or movement is recorded.

2.03 Exposure compensation

Suitable for Elements – 5.0, 4.0, 3.0, 2.0, 1.0 \mid Difficulty level – Intermediate Related techniques – 2.02

One of the real advantages of photographing digitally is the ability to review your efforts immediately after shooting via the built-in screen on the back of the camera. With this tool it is easy to determine the times when the auto exposure system is producing images that are not quite the perfect exposure. When this occurs you can increase or decrease the amount of light reaching the sensor by using the Exposure Compensation feature.

This control effectively changes the shutter speed or aperture selected in steps of a third of an F-stop (sometimes also called EV – exposure value). Most cameras allow changes of up to plus,

or minus, 3 stops. In tricky lighting scenarios I generally shoot a test image, review the results, adjust my exposure compensation settings and shoot again. I continue this process of shooting and reviewing until I am satisfied with the exposure.

A more precise way to determine over- or underexposure is to consult the histogram display of your camera. The histogram can be accessed from your camera's playback menu and it visually graphs the spread of the pixels in the image. This feature takes the guesswork out of determining whether your image has exposure problems.

A bunching of pixels to the left-hand end of the graph usually indicates underexposure and the need for more light, whereas a grouping to the right signals overexposure and requires a reduction in either the aperture or shutter speed setting.

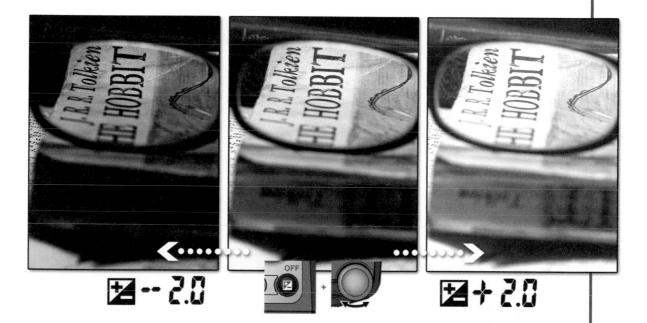

Exposure compensation >> Many digital cameras contain a special feature that can be used to modify your exposure settings without altering the aperture or shutter speed values directly. This Exposure Compensation control allows you to increase or decrease the overall exposure of the picture.

Frame-by-frame control

Apart from the absence of film, the typical digital camera has many familiar features. Experienced shooters on the whole have no difficulty understanding technology such as the shutter, aperture, or ISO sensitivity as these options have their traditional counterparts, but most new digital cameras contain several often overlooked functions that are designed to help you produce the 'ultimate images – shot by shot'.

Book resources at: www.adv-elements.com

CAMERA TECHNIQUES

SCANNER AND

Some of these features include:

- Contrast control,
- · Saturation adjustment, and
- In-built Sharpness control.

These controls are now found on all but the most basic entry-level models and provide a level of flexibility that was never possible in the days when 'film was king'.

2.04 Contrast

Suitable for Elements - 5.0, 4.0, 3.0, 2.0, 1.0 | Difficulty level - Basic

The contrast control is one of the most useful features for the digital camera owner. When you are faced with shooting a beach, or snow scene, on a sunny day the range of brightness between the lightest and darkest areas can be extremely wide. Set to normal your camera's sensor will probably lose detail in both the highlight and shadow areas of the scene. Delicate tones will either be converted to white or black. Changing the setting to 'less contrast' will increase your camera's ability to capture the extremes of the scene and preserve otherwise lost light and dark details.

In the opposite scenario, sometimes your subject will not contain enough difference between shadows and highlights. This situation results in a low contrast or 'flat' image. Typically, pictures made on an overcast winter's day will fall into this category. Altering the camera's setting to 'more contrast' will spread the tonal values of the scene over the whole range of the sensor so that the resultant picture will contain acceptable contrast.

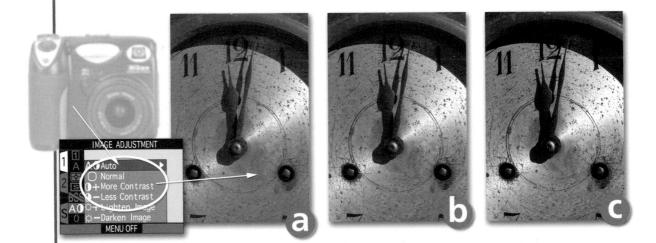

In-camera contrast adjustment >> Altering the way that your camera records the contrast or the extremes of brightness in a scene can help to ensure that you capture important highlight and shadow details.
 (a) Less contrast setting.
 (b) Normal contrast setting.
 (c) More contrast setting.

'How do I know if my scene has either too much or too little contrast?' The beauty of shooting digitally is that we can preview our image immediately. In particular check the shadow and highlight areas using the camera's histogram feature. If the display contains pixels bunched at either end of the graph then the picture is too contrasty and will warrant a contrast change and a re-shoot. Pixels concentrated in a group in the center of the graph indicate an image that is too flat and needs to be re-shot using a higher contrast setting.

Pro's Tip: Contrast correction that is applied via your favorite image editing software package is possible and often used, but it is always preferable to capture the image with the best contrast at the time of shooting. This will guarantee you are making images of the best quality.

2.05 Color saturation

Suitable for Elements – 5.0, 4.0, 3.0, 2.0, 1.0 Difficulty level – Basic

The saturation, or vividness, of color within your images can either make or break them. Sometimes

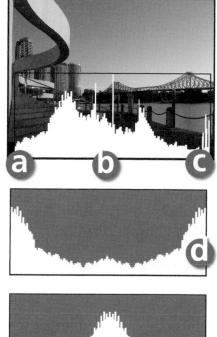

Histograms >> Mid to high range cameras usually contain a Histogram function which displays the spread of the tones in the image. This feature is very useful for determining if a picture is exposed correctly or contains too much or too little contrast. (a) Shadow tones. (b) Middle tones. (c) Highlight tones. (d) High contrast picture. (e) Low contrast picture.

color is the cornerstone of a picture, providing both the focal point and the design for the whole photograph. In these circumstances, desaturated or pastel hues will only serve to weaken the strength of the picture. In contrast, strong color elements can distract from important subject matter, causing the viewer to concentrate on the color rather than the subject of the picture.

Digital shooters can take more control of the color content of their images by selecting just how dominant or vivid the hues will be in their pictures. For shots that rely on their color the vividness can be increased; for those that work more effectively with subdued hues, the color strength can be reduced by way of the camera's saturation control.

Again, the effectiveness or suitability of each setting should be previewed and if necessary, several images with different color settings can be captured and the final choice made later. Though not as critical for retention of details as the contrast settings, it is important to capture as much color information as possible when shooting. This does not mean that you shoot all

CAMERA TECHNIQUES

SCANNER AND

subjects with maximum saturation; it is just a reminder that if color is important, consider changing the saturation settings to suit your needs and your picture.

Pro's Tip: Always shoot in Color mode even if the photograph is to be used as a black and white. The picture can easily be converted to black and white in your image editing program at any time and you have the advantage of a color version if ever you need it.

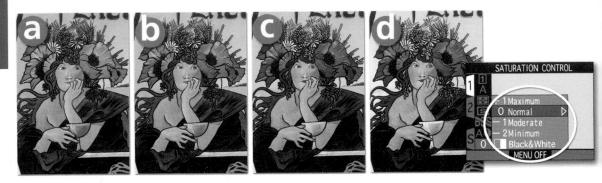

In-camera saturation adjustment >> Using the saturation control in your camera you can alter the strength of the colors in your pictures. (a) Black and white. (b) Minimum saturation setting. (c) Normal saturation setting. (d) Maximum saturation setting.

2.06 Image sharpness

Suitable for Elements – 5.0, 4.0, 3.0, 2.0, 1.0 | Difficulty level – Basic

The digital equivalent of film is a grid of sensors situated behind the lens in your camera. Each of these sensors records the light and color of the image that is focused upon it. In doing so a digital version of the scene is constructed. Despite the high resolution of modern sensors and specially developed lenses, the final image contains a degree of softness that is the direct result of this capturing process.

To help create crisper images the camera manufacturers include in-camera sharpening as one of their auto enhancement tools. Designed to improve the appearance of sharpness across the picture these features enhance the edge of objects by increasing the difference in tones between adjacent pixels. Sound confusing? Just remember that the act of sharpening changes the pixels in your image and just like the other image enhancement tools, too much sharpening can destroy you picture.

How do I know what settings to use? There are two schools of thought for deciding when and where to apply sharpening to your images. Some shooters apply a little sharpening in-camera, using either the minimum or auto setting. Others prefer to leave their images untouched and will use the sharpening tools built into their favorite image editing program to enhance their pictures. I lean towards the second option, as it offers me the greatest control over the sharpening effects and where they occur in my photographs.

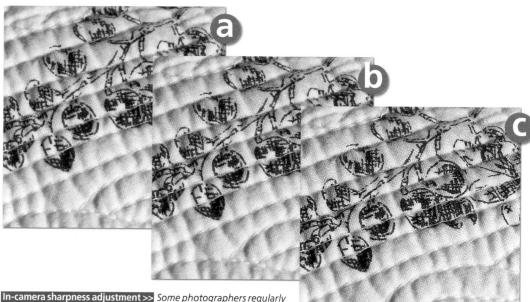

In-camera sharpness adjustment >> Some photographers regularly apply in-camera sharpening to their pictures, but I prefer to leave this task until the images are loaded into Elements where I have more control. (a) No sharpening applied. (b) Normal sharpening setting. (c) Maximum sharpening setting.

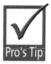

Pro's Tip: When sharpening in your editing program always view the image to be sharpened at 100% so that you can see the effects of the filter at the magnification that the picture will be used at.

2.07 White balance control

Suitable for Elements - 5.0, 4.0, 3.0, 2.0, 1.0 | Difficulty level - Basic

Our eyes are extremely complex and sophisticated imaging devices. Without us even being aware they adjust automatically to changes in light color and level. For instance, when we view a piece of white paper outside on a cloudy day, indoors under a household bulb or at work with fluorescent lights, the paper appears white. Without realizing it our eyes have adapted to each different light source.

Unfortunately digital sensors, including those in our cameras, are not as clever. If I photographed the piece of paper under the same lighting conditions, the pictures would all display a different color cast. Under fluorescent lights the paper would appear green, lit by the household bulb (incandescent) it would look yellow and when photographed outside it would be a little blue. This situation occurs because camera sensors are designed to record images without casts in daylight only. As the color balance of the light for our three examples is different to daylight, that is, some parts of the spectrum are stronger and more dominant than others, the pictures record with a cast. The color of the light source illuminating the subject in your picture determines the cast that will result.

When is white light not white? >> The color of white light varies from source to source. Our eyes adjust to these changes but the camera will record the differences as a color cast in your pictures. The White Balance feature is designed to rid your images of these casts. (a) Candle. (b) Household bulb. (c) Daylight. (d) Flash. (e) Cloud. (f) Skylight (no sun). (g) White fluorescent. (h) 'Daylight White' fluorescent. (i) 'Daylight' fluorescent.

Traditional shooters have been aware of this problem for years and because of the limitations of film, most photographers carried a range of color conversion filters to help change the light source to suit the film. Digital camera producers, on the other hand, are addressing the problem by including White Balance functions in their designs. These features adjust the captured image to suit the lighting conditions it was photographed under. The most basic models usually provide automatic white balancing, but it is when you start using some of the more sophisticated models that the choices for white balance correction can become a little confusing.

Most modern digital cameras provide a vast array of options that should have you shooting 'castfree' in any lighting conditions. The selections include:

- Auto,
- · Fine or Daylight,
- Incandescent,
- Fluorescent,
- Cloudy,
- Speed light or Flash, and
- White Balance Preset.

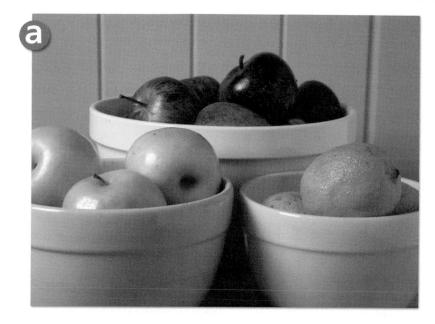

31

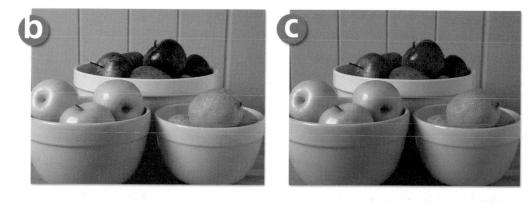

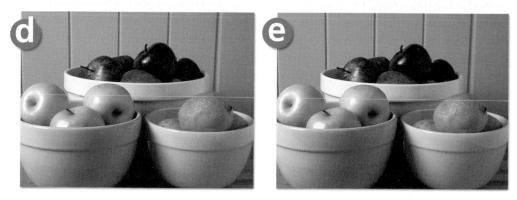

Color casts from different light sources >> Camera sensors are balanced for daylight. Shooting pictures under nondaylight light sources will result in the color casts we see above. (a) Daylight. (b) Fluorescent. (c) Household bulb or incandescent. (d) Flash. (e) Cloudy day.

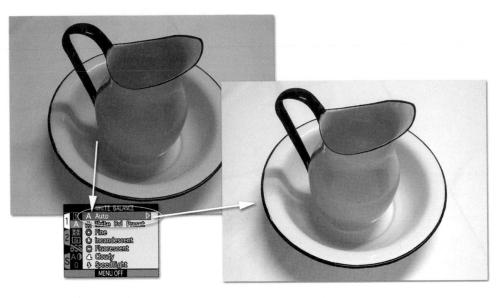

Auto white balance >>> The modern digital camera has a highly developed auto white balance system. It performs well under most lighting scenarios and should be your first choice when shooting under difficult conditions.

Auto white balance

The Auto function assesses the color of the light in the general environment and attempts to neutralize the mid tones of the image. As with most 'auto' camera features, this setting works well for the majority of 'normal' scenarios. The feature does a great job with scenes that contain a range of colors and tones, but you may strike some difficulty with subjects that are predominantly one color, or are lit from behind. Also keep in mind that some subjects, such as cream lace, are meant to have a slight color shift and the use of the Auto feature in this case would remove the subtle hue of the original.

Apart from these exceptions most cameras' Auto features produce great results that require little or no post-shooting color correction work. So it's my suggestion that if in doubt try the Auto setting first. Check the results on the preview screen of the camera and if there is a color cast still present then move on to some more specific white balance options.

Light source white balance settings

The Daylight (Fine), Incandescent, Fluorescent, Cloudy and Flash (Speed light) options are designed for each of these light types. The manufacturers have examined the color from a variety of each of these sources, averaged the results and produced a white balance setting to suit. If you know the type of lighting that your subject is being lit by, then selecting a specific white balance setting is a good move.

Again, for the majority of circumstances these options provide great results, but for those times when the source you are using differs from the 'norm', companies like Nikon have included a fine-tuning adjustment. With the light source set the command dial is turned to adjust the color settings.

Book resources at: www.adv-elements.com

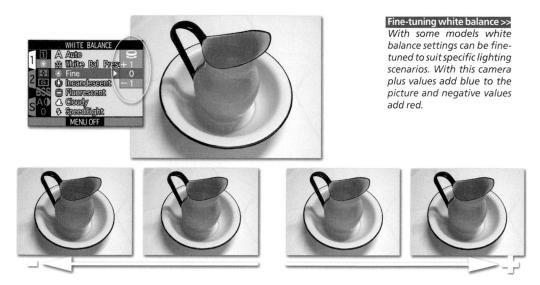

For Daylight, Incandescent, Cloudy and Flash options selecting positive values will increase the amount of blue in the image. Alternatively, negative numbers will increase the red content.

If you have selected Fluorescent as your light source then the Fine-tuning feature will allow you to select one of three different white balance settings. FL1 is suitable for tubes marked 'white', FL2 should be used with 'Daylight White' fluorescents and FL3 is

for those labelled 'Daylight'.

2.08 Applying fine-tuning automatically

Suitable for Elements - 5.0, 4.0, 3.0, 2.0, 1.0 | Difficulty level - Intermediate Related techniques - 2.07

If you are like me and find manually fine-tuning hampers the flow of your photography – shoot, stop, switch to menu, fine-tune white balance, shoot again, stop, switch to menu ... you get the idea - then check to see if you camera has an Auto White Balance Bracketing option. This feature automatically shoots a series of three images starting with the standard white balance settings and then adding a little blue and finally a little red.

I find white balance bracketing particularly useful when shooting difficult subjects like the hand blown colored glass in the example. As three separate images are saved I can make decisions about the most appropriate color by previewing them on my work station's large color calibrated monitor later rather than the small preview screen on the back of my camera in the field.

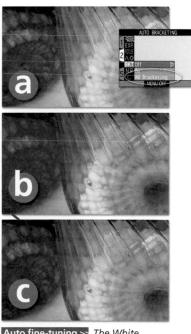

Auto fine-tuning >> The White Balance Bracketing option automatically captures several pictures with slightly different color settings. (a) Standard setting. (b) + Red. (c) + Blue.

33

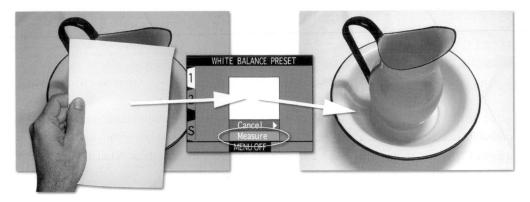

Preset white balance options >> You can obtain a precise white balance setting under mixed lighting conditions by using the Preset or Customize option in your camera. When the feature is activated the camera will analyse a white (or mid gray) card in the scene, neutralize any casts that are present and set the white balance according to the analysis. The images now photographed with this preset white balance setting will be cast-free.

2.09 Customizing your white balance

Suitable for Elements – 5.0, 4.0, 3.0, 2.0, 1.0 | Difficulty level – Intermediate | Related techniques – 2.07, 2.08 In a perfect world the scene you want to shoot will always be lit by a single source. In reality most scenarios are illuminated by a variety of different colored lights. For instance, what seems like a simple portrait taken in your lounge could have the subject partially lit by the incandescent lamp stand in the corner, the fluorescent tube on the dining room ceiling and the daylight coming through the windows. Because of the mixed light sources a specific white balance setting is not appropriate. Instead, you should use the customize, or preset, white balance option on your camera.

Based on video technology, this feature works by measuring the light's combined color as it falls onto a piece of white paper. The camera then compares this reading with a reference white swatch in its memory and designs a white balance setting specifically for your shooting scenario. With the process complete you are now set to shoot your portrait secure in the knowledge that you will produce cast-free images. Always remember though, because this is a customized process if you decide to turn a light off, or move your subject to another position in the room, then you will need to remeasure and reset you white balance.

This way of working is by far the most accurate way to correct the color casts resulting from mixed lighting sources in your pictures.

It takes into account changes in color that result from:

- · Light reflecting off brightly painted walls,
- Bulbs getting older,
- · Mixed light sources,
- · Light streaming through colored glass, and
- Shooting through colored filters.

2.10 Shooting Raw for ultimate control

Suitable for Elements - 5.0, 4.0, 3.0, 2.0, 1.0 | Difficulty level - Intermediate | Related techniques - 2.02 More and more medium to high end cameras are being released with the added feature of being able to shoot and save your pictures in Raw format. For most users this option on the camera's file menu has no real significance, but there are a growing number of photographers who having tried the new file type vow never to go back to using any other format. They boast of the extra quality and control that is achievable when using Raw for their image making and probably most impressive of all often refer to images in this format as being the closest thing to a digital 'negative' that we have yet seen. But why all this talk about Raw? What does the term actually mean and how can it help me take better pictures?

Back to the beginning

To start to understand the importance of Raw formats we need to go back to the beginning of the capture process. All single shot digital cameras (except those using the Foveon chip) contain a sensor that is made up of a grid of light-sensitive sites. Each site responds to the amount of light that hits its surface. By recording and analysing each of these responses a tone is attributed to each sensor site in the grid. In this way a digital picture can be created from the range of scene brightnesses that are focused through the lens onto the sensor's surface. Fantastic though this is, this process only results in a monochrome (black, white and gray) picture as the CCD or CMOS sensors by themselves cannot record the color of the light, only the amount.

To produce a digital color photograph a small filter is added to each of the sensors. In most cameras these filters are a mixture of the three primary colors red, green and blue and are laid out in a special design called a Bayer pattern. It contains 25% red filters, 25% blue and 50% green with the high percentage of green present in order to simulate the human eye's sensitivity to this part of the visible spectrum. In their raw, or unprocessed, format the output from these sensors is made up of a grid of red, green and blue patches (pixels) of varying tones. And yes this does mean that in any individual picture only 25% of the sensor sites are actually capturing information about the red or blue objects in the scene.

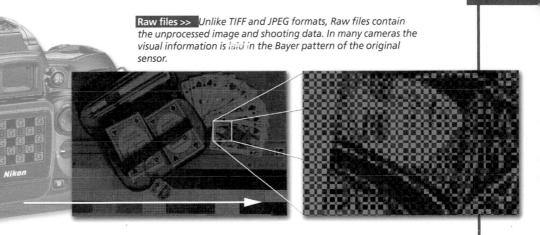

SCANNER AND CAMERA TECHNIQUES

Interpolated color

I hear you saying 'But the images that I download from my camera are not split into discrete RGB colors'. This is true. What emerges from the camera is a full color picture which contains 100% red, 100% blue and 100% green pixels. This occurs because as an integral part of the capture process the raw RGB data that comes from the sensor is interpolated to create a full color image. Using special algorithms, the extra detail for a non-red site, for instance, is created using the information from the surrounding red, green and blue sites. This process is called interpolation and though it seems like a lot of 'smoke and mirrors' it works extremely well on most cameras.

When you opt to save your images in JPEG or TIFF formats this capture and interpolation process happens internally in the camera each time you push the shutter button. In addition your camera will also reduce the number of colors and tones from the 16-bit color depth that was captured to the 8 bits that are stored in the file. Selecting a Raw format stops the camera from processing the color-separated (primary) data from the sensor and reducing the image's bit depth, and saves the picture in this unprocessed format. This means that the full description of what the camera 'saw' is saved in the image file and is available to you for use in the production of quality images.

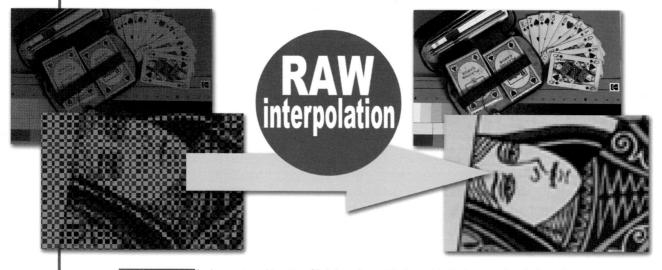

Raw images >>> The image stored in a Raw file is based upon the base data that comes directly from the sensor and needs to be interpolated to create the full color digital file we normally associate with camera output.

DIY Raw processing

Sounds great, doesn't it? All the quality of an information-rich image file to play with, but what is the catch? Well, Raw files have to be processed before they can be used in a standard image editing application. To access the full power of these digital negatives you will need to employ a special dedicated Raw editor. Photoshop Elements 3.0 was the first version of the program to have such an editor built into the program. Called Adobe Camera Raw this feature is designed

specifically to allow you to take the unprocessed Raw data directly from your camera's sensor and convert it into a usable image file format. Chapter 3 is dedicated to the processing of raw files using Photoshop Elements.

The Elements Raw editor also provides access to several image characteristics that would otherwise be locked into the file format. Variables such as color depth, White Balance mode, image sharpness and tonal compensation (contrast and brightness) can all be accessed, edited and enhanced as a part of the conversion process. Performing this type of editing on the Raw data provides a better and higher quality result than attempting these changes after the file has been processed and saved in a non-Raw format such as TIFF or JPEG.

So what is in a Raw file?

To help consolidate these ideas in your mind try thinking of a Raw file as having three distinct parts:

Camera Data, usually called the EXIF or metadata, includes things such as camera model, shutter speed and aperture details, most of which cannot be changed.

Image Data which, though recorded by the camera, can be changed in the Elements Raw editor and the settings chosen here directly affect how the picture will be processed. Changeable options include color depth, white balance, saturation, distribution of image tones and application of sharpness.

The **Image** itself. This is the data drawn directly from the sensor in your camera in a non-interpolated form. For most Raw-enabled cameras, this data is supplied with a 12- or 16-bits per channel color depth providing substantially more colors and tones to play with when editing and enhancing than found in a standard 8-bits per channel camera file. Camera Data

(f-stop, shutter speed, ISO, camera exposure mode, focusing distance etc)

Image Data

(white balance, sharpening, colour mode, tonal compensation)

mage

full 16 or 12bit colour and tone

Raw files make-up >> The Raw file is composed of three separate sections: Camera Data, Image Data and the Image itself. By keeping these components separate it is possible to edit variables like white balance and color mode which are usually a fixed part of the file format. SCANNER AND CAMERA TECHNIQUES

Raw processing in action

When you open a Raw file in Elements 5.0 you are presented with the Adobe Camera Raw dialog containing a full color interpolated preview of the sensor data. Using a variety of menu options, dialogs and image tools you will be able to interactively adjust image data factors such as tonal distribution and color saturation. Many of these changes can be made with familiar slider controlled editing tools normally found in features like Levels and the Shadows/Highlights control. The results of your editing can be reviewed immediately via the live preview image and associated histogram graphs.

Zoom, Move, Highlight Evedropper clipping Clipping Shadow clipping Adjust/Detail tabs tools warnings warning warning Nikon D10 - OSC 0027.NEF (ISO 200, 2,50, 1/27, 18-70@18.0 mm 20100 Previes Shad Highlig R Histogram Settings selections White Balance: As Shot × Set Camera Default 4800 Temperature Color -4 Tint temperature and tint Auto -0.70 Exposure control Shadow control Auto 3 Shadow Brightness control Brightness Auto Contrast control Contrast Auto +33 Saturation control Saturation 0 6 Cancel - + 22.4% Save. Help Open -Depth: 8 B. Channe Zoom level Color Preview of and Preview depth conversion

Adobe Camera Raw dialog >> When you open a Raw file in Elements the Adobe Camera Raw editor is activated providing you with a range of sophisticated controls for the enhancement and conversion of your Raw files. After making your changes, you click Open, the plug-in closes and the converted file is placed into the Elements workspace. (a) Adjust Tab options. (b) Detail Tab options.

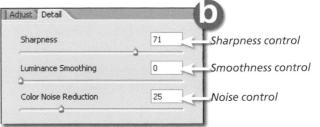

Book resources at: www.adv-elements.com

38

CAMERA TECHNIQUES

SCANNER AND

Rotate

buttons

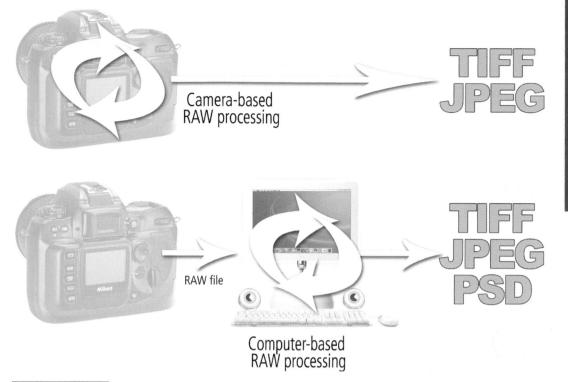

Capture workflow >> Selecting JPEG or TIFF as your picture's file format means that the image processing is handled by the camera. In contrast choosing the Raw format removes this task from the camera and places it firmly with you and your computer. Working this way means that you have a say in decisions about white balance, contrast, brightness, sharpness and color mode.

After these general image editing steps have taken place you can apply some enhancement changes such as filtering for sharpness, removing color noise and applying some smoothing. The final phase of the process involves selecting the color depth and image orientation. Clicking the OK button sets the program into action applying your changes to the Raw file, whilst at the same time interpolating the Bayer data to create a full color image and then opening the processed file into the full Elements Standard Editor workspace.

The Raw advantage

The real advantages of editing and enhancing at the Raw stage are that these changes are made to the file at the same time as the primary image data is being converted (interpolated) to the full color picture. Editing after the file is processed (saved by the camera in 8-bits per channel versions of the JPEG and TIFF format) means that you will be applying the changes to a picture with fewer tones and colors. A second bonus for the dedicated Raw shooter is that actions like switching from the white balance option selected when shooting to another choice when processing are performed without any image loss. This is not the case once the file has been processed with the incorrect white balance setting, as anyone who has inadvertently left the tungsten setting switched on whilst shooting in daylight can tell you.

For a more in-depth look at raw processing steps in Photoshop Elements go to Chapter 3.

Book resources at: www.adv-elements.com

SCANNER AND CAMERA TECHNIQUES

2.11 Shooting workflows

Having an understanding of all these camera techniques is one thing but putting them together when you are out shooting is another. To capture the most detail and in the best quality that your camera offers is a multi-step process. The following table summarizes the steps involved in three different approaches to capturing images using the techniques discussed above. The highest quality is obtained by shooting with a Raw file which is then enhanced using a dedicated editor. If your camera doesn't contain Raw capabilities then the next best option is to shoot TIFF and make your adjustments in Elements. If neither option is available then using 'best quality' JPEG will give good results.

Ree	commended Di	gital Camera W	/orkflow			
	Select highest resolution					
Before Shooting	Pick best color depth (16 bits per channel or 48-bit overall)					
	Select file format – JPEG Select file format – T		Select file format – Raw			
	Choose finest quality (least compression)	No compression	No compression			
	Set Color mode (sRGB for web work, AdobeRGB for print work)					
		Set Saturation				
	Set White balance (Either for the dominant light source or using the Customize option)					
	Arrange composition					
During Shooting	Adjust focus (Check Depth of Field)					
	Set exposure (Check Histogram)					
After Shooting	Adjust Highlig (Eler	Adjust Highlight and Shadov (Adobe Camera Raw plug-in)				
	Alter contrast (Elements)		Alter contrast (Adobe Camera Raw plug-in)			
	Remove color casts (Elements)		Remove color casts (Adobe Camera Raw plug-in)			
	Apply some sharpening (Elements)		Apply some sharpening (Adobe Camera Raw plug-in)			
	Save processed file (Elements)		Save processed file (Elements)			
Image Quality	Good	Better	Best			

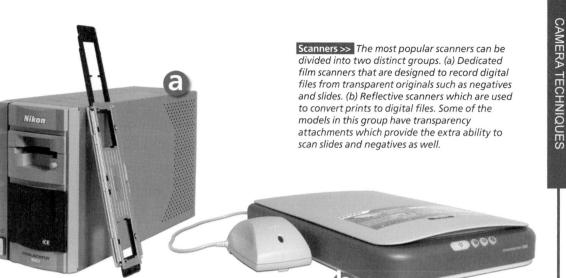

Film and print scanners

It was not too long ago that an activity like scanning was the sole responsibility of the repro house. The photographer's job was finished the moment that the images were placed on the art director's desk. But as we all know, the digital revolution has changed things for ever, and scanning is one place where things will never be the same.

Desktop scanners that are capable of high-resolution color output are now so cheap that some companies will throw them in as 'freebies' when you purchase a complete computer system. The proliferation of these devices has led to a large proportion of the photographic community now having the means to change their prints, negatives or slides into digital files. But as all photographers know, having the equipment is only the first step to making good images.

For the most part, scanners can be divided into three distinct varieties – film, print and the more recent hybrid or combination scanner.

Dedicated film – This device is set up specifically for negative or slide capture and is usually restricted to a single format (135 mm/120 mm/5 x 4 inch). The hardware is not capable of reflective scanning. If your business involves the repeated capture of images of the one film type, a dedicated scanner is a good investment.

Dedicated print – The scanners in this category are the most affordable and easily obtainable of the three types. If you can't afford a digital camera of the quality that you desire and you

SCANNER AND

have loads of prints in boxes lying around the house then spending a couple of hundred dollars here will have you enhancing high quality digital versions of your pictures in no time.

Hybrid – These scanners are capable of both reflective and transmission scanning. This means that the one device can capture both film and print images. Starting life as flatbeds with added transparency adapters, these scanners have developed into multi-function devices that are capable of producing quality files from both types of originals.

2.12 Scanning resolution – 'Know where you are going before you start the journey'

Suitable for Elements – 5.0, 4.0, 3.0, 2.0, 1.0 | Difficulty level – Intermediate Related techniques – 2.01

Just as is the case with camera-based capture, the quality of the digital picture that results from our scanning activities is based primarily on resolution and color depth. It is critical that these two factors are carefully considered before any scanning capture takes place.

Scanning resolution, as opposed to image or printing resolution, is determined by the number of times per inch that the scanner will sample your image. The number of pixels generated by a digital camera has an upper limit that is fixed by the number of sensors in the camera. This is not the case for scanner capture. By altering the number of samples taken for each inch of the original print or negative you can change the total number of pixels created in the digital file. This figure will affect both the 'enlargement' potential of the final scan and it's file size. The general rule is the higher the resolution the bigger the file and the bigger the printed size possible (before seeing pixel blocks or digital grain).

Scanning resolution (samples per inch)	Image size to be scanned	Output size (pixels)	Output size (inches for print @ 200 dpi)	File size (Mb)
4000	35 mm film frame (24 mm x 36 mm)	4000 x 6000	20 x 30	72.00
2900	35 mm	2900 x 4350	14.5 x 21.75	37.80
1200	35 mm	1200 x 1800	6 x 9	6.40
600	35 mm	600 x 900	3 x 4.5	1.62
400	5 x 4 inch print	2000 x 1600	10 x 8	9.60
1000	5 x 4 inch print	5000 x 4000	25 x 20	60.00
400	10 x 8 inch print	4000 x 3200	20 x 16	38.40

Scanning resolution > Adjusting the resolution that you scan at will directly affect the pixel dimensions of your final file. High scanning resolution will create more pixels in the files which translates into bigger prints.

Does this mean that we always scan at the highest resolution possible? The intelligent answer is NO! The best approach is to balance your scanning settings with your printing needs. If you are working on a design for a postage stamp you will need less pixels to play with than if you want your masterpiece in poster format. For this reason it is important to consciously set your scanning resolution keeping in mind your required output size. See section 2.01 for more details about resolution.

Some scanning software will give you an indication of resolution, file size and print size as part of the dialog panel but for those of you without this facility use the table on page 42 as a rough guide.

2.13 Color depth

Suitable for Elements - 5.0, 4.0, 3.0, 2.0, 1.0 | Difficulty level - Basic | Related techniques - 2.02

As we have seen already color depth refers to the number of possible colors that make up the digital file upon the completion of scanning. If you have the choice always select 16-bit scanning mode (sometimes called 48-

bit – 16 bits for red + 16 bits for green + 16 bits for blue) instead of 8-bit as this provides you with the opportunity to capture as much information from your photographic original as possible. Remember this is true even if you intend to convert these files to 8-bit immediately upon opening. The more accurately the image is scanned in the first place the better quality the down sampled file will be after the conversion has been made.

Scan in 16-bit mode >> To capture the best detail, colour and tone always scan in 16-bit mode.

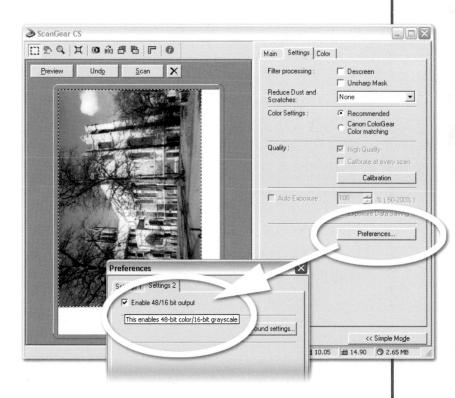

Book resources at: www.adv-elements.com

2.14 Multi-sample

Suitable for Elements - 5.0, 4.0, 3.0, 2.0, 1.0 | Difficulty level - Intermediate Scanners in the mid to high end range often contain another feature that is designed to increase the quality of digital capture, especially in the darkest parts of the negative or print. Called Multi-Sample Scanning, it is a process where the image is sampled or scanned several times and the results averaged. This approach is particularly helpful when the scanner is trying to penetrate the shadow areas of a print or the highlight parts of a negative. It is in these parts of the picture that a single pass scan will most likely provide a 'noisy' result.

You can reduce this noise by making several scans of the same area and then averaging the result. The theory is that the level of noise reduction is directly proportional to the number of samples to be averaged. Therefore machines that offer a multi-sample rate of '16x' will produce better results than those that only contain a '4x' version. The down side to the technology is that all this extra scanning and averaging does take time. For instance the Minolta Dimage Dual III set to 8x Multi-Sample can take up to 14 times

ool Palette 1	
▶ Layout Tools	
> Information	
Crop	2
	2
	Z
	2
▷ ✓ Unsharp Mask	2
Digital ICE cubed	2
Analog Gain	
Strip Film Offset Boundary Offset:	
Manual Focus Adjustment Position:	
Multi Sample Scanning	
Mode: Normal (b) M Help Normal (b) M Fine (b) Fine (b) M	
Cato Super Fine (Bx) Cato Super Fine (16x)	
here	

Multi-sample scan >> Some scanners offer the

option of 'multi-scanning' vour film original. Select this setting for the best overall capture of difficult negatives or slides, but be warned – using this feature dramatically increases your scanning time.

longer to make a high-resolution, high-bit scan of a 35 mm negative. For most well-exposed and processed negatives or prints there will be little extra quality to gain from this procedure, but for those troublesome images that seem to have areas of dark impenetrable detail using multisample will definitely produce a better overall result.

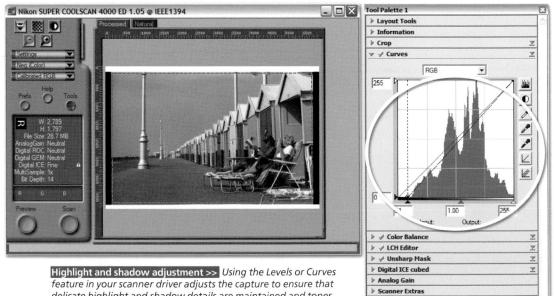

delicate highlight and shadow details are maintained and tones are well spread.

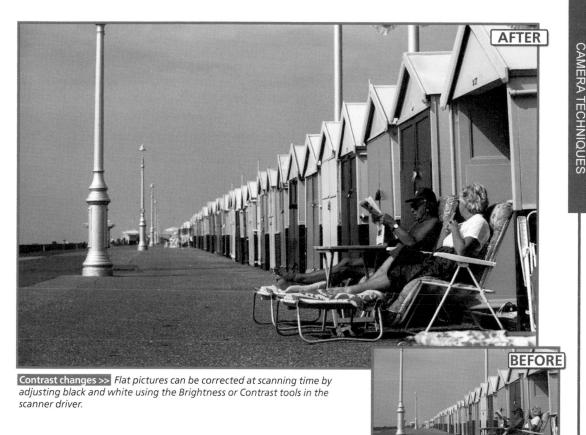

SCANNER AND

2.15 Highlight and shadow capture

Suitable for Elements - 5.0, 4.0, 3.0, 2.0, 1.0 | Difficulty level - Basic

With resolution and color depth set we can now scan the image – well almost! Just as exposure is critical to making a good photograph, careful exposure is extremely important for achieving a good scan.

All but the most basic scanners allow some adjustment in this respect. Preview images are supplied to help judge exposure and contrast, but be wary of making all your decisions based on a visual assessment of these often small and pixelated images. If you inadvertently make an image too contrasty then you will lose shadow and highlight detail as a result. Similarly, a scan that proves to be too light or dark will also have failed to capture important information from your print or film original.

It is much better to adjust the contrast, sometimes called gamma, and exposure settings of your scan based on more objective information. For this reason a lot of desktop scanner companies provide a method of assessing what is the darkest, and lightest, part of the image to be scanned. Often looking like the Info palette in Elements these features give you the opportunity to move

ool Palette 1		
Layout Tools		
Information		
▹ Crop		⊻
V V Curver		Y
		Z
Brightness:		
Contrast: 4	- ;	Þ 0
Red: 4	J	-18
Green: 4	— J——	
b.e. 1	· }	
▶ ✓ LCH Editor		Z
🕨 🖉 Unsharp Mask		⊻
Digital ICE cubed		Z
Analog Gain		
Scanner Extras		

Color cast correction >>> Color casts can be removed from scanned originals using the slider controls found in the scanner driver.

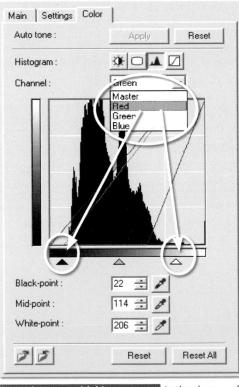

Removing casts with histograms >> In the absence of dedicated cast removal sliders careful adjustment of the histogram for each channel can achieve the same results.

Book resources at: www.adv-elements.com

around the preview image pegging the highlight and shadow areas. Other scanner drivers include their own version of the histogram, which you can use to diagnose and correct brightness and contrast problems. With these tools you can set the black and white points of the image to ensure that no details are lost in the scanning process.

For those readers whose scanning software doesn't contain this option, try to keep in mind that it is better to make a slightly flat scan than risk losing detail by adjusting the settings so that the results are too contrasty. The contrast can be altered later when you edit the picture in Elements.

2.16 Color cast correction

Suitable for Elements – 5.0, 4.0, 3.0, 2.0, 1.0 Difficulty level – Intermediate

Despite our best abilities some photographs are captured with a dominant color cast that pervades the whole picture. Using the scanner driver's own color adjustment feature you can neutralize this tint at the time of capture. Frequently the scanner software provides a before and after thumbnail of you color adjustments so that you can preview your changes before committing the final settings. Now when the picture is scanned the color balance is adjusted and the color cast removed.

It is true that this process can be handled by Elements using the Color Cast or Color Variations features but, as we have already seen with the camera techniques above, the best quality images are generated when adjustments such as these are made at the capture stage.

2.17 Dust and scratches

Suitable for Elements – 5.0, 4.0, 3.0, 2.0, 1.0 Difficulty level – Basic

One of the hidden enemies of quality scans is dust. Though the presence of dust won't reduce the ability of the scanner to record highlight and shadow detail accurately it does decrease the overall quality of the file because the affected area must be retouched later in Elements. No matter how proficent the retouching is, the 'rebuilt' section of the picture that is created to cover the dust mark will never be the same as the detail that existed in the original negative, slide or print. More important, especially for the photographer with hundreds of scans to complete, is the massive amount of time needed to retouch these dusty areas.

Some scanner models will include features designed to remove dust (and scratches) automatically from the picture during the scanning process. This technology when applied carefully can produce truly amazing results. One example is the Digital ICE technology produced by Applied Science Fiction (www.asf.com). Unlike post-capture processing where the dust mark is covered over using samples of other picture detail that surrounds the area, ICE isolates the marks during

BEFORE Digital ICE cubed V Enable Digital ICE On (Normal) Y Enable Post Processing Digital ROC: 4 5 J Digital GEM: > 3 Redraw AFTER

Auto dust removal >> Features like ASF's Digital ICE can remove dust and scratch marks automatically at the time of scanning. (a) Before Digital ICE. (b) After Digital ICE.

the scanning process and then proceeds to erase the defects from the picture. As the process is directly linked to the scanning hardware the Digital ICE technology cannot be applied to a dust affected image after it has been captured.

If you are considering buying a scanner then it is worth considering a make and model that incorporates the ASF Digital ICE feature. It's true that the defect detecting and erasing processes do add to the overall scanning time, but the retouching time saved more than makes up for it.

CAMERA TECHNIQUES

SCANNER AND

2.18 Noise Reduction technologies

Suitable for Elements – 4.0, 3.0, 2.0, 1.0 | Difficulty level – Basic

As part of the process of scanning an image, visual errors are introduced into the file that were not part of the original. This is true to varying degrees for both entry level and high end scanners. The most noticeable of these errors is called noise and usually shows up in shadow or highlight areas of the picture as brightly colored random pixels or speckles. Image noise can be caused by a variety of factors including high speed film grain (high ISO), under- or overexposed negatives or slides, lighting conditions with brightness extremes, and image enlargement, as well as the CCD sensor itself. At worst, high levels of noise within a picture cause the image to appear unsharp and less detailed and have the potential to distract a viewer's attention away from the content of the image. To help correct or, more accurately, minimize the impact of noise

Cameras and noise

Scanners are not the only capture devices that can introduce noise into a digital photograph. The sensors in cameras can suffer from the same problems as those found in scanners.

Generally, noise is at its worst in photographs

taken with high ISO (equivalent) settings or when the shutter speed is longer than one second.

To help remove the noise camera-captured in pictures ASF also produces a plug-in version of their GEM software that can be activated via the Filter menu in Elements. This version of the software provides a little more control than that provided as part of the scanner driver as it allows separate adjustments for highlight and shadow noise as well as a slider control to alter the sharpness of the picture.

Alternatively, Elements versions 5.0 contains the Reduce Noise filter (Editor: Filter > Noise > Reduce Noise). As with the GEM plug-in the filter contains several sliders that help balance noise removal and overall sharpness of the processed picture. in our digital photographs scanner manufacturers like Kodak, Minolta, Nikon and Umax have banded together with software producer Applied Science Fiction(www.asf.com) to include ASF's Digital GEM product in their scanning software. GEM reduces image noise and grain during the scanning process and should be used when standard scanner settings produce noisy results.

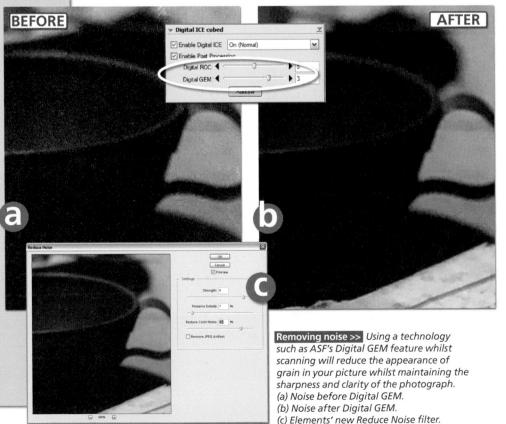

Book resources at: www.adv-elements.com

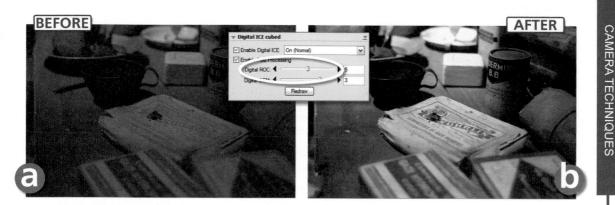

Recreation of color >> ASF's Digital ROC feature recreates the color lost in original pictures due to fading or incorrect color balance at the time of shooting. (a) Before and (b) after color regeneration.

2.19 Color regeneration features

Suitable for Elements - 5.0, 4.0, 3.0, 2.0, 1.0 | Difficulty level - Basic

The last feature in the Applied Science Fiction trinity of scanning products is Digital ROC. Starting life as a feature designed specifically for use in the restoration of faded negatives or prints, many scanner operators now regularly leave the ROC option turned on for their nonrestoration jobs as well. It provides a fast and effective way to automatically adjust the scanned image to account for over- and underexposure, color casts and, of course, fading. The feature analyses the data from the blue, green and red layers, identifying areas of loss and carefully recreating density and detail. ROC can also be used to restore density to faded black and white prints or negatives if the original is scanned in RGB mode initially.

The product is available as a plug-in for Elements or as part of your scanner software. Most scanners that included ICE and GEM also contain the ROC feature as well. The plugin offers more control over the color regeneration process by providing slider adjustments for the red-cyan, greenmagenta and blue-yellow tints.

Digital ROC for cameras >>> The ROC and GEM components of the Digital ICE suite are also available as plug-ins for Photoshop Elements, providing grain reduction and color balancing options for camera-based images.

49

SCANNER AND

Recommended Scanning Workflow

Before Scanning	Select resolution to suit print needs (samples per inch)				
	Pick best color depth (16-bit per channel or 48-bit overall)				
	Set Color mode (sRGB for web work, AdobeRGB for print work)				
	Set media type (reflection – print or transmission – negative, slide)				
	Set original type (negative, slide, print)				
	Flip or rotate (if necessary)				
	Crop out unwanted detail (if necessary)				
	Adjust focus (Manual or Auto)				
	Set exposure (Check Histogram)				
After Preview Scan	Remove color cast (if necessary)				
	Turn off Dust and Scratch Removal feature	Turn on Dust and Scratch Removal feature (if necessary)			
	Turn off Color Restoration feature	Turn on Color Restoration feature (if necessary)			
	Set Single Sample mode (Single Pass)	Set Multi-Sample mode			
	Adjust Highlight and Shadow				
A.6	Alter contrast				
After Scanning in Elements	Remove color casts				
	Apply some sharpening				
	Save processed file				
lmage Quality	Good Best				

2.20 Scanning workflow

Making sure that your negatives/ prints are clean before scanning can save a lot of time spent removing marks from the picture later. Use a soft cloth or a blower brush to remove surface particles before placing the film strip into the holder or the print on the platen. Don't forget to clean the glass of the scanner as well.

Check with your scanner manual to see which way the film should be placed in the holder. Inserting the film the wrong way round will mean that any writing in the picture will be back to front. Place the film in the holder ensuring the strip aligns with holder edges. Insert the film holder into the scanner. For flatbed scanners, place the photograph face down on the glass surface making sure that the edges are parallel with the scanner's edge.

Start the scanner software. You can do this from inside Elements. Simply select the scanner name from the Import (Editor: File > Import) menu. This will open the software that controls the scanner. Some scanners are supplied with a stand-alone version of this software that you can access from your program's menu without having to open an editing package first.

Book resources at: www.adv-elements.com

Fixing common shooting problems

Use the guide below to help diagnose and solve shooting problems.

1. Focus not on main subject

Problem: The main subject in the image is not sharply focused.

Cause: This is usually caused by not having the auto focus area on the main subject at the time of shooting.

Solution: If your subject is off to one side of the frame make sure that you lock focus (pressing the shutter button down halfway) on this point before re-composing and releasing the shutter button.

2. Picture too light

Problem: The photograph appears washed out or too light with no detail in the light areas of the print.

Cause: This is caused by too much light entering the camera causing the overexposure. *Solution:* You can resolve this problem by adjusting the camera's exposure compensation control so that it automatically reduces the overall exposure by one stop. Shoot again and check exposure. If still overexposed, change the compensation to two stops. Continue this process until the exposure is acceptable.

3. Picture too dark

Problem: The photograph appears muddy or too dark with no detail in the shadow areas of the print.

Cause: Again this is a problem of exposure. This time not enough light has entered the camera. *Solution:* Adjust the exposure compensation control to add more light or alternatively use a flash to help light your subject.

Subject too blurry

Problem: The main subject, or the whole picture, appears blurry and unsharp. *Cause:* When images appear blurry it is usually the result of the subject, or the photographer, moving during a long exposure.

Solution: Use a tripod to reduce the risk of camera shake and try photographing the subject at a point in the activity when there is less movement.

5. Flash off glass

Problem: This problem results from the flash bouncing straight back from the glass into the lens of the camera.

Cause: The flash travels directly from your camera hitting the glass and bouncing directly back into the lens.

Solution: Using available light rather than the flash is one solution. Another is to move a little to one side so that the flash angles off the glass surface away from the camera.

Adjusting for backlighting >>> The camera's exposure system can be easily fooled when there is a source of bright light in the photo and the subject is in shadows. Here the portrait sitter is a silhouette because the camera is basing the exposure on the light coming from the window. To correct this situation: 1) Move the subject so that they are no longer framed by the window, or 2) Use fill flash to illuminate the subject in the foreground, or

3) Fill the frame with the subject and then take your exposure reading.

6. Portrait too dark

Problem: Instead of a clear picture of your subject framed by the window you end up with a silhouette effect, where the subject is too dark but the window is well exposed. See above. *Cause:* When your subject is sitting against an open window the meter is likely to adjust exposure settings for the light around your subject.

Solution 1: Move the subject so that the light from the window falls onto them from the front or side rather than behind.

Solution 2: Use the camera's flash system, set to 'fill flash mode', to add some more light to the subject.

Solution 3: Move closer to the subject until it fills the frame. Take an exposure reading here (by holding the shutter button down halfway) and then reposition yourself to make the exposure using the saved settings.

7. Portrait too light

Problem: The main subject is 'blown out' or too light (overexposed).

Cause: This problem is the reverse of what was happening in the example above. Here the meter is seeing the large dark areas within the frame and overcompensating for it, causing the main subject to be too bright.

Solution 1: Manually compensate for the overexposure by adjusting the camera's exposure compensation mechanism so that the sensor is receiving one, two or three stops less light. *Solution 2:* Move close to the subject until it fills the frame. Take an exposure reading here and

then reposition yourself to take the picture using the saved settings.

Book resources at: www.adv-elements.com

Fixing common scanning problems

Use the guide below to help diagnose and solve scanning problems.

1. Marks on the picture

Problem: The photograph contains marks on the surface after scanning.

Cause: This usually occurs because of dust or scratches on the glass plate on the top of the scanner or on the photograph or negative.

Solution: Clean the glass plate and photograph carefully before placing and scanning your picture. If you still have marks use a retouching tool to remove them (see the Eliminating blemishes technique in Chapter 8 for more details).

2. Color picture appears black and white

Problem: After scanning a color picture it appears black and white on screen.

Cause: The 'original' or 'media' option in the scanner software is set to black and white and not color.

Solution: Re-scan the picture making sure that the software is set to color original or color photograph.

3. Picture is too bright

Problem: The picture looks too bright overall. Light areas of the photograph appear to be completely white with no details.

Cause: The picture has been scanned with the wrong 'exposure' or 'brightness' setting. *Solution:* Re-scan the picture, but this time move the brightness or exposure slider towards the dark end of the scale before scanning.

4. Picture is too dark

Problem: The picture looks too dark overall. There is no detail in the shadow parts of the photograph.

Cause: The picture has been scanned with the wrong 'exposure' or 'brightness' setting. *Solution:* Re-scan the picture, but this time slide the Brightness or Exposure slider towards the light end of the scale before scanning.

5. Picture looks washed out

Problem: The picture has no vibrant colors and looks washed out.*Cause:* The contrast control in the scanner software is set too low.*Solution:* Re-scan the photograph altering the scanner's contrast setting to a higher value.

6. Writing is back to front

Problem: The message on a billboard in the picture is back to front. *Cause:* The negative or slide was placed into the scanner back to front. *Solution:* Turn the film or slide over and scan again.

7. The picture has too much contrast

Problem: The delicate light areas and shadow details of the picture can't be seen and have been converted to completely white and completely black.

Cause: The contrast control in the scanner software is set too high.

Solution: Re-scan the photograph altering the scanner's contrast setting to a lower value.

8. When I print my scanned picture it is fuzzy

Problem: The print of a scanned image is fuzzy, not very clear or is made up of rectangular blocks of color.

Cause: To get the best quality prints from your scanned pictures you must make sure that you match the scan quality (resolution) with the output requirements. A fuzzy or unclear print is usually the result of using a scan quality setting that is too low.

Solution: Re-scan the picture using a higher scan quality setting (resolution).

Processing Raw Files

3750

Virhite Tempera

Settings; Image Settings

Adiust

Raw is the new buzz word in photographic circles the world over. Professionals and serious amateurs alike are switching their cameras from the standard JPEG and TIFF capture options to the Raw format. This is despite the fact that doing so will mean that they add an another processing step to their digital photography workflow. It seems that the extra level of control possible when processing your own Raw files (rather than letting the camera do the work) is worth the effort. So how do Photoshop Elements users become part of the Raw Revolution? Well this chapter will outline both the workflow and conversion techniques that you can employ to make Raw capture and processing a regular part of your photographic routine.

The Photoshop Elements approach to Raw processing

As we saw in Chapter 2 Raw files contain both the image and metadata along with the actual picture information in a format which cannot be directly opened into Photoshop Elements. Instead the Raw photo is opened first into a conversion utility where global image characteristics such as white balance, brightness, contrast, saturation, noise reduction and sharpness are adjusted before the converted file is opened into the Full Edit workspace. Alternatively the converted file can be saved as an Adobe Digital Negative or DNG file. Once the converted file is opened in the Elements Editor workspace it is no longer a Raw file and can be edited and enhanced just like an other photo.

This approach to Raw processing is often called Convert then Edit as the original Raw file must be converted before any pixel-based or local editing can take place. In contrast other Raw processing solutions such as Adobe LightRoom provide a full Raw workflow which includes editing functions and output to print and web without ever converting the Raw file.

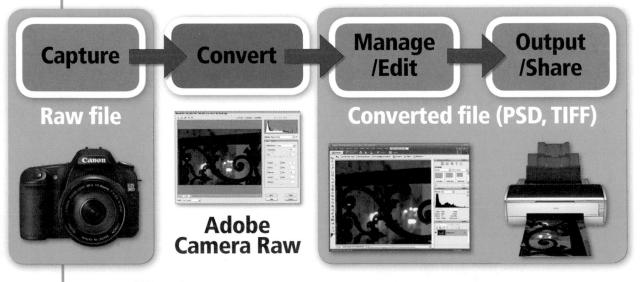

Raw Processing >>> The **Convert then Edit** approach is the most popular workflow currently used by Raw shooting photographers. The Raw file is downloaded from the camera and the first task in the process is to convert the file to a type that is more readily supported by photo editing programs such as TIFF or PSD.

3.01 Enabling your Ravy camera

Suitable for Elements – 5.0, 4.0, 3.0, 2.0, 1.0 | Difficulty level – Basic

With most Raw-enabled cameras, switching from one capture format to another is a simple matter of entering the camera Set up menu and selecting the Raw entry from the Image Quality or File Format options. With some models you can also make this change via a Quality toggle or switch elsewhere on the camera.

Occasionally there is also a choice between saving

compressed and non-compressed versions of the Raw file. Unlike the algorithms used for compressing JPEG files, the method used when compressing Raw files is 'lossless', meaning that all the detail that was captured is retained in the compressed file. Compressing will mean that pictures will take up less space on the memory card, but the process of compression does result in longer saving times. For most shooters this isn't an issue but if you like to photograph sports or action, then the extra time taken to compress the file will reduce the frames per second rate of your camera. In practice most Raw shooters opt for non-compressed files and just buy more memory cards to accommodate the larger file sizes that need to be saved.

CAPTURE FILE SIZE COMPARISONS	JPEG file size (Fine setting)	JPEG file size (Normal setting)	JPEG file size (Basic setting)	TIFF file size	Raw file size	Ravv file size (compressed)
Example file 1	2997 Kb	1555 Kb	782 Kb	17708 Kb	9777 Kb	5093 Kb
Example file 2	2466 Kb	1575 Kb	748 Kb	17712 Kb	9776 Kb	4275 Kb

Capture format versus file size >>> The capture format you select directly affects not only the way the file is saved and its visual quality but also the size of the final file. JPEG produces the smallest files but uses a 'lossy' compression system to do so. In the JPEG format you can adjust the level of compression used when saving the photo. In this table the Fine setting uses the least compression and the Basic option the most. Both TIFF and Raw formats preserve all the image detail and any compression used with these formats is 'lossless'.

There are several cameras on the market that also have the ability to save both Raw and JPEG versions of the same file at the time of capture. This option can be a real time saver if you need to access your pictures quickly, but the feature is less of an advantage if you regularly perform many enhancement steps to your files, as in the end the captured JPEG will not resemble the processed Raw file.

At the big end of town most of the high-resolution camera backs, which are destined for use with medium format camera bodies, only capture in Raw formats. Many make use of dedicated software to control the camera, capture the photo and then process the Raw file. Other manufacturers, such as Hasselblad, Samsung, Richo and Leica even use Adobe's DNG format as the capture format, making the transition to Elements a simple one.

PROCESSING Raw FILES

In practice - enabling your camera

For the purposes of this workflow example I have included step-by-step instructions for both Nikon and Canon cameras below.

Canon workflow (example camera EOS 30D)

- Press the Menu button and turn the Quick Control Dial to select the Quality heading and then press Set; this will display the Recording Quality screen.
- Next, use the Quick Control Dial again to choose one of the Raw options from those listed. Depending on the camera model your choices may include Raw and Raw + JPEG. Press Set to set the selected capture mode.

Note: Canon cameras divide the controls into two levels: Basic and Creative (advanced). They name these control subsets different 'Zones'. If your camera is currently in the Basic Zone you won't be able to choose any Raw caption options. To do this, you will need to switch to the Creative Zone first, and then alter the Recording Quality. Canon's menu system also varies from consumer to pro models so check with the manual if you are unsure.

Nikon workflow (example camera D100)

- 1. To switch the default capture format to Raw, activate the menu on the back of the camera and then use the Multi-selector control to navigate to the Shooting Menu (second option on the left side of the screen). Use the right arrow on the Multi-selector control to pick menu options.
- From the first page of the menu list, select the Image Quality entry. This will display another screen containing a list of quality options – three JPEG, one TIFF and one NEF (Nikon's version of Raw). At this screen choose the NEF (Raw) heading.
- Selecting NEF will display a final screen with a choice of two different Raw capture modes – 'Comp. NEF (Raw)' compressed and 'NEF (Raw)' uncompressed. Select one of these options and then exit the menu.

3.02 Modifying your capture workflow for Raw

Suitable for Elements - 5.0, 4.0, 3.0, 2.0, 1.0 | Difficulty level - Basic

In the previous chapter we looked at the controls that are available to digital camera users that enable them to capture great images. These include such digital-only options as Saturation, Sharpness, White Balance and Contrast Control. Using such features it is possible for the digital photographer to customize their image capture more than was ever possible when film was king. But switching capture formats to Raw impacts directly on the role that these controls play in your digital capture. As we already know factors such as white balance, contrast, saturation and sharpness settings are not fixed in Raw files. These controls are only applied to the file at the time of conversion or after the image exits the Adobe Camera Raw utility and is opened in the Editor workspace. So rather than these factors being applied in-camera, as is the case with JPEG and TIFF capture, they are applied via the ACR utility. In fact any of the adjustments you make to these settings on the camera can be reversed or tweaked in ACR. Remember the white balance illustration? You forget to change from tungsten to daylight and shoot outside. No problem, just make the switch back to the daylight setting in the ACR dialog and the photo is corrected without loss of image quality.

So if these factors are controllable at conversion then should the Raw shooting photographer bother with them at time of capture? This is a good question to which you will receive many answers. Unfortunately many shooters believe that capturing in Raw is a 'fix all' for poor camera technique. Haven't selected the right white balance? No problem fix it in Raw. Haven't judged the light quite right? Again, not a big deal just fix it in Raw. Nor adjusted your lighting for good contrast? Again, not an issue, there is contrast control in Raw. But to my mind although many factors can be altered in Raw this approach has three main drawbacks:

- 1. Correctly captured pictures need less correction when converting, saving valuable time.
- 2. The white balance settings determined at time of capture provide a good starting point for further fine-tuning during the conversion process.
- 3. If a Raw + JPEG capture mode is being used then the color in the accompanying JPEG photo will better match the processed Raw file as it was more accurate at the time of capture.

Raw capture implications on workflow

So what changes to standard capture workflow should the Raw shooter make? Let's examine the impact of Raw capture on some of the standard camera controls.

Resolution – When working with Raw as the capture format, most cameras will not provide the ability to alter the dimensions of your photo. The largest photo possible (one sensor site to one pixel) is generally recorded in the Raw file.

Book resources at: www.adv-elements.com

Raw capture will fix it!

Color Depth – Raw photographers automatically get access to the increased levels of tone afforded by high-bit capture because nominating Raw as the capture format negates the camera's bit depth settings and automatically provides the full depth capable by the sensor. At time of conversion in ACR you can elect the bit depth of the converted file.

Saturation – As the vibrancy or saturation of the converted image can be controlled on a picture-by-picture basis in ACR it is a good idea to leave this camera setting on the default or normal value. This will display your photo with standard saturation in ACR and then give you the option to boost or reduce vibrancy according to the requirements of the photo.

White Balance – Despite the fact that white balance can be losslessly adjusted in ACR it is good practice to match white balance settings with the dominant light source in your scene. This helps to maintain the photographer's own capture skill as well as ensuring speedier color cast removal in ACR, as the camera settings are loaded as default when opening the image. The more accurate these capture settings are the less fiddling the photographer will need to do to ensure a great result.

Contrast – Most cameras have the choice to increase or reduce contrast. The feature is invaluable when shooting in difficult lighting scenarios and saving the results back to TIFF or JPEG files. Raw shooters have the luxury of being able to make these types of contrast adjustments much more accurately and on an image-by-image basis back at the desktop.

Sharpening – Professionals now employ a workflow that applies sharpening at three different times during the enhancement process – at time of capture, during enhancement and then when preparing for output. For Raw shooters adopting this approach means adding a little global sharpening in-camera or at the time of conversion. Both approaches are fine as long as the sharpening is kept to a minimum with the idea that it will be fine-tuned later to account for subject matter and output destination.

Noise Reduction – Reducing noise on the desktop, either during Raw conversion or afterwards inside Photoshop Elements, provides better control over the process and therefore better results than the auto approach adopted by in-camera systems.

ISO – Shooting in Raw doesn't directly affect the selection of ISO setting used for capture. These settings will be based on the available light in the scene or the shutter speed required to freeze or blur motion.

Camera Exposure – Shooting in Raw doesn't change the fact that exposure is key to the creation of high quality images. It is true that the slider controls in ACR provide a great deal of flexibility when it comes to processing the tones in a photo and that this means that slight problems with exposure (under- or over-exposure) can be corrected more easily than with other capture formats. What is important to remember though is that this doesn't provide photographers with a license for poor exposure control. The best conversions are made with images that are well exposed.

3.03 Using the Adobe Photo Downloader

Suitable for Elements - 5.0, 4.0, 3.0, 2.0, 1.0 | Difficulty level - Basic

Over the history of the development of Photoshop Elements one of the most significant additions to the program has been the Organizer workspace. This feature provides a visual index of your pictures and can be customized to display the images in Browser Mode, date mode or sorted by keyword tags or collection. Unlike the standard file browsers of previous editions which created the thumbnails of your pictures the first time that the folder is browsed, the Organizer creates the thumbnail during the process of adding your photographs to a collection.

To commence downloading your Raw files and, in the process, create your first collection, simply select the View and Organize option from the Welcome screen and then proceed to the Organizer: File > Get Photos menu option. Select one of the listed sources of pictures (camera or folders) provided and move through the steps and prompts in the dialogs that follow. If you are sourcing your files from a camera or card reader then the Adobe Photo Downloader (APD) automatically starts when you attach these devices, removing the need for you to go to the Get Photos menu to start the downloading process.

Option 1: Getting your Raw files from camera or card reader

To demonstrate the process let's start by downloading some photographs from a memory card or camera. This will probably be the most frequently used route for your Raw images to enter the Elements program. Connect the camera, being sure that you have first installed the drivers for the unit. Alternatively you may wish to eject the memory card from the camera and insert it into a card reader that is already attached to the computer. The Adobe Photo Downloader utility should automatically start; if it doesn't then manually select the From Camera or Card Reader option from the File > Get Photos menu.

Downloading files >> Raw files can be imported directly from the camera or by inserting the memory card into an attached reader.

After attaching the camera, or inserting a memory card into the reader, you will see the Adobe Photo Downloader dialog. This is a utility designed specifically for managing the download process and has both a Basic and Advanced dialog mode. The **Basic Dialog** is displayed by default. The first step is to select the location of the pictures (the card reader or memory card in the camera) from the Source drop-down menu in the top right of the dialog. The first photo in the group is shown as a thumbnail on the left of the window. Below this area is the Import Settings section where you can choose the folder location for the pictures that are downloaded

as well as options to create new subfolders, rename photos and delete successfully downloaded files. There is also a checkbox for activating the new Automatic Download feature which imports photos directly from card reader or camera, bypassing the Adobe Photo Downloader dialog and instead using the import options saved in the Camera or Card Reader preferences (Edit > Preferences > Camera or Card Reader).

Clicking the **Advanced Dialog** button at the bottom left switches the window to a more sophisticated version of the feature. Here all the photos on the card/camera are previewed and you have the additional options of fixing red eyes, creating photo stacks and adding group tags

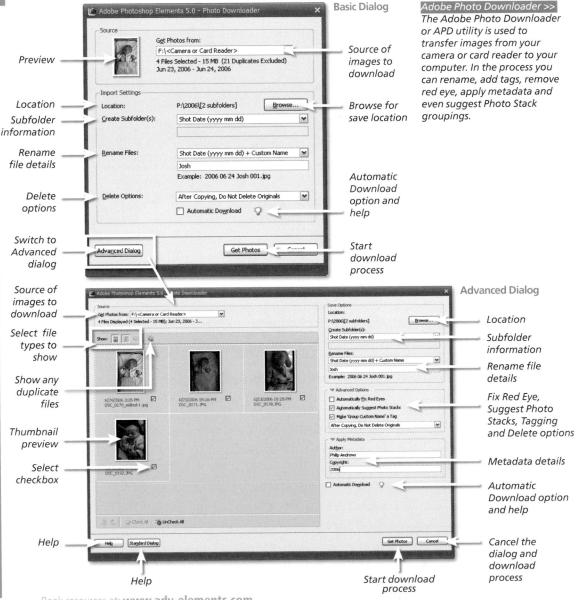

and metadata information automatically as files are downloaded. By default all pictures on the card will be selected ready for downloading and cataloging. If for some reason you do not want to download all the images then you can deselect them by unchecking the tick box at the bottom right-hand of the thumbnail.

After selecting the options in either the Basic or Advanced dialog click the Get Photos button to transfer the pictures. After the process is complete Elements will tell you that the files have been successfully imported.

Option 2: Loading Raw files from an existing archive, disk or drive

Acting much like the File > Open option common to most programs the Get Photos > From Files and Folders selection provides you with the familiar operating system browse window that allows you to search for and open pictures that you have already saved to your computer. You generally have the option to view your files in a variety of ways including Thumbnails, Tiles, Icons, List and Detail Views using the drop-down menu from the top of the window. However the Thumbnail option will only display small previews of your Raw files if the Microsoft Raw Image Thumbnailer and Viewer utility is installed. This is available free from http://www. microsoft.com/windowsxp/using/digitalphotography/prophoto/Raw.mspx. Users can also elect to automatically fix red eyes or suggest photo stacks here as well. After selecting the image, or images, you wish to import into Elements, select the Get Photos button.

How to multi-select the files to import

To select several images or files at once hold down the Ctrl key whilst clicking on the pictures of your choice. To select a complete list of files without having to pick each file in turn click on the first picture and then, whilst holding down the Shift key, click on the last file in the group.

Disable the Adobe Photo Downloader

- 1. Select Organizer: Edit > Preferences > Camera Or Card Reader.
- 2. Deselect 'Auto Launch Adobe Photo Downloader on Device Connect'.

Enable the Adobe Photo Downloader

- 1. For Elements 5.0 users select Organizer: Edit > Preferences > Camera Or Card Reader.
- 2. Select 'Auto Launch Adobe Photo Downloader on Device Connect'.

Enabling the Automatic Download option in Adobe Photo Downloader (APD)

- 1. Choose the Automatic Download option from the APD Basic or Advanced dialogs. The downloader will commence automatically the next time a card/camera is connected.
- 2. Select Organizer: Edit > Preferences > Camera Or Card Reader and set the preferences for the download in the Files and Download sections of the dialog.

3.04 The Adobe Camera Raw interface

Suitable for Elements – 5.0, 4.0, 3.0, 2.0, 1.0 | Difficulty level – Basic

Before commencing introducing a Raw processing workflow, let's take a close look at the Adobe Camera Raw feature as it appears in Photoshop Elements 5.0. When opening a Raw photo from inside either the Organizer or Editor workspaces, this ACR dialog will be displayed. It is the tools and features contained in this window that will govern the way in which your Raw file is converted to a standard RGB format that can be edited in Photoshop Elements.

Histogram

A full color histogram is located under the RGB values readout. The feature graphs the distribution of the pixels within your photo. The graph updates after changes are made to the color, contrast and brightness of the picture. By paying close attention to the shape of the graph you can pre-empt many image problems. The aim with most enhancement activities is to obtain a good spread of pixels from shadow through mid tones to highlights without clipping (converting delicate details to pure black or white) either end of the tonal range.

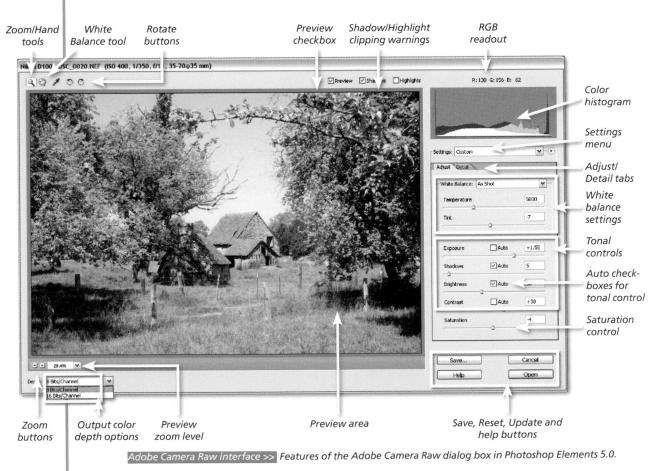

Adjust Detail			Camera Raw Defaults Image Settings Camera Raw Default<	÷ o	ettings menu options riginal photo settings amera settings
	As Shot	_	Previous Conversion Custom		ast conversion settings ser customized settings
Temperature		5000	As Shot	V	Vhite Balance menu options
Tint		-7	As Shot		amera white balance settings
Exposure	Auto	+1.55	Devight Cloudy Shade Tungsten Fluorescent	Contraction of the local division of the loc	ght source based hite balance settings
Shadows	⊇ Auto	5	Tiasri Custom	Cu	ustomized white balance settings
Brightness	2	E	Adjust Detail		Details tab options
Contrast	Auto	+38	Sharpness	69	Sharpness controls
Saturation		-4	Luminance Smoothing	0	Luminance Smoothing controls for grayscale noise reduction
			Color Noise Reduction	25	Color Noise Reduction controls
Save		Cancel	ACR options and con		

The Settings menu

Below the histogram is the Settings drop-down menu which contains the Image Settings, Camera Raw Defaults, Previous Conversion, and Custom entries.

Image Settings: The Image Settings option restores the original settings of the current photo. Use this selection when you want to reverse changes that you have made and wish to restore the photo to its virgin state.

Camera Raw Defaults: This option applies to a group of slider settings that are default values associated with a specific camera and photograph. When a photo is opened for the first time, the settings and White Balance controls will be altered to Camera Raw Defaults (based on the camera model) and As Shot (based on the camera settings used for the photograph), respectively.

Previous Conversion: Another option in the Settings drop-down menu is Previous Conversion. This setting stores the 'last used' values for all controls and is an efficient way to apply the enhancements used with the previous image to one currently open in the dialog. Using this option will help speed up the conversions of a series of photos taken at the same time under the same lighting conditions. Simply make the adjustments for the first image and then use the Previous Conversion option to apply the same settings to each of the successive photos from the series in turn.

Custom: Moving any of the slider controls such as Temperature or Tint sliders under the White Balance menu automatically changes the settings entry to Custom. Once the settings have been customized for a particular photograph the values can be saved as a new Camera Raw Default entry using the Save option in the pop-up menu accessed via the sideways arrow next to the Settings menu. PROCESSING Raw FILES

As ACR recognizes the Raw file created with different cameras the new Camera Raw Default will be applied to only those photos captured with the specific camera that the settings have been saved for.

Large preview

The dialog box also contains a large preview of how the Raw file will appear with the current settings applied. The preview has a couple of Zoom-in and -out options. You can alter the magnification of the preview using the Zoom tool, the Zoom Level menu or buttons at the bottom of the dialog or with the Ctrl + or Ctrl - keystrokes. Examining parts of the image close in is important and useful, particularly in areas where shadows and/or highlights are problematic.

White balance correction

Adjustable preview >>> The preview can be magnified via the (a) Zoom Level buttons or menu or the (b) Zoom tool.

White balance is used to correctly balance the color of the scene to the lighting conditions at the time the shot was taken. Leaving white balance set at As Shot means you elect to keep the White Balance values that were used when taking the picture. As you know one of the advantages shooting Raw is that this setting is not a fixed part of the picture file. Altering the specific white balance setting at the time of Raw conversion is a 'lossless' action. This is not the case if you have used an incorrect setting and have shot in JPEG or TIFF. Use either of these two formats and the white balance setting will be fixed in the file and can only be changed with destructive adjustments using features like Color Variations or Remove Color Cast. In this regard Raw shooters have much more flexibility.

For instance, if you selected a Daylight setting in-camera and think that Shade or another white balance preset may be closer to the actual lighting conditions you may select one of the options from the list of presets under the White Balance drop-down menu. Moving either the Temperature or Tint sliders switches the setting to Custom. These controls are used for matching the image color temperature with that of the scene.

Temperature: The Temperature slider is a fine-tuning device that allows you to select a precise color temperature in units of degrees kelvin. When an image is too yellow, meaning it has a lower color temperature than you prefer, move the Temperature slider to the left to make the colors bluer and compensate for the lower color temperature. When an image is too blue, or higher in temperature than you prefer, move the slider to the right to make the image warmer, adding more yellow compensation. So, left is to make image colors cooler and right is to make image colors warmer.

66

Adjust Detail		
		a
- White Balance:	As Shot	v
	As Shot	
Temperature	Auto	
	Daylight Cloudy	
Tint	Shade	
	Tungsten	
	Fluorescent Flash	
	Custom	
Adjust Detail	L	
White Balance:	Custom	v -
Temperature		4000
Tint		-10
	O	
		D
Q ST A	n a	and the second second
1 10		
G	\sim	
	X	
		1)

Changing white balance >> The white balance in your Raw photo can be adjusted in one of three ways: (a) Selecting the light source-specific entry that best matches the lighting in the scene from the dropdown list.

(b) Manually adjusting the Temperature and Tint slider values until the preview appears neutral and free from color casts.

(c) Selecting the White Balance tool and then clicking on a picture part that should be neutral.

Tint: The Tint slider fine-tunes the white balance to compensate for a green or magenta tint. Moving the Tint slider to the left adds green and to the right adds magenta. This control is often used to neutralize a color cast caused by lighting from fluorescent tube or strip sources.

White Balance tool: The quickest and perhaps easiest way to adjust white balance is to select the White Balance tool and then click in an area that should be neutral gray or even amounts of red, green and blue. For best results, use a textured white or light gray as the reference and be careful not to click on an area with pure white or specular highlights. These will produce unreliable results so keep away from the bright highlight areas of highly reflective or chrome surfaces. One suggestion for working with neutral gray is to:

- 1. Click on the White Balance tool.
- 2. Move the White Balance tool cursor over a mid tone area which should be neutral gray but contains a color cast in the preview.
- 3. Click on the image location to neutralize the cast not just in the selected area but in the whole photo.

PROCESSING Raw FILES

Making tonal adjustments

Exposure, Shadows, Brightness, Contrast and Saturation sliders are available for making adjustments to Raw files. Adobe has positioned these controls in the dialog so that when working from top to bottom you follow a specific enhancement workflow. For this reason you should follow these steps in order:

- 1. Set the white clipping points using the Exposure slider.
- 2. Set the black clipping points using the Shadows slider.
- 3. Adjust the overall brightness using the Brightness slider.
- 4. Adjust contrast using the Contrast slider.
- 5. Adjust saturation, if needed, using the Saturation slider.

Exposure

The Exposure slider adjusts the brightness or darkness of an image using value increments equivalent to f-stops or EV (exposure values) on a camera. An image is underexposed when it is not light enough or too dark, and it is overexposed when it is too light. Simply move the slider to the left to darken the image and to the right to lighten (brighten) the image.

What do the f-stop or EV equivalents indicate? An adjustment of -1.50 is just like narrowing the aperture by 1.5 (one and a half) f-stops. Moving the slider 1.33 places to the left will dramatically darken an image and to the right the same amount will result in a bright image. If you have to move more than two full stops in either direction this probably indicates your settings at capture were inaccurate. Making adjustments beyond two stops starts to deteriorate image quality as invariably shadow or highlight detail is lost (clipped) in the process.

For those of you who are interested, the Exposure slider sets the white clipping points in the image. Clipping shows as values creeping up the left (shadow) and right (highlight) walls of your histogram (and red and blue areas in the image if shadow and highlight previews are turned on), and occurs when the pixel values shift to the highest highlight value or the lowest shadow value. Clipped areas are completely black or white and contain no detail. As you want to maintain as much detail in the shadows and highlights as possible your aim should always be to spread the picture tones but not to clip delicate highlight or shadow areas.

Exposure	Auto	-1.30
Shadows	Auto	6
Brightness	Auto	94
Contrast	Auto	0
Saturation		+5

Tonal changes from top to bottom >>> Adobe has positioned the slider controls that adjust the tones within the image in the order (top to bottom) that they should be applied within the ACR dialog. The Exposure and Shadows sliders should be used first to set the white and black points in the photo. Use the Alt/Option keys in conjunction with these sliders to preview the pixels being clipped and to accurately peg the white/black points. Or alternatively switch on the Shadows/ Highlights Clipping Warnings which perform the same function whilst leaving the full color preview visible.

Next lighten or darken the photo using the Brightness slider. Unlike the Exposure control this slider doesn't affect the white and black points of the image but rather adjusts the appearance of the photo by compressing or extending the altered tones.

Shadows

Moving the Shadows slider adjusts the position of the black point within the image. Just as was the case with the Exposure slider you should only make Shadows adjustments when the clipping warning is active. This will ensure that you don't unintentionally convert shadow detail to black pixels. Remember movements of the slider to the left decrease shadow clipping. Moving it to the right increases or produces clipping.

Brightness and Contrast

The Brightness slider is different to the Exposure slider although both affect the brightness of an image. Brightness compresses the highlights and expands the shadows when you move the slider to the right. When adjusting your photos your aim is to set the black and white points first and then adjust the brightness of the mid tones to suit your image.

Contrast adjusts the spread of the mid tones in the image. A move of the Contrast slider to the right spreads the pixels across the histogram, actually increasing the mid tone contrast. Conversely, movements to the left bunch the pixels in the middle of the graph. It is important to adjust the contrast of mid tones after working on exposure, shadows and brightness.

Auto tonal control

When first opening a picture ACR will automatically adjust the tonal controls to an average setting for the picture type and camera make/model. The Auto checkbox is selected when these settings are in place. Moving the associated slider will remove the selection but these values can be reinstated by selecting the checkbox again.

Pro's tip: In some instances you may need to readjust Exposure and Shadow sliders after using the Brightness and Contrast controls to fine-tune your enhancements.

Saturation

If desired, the Saturation slider may be used to adjust the strength of the color within the photo. A setting of -100 is a completely desaturated monochrome image and a value of +100 doubles the saturation. Watch changes in the histogram when you move the Saturation slider in either direction.

Clipping warnings >> ACR contains two different types of 'Clipping' warnings. (a) When the Shadows and Highlights Clipping Warning features are selected at the top of the dialog, areas of highlight clipping are displayed in the preview as red and shadows as blue. (b) Holding down the Alt/ Option key whilst moving either the Exposure or Shadows sliders will convert the preview to black (for Exposure) or white (for Shadows). Any pixels being clipped will then be shown as a contrasting color against these backgrounds.

Sharpening, Luminance Smoothing and Color Noise Reduction

Sharpening, Luminance Smoothing and Color Noise Reduction are all controls that can be accessed under the Detail tab.

Sharpening is an enhancement technique that is easily overdone and this is true even when applying the changes at the time of Raw conversion. The best approach is to remember that sharpening should be applied to photos as the very last step in the editing/ enhancement process and that the settings used need to match the type of output the photo is destined for. In practice this means images that are not going to be edited after Raw conversion should be sharpened within ACR, but those pictures that are going to be enhanced further should be sharpened later using the specialist filters in Photoshop Elements.

When a picture is first opened into the ACR the program sets the sharpening and noise values based on the camera type and model used to capture the image. For many photographers making further adjustments here is an exception rather than a rule as they prefer to address sharpening in the Editor after cropping, straightening, enhancing, resizing and going to print.

ACR contains two different noise reduction controls – the Luminance Smoothing slider and the Color Noise Reduction control. The Luminance Smoothing slider is designed to reduce the appearance of grayscale noise in a photo. This is particularly

Noise reduction >> ACR provides two separate Noise Reduction controls for use with photos taken with high ISO settings. (a) No noise reduction. (b) ACR noise reduction applied.

useful for improving the look of images that appear grainy. The second type of noise is the random colored pixels that typically appear in photos taken with a high ISO setting or a long shutter speed. This is generally referred to as 'chroma noise' and is reduced using the Color Noise Reduction slider in ACR. The noise reduction effect of both features is increased as the sliders are moved to the right.

Outputting the converted file

Now to the business end of the conversion task – outputting the converted Raw file. At this stage in the process ACR provides several options that will govern how the file is handled from this point onwards. To this end, the lower right-hand corner of the Adobe Camera Raw dialog has four buttons: Save, Cancel, Open and Help and a further three – Save (without the options dialog), Reset and Update – when the Alt/Option button is pushed.

Help: Opens the Photoshop Elements Help system with Raw processing topics already displayed. Book resources at: **www.adv-elements.com**

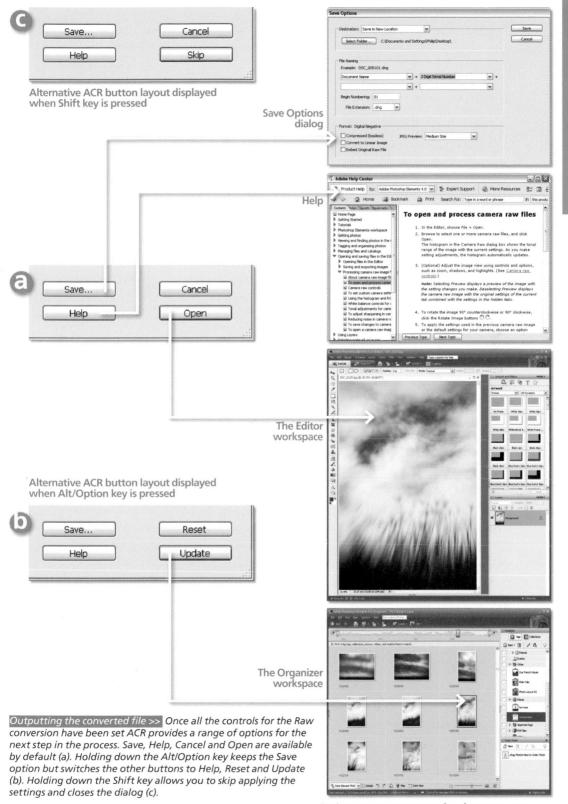

Book resources at: www.adv-elements.com

71

PROCESSING Raw FILES

Cancel: This option closes the ACR dialog without saving any of the settings to the file that was open.

Save: The normal Save button, which includes several dots (...) after the label, displays the Save options dialog. Here you can save the Raw file, with your settings applied, in Adobe's own DNG format. The dialog includes options for inputting the location where the file will be saved, the ability to add in a new name as well as DNG file-specific settings such as compression, conversion to linear image and/or embed the original Raw file in the new DNG document. It is a good idea to select Save in Different Location in the Destination drop-down at the top to separate processed files from archive originals. Clearly the benefits of a compressed DNG file are going to help out in the storage issue arena and compression is a big advantage with DNG. Embedding the original Raw file in the saved DNG file begs the questions of how much room you have in the designated storage device and whether you really want to have the original Raw file here.

Open: If you click on the Open button Elements applies the conversion options that you set in ACR and opens the file inside the Editor workspace. At this point, the file is no longer in a Raw format so when it comes to saving the photo from the Editor workspace Elements automatically selects the Photoshop PSD format for saving.

Reset: The Reset option resets the ACR dialog's settings back to their defaults. This feature is useful if you want to ensure that all settings and enhancement changes made in the current session have been removed. To access the Reset button click the Cancel button whilst holding down the Alt/Option key.

Update: Clicking the Open button in conjunction with the Alt/Option key will update the Raw conversion settings for the open image. Essentially this means that the current settings are applied to the photo and the dialog is then closed. The thumbnail preview in the Photo Browser workspace will also be updated to reflect the changes. If the thumbnail doesn't update automatically, select the picture and then choose Edit > Update Thumbnail in the Photo Browser workspace.

Skip: Holding down the Shift key whilst clicking the Open button will not apply the currently selected changes and just close the dialog. In this way it is similar to the Cancel button except the Cancel will dismiss the dialog, and Skip will continue to reload the dialog with any other Raw files that have been multi-selected to open.

3.05 The Conversion process

Suitable for Elements - 5.0, 4.0, 3.0, 2.0, 1.0 | Difficulty level - Basic

Okay, now that we have a good understanding of the features and controls within the Adobe Camera Raw dialog let's move on and look at a typical conversion workflow.

New	:
Open Open As Open Recently Edito Duplicate	Ctrl+O F Alt+Ctrl+O
Close Close All Save Save As Save for Web	Ctrl+W Alt+Ctrl+W Ctrl+S Shift+Ctrl+S Alt+Shift+Ctrl+S
File Info	
Organize Open File: Process Multiple File Import Export Automation Tools	215

Step 1 >> Once you have downloaded your Raw files you can start the task of processing. Keep in mind that in its present state the Raw file is not in the full color RGB format that we are used to, so the first part of all processing is to open the picture into a conversion utility or program. Selecting File > Open from inside the Editor will automatically display the photo in the Adobe Camera Raw (ACR) utility.

Step 2 >>> To start the process from inside the Photo Browser or Organizer workspace simply right-click on the thumbnail of the Raw file and select Go to Standard Edit from the pop-up menu to transfer the file to the Elements version of ACR in the Editor workspace.

Step 3 >> Once the Raw photo is open in ACR you can rotate the image using either of the two Rotate buttons at the top of the dialog. If you are the lucky owner of a recent camera model then chances are the picture will automatically rotate to its correct orientation. This is thanks to a small piece of metadata supplied by the camera and stored in the picture file that indicates which way is up.

Step 4 >> As we have seen you can opt to stay with the settings used at the time of shooting ('As Shot') or select from a range of light source-specific settings in the White Balance dropdown menu of ACR.

For best results, try to match the setting used with the type of lighting that was present in the scene at the time of capture. Or choose the Auto option from the drop-down White Balance menu to get ACR to determine a setting based on the individual image currently displayed.

Vhite Balance:	Custom	
Temperature		5250
Tint	3	-2
Exposure	🗹 Auto	-1.75
Shadows	🗹 Auto	14
Brightness	Auto	90
Contrast	Auto	+42

Step 5 >> If none of the preset White Balance options perfectly matches the lighting in your photo then you will need to fine-tune your results with the Temperature and Tint sliders (located just below the Presets drop-down menu). The Temperature slider settings equate to the color of light in degrees kelvin - so daylight will be 5500 and tungsten light 2800. It is a blue to yellow scale, so moving the slider to the left will make the image cooler (more blue) and to the right warmer (more yellow). In contrast the Tint slider is a green to magenta scale. Moving the slider left will add more green to the image and to the right more magenta.

Step 6>> Another quick way to balance the light in your picture is to choose the White Balance tool and then click on a part of the picture that is meant to be neutral gray or white. ACR will automatically set the Temperature and Tint sliders so that this picture part becomes a neutral gray and in the process the rest of the image will be balanced.

For best results when selecting lighter tones with the tool ensure that the area contains detail and is not a blown or specular highlight. 73

Step 7>> To start, adjust the brightness with the Exposure slider. Moving the slider to the right lightens the photo and to the left darkens it. The settings for the slider are in f-stop increments with a +1.00 setting being equivalent to increasing exposure by one f-stop.

Use this slider to peg or set the white tones. Your aim is to lighten the highlights in the photo without clipping (converting the pixels to pure white) them. To do this, hold down the Alt/ Option whilst moving the slider. This action previews the photo with the pixels being clipped against a black background. Move the slider back and forth until no clipped pixels appear but the highlights are as white as possible.

Step 8 >>> The Shadows slider performs a similar function with the shadow areas of the image. Again the aim is to darken these tones but not to convert (or clip) delicate details to pure black. Just as with the Exposure slider, the Alt/Option key can be pressed whilst making Shadows adjustments to preview the pixels being clipped.

Alternatively the Shadow and Highlights Clipping Warning features can be used to provide instant clipping feedback on the preview image. Shadow pixels that are being clipped are displayed in blue and clipped highlight tones in red.

Step 9 >> The next control, moving from top to bottom of the ACR dialog, is the Brightness slider. At first the changes you make with this feature may appear to be very similar to those produced with the Exposure slider but there is an important difference. Yes, it is true that moving the slider to the right lightens the whole image, but rather than adjusting all pixels the same amount the feature makes major changes in the mid tone areas and smaller jumps in the highlights. In so doing the Brightness slider is less likely to clip the highlights (or shadows) as the feature compresses the highlights as it lightens the photo. This is why it is important to set white and black points first with the Exposure and Shadows sliders before fine-tuning the image with the Brightness control.

Step 10>> The last tonal control in the dialogue, and the last to be applied to the photo, is the Contrast slider. The feature concentrates on the mid tones in the photo with movements of the slider to the right increasing the mid tone contrast and to the left producing a lower contrast image. Like the Brightness slider, Contrast changes are best applied after setting the white and black points of the image with the Exposure and Contrast sliders.

Step 11 >> The strength or vibrancy of the colors in the photo can be adjusted using the Saturation slider. Moving the slider to the right increases saturation with a value of +100 being a doubling of the color strength found at a setting of 0. Saturation can be reduced by moving the slider to the left with a value of -100 producing a monochrome image. Some photographers use this option as a quick way to convert their photos to black and white but most prefer to make this change with features such as the new Convert to Black and White feature.

74

Step 12 >> The sharpening control in ACR is based on the Unsharp Mask filter and provides an easy-to-use single slider sharpening option. A setting of 0 leaves the image unsharpened and higher values increase the sharpening effect based on Radius and Threshold values that ACR automatically calculates via the camera model, ISO and Exposure compensation metadata settings.

Step 13 >> ACR contains two different reduction controls. The noise Luminance Smoothing slider is designed to reduce the appearance of grayscale noise in a photo. This is particularly useful for improving the look of images that appear grainy. The second type of noise is the random colored pixels that typically appear in photos taken with a high ISO setting or a long shutter speed. This is generally referred to as 'chroma noise' and is reduced using the Color Noise Reduction slider in ACR. The noise reduction effect of both features is increased as the sliders are moved to the right.

Step 14>>> The section below the main preview window in ACR contains the output options settings. Here you can adjust the color depth (8 or 16 bits per channel) of the processed file. Earlier versions of Photoshop Elements were unable to handle 16-bits per channel images but the last two releases have contained the ability to read, open, save and make a few changes to these high color files.

Destination: Save	in New Loc	ation	
Select Folder	P:\20	061	
File Naming			
Example: summer	break01.d	ng	
summer break			v +
			+
Begin Numbering:	01		
File Extension:	.dng	•	
Format: Digital Nec	jative		
Compressed (la	verlages)		Preview

Reset Update

Step 15 >> The most basic option is to process the Raw file according to the settings selected in the ACR dialog and then open the picture into the Editor workspace of Photoshop Elements. To do this simply select the OK button. Select this route if you intend to edit or enhance the image beyond the changes made during the conversion. Step 16 >> Users have the ability to save converted Raw files from inside the ACR dialog via the Save button. This action opens the Save Options dialog which contains settings for inputting the file name as well as file type specific characteristics such as compression.

Use the Save option over the Open command if you want to process photos quickly without bringing them into the Editing space or if you want to process different versions of the same image. Step 17>>> There is also an option for applying the current settings to the Raw photo without opening the picture. This is called updating. By Alt-clicking the Open button (holding down Alt/Option key changes

(holding down AIT/Option key changes the button to the Update button) you can apply the changes to the original file and close the ACR dialog in one step. 75

PROCESSING Raw FILES

3.06 Keeping ACR up to date

Suitable for Elements - 5.0, 4.0, 3.0, 2.0, 1.0 | Difficulty level - Basic

The Adobe Camera Raw feature is installed as a plug-in inside Photoshop Elements when you first install the program. Periodically Adobe updates the feature releasing a new version that can be freely downloaded and installed. Typically the updates contain support for the latest digital camera models and occasionally new features and tools are included as well.

To download the latest ACR update point your browser to **www.adobe.com** (specifically http:// www.adobe.com/products/photoshop/cameraRaw.html) and then look for the Adobe Camera Raw update page. Next download the latest version of the utility and install using these steps:

- 1. If Photoshop Elements is open exit the program.
- 2. Open the system drive (usually C:).

3. Locate the following directory: **Program Files\Adobe\Photoshop Elements 5.0\Plug-Ins\File Formats**

- 4. Find the Adobe Camera Raw.8bi file in this folder.
- 5. Move the plug-in to another folder and note down its new location just in case you want to restore the original settings.
- 6. Drag the new version of the Adobe Camera Raw plug-in, the Adobe Camera Raw.8bi file (that you downloaded), to the same directory as in Step 3.
- 7. Restart Photoshop Elements.

	active Photosical		Next Steps	
Adob	e Photoshop	CS2	⊗ Boynow	
			🗟 Try now (win)	
Digital ca	mera raw file support		2 Try now (mac)	
within Photos midrange dig	shop to the "raw" image formats plat cameras. By working with th	Inshop® coffware provides fast and easy access produced by many leading professional and rese "digital negatives," you can achieve the results	Call 1-800-833-6887	
you want with	greater artistic control and field	billy while still maintaining the original "rew" files.	Photosbop horse	
		e the latest must-have tool for professional	Product info	
		uary 2003. This powerful plug-in has been updated features, and is available as part of Adobe	Overview	
		invatores, and is available as part of Adobe at not only the latest camera raw plug-in, but also the	New features	
	eciling new features that are pa		In depth	
The Obeleville	on Conners Row along in (2.3 or	highed now also supports raw files in the DNO	System requirements	
		regner) now also supports raw tiles in the Divid le Digital Negative, a publicly documented raw file	Camara ray support	
	ly announced by Adobe.		Product activation	
			Customer stories	
To learn mor	e about Camera Raw, read the	Le primers.	Rusievs Avards Events & seminars	
A Linderstein	nding digital new capture (POF)	1.0000		
		10600		
D Linear ga	mma (PDF 2,25ic)			
			information for	
			Information for	
GET 15	Adobe Lightroom ⁻¹⁰ beta 3 m		Photographers	
	Adobe Lightnom [™] beta 3 ee Photographers can now impo	rt, manage, and showcase volumes of	Photographers Graphic designers	
	Adobe Lightnom ¹⁰ beta 3 or Photographers can now impo photographs with ease on an		Photographers Graphic designers Engineers and architects	
	Adobe Lightnom [™] beta 3 ee Photographers can now impo	rt, manage, and showcase volumes of	Photographers Graphic designers	
	Adobe Lightnom ¹⁰ beta 3 or Photographers can now impo photographs with ease on an	rt, manage, and showcase volumes of	Photographers Graphic designers Engineers and architectr Scientists Film & video professionalit	
	Adobe Lightnom ¹⁰ beta 3 or Photographers can now impo photographs with ease on an	rt, manage, and showcase volumes of	Photographers Graphic designers Engineers and architects Scientists Film & video professionals Downloads	
Supported C	Adobe Lightnoon ³⁴ beta 3 m Photographers can nov impo photographis with ease on the studio, or in the office.	rt, manage, and showcase volumes of	Photographers Graphic derigners Engineers and architector Scientists Film & video professionale Dowtloads Tryout (Win)	
	Adobe Lightnoom ^m beta 3 or Photographers can now impo photographers with ease on any the studio, or in the office.	f, manage, and showcase volumes of Windows or Masintosh computer on location, in	Photographers Graphic designers Engineers and architects Scientists Film & video professionalis Develoads Trysoct (Win) Trysoct (Win)	
Carnera Raw	Adobe Lightnoom ¹⁰ beta 3 os Photographers can now ingo photographs with ease on an the studio, or in the office.	f, manage, and showcase volumes of Windows or Maximosh computer on location, in Macmosch microdows@	Photographers Grephic designers Engineers and architectr Scientists Film & index professionalit Downloads Trayot (Witk) Trayot (Witk)	
Carnera Raw licenty suppo	Adobe Lightnoom ^m beta 3 or Photographers can now impo photographers with ease on any the studio, or in the office.	f, manage, and showcase volumes of Windows or Maximosh computer on location, in Macmosch microdows@	Photographers Graphic designers Engineers and arthitecte Scientists Film & index professionale Destination Trayout (Web) Trayout (Web) Third party plug-ins Windexs cylatects	
Carnera Raw Kewly suppo — May 2006	Adobe Lightnesee" beta 3 es Photographers can now impo photographs with ease on an the studio, or in the office. ameraa 23.4 fed cameras for Caesara Ras	It, manage, and showcase volumes of Withdows or Maximisish compadie on location, in Machilosh Machilosh Conduction Machilosh Moders/0	Photographers Grephic designers Engineers and architectr Scientists Film & index professionalit Downloads Trayot (Witk) Trayot (Witk)	
Carnera Raw Kewly suppo — May 2006	Adobe Lightnesee" beta 3 es Photographers can now impo photographs with ease on an the studio, or in the office. ameraa 23.4 fed cameras for Caesara Ras	f, manage, and showcase volumes of Windows or Maximosh computer on location, in Macmosch microdows@	Photographers Graphic designers Engineers and arthitecte Scientists Film & index professionale Destination Trayout (Web) Trayout (Web) Third party plug-ins Windexs cylatects	
Camera Raw lewly suppo – May 2006 Support for th Canon	Adobe Lightnesee" beta 3 es Photographers can now impo photographs with ease on an the studio, or in the office. ameraa 23.4 fed cameras for Caesara Ras	r, matage, and showcase volumes of Withdows of Maximition Computer on Inciden, in Machinesis Microsoft Andrews 3.4 Added from Camera Raw 3.3 to 3.4. Openant	Photographers Graphic designers Carpiners and advitestor Scientists Film & video professionale Devetoads Trypot (Win) Third-parky plong-ins Winders cipaletes Macrotesh updates	
Carnera Raw levely sappo - May 2006 Support for th	Adobe Lightnesee" beta 3 es Photographers can now impo photographs with ease on an the studio, or in the office. ameraa 23.4 fed cameras for Caesara Ras	(matage, and showcas induces of Windows of Maximitian Comparison of Catalon, in Machines of Maximitian Machines (Machines (Mac	Hatopraphers Group-Lever and extribution Cognitives and extribution Scientis - Times extreme surfaces annual Downloads Times (Winks) Times (Winks) Times (Winks) Times and party physics Windower updates Haterheak hug-steet	
Carnera Raw levely suppo – May 2006 Support for B Canon EOG 300	Adobe Lightnesee" beta 3 es Photographers can now impo photographs with ease on an the studio, or in the office. ameraa 23.4 fed cameras for Caesara Ras	r, matage, and showcase volumes of Withdows of Maximition Computer on Inciden, in Machinesis Microsoft Andrews 3.4 Added from Camera Raw 3.3 to 3.4. Openant	Photographicg Graphic designers Expenses and arbitratis Scientists Thin is index professionalis Devisibads Transt (Neik) Transt (Neik) Thind-party physics Windows updates Nachristik updates Nachristik updates Cultures support	
Carnera Naw levely suppo – May 2006 Support for 8 Canon EOS 300 Epson	Adobe Lightnesee" beta 3 es Photographers can now impo photographs with ease on an the studio, or in the office. ameraa 23.4 fed cameras for Caesara Ras	t matage, and shorecase volumes of Windows in Maximition Computer on totalline, in Machine in Maximition Computer 2.4 Kacemotic Conductor 2.4 Kacemotic Conductor 2.5 State Computer Revort E-329 SIR-329	Photographics Graphic Generation Topper Search Solaritist Film & index professionalit Deschools Torsen (Hec) Third-party playing Windex updates Machines updates Restricts updates Support & training Customer support	
Carnetra Raw levely support May 2006 Support for the Canon EOS 300 Epson R-D15	Adobe Lightnesee" beta 3 es Photographers can now impo photographs with ease on an the studio, or in the office. ameraa 23.4 fed cameras for Caesara Ras	(matage, and showcas induces of Windows of Maximitian Comparison of Catalon, in Machines of Maximitian Machines (Machines (Mac	Photographos Graphic despect Scaletts Solaritis Trimol. (Wa) Trimol. (Wa) Trimol. (Wa) Thiol. gang Stages Wolkers: galantis Wolkers: galantis Wannian (Wal) Stagest Statistics Wolkers: galantis Kannisa (Wal) Coutenes: agant Casantis	
Carner a Raw levely suppo – May 2006 Support for II Canon EOS 300 Epson R-D1s Level	Adobe Lightnesee" beta 3 es Photographers can now impo photographs with ease on an the studio, or in the office. ameraa 23.4 fed cameras for Caesara Ras	(f minutg), and devices relations of Middows or Manifolds (minutg) or in floating, in Middows or Manifolds (minutg) or in floating, in 1.3.4 National (Minutg) or information (Minutg) or information	Photopupahos display dangser Jognases and excitations Sounders Sounders Tomore (Whis) Tomore (Whis) Counters buildings Tomore (Whis) Tomore (W	
Carnera Raw levely support May 2006 Support for the Canson EOS 300 Epson R-D1s Leaf Actus 85	Adobe Lightnesee" beta 3 es Photographers can now impo photographs with ease on an the studio, or in the office. ameraa 23.4 fed cameras for Caesara Ras	fr manage, and downess values of Minister Computer on Northin, in Ministerio or Manisterio Computer on Northin, in 	Photographos Graphic despicer Scaretes Termin (win) Termin (win) Termin (win) Termin (win) Termin (win) Termin (win) Termin (win) Termin (win) Termin (win) Contense regulates Teatman Contense regulates Teatman Teatman User forumes	
Carner a Raw levely suppo – May 2006 Support for II Canon EOS 300 Epson R-D1s Level	Adobe Lightnesee" beta 3 es Photographers can now impo photographs with ease on an the studio, or in the office. ameraa 23.4 fed cameras for Camera Ree	(f minutg), and devices relations of Middows or Manifolds (minutg) or in floating, in Middows or Manifolds (minutg) or in floating, in 1.3.4 National (Minutg) or information (Minutg) or information	Mediapopalonis Gospitul despisori Topinares and urbitestri Solariesti Toma des anteressiones Tomas (With) Tomas (With) Tomas (With) Tomas (With) Tomas (With) Mediates anteression Mediates anteression Mediates anteression Totamas User forumes Community Developer response Despisor	
Carnera Raw levely support May 2006 Support for the Canson EOS 300 Epson R-D1s Leaf Actus 85	Adobe Lightnesee" beta 3 es Photographers can now impo photographs with ease on an the studio, or in the office. ameraa 23.4 fed cameras for Camera Ree	fr manage, and downess values of Minister Computer on Northin, in Ministerio or Manisterio Computer on Northin, in 	Hungspahen Hungspahen Tophene auf einföhnt Societtes För eller eine profestenske Tophene (eller Tophene) Tophene (eller Tophene) Tophene auf eller Tophene	
Careera Raw lendy sappe – May 2006 Support for B Canon EOS 300 Epson R-O1s Leaf Aplus 75	Addet Light was " held a to "Protographen can nee legal by designed and the set on any the stated, or in the office anterna 3.4 In that common for Common Ree in biblioring common heat been	fr manage, and downess values of Minister Computer on Northin, in Ministerio or Manisterio Computer on Northin, in 	Hungspakes Bigshaf dargen Eigense sid eithikt Indenset Titte dare prinkenset Titte dare prinkenset Titte dare prinkenset Titte dare bigshaf Titte dare bigshaf Titte dare bigshaf Media bigshaf Dare bigshaf menga Dare bigshaf menga Dare bigshaf menga Dare bigshaf menga	
Carnera Raw Kewly support May 2000 Support for B Canon EOS 300 Epson A-D1s Leaf Adus 85 Adus 75 Supported c	Adula Lightness ¹⁰ Perla 3 to Photoproperties can neer import photoproperties where is any to study, or in the office. The study, or in the office. Adult cancers for Canver's Rase in factor of the study of the study interests for Canver's New 33.	rt manage with developer without of Withdows or Markinot computer on societies, in Stationary States (States) Stationary States (States) States)	Hungspakes Bigshe dargen Engenes and exhibits Indentess Prime Adde softwarend Prime Adde softwarend Transfer Under Anderson Hander and Anderson Hander Calantee update Takande User Norme Takande User Norme Takande User Norme Takande User Norme Passate Pas	
- May 2006 Support for II Canon EOS 200 Epson R-D1s Leas Actus 85 Actus 75 Supported C Support for II	Adula Lightness ¹⁰ Perla 3 to Photoproperties can neer import photoproperties where is any to study, or in the office. The study, or in the office. Adult cancers for Canver's Rase in factor of the study of the study interests for Canver's New 33.	fr manage, and downess values of Minister Computer on Northin, in Ministerio or Manisterio Computer on Northin, in 	Hungspakes Bigshaf dargen Eigense sid eithikt Indenset Titte dare prinkenset Titte dare prinkenset Titte dare prinkenset Titte dare bigshaf Titte dare bigshaf Titte dare bigshaf Media bigshaf Dare bigshaf menga Dare bigshaf menga Dare bigshaf menga Dare bigshaf menga	

3.07 Other Raw plug-ins

Suitable for Elements - 5.0, 4.0, 3.0, 2.0, 1.0 | Difficulty level - Basic

Often when installing the support software that was supplied with your digital camera an extra Raw utility is installed on your computer. This can mean that after installing the camera drivers you find that you no longer have access to Adobe Camera Raw and that instead the camera-based plug-in keeps appearing when you are attempting to open Raw files. If this occurs and you want to restore ACR as the default Raw utility then you will need to remove the camera-based plug-in from the plug-ins\Adobe Photoshop Elements 5.0\File Formats folder in Elements and add in the Adobe Camera Raw.8bi instead.

This is a problem that is often seen with Nikon users as the NEF.8bi plug-in designed to display and adjust Nikon Raw or NEF files takes precedence over the ACR utility.

Photo Organization and Management

Tags Collections

New -

A St Faw

Hi

Peo Peo

L Events

Sther Other

ints

3

9

Places

100000

History

a Toowoomba

Metadata

ADVANCED PHOTOSHOP ELEMENTS 5.0 FOR **DIGITAL PHOTOGRAPHERS**

Organizing your photos with Photoshop Elements

With no film or processing costs to think about each time we take a picture, it seems that many of us are pressing the shutter more frequently than we did when film was king. The results of such collective shooting frenzies are hard drives all over the country full of photos. Which is great for photography but what happens when you want to track down that once in a lifetime shot that just happens to be one of thousands stored on your machine? Well, believe it or not, being able to locate your files quickly and easily is more a task in organization, naming and camera set up than browsing through loads of thumbnails.

4.01 Add picture details in-camera

Suitable for Elements – 5.0, 4.0, 3.0, 2.0, 1.0 | Difficulty level – Basic | Related techniques – 4.02, 4.03, 4.04, 4.05 Getting those pesky picture files in order starts with your camera set up. Most models and makes have options for adjusting the numbering sequence that is used for the pictures you take. Generally you will have a choice between an ongoing sequence, where no two photos will

In-camera labelling >>> Most cameras provide options for selecting the way in which files are numbered. The continuous option ensures that a new number is used for each picture even if memory cards are changed in the middle of a shoot. have the same number, and one that resets each time you change memory cards or download all the pictures. In addition, many models provide an option for adding the current date to the file name, with some including customized comments (such as shoot location or photographer's name) in the naming sequence or as part of the metadata stored with the file.

To adjust the settings on your camera search through the Set Up section of the camera's menu system for headings such as File Numbering and Custom Comments to locate and change the options. Ensure that number sequencing and date inclusion options are switched on and, where available, add these comments along with the photographer's name and copyright statement to the metadata stored within the picture file.

4.02 Organize photos whilst downloading

Suitable for Elements – 5.0, 4.0, 3.0 | Difficulty level – Basic | Related techniques – 4.01, 4.03, 4.04, 4.05 As we saw in the last chapter Photoshop Elements 5.0 includes the Adobe Photo Downloader utility that move pictures from your camera or memory card to the computer. As part of the download process, the user gets to select the location of the files and the way that the files are to be named and numbered, and automatically stack, tag and apply metadata to the photos.

It is at this point in the process that you need to be careful about the type of folder or directory structure that you use. Most photographers group their images by date, subject, location or client, but the approach that you employ is up to you. Once you have selected a folder structure though, try to stick with it. Consistency is the byword of photo organization.

If your camera doesn't provide enough Automatic Naming and metadata options to satisfy your needs then use the Elements Photo Downloader feature to enhance your ability to distinguish the current images with those that already exist on your hard drive by setting the location and filename of the picture files as you transfer them.

Nominate and create a new directory for each session of downloaded photos. Add extra metadata captions, keywords, photographer and copyright details using the tagging options in Elements.

	gt Photos from: :\ <camera card="" or="" reader=""> Files Selected - 15 MB (21 Duplicates Exclu in 23, 2006 - Jun 24, 2006</camera>
Import Settings	
Location:	P:\2006\[2 subfolders]
<u>C</u> reate Subfolder(s):	Shot Date (yyyy mm dd)
<u>R</u> ename Files:	Custom Name
	Josh
	Example: Josh 001.jpg
Delete Options:	After Copying, Do Not Delete Origin
	Automatic Do <u>w</u> nload
	📋 Automatic Do <u>w</u> nload 🛛 🖓

Naming via the downloader >> Use the options in the Photo Downloader to thoughtfully locate (1) and name (2), your digital photos.

ocation 12006 Browse ... Create Subfolder(s) Create Subfolder(s): ustom Groups(Advanced) None N. Custom Groups(Advanced) ~ None Custom Name Rename Files Today's Date (yyyy mm dd) ______ 2 Custom Name Custom Name Y Shot Date (yyyy mm dd) Shot Date (vv dd mm Shot Date (vv dd mm) ost Group Name: Shot Date (dd mm yy) Shot Date (dd mm yy) Example: Josh 001.jpg ~ Custom Name Shot Date (dd mm) Shot Date (dd mm) Shot Date (yyyy dd mmm) Shot Date (yyyy dd mmm) Advanced Options Shot Date (dd mmm yyyy) Shot Date (dd mmm yyyy) Custom Name Custom Groups(Advanced Automatically Eix Red Eyes Shot Date (yyyy mm dd) + Custom Nam Automatically Suggest Photo Stacks Shot Date (yy dd mm) + Custom Name Shot Date (dd mm yy) + Custom Name A variety of names for any Make 'Group Custom Name' a Tag Shot Date (dd mm) + Custom Name subfolders that are created for the After Copying, Do Not Delete Originals × downloaded photos can also be You can select from a V Apply Metadata selected range of different Author: Choosing the Custom Groups naming schemes in the Philip Andrews (Advanced) option redisplays the Rename drop-down Copyright thumbnails in groups based on menu 2006 setting of the Slider control. Automatic Download O

Organize as you download >> The Adobe Photo Downloader allows the user to automatically apply naming changes, metadata, group tags, suggest photo stacks and determine the location where transferred files will be saved. The downloader features provide five different ways to organize your pictures: (1) Locating existing, or creating new, folders for downloading. (2) Renaming pictures with meaningful titles. (3) Suggesting Photo Stack groupings. (4) Applying Group Custom Name as a Tag. (5) Adding custom metadata to the picture file which can be used as search criteria inside the Organizer workspace.

Book resources at: www.adv-elements.com

PHOTO ORGANIZATION AND MANAGEMENT

Organizing using Photo Browser

The Photo Browser mode in the Organizer workspace not only provides thumbnail previews of your photos but the images can be categorized with different Tags (keywords), Notes and Caption entries, split in different collections and then searched based on the Tags and Metadata associated with each photo. Unlike a traditional browser system, which is folder based (i.e. it displays thumbnails of the images that are physically stored in the folder), the Elements Photo Browser creates a catalog version of the pictures and uses these as the basis for searches and organization. With this approach it is possible for one picture to be a member of many different collections and to contain a variety of different keywords.

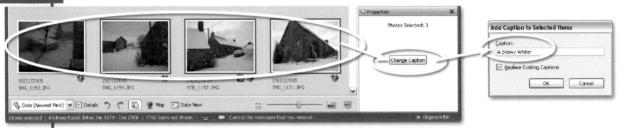

Adding captions to several photos >> After multi-selecting pictures in the Photo Browser workspace press the Change Caption option located in the Properties palette and then add the new caption in the dialog that is displayed. These captions can be added to or used to replace existing captions.

4.03 Captioning

Suitable for Elements – 5.0, 4.0, 3.0 | Difficulty level – Basic | Related techniques – 4.01, 4.02, 4.04, 4.05 Captions are another way to 'title' your photos beyond the standard file name. Adding a meaningful caption provides yet another avenue for searching for individual photos as the Find > Find by Caption or Note feature targets the entries you make here. Captions can also be used, printed or displayed in Photo Creations (but need to be added before starting the creation process) and Photo Galleries as well as on contact sheets. In Photoshop Elements 5.0 captions can be added and used in a range of different ways.

Adding a single caption – Captions can be added in the Single Photo View of the Photo Browser, the Properties pane (General tab), via the Add Caption command or in the Caption field in the Date View.

Adding multiple captions – Multi-select the images to be captioned and press the Change Caption button in the Properties palette, add in the caption details and click OK.

4.04 Naming and renaming

Suitable for Elements – 5.0, 4.0, 3.0 | *Difficulty level – Basic* | *Related techniques – 4.02, 4.03, 4.04, 4.05* Along with captioning, adding logical file names to photos is probably the most popular way that photographers organize their pictures. If the downloading utility that you use doesn't provide the opportunity to rename on-the-fly, the file titles can be changed either individually, via the Name section of the Properties palette, or as a group, using the Editor: File > Rename feature. Be sure to use a unique name for your photos and preferably one that will help you locate them later.

Changing names >> Rename a file by selecting its thumbnail in the Photo Browser workspace and then clicking on the General tab in the Properties palette. Type in the new title for the file in the Name section of the dialog that is displayed.

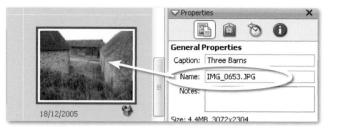

4.05 Tagging your photos

Suitable for Elements – 5.0, 4.0, 3.0 | Difficulty level – Basic | Related techniques – 4.01, 4.02, 4.03, 4.05 In Elements 5.0 keywords are added to your photos in the form of Tags. The Tags pane stores the Tags, provides an easy drag and drop approach to adding tags to selected photos and sits to the right of the main thumbnail area in the Photo Browser workspace. The pane is grouped together with the Collections and Properties panes in the Organize Bin.

Tags are applied to a picture by selecting and dragging them from the pane onto the thumbnail or alternatively the thumbnail can be dragged directly onto the Tags pane. Multiple Tags can be attached to a single picture by multi-selecting the Tags first and then dragging them to the appropriate thumbnail.

- 1. To add a Tag to a single image click-drag the tag from the Tags pane to the thumbnail image in the browser (Organizer) workspace.
 - 2. To add a single Tag to multiple thumbnails, multi-select the thumbnails in the images and then drag the Tag from the Tags pane onto one of the selected thumbnails.

Creating new Tags

New Tags are created and added to the pane by selecting the New Tag option from the menu displayed after pressing the New button at the top left of the pane. Next, fill out the details of the new entry in the Create Tag dialog, select a suitable icon for the Tag label and click OK. The first picture that you drag to the new tag determines the thumbnail you see on the Tag. This is the quickest way to add an image to the Tag icon.

Tags and Collections >> Tags and Collections are used to organize the pictures in the Organizer workspace. One photo can belong to many different collections and contain multiple Tags.

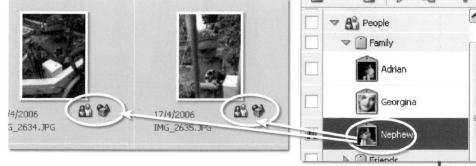

Book resources at: www.adv-elements.com

81

PHOTO ORGANIZATION

AND MANAGEMENT

Collections

Tags

New

- 1. To create a new Tag, select the New Tag option from the New Button menu at the top of the Tags pane.
- 2. In the File Tag dialog that is displayed select a category for the Tag, add in a name and include any explanatory notes.
- Next press the Edit Icon button and import for a picture to include the Tag label before sizing and cropping the photo in the Edit Tag Icon dialog.
- Tag Icon dialog.4. Click OK to close both dialogs and add the new Tag to the Tag list.

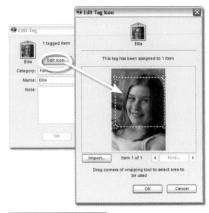

Make a new Tag >> You can add to the existing set of Tags using the New Tag option. There is even an option to add your own pictures as the Tag icon.

4.06 Auto Face Tagging

Suitable for Elements - 5.0, 4.0, 3.0 | Difficulty level - Basic | Related techniques - 4.05

Brand new for Elements 5.0 is the ability to search through a group of photos and automatically select those that contain faces. Using this feature makes it much easier to locate and tag photos of family and friends in the batches of pictures that you import. Start by selecting a group of photos from inside the Organizer workspace. Next, click the Find Faces for Tagging button in the Tags pane. The faces identified will be displayed in a new dialog box which also includes the Tags pane. From here your Tags can be quickly dragged onto individual or groups of selected face photos.

- 1. Multi-select a group of images from inside the Organizer workspace.
- 2. Either choose Find > Find Faces for Tagging or press the Find Faces for Tagging button at the top of the Tags pane.
- 3. Drag Tags onto the pictures that are displayed in the Face Tagging dialog. Click Done to return to the Photo Browser workspace.

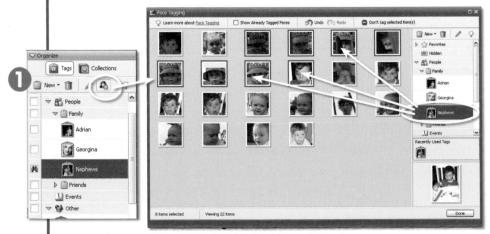

Tagging by faces >>

The Face Tagging option in Elements 5.0 quickly scans a group of selected photos and identifies those pictures that contain faces then displays these in a separate dialog ready for tagging. (1) Organizer pane.

82

4.07 Collections and how to group photos

Suitable for Elements - 5.0, 4.0, 3.0 | Difficulty level - Basic | Related techniques - 4.11, 4.12

Apart from tagging, Photoshop Elements also uses Collections as a way to organize your photos. Collections allow you to group images of a similar theme together in the one place making it easier to locate these images at a later date. After creating a collection in the Collections pane, photos can be dragged from the Photo Browser workspace to the Collection heading to be added to the group, or alternatively the Collection entry can be dragged to the photo to produce the same result.

The Collections feature allows you to allocate the same image to several different groups. Unlike in the old days, this doesn't mean that the same file is duplicated and stored multiple times in different folders. Instead the picture is only stored or saved once and a series of collection associations is used to indicate its membership in different groups.

When you want to display a group of images based on a specific subject, taken at a particular time or shot as part of a certain job, the program searches through its database of collection keywords and only shows those images that meet your search criteria.

The Collections pane is the pivot point for all your collection activities. Here you can view, create, rename and delete collections. If the pane is not displayed in the Photo Browser workspace then click the Organize Bin at the bottom right of the browser and then choose the Collections tab.

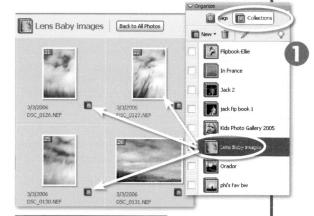

Grouping with Collections >>> Sort your pictures into groups of the same subject or theme using the Elements' Collections feature. (1) Collection Pane.

Adding photos to a collection

To start using Collections make a new collection first and then add it to your photos.

- 1. Start making a new collection by clicking on the New button in the Collections pane and select the New Collection menu item.
- 2. In the Create Collection dialog choose the group that the new collection will belong to, add the name and include any explanation details for the group. Click OK.
- 3. Select the photos to be included in the collection in the Photo Browser and drag them to the Collection heading in the Collections pane.
- 4. To view all the pictures contained in a collection double-click on the Collection heading or click on the column to the left of the collection. A Binoculars icon will appear.
- 5. Single photos or even groups of pictures can be added to more than one collection at a time by multi-selecting the collection names first before dragging the images to the pane.

Using Collection groups

Different collections (and the photos they contain) can also be organized into groups that have a common interest or theme. For instance, collections that contain pictures of the kids, family vacations, birthday parties and mother- and father's-days events can all be collated under a single 'Family' collection group heading. The advantage of using a collection over just viewing tagged files in the Photo Browser is that files in a collection can be reordered by dragging them. Files in the Photo Browser window cannot be reordered in this way. Create a Collection group by selecting New > New Collection Group from the Collection Pane. Next click-drag existing collection entries listed in the pane to the Group heading.

The best way that you choose to make use of the Tagging and Collection features in Elements will depend a great deal on the way that you work, the pictures you take and the type of content that they include, but here a few different proven methods that you can use as a starting point.

Subject:

Photos are broken down into subject groups using headings such as family, friends, holidays, work, summer, night shots, trip to Paris, etc. This is the most popular and most applicable approach for most readers and should be the method to try first.

Time line:

Images are sorted and stored based on their capture date (when the picture was photographed), the day they were downloaded or the date that they were imported into the organizational package. This way of working links well with the auto file naming functions available with most digital cameras but can be problematic if you can't remember the approximate dates that important events occurred. Try using the date approach as a subcategory for subjects headings, e.g. Bill's Birthday > 2005.

File type:

Image groups are divided into different file type groups. Although this approach may not seem that applicable at first glance it is a good way to work if you are in the habit of shooting RAW files which are then processed into PSD files before use.

Project:

This organizational method works well for the photographer who likes to shoot to a theme over an extended period of time. All the project images, despite their age and file type, are collated in the one spot making for ease of access.

Client or Job:

Many working pros prefer to base their filing system around the way that their business works, keeping separate groups for each client and each job undertaken for each client.

4.08 Changing your view

Suitable for Elements – 5.0, 4.0, 3.0 | Difficulty level – Basic Related techniques – 4.09

Your photos can be viewed in a range of different ways in the Organizer or Photo Browser workspace. The standard view (**Photo Browser View**) displays the pictures as a series of thumbnails in a 'rows and columns' format. You can sort the sequence of the photos according to date and import batch or folder location using the drop-down menu at the bottom left of the workspace. It is also possible to display only those images with a specific associated Tag or belonging to a particular collection by double-clicking on the entry in Tags or Collections or clicking on the column on the left of the palette.

Selecting the View >> Choosing one of the options from the dropdown menu at the bottom left of the Photo Browser determines how the thumbnails are presented in the workspace.

Another option is to view the photos in **Date View** mode. Here the images are also grouped and displayed based on the date they were taken, but they are shown in a calendar format. You can choose a year-, month- or day-based calendar with each view containing a slide show feature that will automatically flick through all the photos taken on a specific date. Pictures displayed in Date View can be edited, printed, shared and included in Photo Creation projects by clicking one of the shortcut buttons at the top of the screen.

The View Photos in Full Screen option provides an instant slide show of the files that you have currently displayed in the Photo Browser. Seeing the photos full size on your machine is a good way to edit the shots you want to keep from those that should be placed in the 'I will remember not to do that next time' bin. With the provided menu you can play, pause, or advance to next or last photos, using the VCR-like controls. You can enlarge or reduce the size that the picture appears on screen with the Magnification slider (Zoom Level control). For quick magnification changes there are also 'Fit to Window' and 'Actual Pixels' buttons. But the real bonus of the feature is the list of actions that you can perform to pictures you review. You can automatically enhance, add and remove tags, mark the file for printing and add the file to a chosen collection using the choices listed under the Action menu. Specific picture properties such as Tag, History, and Metadata are available by hitting the Alt + Enter keys to display the properties window. As well as showing all the photos currently in the browser you can also multi-select the images to include in the review session before starting the feature. or even limit those pictures displayed to a particular collection. The Full Screen View options can be set when the feature is first opened or accessed via the last item on the Action menu.

Closely linked to the View Photos in Full Screen feature detailed above is the **Compare Photos Side by Side** option which allows users to display two similar pictures side by side. This is a great way to choose between

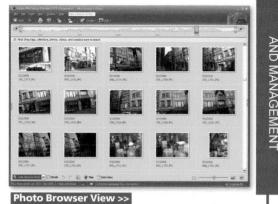

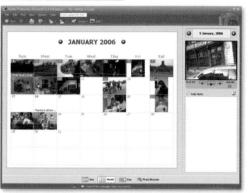

Date View >>

View Photos in Full Screen mode >>

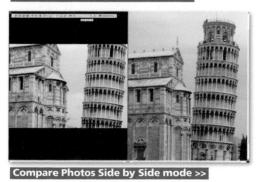

Book resources at: www.adv-elements.com

85

HOTO ORGANIZATION

several images taken at the same time to ensure that the best one is used for printing or passed on to the Editor for enhancement. To select the images to display click onto one of the compare workspaces (left or right in the example on page 85) and then click on a thumbnail. Now select the other workspace and click the comparison image thumbnail. Pressing the X key switches the photos in the display so that you can always keep the best images on the left of the screen as you flip through other photos on the right. All the same Full Screen adjustment and organizational controls are available in the Compare Photos feature, including the Zoom Control which provides the ability to examine candidate files more closely.

Find options >> The Find menu in the Photo Browser workspace lists the many different ways to locate images within Elements.

Find it	ems with filer	name containing:
UK		
Г	ок	Cancel

Locate by filename >>> When choosing the Date Range, Caption or Note, Filename (see above), History, and Details find options Elements displays a new dialog into which your search criteria can be entered.

4.09 Locating files

Suitable for Elements - 5.0, 4.0, 3.0 | Difficulty level - Basic | Related techniques - 4.08

One of the great benefits of organizing your pictures in the Photo Browser workspace is the huge range of search options that then become available to you. In fact there are so many search options that Adobe created a new menu heading 'Find' specifically to hold all the choices. Here you will be able to search for your photos based on a selected date range, filename, caption, media type (video, photo, audio or creation), history (when an item was emailed, printed, received, imported, used in a creation project or even shared on-line) and even by the predominant color in the photo (see above). After selecting one of the Find menu options Elements either displays files that meet the search criteria in a new window (Find by Version Sets, Media Type, Untagged Items, Items not in a Collection) or opens a new dialog where the user must enter specific details (dates, filenames, details, captions) which will be used to base the search.

Locate tagged photos >> To display all images tagged with a specific entry, doubleclick the Tag name in the Tags pane. Return the view to the whole collection by clicking the Back to All Photos button (1).

Book resources at: www.adv-elements.com

Finding tagged photos or those contained in a collection

As well as the search options located in the Organizer: Find menu, you can make use of the Tags and Collections features to quickly locate and display sets of photos from your catalog.

To find tagged photos: Double-click the Tag entry in the Tags pane.

To display all the images in a collection: Double-click on the Collection entry in the Collections pane or click on the column on the left of the pane. This will display the Binoculars icon.

To return the browser back to the original catalog of thumbnails: Click on the Back to All Photos button at the top of the thumbnail group.

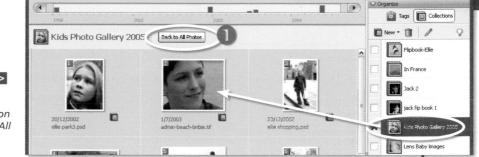

Find collections of photos >> To show all the photos in a collection double-click the Collection name in the Collection Pane. Again, press the Back to All Photos button to return to the catalog (1).

Find by details or metadata

Version 5.0 of Elements also contains a Find option that is designed to allow users to search the details or metadata that is attached to their picture files. Most digital cameras automatically store shooting details from the time of capture within the photo document itself. Called metadata, you can view this information by clicking the Metadata button inside the Properties palette.

The Find > By Details (Metadata) option displays a sophisticated Search dialog that allows you to nominate specific criteria to use when looking within the metadata portion of the picture file. The dialog provides a section to input the text to search for as well as two drop-down menus where you can set where to look (Filename, Camera Make, Camera Model, Capture Date, etc.) and how to match the search text (Starts with, Ends with, Contains, etc.).

Beyond camera-based metadata you can also use this dialog to search for any Captions, Notes, Tags or Collections that you have applied to your pictures.

- 1. Select Find > By Details (Metadata) from the Photo Browser workspace.
- 2. Choose the type of details that you are looking for Filename, Camera Make, Camera Model, etc. from the drop-down list in the Find by Details dialog.
- 3. Enter the text you want to search for (if needed).
- 4. Enter how the search text should appear in the located files (contained, not contained, etc.)

87

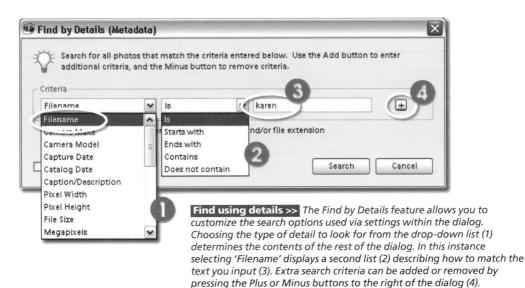

Protecting your assets

Ensuring that you keep up-to-date duplicates of all your important pictures is one of the smartest work habits that the digital photographer can learn. Ask yourself 'What images can't I afford to loose – either emotionally or financially?' The photos you include in your answer are those that are in the most need of backing up. If you are like most image-makers then every picture you have ever taken (good and bad) has special meaning and therefore is worthy of inclusion. So let's assume that you want to secure all the photos you have accumulated.

Burn/Backup				×
Choose a				SEL
Step: 1 2				- 77
	Files otos, movie clips, or aud rowser to a CD/DVD disk			
 Backup the Copy the cut 	Catalog rrent open catalog — Inci	Indian the estalon file a		
audio clips,	movie clips, and creation ilarly to protect your cate	ns — to a CD/DVD disk or	r hard disk.	
			Next>	Cancel

Backup/Copy files >>

The first screen of the Elements' Backup feature contains the choice of two different actions:

(1) Copy/Move Files – use this selection to make copies of files that you have selected in the Photo Browser workspace or to permanently move files to another destination.

(2) Backup the Catalog – this option provides a complete backup of all the files in your catalog and then the next time it is used allows you to add any files that have been changed or added since the last backup.

88

PHOTO ORGANIZATION AND MANAGEMENT

4.10 Creating a backup

Suitable for Elements - 5.0, 4.0, 3.0 | Difficulty level - Basic | Related techniques - 4.11

Gone are the days when creating a backup of your work involved costly tape hardware and complex server software. Now you can archive your pictures from inside the very software that you use to enhance them – Photoshop Elements.

The Backup feature (Organizer: File > Backup the Catalog) is designed for copying your pictures (and catalog files) onto DVD, CD or an external hard drive for archiving purposes. To secure your work simply follow the steps in the wizard. The feature includes the option to backup all the photos you currently have catalogued in the Photo Browser along with the ability to move selected files from your hard disk to CD or DVD to help free up valuable hard disk space.

- 1. To start the backup process select File > Backup from the Photo Browser workspace.
- 2. Next select Backup the Catalog. Click Next.
- 3. At the next screen choose **Full Backup** for first time archiving or **Incremental Backup** for all backups after the first one. Click Next.
- 4. And finally select the place where you want the backup to be stored. This may be on a series of CD or DVDs or on an internal drive. Then click Done to backup your files.

Backup glossary:

Multi-disk archive – A process, often called spanning, by which chunks of data that are larger than one disk can be split up and saved to multiple CD-ROMs or DVDs using spanning software. The files can be recompiled later using utility software supplied by the same company that wrote the disks.

Full backup – Duplicates all files even if they haven't changed since the last time an archive was produced (1).

Incremental – Backs up only those files that have changed since the last archive was produced. This makes for faster backups but means that it takes longer to restore files as the program must look for the latest version of files before restoring them (2).

Restore – Reinstates files from a backup archive to their original state on your hard drive.

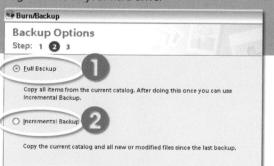

CD-ROM or DVD writer – This option is very economical when coupled with writing software that is capable of writing large numbers of files over multiple disks. The sets of archive disks can easily be stored off site ensuring you against theft and fire problems but the backup and restore process of this approach can be long and tedious.

Internal hard drive – Adding an extra hard drive inside your computer that can be used for backing up provides a fast and efficient way to archive your files but won't secure them against theft, fire or even some electrical breakdowns such as power surges.

External hard drive – Connect via USB or Firewire, these external self-contained units are both fast and efficient and can also be stored off site providing good all-round protection. Some, like the Maxtor One Touch models, are shipped with their own backup software. Keep in mind that these devices are still mechanical drives and that care should be taken when transporting them.

Backup hardware:

Backup regularly

There is no point having duplicate versions of your data if they are out of date. Base the interval between backups on the amount of work you do. In heavy periods when you are downloading, editing and enhancing many images at a time backup more often; in the quieter moments you won't need to duplicate files as frequently. Most professionals backup on a daily basis or at the conclusion of a work session.

Store the duplicates securely

In ensuring the security of your images you will not only need to protect you photos from the possibility of a hard drive crash but also from such dramatic events as burglary and fire. Do this by storing one copy of your files securely at home and an extra copy of your archive disks or external backup drives somewhere other than your home or office. I know that this may sound a little extreme but swapping archive disks with a friend who is just as passionate about protecting their images will prove to be less painful than losing all your hard work.

New Backup eatures for 5.0 In version 5.0 the Backup Catalog feature has been enhanced so that now it is possible to archive your catalog over a series of CD or DVD disks. In previous versions, the Backup feature only allowed writing to a single disk and even with the growing use of DVD-ROMs for archive scenarios, many digital photographers have a catalog of photos that far exceeds the space available on a single disk. The feature estimates the space required for creating the backup copy of the catalog and, after selecting the drive that will be used for archiving, the feature also determines the number of disks required to complete the action. During the

Book resources at: www.adv-elements.com

writing process the feature displays instruction windows at the end of writing each disk and when you need to insert a new disk. All disks need to be written for the backup to be complete. To restore a catalog from a set of backup disks use the File > Restore Catalog option in the Organizer workspace.

The revised backup feature also allows multisession recording of archives. Multi-session DVD or CD-ROM recording means that you can add extra backup files to disks that you have already recorded to. Most Elements users will find this useful when performing incremental backups.

In addition a new online archive option is included with version 5.0, called Online Backup; the feature provides a way of storing a copy of important image files on a server on the internet. The service is provided by Iron Mountain. After registering Elements users can backup their pictures, but not their catalog, to the secure server.

4.11 Versioning your edits

Suitable for Elements - 5.0, 4.0, 3.0 | Difficulty level - Basic | Related techniques - 4.07, 4.12

Creating a good archival system goes a long way to making sure that the images you create are well protected, but what about the situation where the original photo is accidentally overwritten as part of the editing process? Embarrassing as it is, even I have to admit that sometimes I can get so involved in a series of complex edits that I inadvertently save the edited version of my picture over the top of the original. For most tasks this is not a drama as the edits I make are generally non-destructive (applied with adjustment layers and the like) and so I can extract the original file from inside the enhanced document but sometimes, because of the changes I have made, there is no way of going back. The end result of saving over the original untouched digital photo is equivalent to destroying the negative back in the days when film was king. Yep, photographic sacrilege!

So you can imagine my relief to find that in version 5.0 of Photoshop Elements Adobe has a technology that protects the original file and tracks the changes made to the picture in a series of successively saved photos. The technology is called Versioning as the software allows you to store different versions of the picture as your editing progresses. What's more, the feature provides options for viewing and using any of the versions that you have previously saved. Let's see how this file protection technology works in practice.

Versions and Photoshop Elements

Versioning extends the idea of Elements image stacks by storing the edited version of pictures together with the original photo in a special Version Set. All photos enhanced in the Photo Browser space using a tool like Auto Smart Fix are automatically included in a Version Set. Those images saved in the Quick and Full Edit workspaces with the Save As command can also be added to a Version Set by making sure that the Save in Version Set with Original option is ticked before pressing the Save button in the dialog.

Saving in this way means that edited files are not saved over the top of the original; instead a new version of the image is saved in a Version Set with the original. It is appended with a file name that has the suffix '_edited' attached to the original name. This way you will always be able to identify the original and edited files. The two files are 'stacked' together in the Photo Browser with the most recent file displayed on top.
 File pame:
 IMG_1273_edited:3.psd
 Save

 My Network
 Earmat:
 Photoshop (* PSD;*PDD)
 Cancel

 Save Options
 Organize:
 Include in the Organize
 Save in Version Set with Original

 Save:
 Layers
 As a Copy

Save a version from Editor >>> To create a Version Set when saving an edited file from inside the Quick Fix or Standard Editor workspace make sure that the 'Save a Version Set with Original' option is selected.

Version Set icon >> The Bundled photos icon at the top right of the thumbnail shows that the photo is part of a version set.

Displaying Version Set photos >> Selecting the Version Set > Expand Items in Version Set option from the right-click menu (context menu) displays the various pictures that have been bundled together in the set. Alternatively you can click the Expand/Collapse arrow on the right of the version set.

When a photo is part of a Version Set, there is a small icon displayed in the top left of the Photo Browser thumbnail. The icon shows a pile of photos and a paint brush. To see the other images in the Version Stack simply right-click the thumbnail image and select Version Set > Expand Items in Version Set or click on the Expand/Collapse arrow button on the right of the version set thumbnail.

Using the other options available in the right-click pop-up menu the sets can be expanded or collapsed, the current version reverted back to its original form or all versions flattened into one picture. Version Set options are also available via the Photo Browser Edit menu. Unlike Stacks, you cannot add other images to a Version Set as the set only contains edits of the same image.

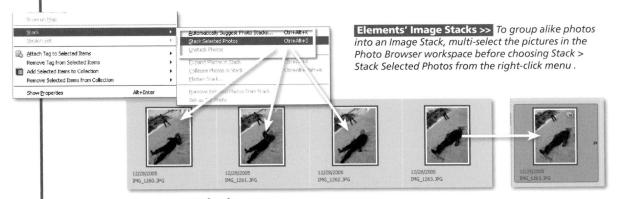

Book resources at: www.adv-elements.com

92

PHOTO ORGANIZATION AND MANAGEMENT

4.12 Creating Image Stacks

Suitable for Elements – 5.0, 4.0, 3.0 | Difficulty level – Basic Related techniques – 4.07, 4.11

An Image Stack is slightly different from a Version Set as it is a set of pictures that have been grouped together into a single place in the Organizer workspace. Most often Stacks are used to group pictures that have a common subject or theme and the feature is one way that Elements users can sort and manage their pictures. To create a Version Stack, multi-select a series of thumbnails in the workspace then right-click on one of the selected images to show the menu and from here select the Stack > Stack Selected Photos option. You can identify stacked image groups by the small icon in the top right of the thumbnail.

Auto photo stacking

The idea of grouping together like photos in a single stack was introduced in version 3.0 of the program. New for 5.0 is the ability to auto stack images as they are downloaded from camera, imported into Elements from folders or even when displayed in the Organizer workspace.

The feature searches for similar images, either visually similar, or multiple photos taken within a short period of time, and then assembles these in groups in the 'automatically suggest photo stacks' window. From here you can choose to remove selected photos from a group or even remove a group all together from the window. Once you have fine-tuned which photos to include, clicking the Stack All Groups button will create Photo Stacks from all the groups in the window.

To auto stack pictures that are already in your catalog select a group of thumbnails first and then choose Automatically Suggest Photo Stacks from either the Edit > Stack or the right-click pop-up menus. Alternatively, to stack when importing pictures from a folder, camera or card reader choose the Automatically Suggest Photo Stacks option in the Get Photos or Adobe Photo Downloader dialog.

Image Stacks icon >> Image Stacks use a Layered Photos icon in the top right of the thumbnail to indicate that the picture is one of several images that have been grouped.

JHUCDAU	e (уууу mm dd)	
<u>R</u> ename F	iles:	
Do not re	name files	¥
Example:	DSC_0170_edited-1.jpg	
🖙 Advar	iced Options	
Auton	natically Fix Red Eves	
Auton	natically Suggest Photo Stacks	
	aroup custom name a rag	
After Cop	oying, Do Not Delete Originals	¥
🗢 Apply	Metadata	
Aut <u>h</u> or:	1	
Copyright	1	

Auto stack whilst downloading >> The Advanced dialog of the Adobe Photo Downloader contains the Automatically Suggest Photo Stacks option so you can group alike images as you transfer your files from camera to computer.

Either of these two options will then display a new window with alike pictures pre-grouped. Choosing the Stack All Groups button converts the groups to stacks. The Remove Group or Remove Selected Photos buttons prevent individual images or group of pictures being made into a stack.

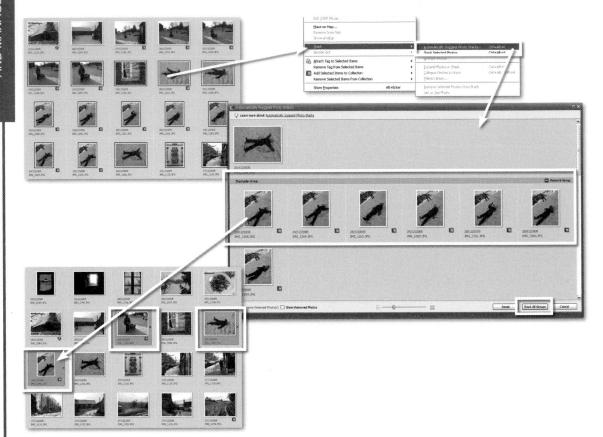

Stacking cataloged photos >> To employ the Auto Stacking feature with photos that you have already cataloged, start by multi-selecting several images in the Photo Browser workspace. Next right-click one of the pictures and choose Stack > Automatically Suggest Photo Stacks from the pop-up menu. Elements will then display a window containing groups of photos that are suitable for converting into Photo Stacks. You can remove images from groups by selecting the photo and then pressing the Remove Selected Photos button at the bottom left of the dialog. Stop specific groups from being converted to a Photo Stack by clicking on the Remove Group button at the top right of each group section. Finally, press the Stack All Groups button to convert the groups to Photo Stacks and show these in the Photo Browser.

94

Pathways to Editing in Elements

ADVANCED PHOTOSHOP ELEMENTS 5.0 FOR DIGITAL PHOTOGRAPHERS

ersions 3.0 heralded a completely new approach to editing photos within Photoshop Elements. Whereas in previous editions all actions were centered upon the tools and features in the Full Edit workspace, the recent versions of the program provide the digital photographer with several different levels of editing.

The options can be grouped around three different approaches to the task:

- Automatic.
- Semi-automatic and
- Manual.

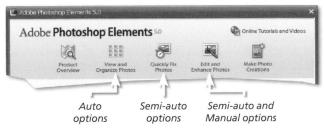

Automatic editing

The simplest tools are almost always fully automatic with the user having little control over the final results. These are the Types of color, Contrast and Brightness controls that are available in the Photo Browser either via the menu selections – Edit > Auto Smart Fix and Auto Red Eye Fix – or from the pop-up menu that is displayed when you right-click a thumbnail image in the workspace. These options provide a great place to start if you are new to digital photography and want good results quickly and easily, but experienced users will find the lack of control frustrating.

Auto-editing options >> The Auto Smart Fix, Auto Red Eye Fix and Rotate features are accessed by right-clicking on the thumbnail and then selecting the required option from the pop-up menu.

Simple control using the Auto Smart Fix and Auto Red Eve Fix

- Rotate left or right
- Changes applied automatically
- New users start here for good, quick results
- Automatic control of: contrast, color, shadow and highlight detail

96

5.01 Auto Smart Fix

Suitable for Elements – 5.0, 4.0, 3.0 | Difficulty level – Basic Related techniques – 5.02, 5.03

The Auto Smart Fix feature enhances both the lighting and color in your picture automatically. The command is used to balance the picture hues and improve the overall shadow and highlight detail. Most images are changed drastically using this tool. In some cases the changes can be too extreme. If this occurs, the effect should be reversed using the Edit > Undo command and the more controllable version of the tool – Adjust Smart Fix – used instead. Adjust Smart Fix is located in the Editor workspace.

5.02 Adjust Smart Fix

Suitable for Elements – 5.0, 4.0, 3.0 | Difficulty level – Basic Related techniques – 5.01, 5.03

The Adjust Smart Fix (Editor: Enhance > Adjust Smart Fix) version of the Auto Smart Fix feature provides the same control over color, shadow and highlight detail but with the addition of a slider control that determines the strength of the enhancement changes. Moving the slider from left to right will gradually increase the amount of correction applied to your picture. This approach provides much more control over the enhancement process and is a preferable way to work with all but the most general photos.

The Auto button, also located in the dialog, automatically applies a fix amount of 100% and provides a similar result to selecting Enhance > Auto Smart Fix.

5.03 Auto Red Eye Fix

Suitable for Elements – 5.0, 4.0 | Difficulty level – Basic Related techniques – 5.01, 5.03

One of the possible side effects of using the inbuilt flash on your compact digital camera is the appearance of red eyes in the subject. Elements has always had great options for correcting this problem and the current release is no different containing a specific Red Eye Removal tool. All new for Elements 5.0 is the ability to automatically detect the presence of red eye in a photo and then correct the problem. The feature cleverly checks out the metadata attached to the photo to see if flash was used to record the image before searching for the problem eyes and automatically correcting the red hue.

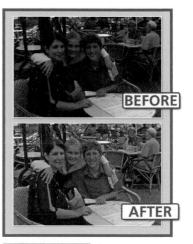

Auto Smart Fix >> The Auto Smart Fix feature enhances color, brightness, shadow and highlight detail automatically.

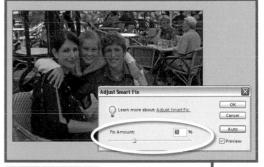

Adjust Smart Fix >> The Adjust Smart Fix option provides a slider control for the auto enhancement effects applied by the feature.

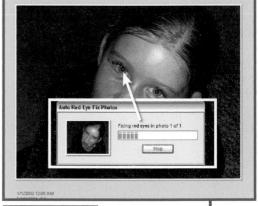

Auto Red Eye Fix >> The Auto Red Eye Fix feature searches for and corrects the red eyes caused by on-camera flash.

Book resources at: www.adv-elements.com

97

PATHWAYS TO EDITING

IN ELEMENTS

Automating editing of several pictures at once

It's true that shooting digital has meant that many photographers have saved the time that they used to spend in the darkroom processing their images. The flip side to this coin is that now we while away the hours in on-screen production instead. Surely with all the power of the modern computer and flexibility of Elements there must be quicker ways to process files. Well yes there is!

5.04 Processing multiple files

Suitable for Elements – 5.0, 4.0, 3.0 | Difficulty level – Basic Related techniques – 5.05, 5.06

Photoshop Elements users are able to automate a variety of editing functions with the Process Multiple Files feature located in the File menu of the Full Edit workspace. The feature is like a dedicated batch processing tool that can name, size, enhance, label and save in a specific file format a group of photos stored in a folder or selected via the file browser. The dialog's options include:

ocess Multiple Files			2
Learn more about: Process Multiple Files			
Process Files From: Opened Files	🗢 Quick Fix		alatente
Source: Opened Files	Auto Levels	t	
Destination:	Sharpen		
P:\2006\ Browse	✓ Labels		
Same as Source	Watermark		~
File Naming Rename Files Philps-Folio-2006 + 3 Digit Serial Number		Philip Andrews 2	United
Example: Philips-Folio-2006001.gf Starting serial#: 1 Compatibility: Windows	Position: Font:	Bottom Left Arial	*
Image Size Resize Images	ri T Opacity:	12 ¥	
Width: 800 cm M Besolution: 72 M dpi	Color:	30	
Height: cm 🖌			
- File Type			
Convert Files to: JPEG High Quality			

Batch processing of files >> Elements users can automate the application of basic enhancement and editing features to a group of files using the Process Multiple Files feature located in the Full Edit workspace. **Source** – Files to be processed can be stored in a single folder, the files currently open in the workspace, pictures in the Photo Bin or images multi-selected in the file browser.

Destination – Sets the location where processed files will be saved.

File naming – Options for naming or renaming of selected files including a range of preset naming styles.

Image Size – Specify size and resolution changes after choosing the unit of measure to work with from the drop-down menu. Proportions can be constrained.

File type – Select the file format that processed files will be saved or converted to.

Quick Fix enhancement – Use the options here to apply automatic enhancement of the files being processed.

Add Labels – Add caption or file name labels to each of the processed files. Also contains an option for watermarking the pictures.

After setting the options for each of the sections in the dialog press the OK button to process the pictures.

5.05 Multi-selection editing

Suitable for Elements - 5.0, 4.0, 3.0 | Difficulty level - Basic | Related techniques - 5.04, 5.06

Another method of applying automatic changes to several photos at once is to multi-select photos in the Photo Browser workspace then choose an editing option from the right-click pop-up menu. There are a multitude of options available in this menu with the Rotate, Auto Smart Fix and Auto Red Eye Fix features providing quick editing changes to the selected photos. For best results always apply critical edits and enhancements manually but this technique is particularly useful if you want to process a bunch of files quickly. The added bonus is that the edited versions of the pictures are not saved over the original file but rather they are kept in a Version Set so that it is always possible to extract the original file if need be.

> Rotate Photos 90° Left – Ctrl + Left Rotate Photos 90° Right – Ctrl + Right

Auto Smart Fix – Ctrl + Alt + M **Auto Red Eye Fix** – Ctrl + R

Keystrokes for fast edits of multi-selected photos

The editing and enhancement options located on the menu that is displayed when you right-click a thumbnail in the Photo Browser workspace can be just as easily applied to several photos that have been multi-selected as to a single picture.

This method is a quick and easy means of making automatic changes to a group of photos.

to a group of priotos.

5.06 Bulk Red Eye fixing

Suitable for Elements – 5.0, 4.0 | Difficulty level – Basic Related techniques – 5.04, 5.05

As well as being able to apply the Auto Red Eye Fix feature to individual photos this correction option is also available in the File > Get Photos and Adobe Photo Downloader dialogs. So now it is possible to download pictures from your camera, or import them from a folder, and at the same time be searching the images for red eye and correcting it when it is present. This is a great time saver if you regularly photograph with on-camera flash but as always for the absolute best results apply the Red Eye Fix yourself manually.

Auto Red Eye Fix >> The Auto Red Eye fix option is also available in dialogs that are used to import or download pictures onto your computer. Selecting this option instructs Elements to search and correct any occurrence of red eye in the photos you are loading into the Organizer workspace. PATHWAYS TO EDITING

IN ELEMENTS

Semi-automatic editing

The second level of features sits in the middle ground between total user control and total program control over the editing results. The tools in this group are primarily available in the Quick Fix editor but also encompass some of the more automatic or easy-to-use controls available in the Full Edit workspace. Move to these tools once you feel more confident with the digital photography process as a whole (downloading, making some changes, saving and then printing) and find yourself wanting to do more with your pictures. Again, for the advanced user the tools listed here will provide a degree of frustration as the amount of control over the results is still limited.

- Middle-level control using the features in the Quick Fix and Full Edit
- Some changes applied automatically, others via a user controlled slider
- New users progress here with experience and understanding
- Control of: cropping, rotation, contrast, color, saturation, hue, temperature, tint, shadow and highlight detail, red eye, mid tone contrast and sharpening

Semi-auto editing summa

5.07 Using the Quick Fix Editor

Suitable for Elements – 5.0, 4.0, 3.0 | Difficulty level – Basic Related techniques – 5.08, 5.09

The Quick Fix Editor contains a reduced tool, feature set designed to facilitate the fast application of the most frequent of all enhancement activities undertaken by the digital photographer.

The Zoom, Hand, Crop and Red Eye Removal tools and the Magic Selection Brush and Selection Brush are located in a small toolbar to the left of the screen and are available for standard image editing changes; the fixed Palette Bin, to the right, contains the necessary features to alter and correct the lighting, color and sharpness of your pictures. Rotate buttons are located at the bottom of the dialog.

One of the best aspects of the Elements 5.0 version of this editing option is the fact that the user can choose to apply each image change automatically, via the Auto button, or manually using the supplied sliders. This approach provides both convenience and speed when needed, with the option of a manual override for those difficult editing tasks.

The adjustment features are arranged in a fashion that provides a model enhancement workflow to follow – simply move from the top to the bottom of the tools starting with smart fixing and red eye correction, working through lighting and color alterations and, lastly, applying sharpening.

There is no doubt that for making speedy adjustments of your favorite images with the option of some override control, the Quick Fix editor is a great place to start. And the best thing of all is you can see the before and after results of your changes on screen via the zoomable preview windows.

PATHWAYS TO EDITING IN ELEMENTS

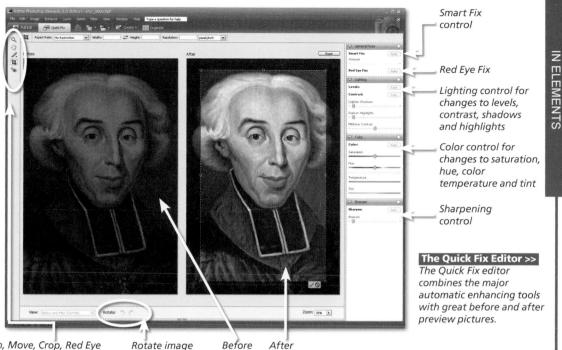

Zoom, Move, Crop, Red Eye Rot Removal, Magic Selection Brush and Selection Brush tools

Rotate image buttons

Before After preview preview

5.08 Semi-auto Full Edit features

Suitable for Elements – 5.0, 4.0, 3.0, 2.0, 1.0 Difficulty level – Basic | Related techniques – 5.07, 5.09 Slightly different versions of the many options found in the Quick Fix Editor workspace are also available in the Full Edit as menu selections in the Enhance menu.

Unlike the Auto Smart Fix option which enhances several different image characteristics in the one action, features like Auto Levels, Auto Contrast, Auto Sharpen, Auto Red Eye Fix and Auto Color Correction generally concentrate on adjusting just one aspect of the photo, providing more specific and controllable changes to your photo.

Quick guide to the Auto features in the Full Edit workspace

Correction needed	Feature to use
Low contrast problem	Enhance > Auto Contrast
High contrast problem	Enhance > Auto Contrast
Color cast problem	Enhance > Auto Color Correction or Enhance > Auto Levels
Color cast and contrast problem	Enhance > Auto Levels

💐 Auto Smart Fix	Alt+Ctrl+M
Auto Levels	Shift+Ctrl+L
Auto Contrast	Alt+Shift+Ctrl+L
Auto Color Correction	Shift+Ctrl+B
Auto Sharpen	
👁 Auto Red Eye Fix	Ctrl+R
Adjust Smart Fix	Shift+Ctrl+M
Adjust Lighting	
Adjust Color	
Convert to Black and White	Alt+Ctrl+B
Unsharp Mask	
Adjust Sharpness	

Auto options in the Full Edit >> The first features listed in the Enhance menu of the Full Edit apply changes to specific aspects of your photo automatically.

Book resources at: www.adv-elements.com

PATHWAYS TO EDITING

Auto Contrast is designed to correct images that are either too contrasty (black and white) or too flat (dull and lifeless). Unlike the Auto Levels feature, Auto Contrast ensures that the brightest and darkest pixels in the picture (irrespective of their colors) are converted to pure white and black. In doing so all the tones in between are expanded or contracted to fit.

Auto Color Correct concentrates on correcting the color in the mid tones of the picture and adjusting the contrast by reassigning the brightest and darkest pixels to white and black.

Auto Levels is similar to Auto Contrast in that it maps the brightest and darkest parts of the image to white and black but differs in that each individual color channel is treated separately.

In the process of mapping the tones (adjusting the contrast) in the red, green and blue channels, dominant color casts can be neutralized.

Sometimes such automatic fixes do not produce the results that you expect. In these scenarios use the Undo (Edit > Undo) command to reverse the changes and try one of the manual correction tools detailed in the next section.

Auto options examples >> (a) Original uncorrected image. (b) After applying Auto Levels. (c) After applying Auto Contrast. (d) After applying Auto Color Correction.

Manual editing

The final group of tools includes those designed to give the user professional control over their editing and enhancement tasks. Many of the features detailed here are very similar to, and in some cases exactly the same as, those found in the Photoshop program itself. These tools provide the best quality changes available with Elements, but they do require a greater level of understanding and knowledge to use effectively.

The extra editing and enhancement power of these tools comes at a cost of the user bearing all responsibility for the end results. Whereas the automatic nature of many of the features found in the other two groups means that bad results are rare, misusing or over-applying the tools found here can actually make your picture worse. This shouldn't stop you from venturing into these waters, but it does mean that it is a good idea to apply these tools cautiously rather than with a heavy hand. In fact once most users develop a good level of understanding and skill with the manual tools and features in the Full Edit workspace they seldom return to using automatic enhancement options, preferring to remain in complete control over the pixels in their pictures.

5.09 The Full Edit workspace

Suitable for Elements – 5.0, 4.0, 3.0, 2.0, 1.0 | Difficulty level – Basic Related techniques – 5.07

The Full Edit contains the features and tools used for the most sophisticated of the three different editing pathways provided in Elements 5.0. The groups of tools included in this workspace are designed to give the user professional control over all their editing and enhancement tasks.

Manual options >> The manual versions of many automatic or semi-automatic enhancement features are located in the lower part of the Enhance menu. Shadows/Highlights... Brightness/Contrast... Levels... Ctrl+L

Remove Color Cast... Adjust Hue/Saturation... Ctrl+U Remove Color Shift+Ctrl+U Replace Color... Adjust Color Curves... Adjust Color for Skin Tone... Defringe Layer... Color Variations... lanual editing summary:

 Sophisticated control using the features in the Full Edit workspace

 Most editing changes applied manually via settings input by the user

Great for complex editing and enhancement tasks performed by more experienced users
The most control of all the major editing and enhancing of

your digital

PATHWAYS TO EDITING IN ELEMENTS

As well as providing manual versions of all the automatic enhancement options that we have looked at so far, the Editor workspace also includes tools that enable the user to isolate where and how the editing changes are applied to photos. For this reason most advanced techniques detailed in the ensuing chapters of this book make use of the extensive tool and feature set provided in this Editor workspace.

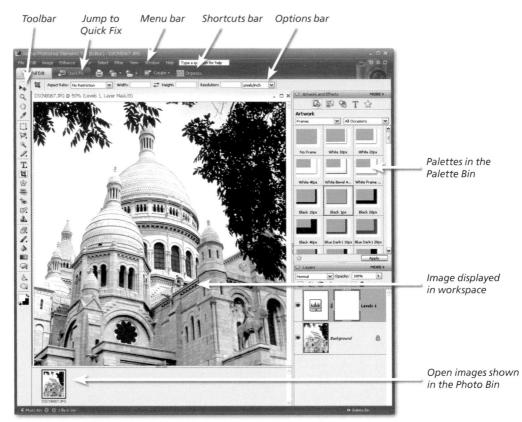

Auto/manual feature equivalents		
Automatic feature	Manual equivalent	
Auto Levels	Levels or Shadows/Highlights or Brightness/Contrast or Adjust Color Curves	
Auto Color Correction	Remove Color Cast or Color Variations or Adjust Color For Skin Tones	
Auto Contrast	Levels or Shadows/Highlights or Brightness/Contrast or Adjust Color Curves	
Auto Red Eye Fix	Red Eye Removal Tool	
Auto Smart Fix	Levels or Shadows/Highlights or Brightness/Contrast or Adjust Color Curves together with Remove Color Cast or Color Variations or Adjust Color For Skin Tones	
Auto Sharpen	Unsharp Mask or Adjust Sharpness	
1		

The Full Edit >> Advanced editing and enhancement techniques are generally applied in the Full Edit workspace.

Manual pathway choices >> Photoshop Elements provides manual alternatives for all its automatic and semi-automatic editing options. This table summarizes the specific manual features that can be used as alternatives.

104

Image Changes – Beyond the Basics

ADVANCED PHOTOSHOP ELEMENTS 5.0 FOR DIGITAL PHOTOGRAPHERS

Advanced selection techniques

Many great image editing techniques are based on the 'selection' prowess of the photographer. Being able to manipulate the selection tools to isolate the precise pixels that you wish to edit is a key skill that we all should possess. The following techniques will help you build on your existing selection skills.

6.01 Adding to and subtracting from selections

Suitable for Elements – 5.0, 4.0, 3.0, 2.0, 1.0 | Difficulty level – Basic Related techniques – 6.02, 6.03, 6.04, 6.05 | Tools used – Magic Wand, Lasso, Marquee

Only on a very rare occasion will you be able to create the perfect selection with a single tool applied once. Most editing jobs require the building of selections using multiple tools, creating new selections that are either added to, or subtracted from, existing selections. Photoshop Elements provides a range of features that are designed for just this purpose.

When a selection tool is in use four selection modes are available in the option bar. By switching between these modes whist making additional selections you can:

- Create a **new** selection each time the tool is applied,
- Add to an existing selection,
- Subtract from an existing selection, or
- Make a selection from the **intersection** of the new and old selections.

The modes are available for all selection tools the exception being that the Intersect mode can not be used with the Magic Selection Brush or the Selection Brush tools. The New Selection option

Adding to selections >> Modify your selections by switching selection modes using the buttons found in the Options menu. (a) New selection. (b) Add to selection. (c) Subtract from selection. (d) Make new selection from the intersection.

being the default. Complex areas of a picture can be isolated by making a series of selections choosing the necessary tool (Lasso, Marquee, Magic Wand, Selection Brush or Magic Selection Brush) and mode (new, add to, subtract from, intersection of) as you go. The mode of the current tool can also be changed using a keyboard shortcut whilst selecting. Hold down the Shift key to add to a selection or the Alt key.

6.02 Using the Selection Brush

Suitable for Elements – 5.0, 4.0, 3.0, 2.0 | Difficulty level – Intermediate | Resources – Web image 6.02 Related techniques – 6.01, 6.03, 6.04, 6.05 | Tools used – Selection tools | Menus used – Select

Responding to photographers' demands for even more options for making selections, Adobe included the Selection Brush for the first time in version 2.0 of Elements. The tool lets you paint a selection onto your image. The size, shape and edge softness of the selection are based on the brush properties you currently have set. These can be altered in the Brush Presets pop-up palette located in the options bar.

The tool can be used in two modes – Selection and Mask:

• The **Selection mode** is used to paint over the area you wish to select. The Mask mode works by reverse painting in the areas you want to 'mask from the selection'.

• The **Mask mode** is particularly well suited for showing the soft or feathered edge selections made when painting with a soft-edged brush or when making detailed edits to the selection.

Holding down the Alt (Windows) or Option (Mac) keys whilst dragging the brush switches the tool from adding to the selection to taking away from the area.

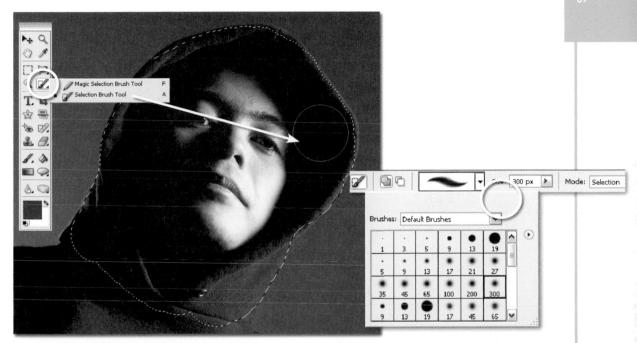

Painting selections >> The Selection Brush tool allows the user to create selections by painting directly onto the picture surface.

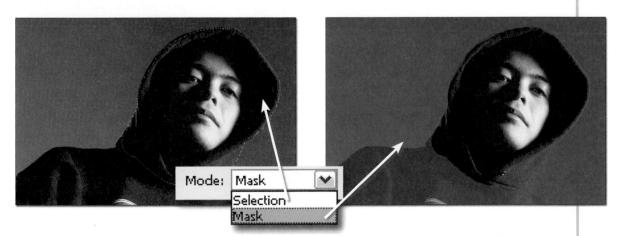

Selection Brush modes >> The Selection Brush can work in either selection or mask modes.

Book resources at: www.adv-elements.com

107

6.03 Magical selections

Suitable for Elements – 5.0, 4.0 | Difficulty level – Intermediate | Resources – Web image 6.03 Related techniques – 6.01, 6.02, 6.04, 6.05 | Tools used – Selection tools | Menus used – Select

Along with the Selection Brush tool the Magic Selection Brush provides Elements users with an unique approach to creating and modifying selections. As we have seen, when using the Selection Brush the user must paint over the area to be encompassed by the selection. The accuracy of this painting step determines the accuracy of the final selection. For example, painting over an edge accidently will result in the creation of a selection that goes beyond this picture part. The Magic Selection Brush provides a quicker, easier and, in most cases, more accurate way to make selections by combining both the drawing and color selection approaches of the other tools we have covered. To make a selection choose the tool from the tool bar. If it is hidden from view click the small arrow at the bottom right of the Selection Brush button to reveal the tool. Now use the tool to scribble or place dots on the picture parts that you want to select. Once you finish drawing release the mouse button, Elements will then create a selection based on the parts you have painted. You don't have to be too careful with your initial painting as the program registers the color, tone and texture of the picture parts and then intelligently searches for other similar pixels to include in the selection.

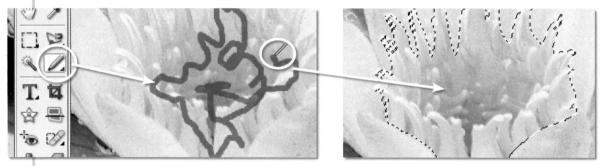

Scribble your selections >> After using the Magic Selection Brush to draw over the picture parts to be selected, Elements automatically generates a selection of all the adjacent areas in the picture that have similar color, texture or tone.

Refining the areas selected with Magic Selection Brush

Although this new tool does a pretty good job of selecting alike areas there will always be occasions when either too much or too little of the picture has been included. Just like the other tools we have looked at, the Magic Selection Brush allows you to easily modify existing selections. To include other areas in the selection click the Indicate Foreground button in the tool's options bar and paint or place a dot on a new picture part. This step will cause Elements to regenerate the selection to include your changes (note that after making your initial markup, the tool automatically switches to Indicate Foreground button and scribble or dot the part to eliminate. Again Elements will regenerate the selection to account for the changes. The Shift and Alt keys can be used whilst drawing to change modes on-the-fly and add to or subtract from the selection. As Elements regenerates the selection with each change it may be more efficient to refine a selection by switching to the Selection Brush and manually finishing a selection.

Adjusting the magic >> The options bar of the Magic Selection Brush contains several modes that can be used for altering or refining the selection created by the tool. You can add other picture parts to a selection by clicking on the indicate foreground mode and then painting over the new area. Parts already selected can be removed by changing to the indicate background mode and painting on these areas.

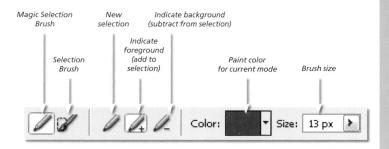

6.04 Saving and loading selections

Suitable for Elements – 5.0, 4.0, 3.0, 2.0, 1.0 | Difficulty level – Intermediate | Resources – Web image 6.04 Related techniques – 6.01, 6.03, 6.04, 6.05 | Tools used – Selection tools | Menus used – Select

Photoshop Elements thankfully gives you the option to save all your hard selecting work so that it can be used again later. With your selection active choose the Save Selection option from the Select menu. Your selection will now be saved as part of the file when you save in PSD, TIFF,

PDF or JPEG 2000 formats. When you open the file later you can retrieve the selection by choosing Load Selection from the same menu. This feature is particularly useful when making sophisticated multi-step selections, as you can make sequential saves, marking your progress and ensuring that you never lose your work. The Save Selection dialog also provides you with another way to modify your selections. Here you will find the option to save a newly created selection in any of the four selection modes we looked at earlier. This provides you with an alternative method for building complex selections which is based on making a selection and then saving it as an addition. In this way you can create a sophisticated selection one step at a time.

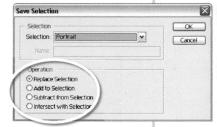

Save Selection dialog >> You can also choose to modify your selection via the modes in the Save Selection dialog.

Step 1 >> Use your favorite tool to make your first selection.

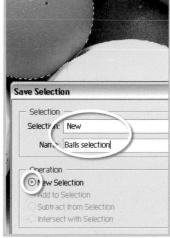

Step 2 >> Save this as a new selection using the Select > Save Selection feature. Deselect (Ctrl + D).

Step 3 >> Make a new selection and then save it using the Add to Selection mode in the Save dialog.

38.82

109

6.05 Modifying selections

Suitable for Elements – 5.0, 4.0, 3.0, 2.0, 1.0 | Difficulty level – Intermediate | Resources – Web image 6.04 Related techniques – 6.01, 6.02, 6.04 | Tools used – Selection tools | Menus used – Select

Apart from adding to and subtracting from selections, Photoshop Elements also offers several other ways to modify your selections. Nested under the Select menu, most of these options change the positioning or character of the selection's edge. They can provide quick ways to adjust your selections.

- **Select > Feather** adjusts the smoothness of the transition between selected and non-selected areas. Low values are used for sharp-edged selections and higher values for softer ones.
- Select > Modify > Border creates a border of a specific pixel width at the selection's edge. Add color to this border using the Edit>Fill command. This option only creates soft edge borders. Use Edit>Stroke to create hard-edged lines around a selection.
- **Select > Modify > Smooth** searches for unselected pixels within the nominated radius. If these areas are surrounded by selected pixels then they will be included in the selection; if the surrounding areas are not selected then they will be removed from the selection.
- **Select > Modify > Expand** increases the size of the selection evenly by the pixel amount selected.
- **Select > Modify > Contract** decreases the selection size by the pixel amount selected.
- **Select > Grow** selects pixels adjacent to the selection that are within the tolerance range of the Magic Wand settings.
- **Select > Similar** chooses all pixels throughout the picture that fall within the Magic Wand tolerance settings.

Feather >> Use this option to create graduated edges to your selections.

Border >> This option creates a softedged border, a specific number of pixels wide.

Smooth >>> Use this option to include random unselected pixels in an otherwise selected area.

Expand >> Increase a selection's size by a given number of pixels with this command.

Contract >> Reduce the size of the selection by a given number of pixels with this setting.

Grow >> Use this option to select all adjacent pixels that fall within the current Magic Wand settings.

Similar >> This command selects all other pixels in the whole image that fall within the Magic Wand settings.

6.06 Transforming a selection

Suitable for Elements – 5.0, 4.0, 3.0, 2.0, 1.0 | Difficulty level – Intermediate | Resources – Web image 6.06 Related techniques – 6.01, 6.02, 6.03, 6.05 | Tools used – Selection tools | Menus used – Image

By combining the abilities of the transformation tools that Photoshop Elements provides with several selection techniques you have the power to seamlessly change the way that your pictures look. The features grouped under the Transform heading include tools that can alter the scale and rotation of your picture as well as those that can be used to skew, distort or apply perspective to the image. These changes can be made to the photograph as a whole, to the contents of a layer, to a selection or to a shape that you have drawn. Not all transformation options are available in all situations. For example, the Distort & Perspective options cannot be applied to the contents of a text layer.

Select, copy and paste >>

By manipulating selected parts of your picture you can change a straight image into something that on the one hand is obviously not real, but because it has been so seamlessly altered, it has an aspect of believability. Here the eyes and mouth of the subject have been selected, copied and enlarged before being blended back into the original picture.

Image			
Rotate			
Transform	(+	Free Transform Ctrl+T
🗖 Crop			Skew
Divide Scanned P	hotos		Distort
Resize		•	Perspective
Mode Convert Color Pro	ofile	} }	Transform >> The Free Transform tool provides a
Magic Extractor	•		fast and effective way to manipulate the size and shape of your pictures.

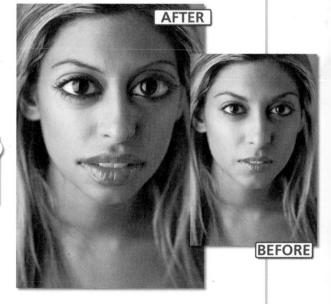

Book resources at: www.adv-elements.com

111

When a transformation tool is active the image area will be surrounded by a 'bounding box' containing several adjustment handles at its corners and sides. By dragging these handles you will be able to manipulate the picture. Most experienced image editors use the Free Transform tool (Image > Transform > Free Transform) for all their transformation changes. With this one feature and a few different keyboard combinations you can perform all your image adjustments without selecting another feature. Use the guide below to help you use the Free Transform tool:

- To scale drag on one of the corner handles of the bounding box.
- To scale from the center press the Alt key whilst dragging a corner handle.
- To maintain aspect ratio whilst scaling hold down the Shift key whilst dragging.
- **To rotate** move the cursor outside the bounding box until it changes to a curved two-ended arrow, then click and drag to rotate the picture.
- **To distort** hold down the Ctrl key whilst dragging any handle.
- To skew hold down the Ctrl + Shift keys whilst dragging a side handle.
- **To apply a perspective change** hold down Ctrl + Alt + Shift whilst dragging a corner handle.
- **To commit changes** double-click inside the bounding box or hit Enter, or click the Commit icon (green tick) at the bottom of the marquee.

In the example the exaggerated eyes and mouth were created by firstly selecting the face parts, feathering the edge of the selection (Select > Feather) and then copying (Edit > Copy) and pasting (Edit > Paste) each part onto a new layer. With the appropriate layer selected the parts were then enlarged using the Free Transform feature (Image > Transform > Free Transform) and distorted a little (Image > Transform > Distort) to suit the rest of the face. As a final step a soft-edged eraser was used to remove sections of the face parts that didn't match the picture below. This step helped to blend changes into the original image.

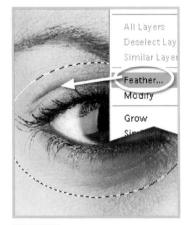

Step 1 >> Copy and paste onto new layers parts of the picture that were selected using a feather.

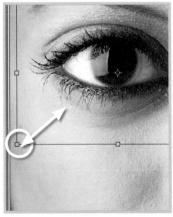

Step 2 >>> Change the size of the face parts and apply some distortion using the Free Transform tool. Double-click inside the bounding box to commit your changes.

Step 3 >> Carefully erase the edge of the transformed face parts to blend them with the rest of the original image below.

6.07 Precise control of selection size

Suitable for Elements – 5.0, 4.0, 3.0, 2.0, 1.0 | Difficulty level – Intermediate Related techniques – 6.01, 6.02, 6.03, 6.04 | Tools used – Marquee | Menus used – Window, Edit, View

There will be times when you will need to know the precise size of the selections you make. You can get this information from the Info palette (Window > Info) where Elements reports the width and height of your selection in the units selected in the Units preferences (Edit > Preferences > Units and Rulers). This dialog also shows the exact position of the cursor. This can be helpful when you need to start and end a selection at a set screen reference.

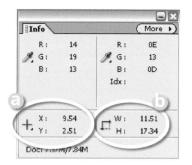

Info >>> The Info palette shows the position of the cursor (a) as well as the size of the selection (b).

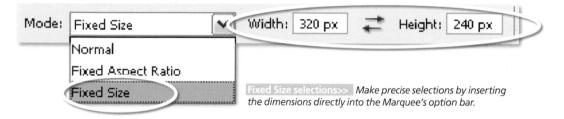

If instead of just viewing the dimensions of the selection you actually want to specify the size, you can input these values into the options bar of the Marquee tool. After selecting the tool, choose Fixed Size from the Style drop-down menu in the Options bar. You can then enter the value for width and height into the fields in the bar. Now when you click on the canvas with the Marquee tool, a selection of the precise dimensions you input will appear on the picture. As with the Info

dialog the measurement units used here are controlled by the settings in the Units and Rulers preferences.

Another way to precisely control the size of your selections is to use the Elements Grid system as a guide. Simply display the Grid over your picture (View > Grid) and switch on the Snap to Grid option (View > Snap to Grid). Now as you are drawing a selection the cursor will align itself with the grid lines or intersections. The interval of the grid lines and spacings can be altered via the Grid preferences (Edit > Preferences > Grid).

Grid as guide >> Use the Elements Grid option to help make precise selection. Image courtesy of www.darranleal.com.au.

Understanding layers

In a lot of ways traditional film-based shooting is very similar to digital photography. After all, apart from a few useful additions such as a preview screen on the back and a slot for my memory card, my digital camera is not unlike my film camera (in fact they even share the same lenses). But thinking that these similarities extend to the pictures themselves can mean that you are missing out on some of the more powerful capabilities of your digital pictures.

Digital pictures are not always flat

The traditional photograph contains all the picture elements in a single plane. Digital images captured by a camera or sourced from a scanner are also flat files. And for a lot of new digital photographers this is how their files remain – flat. All editing and enhancing work is conducted on the original picture, but things can be different.

Most image editing packages contain the ability to use layers with your pictures. This feature releases your images from having to keep all their information in a flat file. Different image parts, added text and certain enhancement tasks can all be kept on separate layers. The layers are kept in a stack and the image you see on screen in the work area is a composite of all the layers.

Sound confusing? Well try imagining for example that each of the image parts of a simple portrait photograph are stored on separate plastic sheets. These are your layers. The background sits at the bottom. The portrait is laid on top of the background and the text is placed on top. When viewed from above the solid part of each layer obscures the picture beneath. Whilst the picture

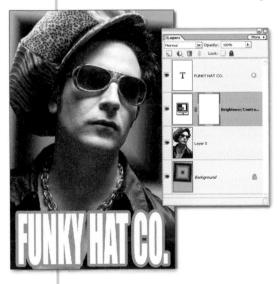

Layers >> A digital picture is often composed of many parts, each stored on a separate layer. Image courtesy of www.ablestock.com © 2005. parts are based on separate layers they can be moved, edited or enhanced independently of each other. If they are saved using a file format like Photoshop's PSD file (which is layer friendly) all the layers will be preserved and present next time the file is opened.

Types of layers

Image layers: This is the most basic and common layer type, containing any picture parts or image details. Background is a special type of image layer.

Text layers: Designed solely for text, these layers allow the user to edit and enhance the text after the layer has been made.

Fill layers: Users can also apply a Solid Color, Gradient or Pattern to an image as a separate layer.

Adjustment layers: These layers alter the layers that are arranged below them in the stack. They act as a filter through which the lower layers are viewed. You can use adjustment layers to perform many of the enhancement tasks that you would normally apply directly to an image layer without changing the image itself. **Shape layers**: Drawing with any of the shape tools creates a new vector-based Shape layer. The layer contains a thumbnail for the shape as well as the color of the layer.

Frame layers: In Elements 5.0 Adobe introduces a new layer type to coincide with its Photo Layout creation project. Called the Frame layer, its role is to store both the frame and the picture that sits within it. Both the component parts remain as separate individual images despite being stored as one layer. What does this mean in day-to-day editing? Well it means that you can do things like change the size, shape and orientation of either the frame and picture combination, or the picture, independently of each other.

Background layers: An image can only have one background layer. It is the bottom-most layer in the stack. No other layers can be moved beneath this layer. You cannot adjust this layer's opacity or its blending mode. You can convert background layers to standard image layer's by doubleclicking the layer in the Layers palette, setting your desired layer options in the dialog provided and then clicking OK.

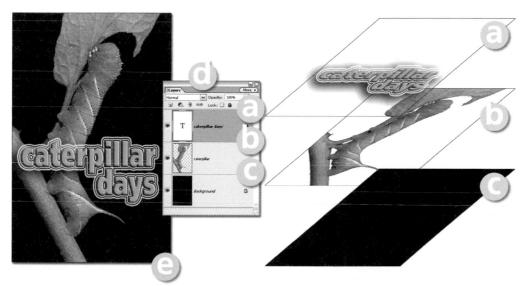

Layer types >>> (a) Text or type layer, (b) image layer with chequered transparent area, (c) background layer, (d) Layer palette, (e) preview window with separate layers viewed as a composite image. Image courtesy of www.ablestock.

Adding layers

When a picture is first downloaded from your digital camera or imported into Photoshop Elements it usually contains a single layer. It is a 'flat file'. By default the program classifies the picture as a background layer. You can add extra 'empty' layers to your picture by clicking the New Layer button at the bottom of the Layer's palette or choosing the Layer option from the New sub-menu in the Layer menu (Layer > New > Layer). The new layer is positioned above your currently selected layer. Some actions, such as adding text with the Type tool, automatically create a new layer for the content. This is true when adding adjustment and fill layers to your image. When selecting, copying and pasting image parts, Photoshop also creates a new layer for the copied portion of the picture.

Viewing layers

Photoshop Elements's Layers palette displays all your layers and their settings in the one palette. If the palette isn't already on screen when opening the program, it may be hidden in the Pallete Bin or you may have to choose the option from the Window menu (Window > Layers). The individual layers are displayed, one on top of the other, in a 'layer stack'. The image is viewed from the top down through the layers. When looking at the picture on screen we see a preview of how the image looks when all the layers are combined.

Visible layers >> When the Eye icon is present the layer is visible. Clicking on the eye turns the icon off, removing the layer from the preview window.

Each layer is represented by a thumbnail on the right and a name on the left. The size of the thumbnail can be changed, as can the name of the layer. By default each new layer is named sequentially (layer 1, layer 2, layer 3). This is fine when your image contains a few different picture parts, but for more complex illustrations it is helpful to rename the layers with titles that help to remind you of their content (portrait, sky, tree).

You can edit or enhance only one layer at a time. To select the layer that you want to change you need to click on the layer. At this point the layer will change to a different color from the rest in the stack. This layer is now the selected layer and can be edited in isolation from the others that make up the picture. Layers can be turned off by clicking the eye symbol on the far left of the layer so that it is no longer showing. This action removes the layer from view but not from the stack. You can turn the layer back on again by clicking the space where the eye symbol was. Holding down the Alt key whilst clicking on a layer's eye symbol will turn off or hide all layers other than the one that you are clicking.

Manipulating layers

Layers can be moved up and down the layer stack by click-dragging. Moving a layer upwards will mean that its picture content may obscure more of the details in the layers below. Moving downwards progressively positions the layer's details further behind the picture parts of the layers above.

You can reposition the content of any layers (except background layers) using the Move tool. Two or more layers can be linked together so that when the content of one layer is moved the other details follow precisely. Simply multi-select the layers in the Layers palette and then click on the Chain icon (Link Layers button) at the top of the palette. The chain will be added to all the linked layers on the right of the thumbnail. Unwanted layers can be deleted by click-dragging them to the Dustbin icon at the top of the Layers palette.

Layer styles

In early image editing programs creating a drop shadow edge to a picture was a process that involved many steps. Thankfully Elements includes this as one of the many built-in styles that can be quickly and easily applied to your layers. Users can add effects by clicking on the Artwork and Effects palette tab in the Palettes pane and selecting a layer style from those listed in the Special Effects section. You can edit the style settings by double-clicking on the small Starburst icon on the right of the thumbnail in the Layers palette.

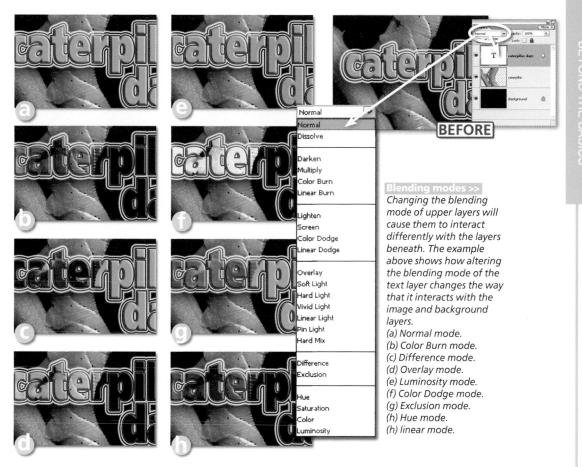

Blending modes and opacity

As well as layer styles, or effects, the opacity (how transparent a layer is) of each layer can be altered by dragging the Opacity slider down from 100% to the desired level of translucency. The lower the number the more detail will show through from the layers below. The Opacity slider is located at the top of the Layers palette and changes the selected layer only. On the left of the Opacity control is a drop-down menu containing a range of blending modes. The default selection is 'normal', which means that the detail in upper layers obscures the layers beneath. Switching to a different blending mode will alter the way in which the layers interact. For more details see the full blending mode example in the Appendix.

- To display Layers palette Choose Window>Layers
- To access Layers options Click More button in the upper right-hand corner of the Layers palette
- To change the size of layer thumbnails Choose Palette options from the Layers Palette menu and select a thumbnail size
- To make a new layer Choose Layer>New>Layer
- To create a new adjustment layer Choose Layer>New Adjustment Layer and select the layer type
- To add a style or effect to a layer Select the layer and choose a style from those listed in the Layer Styles section of the Artwork and Effects palette.

117

Masking techniques

Masking in traditional photography is used to physically protect part of the picture from development or exposure. In black and white darkrooms this process often involved the positioning of specially cut 'ruby' red sheets over the photographic paper, which shielded this part of the picture from being exposed during the enlargement process.

The digital version of masking is also designed to restrict effects to only certain portions of an image. Photoshop Elements provides a variety of ways to employ a masking system when editing your pictures.

6.08 Painting masks with the Selection Brush

Suitable for Elements – 5.0, 4.0, 3.0, 2.0 | Difficulty level – Intermediate | Resources – Web image 6.08 Related techniques – 6.02, 6.03 | Tools used – Selection Brush

The Selection Brush was a welcome addition to the Photoshop Elements tools line up when it was added in revision 2.0 of the program and, although its primary purpose is to aid the creation of complex selections, it can also be used in a 'Rubylith' Mask mode. Activate the mode by selecting the Mask option from the mode drop-down menu in the Tools option bar. Now when the brush is dragged across the surface of a picture it will leave a red, semi-transparent mask behind it. The mask will protect these parts of the picture from the effects of filters, color changes and tonal correction.

The size and edge softness of the Selection Brush as well as the mask opacity (overlay opacity) and mask color can be altered in the options bar. Switching back to the Selection mode will turn off the mask and make a selection from the parts of the picture that weren't painted. Whilst in Mask mode painting with the brush will add to the mask. Applying the brush in the Selection mode will add to the selection, which effectively is removing masked areas. You can also save carefully painted masks using the Save Selection option in the Select menu and pre-saved selections can be converted into a mask by loading the selection and then switching back to Mask mode. A quick tip for powers users – Alt-clicking the Layer Mask thumbnail displays shows the rubylith mask, which is handy when making lots of adjustments to the selected area.

Step 1>>> Choose the Selection Brush (under the Magic Selection Brush) from the tool box and switch the brush to Mask mode.

Step 2 >> Paint on the parts of the picture that you want to shield from the editing process.

Step 3 >>> Apply the editing changes to the non-masked areas. Here we applied the Crystallize filter.

6.09 Fill and adjustment layer masks

Suitable for Elements – 5.0, 4.0, 3.0, 2.0, 1.0 | Difficulty level – Intermediate | Resources – Web image 6.08 Related techniques – 6.08, 6.10, 6.11 | Menus used – Layer

Another form of masking is available to Elements users via the Fill and Adjustment Layers features. Each time you add one of these layers to an image two thumbnails are created in the Layers palette. The one on the left controls the settings for the adjustment layer. Double-clicking this thumbnail brings up the dialog box and the settings used for the fill or adjustment layer. The thumbnail on the right represents the layer's mask which governs how and where the settings are applied to the image.

Eraser >> Erasing parts of the fill layer reveals the picture beneath.

Black paint >> Painting the mask with black paint has the same effect as erasing.

White paint >>> Painting with white paint restores the mask and the pattern.

The mask is a grayscale image. In its default state it is colored white, meaning that no part of the layer's effects are being masked or held back from the picture below. Conversely, if the thumbnail is totally black then none of the layer's effects is applied to the picture. In this monochrome world shades of gray equate to various levels of transparency. With this in mind we can control which parts of the picture are altered by the fill or adjustment layer and which parts remain unchanged by painting (in black and white and gray) and erasing directly on the layer mask.

To start editing a layer mask, firstly apply a fill layer such as Pattern to the image. Check to see that the default colors (white and black) are selected for the Elements foreground and background colors. Next select the Eraser tool, and with the fill layer selected in the Layer palette, proceed to remove part of the layer. The pattern is removed and the picture beneath shows through and a black mark now appears in the layer thumbnail corresponding to your erasing actions. Switch to the Paint Brush tool and select black as your foreground color and paint onto the patterned surface. Again this action masks the picture beneath from the effects of the fill layer and adds more black areas to the thumbnail. Painting with white as your foreground color restores the mask and paints back the pattern. You can experiment with transparent effects by painting on the mask with gray. The lighter the gray the more the pattern will dominate, the darker the gray the less the pattern will be seen. A similar semi-transparent effect can be achieved if the opacity of the eraser or brush is reduced.

6.10 Using selections with layer masks

Suitable for Elements – 5.0, 4.0, 3.0, 2.0, 1.0 | Difficulty level – Intermediate Resources – Web image 6.08 | Related techniques – 6.08, 6.09, 6.11 | Tools used – Select

In addition to employing painting and erasing tools to work directly on the layer mask you can also use a selection in conjunction with an adjustment or fill layer to restrict the area of your image that is altered. Make a selection in the normal way and then, with the selection still active, create a new adjustment or fill layer. The selection confines the changes made by the new adjustment/fill layer. You will notice the selected area is colored white in the Layer Mask thumbnail. A layer mask made in this way can be edited using the same painting techniques as discussed above.

Selection >> By having a selection active when you make a new adjustment or fill layer you immediately restrict the effects of this layer to just the confines of the selection.

6.11 'Group with Previous' masks

Suitable for Elements – 5.0, 4.0, 3.0, 2.0, 1.0 | Difficulty level – Intermediate | Resources – Web image 6.08 | Related techniques – 6.08, 6.09, 6.10 | Menus used – Layer

The final masking technique that Photoshop Elements employs uses the special Group with Previous command found in the Layer menu. This command uses the transparency surrounding objects on a layer as a mask for the content of any layers that are above it in the stack. In the example the balloon image was placed above the test text layer. With the balloon layer active the Group with Previous command (Layer > Group with Previous) was selected. The example image now fills the text shape but is masked from showing through the rest of the layer by the transparency surrounding the type. This technique also works with shapes and filled selections drawn on a separate layer surrounded by transparency.

Step 1 >> Create some bold text in a new document with a white background layer.

Step 2 >> Copy and paste a color image in a layer above the text.

Step 3 >> Select the color layer and choose the Group with Previous command from the Layers menu.

Step 1>> Select Image > Mode > Grayscale and then click on the OK button in the Discard Color warning box.

Step 2 >> Using the Levels control, map the dark pixels to black by dragging the black point slider to the right.

Step 3 >>> Correct the highlights by dragging the white point slider to the left.

Converting color to black and white

One of the real advantages of shooting digital is the ease with which you can convert color images to black and white. Gone are the days of having to carry two camera bodies, one loaded with color film the other with black and white. Now you simply shoot color all the time and then convert selected images to black and white using a few simple steps.

increase contrast >> By moving the black and white input sliders towards the center of the dialog you can increase the contrast of your picture.

6.12 Changing the mode to grayscale

Suitable for Elements – 5.0, 4.0, 3.0, 2.0, 1.0 | Difficulty level – Basic | Resources – Web image 6.12 | Related techniques – 6.13, 6.14 | Menus used – Image, Enhance

The simplest way to lose the colors in your picture is to convert the image to a grayscale. This process changes the photograph from having three color channels (red, green and blue) to being constructed of a single channel that contains the picture's detail only. Often this conversion produces a flat and lacklustre photograph and so a little manipulation of the tones is in order. My first point of call to help solve this problem would always be the Levels dialog (Enhance > Adjust Brightness and Contrast > Levels). Using this control you can make sure that your image tones are spread across the grayscale spectrum.

Most grayscale conversion pictures need a general contrast increase. You can achieve this by moving the black and white input sliders towards the center of the dialog. Holding the Alt key down whilst you are moving the slider will enable you to preview the pixels that are being converted to pure black or pure white. Your aim is to map the darkest pixels in the picture to black and the lightest ones to white. Work carefully here as a heavy handed approach will produce pictures where delicate shadow and highlight details are lost forever.

121

AFTER BEFORE Grayscale >> You can convert your color digital photographs to grayscale using two different methods in Adobe Photoshop Elements. The simplest is to change color modes from RGB to Grayscale. The alternative is to desaturate the photograph. This process has the added advantage of leaving the black and white picture in RGB mode so that color can be added to the monochrome later. Images created with either process do benefit from some adjustment of tones after conversion.

6.13 Desaturate the color file

Suitable for Elements – 5.0, 4.0, 3.0, 2.0, 1.0 | Difficulty level – Basic | Resources – Web image 6.13 Related techniques – 6.12, 6.14, 6.15 | Tools used – Dodge and Burn-in | Menus used – Image

Photoshop Elements uses the term 'saturation' to refer to the strength of the colors in a picture. Increasing saturation makes the colors in a picture more vivid, decreasing saturation makes the hues weaker. The program employs the Hue/Saturation (Enhance > Adjust Color > Hue Saturation) control to adjust the color's strength. If the Saturation slider is moved all the way to the left of the dialog (to a setting of -100) then all color is removed from the picture. You are effectively left with a grayscale or black and white photograph that is very similar to the 'convert to grayscale' version above but with one important difference – the picture is still an RGB file. This means that even though the photograph no longer contains any color, the color mode it is stored in is capable

luto Smart Fix	Alt+Ctrl+M	000
uto Levels	Shift+Ctrl+L	eate • 👸 Ovganize
uto Contrast	Alt+Shift+Ctrl+L	Ppt V AA TT
uto Color Correction	Shift+Ctrl+B	En INCAL 1 1
uto Sharpen		
uto Red Eye Fix	Ctrl+R	
djust Smart Fix	Shift+Ctrl+M	
anguist tightang	,	
djust Color	•	manove Color Cesan
	Alt+Ctrl+B	Adjust Hue/Saturation
insharp Mask		Remove Color C
diust Sharpness		Replace Color
ujust priarpriess	A Design of the same point of the same same	Adjust Color Curves
		Adjust Color for Skin Tor
		Defringe Layer
		Color Variations

Step 1 >> Select the Hue/Saturation control from the Adjust Color heading in the Enhance menu.

Step 2 >>> Move the Saturation slider completely to the left, removing all color from the picture.

Step 3 >> Use the Dodging and Burning-in tools to lighten and darken selected areas of the picture.

of supporting color. So if you are wanting to try a little digital hand coloring, or experiment with pictures that contain monochrome as well as color components, then this is the technique for you. More details on these techniques can be found later in this chapter. Be warned though, once your picture is desaturated the color is lost for ever and so it is always a good idea to save a copy of the color version of the image before proceeding.

Pro's Tip

You can shortcut the desaturation process by selecting Enhance > Adjust Color > Remove Color, which provides the same results as using the Hue/Saturation control but in a single step.

Once the picture has been desaturated you may need to tweak the shadow, highlight and mid tones using the Levels feature. Finally, add some drama to the picture by selectively lightening and darkening parts of the image using the Dodging and Burning-in tools. Used judiciously these devices can change the whole atmosphere of a photograph. In the example, I darkened the walls closest to the viewer and lightened those parts of the French alleyway that were in the background. These changes increased the sense of distance in the picture as well as helping to draw the viewer's eyes into the picture.

Auto Smart Fix Auto Levels	Alt+Ctrl+M Shift+Ctrl+L	eate 🕶 🚟 Organize
Auto Contrast Auto Color Correction Auto Sharpen	Alt+Shift+Ctrl+L Shift+Ctrl+B	Shadows 💟 Exposure: 21%
Auto Red Eye Fix	Ctrl+R	
Adjust Smart Fix Adjust Lighting	Shift+Ctrl+M	
Adjust Color	,	Remove Color Cast
Convert to Black and White.	Alt+Ctrl+B	nue/Saturation
Unsharp Mask Adjust Sharpness		Remove Color Shift+Ctrl+U
		Adjust Color Curves Adjust Color for Skin Tone Defringe Layer Color Variations

Desaturation shortcut >> The Enhance > Adjust Color > Remove Color option is a shortcut that produces the same results as moving the Saturation slider to -100 in the Hue/Saturation feature.

Saturation control >> By decreasing the saturation of the colors in a picture completely you convert the image to just black and white.

122

6.14 A more sophisticated approach

Suitable for Elements – 5.0, 4.0, 3.0, 2.0, 1.0 | Difficulty level – Basic | Resources – Web image 6.14 Related techniques – 6.12, 6.13, 6.15 | Menus used – Layer

Despite the straightforward nature of the two conversion approaches detailed above, transforming a color photo to grayscale is not as simple as it first seems. Many converted images seem a little flat and lack the separation of tones that existed in the original photo. The trick with good conversions from color to grayscale is ensuring that the hues in the original picture are translated into distinct and different tones. For this reason no one conversion process will be suitable for all pictures.

Take for instance the example of a red flower photographed against the background of rich green foliage. When converted to grayscale by switching modes or desaturating there is a tendency for both the red of the flower and the green of the leaves to be converted to the same gray tone, making the monochrome picture much less vibrant and dynamic than the original. In order to restore some visual separation between flower and background it is necessary to convert these hues to different grays.

Just such a technique was developed by the Adobe evangelist, Russell Brown (www. russellbrown.com). The original method was designed for Photoshop but works just as well with Elements. It uses the Adjustment Layers technology in Photoshop Elements as a way to both convert the color image to black and white and also to control how the colors are represented in the grayscale. Like a lot of Russell's techniques it leaves the original image unchanged in the background. Hence this style of image enhancing is called non-destructive editing.

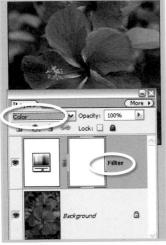

Step 1>> Make a new Hue/Saturation layer above your background. Don't make any changes to the default settings for this layer.

Set the mode of the adjustment layer to Color. Label this layer 'Filter'.

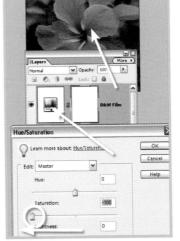

Step 2 >> Make a second Hue/Saturation adjustment layer above the Filter layer and alter the settings so Saturation is -100. Call this layer Black and White Film. The monochrome image now on screen is the standard result we would expect if we just desaturated the colored original.

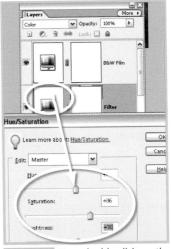

Step 3 >> Next double-click on the layer thumbnail in the Filter layer and move the Hue slider. This changes the way that the color values are translated to black and white. Similarly, if you move the Saturation slider you can emphasize particular parts of the image.

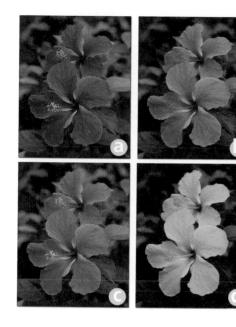

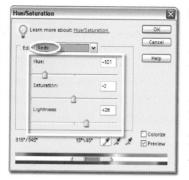

For more precise control of the separation of tones you can restrict your changes to a single color group (red, blue, green, cyan, magenta) by selecting it from the drop-down menu before manipulating the Hue and Saturation controls.

Gray conversion options >> Photoshop Elements provides a variety of options when you are wanting to convert color pictures to a grayscale or black and white photo. (a) Original color photo. (b) Change to grayscale mode. (c) Desaturate the photo. (d) The Russell Brown technique.

6.15 The new Convert to Black and White feature

Suitable for Elements – 5.0 | Difficulty level – Basic | Resources – Web image 6.15 | Related techniques – 6.12, 6.13, 6.14 | Menus used – Enhance

Taking this idea further the brand new Convert to Black and White feature (Editor: Enhance > Convert to Black and White) provides the ability to customize the way that color areas are mapped to gray during the conversion process. The dialog consists of a large before and after previews, a series of six conversion presets that are based on popular subject types, an Amount slider that controls the strength of the changes and eight thumbnail buttons for fine-tuning the results.

This new feature provides the options for more sophisticated conversions by allowing the user to adjust which colors (red, green or blue) feature more prominently in the final result.

(b) Desaturate or Remove Color conversion.

⁽c) Convert to Black and White conversion emphasizing the blue areas in the original color photo.

Book resources at: www.adv-elements.com

125

IMAGE CHANGES -BEYOND THE BASICS

Convert to Black and White >> Photoshop Elements 5.0 contains a brand new control for transforming color photos to grayscale. The Convert to Black and White feature allows you to control how the colors are mapped to gray. (a) Original color photo.

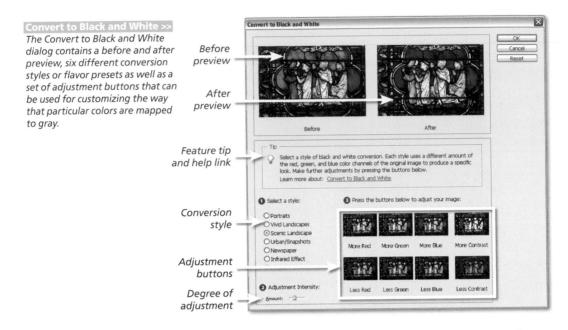

This new feature is great for situations where the color contrast of a scene isn't reflected in the monochrome conversion. Imagine the color contrast of a red rose against green foliage. Using a simple conversion feature such as Remove Color would result in both the rose and foliage being the same tone of gray. With Convert to Black and White the contrast of the original can be retained in the result by boosting or reducing the prominence of green or red parts of the picture.

Step 1>>> With a suitable color image open in the Full Edit workspace select the Convert to Black and White feature from the Enhance menu. Click through the different conversion styles checking the After preview for a suitable result. Click OK to apply the conversion, Reset to remove current settings or Cancel to guit the feature.

Step 2 >>> For a more customized conversion start by selecting a conversion style that is closest to your desired result and then fine-tune the results by clicking one of the adjustment buttons – more bluelless blue, etc. The effects can be more dramatic by also clicking the opposite of another another option – less/more red.

Step 3 >> In situations where the changes made with each click of an adjustment button are too great alter the Adjustment Intensity slider that is located in the bottom left of the dialog. Moved the slider to the left for smaller increments of change and to the right for more dramatic effects.

Super pro tip: The bwconvert.txt file located in the *C:\Program Files\Adobe\ Photoshop Elements 5.0\Required* folder sets the values for the presets in the feature. This can be easily edited if a user wants to have their own conversion preset values. Of course, I highly recommend backing up the installed version of the file so that you can easily restore the settings back to the default values.

126

Advanced dodging and burning-in

After years of my 'hit and miss' approach to dodging and burning in the darkroom I can still remember my reaction to seeing Photoshop Elements performing real-time lightening and darkening – 'You are kidding!'. Not only could I paint in light and dark areas on my picture using a soft-edged brush, I could also vary the strength of the effect and the size of the brush

used for application. In addition, I could choose to alter shadow, mid tones or highlights separately and 'undo' my actions with a single keystroke. All this flexibility and with the lights on as well!

I would think that most new users to Photoshop Elements would experience much of the same excitement as I did when they first discover the Dodge and Burn-in tools. For the majority of simple enhancement tasks a few quick strokes of these tools will provide plenty of control over your picture's tones, but there are occasions when you need a little more flexibility. I use the following techniques to provide a little more customization to my dodging and burning in my work.

Suitable for Elements – 5.0, 4.0, 3.0, 2.0, 1.0 | Difficulty level – Intermediate | Resources – Web Image 6.16 Related Techniques – 6.17 | Tools used – Selection tools| Menus used – Select

You can evenly alter the tone of a large area of your picture quickly by making a feathered selection of the area first and then using the Levels control to darken or lighten the pixels. The amount you feather the selection will determine how soft the transition will be between dodged or burnt areas and the original picture. Using the Levels feature gives you great control over the brightness of shadow, mid tone and highlight areas.

By manipulating the Input and Output sliders you can selectively alter specific tones in your image. You can also decrease or increase the contrast of the selection as well.

Use this table to help get you started.

Required image change	Action to take
To lighten the mid tones of a selected area	Move the midpoint input triangle to the left
To darken the mid tones of a selected area	Move the midpoint input triangle to the right
To lighten the mid tones and highlights	Move the white point input triangle to the left
To darken the mid tones and shadows	Move the black point input triangle to the right
To lighten the shadow tones	Move the black point output triangle to the right
To darken the highlight tones	Move the white point output triangle to the left
To decrease contrast	Move the white and black point Output sliders closer together
To increase contrast	Move the white and black point Input sliders closer together

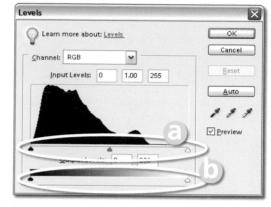

(a) Black, mid tone and white Input sliders.
 (b) Black and white Output sliders.

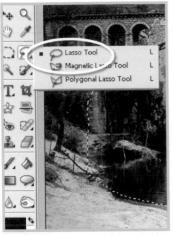

Step 1>> Using one of the selection tools draw a rough selection around the area to dodge or burn-in.

Step 2 >>> Inverse and feather the selection. Use a large pixel amount for high-resolution pictures.

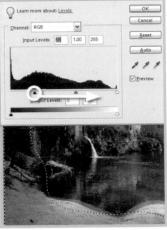

Step 3>> With the selection still active manipulate the Levels Input and Output sliders to darken/lighten tones.

Pro's Tip: Non-destructive dodging and burning-in

If you want to dodge and burn but not make any permanent changes to the picture you can use the same feathered selection technique, but apply the changes through an adjustment layer. Make the selection as before, inversing (Select > Inverse) and feathering (Select > Feather) the edge. With the selection still active, click onto the Create New Adjustment Layer button on the bottom of the Layers palette and choose Levels. If the Layers palette is not visible then you can perform the same action via the Layer menu (Layer > New Adjustment Layer). The Levels dialog appears and any changes made with the sliders alter the tones in the selected area of the picture just as before. The difference with this approach is that the dodging and burning-in takes place via an adjustment layer, leaving the original picture unchanged in the layer beneath.

The selection is used as a basis to form a mask in the adjustment layer. We view the levels changes through the clear areas of this mask only. A second advantage to this approach is that the levels settings can be changed at a later date. Simply double-click the thumbnail on the left-hand side of the layer and alter the Levels settings.

selection active click the New Adjustment Layer button.

Step 2>>> Select the Levels adjustment layer and adjust the dialog's settings to Dodge and Burn-in.

A second non-destructive approach that was pioneered by Julianne Kost starts with you creating two empty layers above the background or image layer. Name them Dodge and Burn and set the blending mode for both of them to Soft Light. Using a Black brush at a low opacity (10-15%) paint on the burn layer to darken areas. Use a White brush at the same opacity on the dodge layer to lighten. This provides a non-destructive, subtle and artistic method for dodging and burning-in.

128

IMAGE CHANGES BEYOND THE BASIC

Dodging and burning-in >>> Dodging and burning-in has always been used to add a little visual drama into photographs. The careful lightening and darkening of areas of the print can create a sense of depth and also help to direct the viewer's eye to specific focal points in the image. Image courtesy of www.ablestock.com Copyright 2005.

BEFORE

6.17 Erase back through tonal layers

Suitable for Elements – 5.0, 4.0, 3.0, 2.0, 1.0 | Difficulty level – Intermediate | Resources – Web image 6.17 | Related Techniques – 6.15 | Tools used – Eraser Menus used – Enhance, Layer

A more artistic approach to dodging and burning-in can be found in a technique that involves making several different copies of the base picture. The background layer can be copied by either choosing Layer > Duplicate Layer or by dragging the layer to the Create New Layer button at the bottom of the Layer's palette.

Each copy is stored on a separate layer and the overall tone of the duplicate image is changed using the Layers control. In the example I have created four layers, labelled them *light, mid tone, dark* and *very dark,* and changed their tones accordingly. Next I selected the Eraser tool, set the mode to brush, the edge option to soft and the opacity to 20%. I then clicked on the Eye icon in both the light and mid tone layers and selected the dark layer. Using the Eraser in overlapping strokes, I gradually removed sections of

Make creative tonal changes Make creative tonal changes using the Eraser tool and several adjusted layer copies. (a) Light copy. (b) Mid tone/normal copy. (c) Dark copy. (d) Very dark copy.

the dark layer to reveal the very dark layer beneath. I then selected the mid tone layer and performed the same action and finally I selected the light layer and erased sections to reveal the darker layers below. If this all sounds a little confusing, try thinking of the erasing action as actually painting the image darker, or burning the picture area in, and take my advice – make sure that you name your layers as you create them. This technique works particularly well if used with a graphics tablet as the opacity of the erasing stroke can be linked to the pressure on the stylus. Pressing harder with the stylus erases more of the layer and creates a greater change. Lighter strokes can be used to produce more subtle adjustments.

Step 1 >> Make several copies of the basic image layer by dragging the layer to the Create New Layer button.

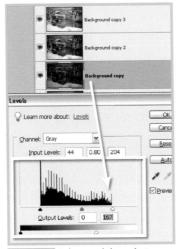

Step 2 >> Select each layer in turn and alter the overall brightness using the Levels dialog.

Step 3 >>> Rename the layers by double-clicking the names in the Layer's palette.

Step 4 >> Turn off the Eye icon for the light and mid tone layers and select the dark layer.

Step 5 >> Using the Eraser tool remove parts of the dark layer to reveal the very dark picture below.

Step 6 >> Work your way through the other layers gradually removing unwanted areas to build up the picture.

6.18 Paint on dodging and burning-in

Suitable for Elements – 5.0, 4.0, 3.0, 2.0, 1.0 | Difficulty level – Intermediate | Resources – Web image 6.18 | Related Techniques – 6.16, 6.17 | Tools used – Brush | Menus used – Layer

What if you want the flexibility of painting in your density changes (dodging and burning) but wanted to apply these changes non-destructively to your photo? Well, a solution can be found by combining aspects of the last technique with our understanding of adjustment layers and their associated layer masks.

Start by adding a Levels adjustment layer (Editor: Layer > New Adjustment Layer > Levels) to your photo. In the Levels dialog drag the Input midpoint slider to the right and the Output white point slider to the left. This will created an adjustment layer effect that darkens the whole image. Think of this change as how the image would look if you applied the Burn tool to the whole picture. Click OK to apply the change. Nothing new here you say. True, but what if we could selectively paint in this effect rather than apply it to the whole image? Well here is the trick. Click on the mask of the adjustment layer and fill it with black (Editor: Edit > Fill Layer). Remember black hides the adjustment layer effect so you should see the original tones of your photo restored in the preview window. With the mask still selected choose a soft-edged brush, lower the opacity slightly and make sure the paint colour is white.

Now paint onto the surface of the photo. The painted areas will darken. In reality you are not painting the photo but rather painting the mask and in so doing adding the adjustment layer effect in these areas.

Step 1 >> Create a new Levels adjustment layer that darkens the photo.

Step 2 >> Select the layer mask of the adjustment layer in the Layers palette and fill with black.

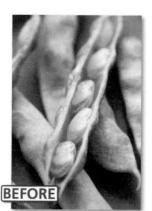

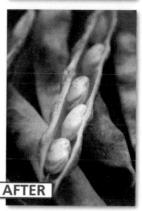

'Paint on' image changes >> Use the mask of the Levels adjustment layer to paint burn and dodge effects nondestructively onto your photos.

Step 3 >> To burn non-destructively brush onto the photo with white whilst the layer mask is still selected.

Enhance your poorly exposed pictures

Good exposure is the cornerstone of great images. No matter how good your subject is, how well you have composed the image or how brilliantly you captured the scene, if your exposure is a little astray then you will be left with a less than perfect result. This is just as true for digital images as it was for traditional photographs. Overexposure leads to delicate highlight detail being recorded as pure white; underexposure on the other hand produces a picture with little detail in the shadow areas.

The best way to solve these problems is to re-shoot your picture using an aperture and shutter combination that will produce a well-exposed image but, as we all know, sometimes a 're-shoot' is just not possible. So how can Photoshop Elements help us enhance our poorly exposed pictures? I have found the following techniques particularly helpful when trying to enhance, or should that be disguise, images that are suffering from bad exposure.

6.19 Screening image layers to enhance tones

Suitable for Elements – 5.0, 5.0, 4.0, 3.0, 2.0, 1.0 | Difficulty level – Intermediate | Resources – Web image 6.17 Related Techniques – 6.20 | Menus used – Layer, Enhance

The shadow and mid tones of a picture are areas that suffer greatly when a photograph is underexposed. Valuable details are lost, the individual tones are too dark and the whole area is lacking in contrast. One way to help rectify this problem is to make an exact copy of the pictures and then combine the two images together in order to multiply the apparent detail and tone in the shadow areas. Photoshop Elements, via layers and blending modes, provides us with the tools necessary to perform these actions.

Layers ✔ Opacity: 100% Screen Normal Lock: Dissolve Darken Multiply Color Burn inear Burn Screen nlor Dodge Linear Dodge Overlav Soft Light Hard Light Vivid Light Linear Light Pin Light

Eevels

Channel: RGB

Irput Levels:

Irput Levels:

Irput Levels:
Irput Levels:
Irput Levels:
Irput Levels:
Irput Levels:
Irput Levels:
Irput Levels:
Irput Levels:
Irput Levels:
Irput Levels:
Irput Levels:
Irput Levels:
Irput Levels:
Irput Levels:
Irput Levels:
Irput Levels:
Irput Levels:
Irput Levels:
Irput Levels:
Irput Levels:
Irput Levels:
Irput Levels:
Irput Levels:
Irput Levels:
Irput Levels:
Irput Levels:
Irput Levels:
Irput Levels:
Irput Levels:
Irput Levels:
Irput Levels:
Irput Levels:
Irput Levels:
Irput Levels:
Irput Levels:
Irput Levels:
Irput Levels:
Irput Levels:
Irput Levels:
Irput Levels:
Irput Levels:
Irput Levels:
Irput Levels:
Irput Levels:
Irput Levels:
Irput Levels:
Irput Levels:
Irput Levels:
Irput Levels:
Irput Levels:
Irput Levels:
Irput Levels:
Irput Levels:
Irput Levels:
Irput Levels:
Irput Levels:
Irput Levels:
Irput Levels:
Irput Levels:
Irput Le

Step 1 >> Copy the background layer by dragging it to the New Layer button in the Layers dialog.

Step 2 >> Select the copied layer and then change the blending mode to Screen.

Step 3 >>> As a final touch insert a Levels Adjustment layer between the two layers. Peg the black and white points and lighten the mid tones by dragging the midpoint to the left.

Firstly, duplicate the background (image layer) by dragging it to the New Layer button at the bottom of the Layers dialog. Now, with the copy layer selected, change the layer blending mode to Screen. You should see an immediate brightening of the picture and the appearance of more detail in the shadow areas.

As a final tweaking of the image insert a Levels adjustment layer between the two layers. Do this by clicking on the bottom layer first and then selecting Levels from the drop-down list found when clicking the Create New Adjustment Layer button at the bottom of the Layers palette. Peg the highlights and shadows of the picture by moving the black and white points towards the center until they meet the first pixels in the histogram. Next, move the mid tone to the left to increase the overall brightness of the image.

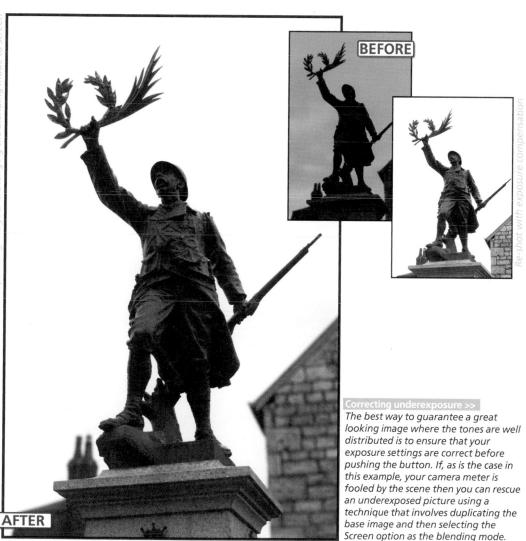

Those of you who are intimate with Elements will no doubt be asking 'Why not just use the Fill Flash or Shadows/Highlights feature to fix this underexposure problem?' and you are right to ask that question. The Fill Flash option is a great tool for lightening mid to dark tones that have plenty of details, but I have found that this 'duplication layers' technique provides a more pleasing result for underexposed images with little shadow information.

Solving exposure problems when shooting

The statue picture not only provides a great example for this technique but also demonstrates how such underexposure can occur. Set against a white overcast sky this dark statue was underexposed because the camera's meter was fooled by the bright sky behind the subject and therefore provided a shutter/aperture combination which was too dark. The thinking photographer would have predicted this problem and used the Exposure Compensation system on the camera to increase exposure by one to one-and-one-half stops to adjust for the back lighting. Most mid range digital cameras and above incorporate an Exposure Override system like this.

+ 2.0

Use the camera's Exposure Compensation system to override your camera's settings.

To try this for yourself, the next time you encounter a back lit scene shoot two pictures – one with the camera set to auto and the other where you have added to the exposure. Compare the results later on the desktop, or better still, check your exposure in the field by examining the histogram graph of your image on you camera's monitor. This graph works exactly the same way as the graph in the Levels feature in Photoshop Elements. It displays the spread of tones of your image across a grayscale from black to white. Underexposure will result in a graph that bunches towards the black end of the spectrum whereas overexposure moves the pixels towards the white point. A simple check of this graph when shooting can indicate whether you need to adjust your camera and re-shoot to compensate for an exposure problem.

Step 1 >>> With the image at 100% magnification apply the Add Noise filter with Uniform/Monochrome settings.

Step 2>> Select Burn-in tool, reduce exposure to 10% and choose mid tone range. Set brush size and edge softness.

Step 3 >>> Burn-in the white area using several overlapping strokes to build up the effect. Change to Shadow range and repeat if necessary.

Texture burn-in >> (a) Original image with blown highlights. (b) Highlights burnt in using Burn-in tool. (c) Highlights burnt in after adding a little texture.

6.20 Adding detail to highlights and shadows

Suitable for Elements – 5.0, 4.0, 3.0, 2.0, 1.0 | Difficulty level – Intermediate | Tools used – Dodging and Burning-in Menus used – Filter

Sometimes, despite the utmost care on behalf of the photographer, digital images are captured with little or no shadow or highlight details. This scenario should ring true for any reader who has had the pleasure of photographing in very sunny countries. Along with the warmth, strong sun can provide a problem with contrast for the photographer. The deepest shadows and the brightest highlights are so far apart that even the best digital cameras have difficulty in recording all the tones. The result is a picture where either shadow or highlight detail (or in some extreme cases both) is not recorded. These parts of the picture are converted to pure black and white pixels in a process referred to as 'clipping'.

The same scenario can occur when using a scanner to convert slide or film originals into digital files. Incorrect scanner settings coupled with slides that are very dark or negatives that have been overdeveloped are the circumstances that most often produce 'clipped' files.

When presented with such pictures the experienced Elements user will attempt to restore detail in the highlight and shadow areas using the program's Dodging and Burning-in tools. But often such action only results in murky gray highlights and washed out shadow areas. The problem is that the program has no detail in these parts to actually lighten or darken. A solution to this scenario is to add a little (very little) texture to the image and then dodge and burn-in. The texture breaks up the pure white and pure black areas by filling these picture parts with random multi-tone (black, gray and white) pixels. This gives the tools some detail, albeit artificially created, to work on.

I use the Add Noise filter (Filter > Noise > Add Noise) to provide the texture and then select the Dodging tool set to mid tones to work on the dark tones, or you could use the Burning-in tool also set to mid tones to work on the highlights. A low exposure value of around 10% is coupled with repeated strokes over the offending area. To restrict the noise to just the highlight areas you could select these first using the Magic Wand and then apply the Noise filter. Book resources at: www.adv-elements.com This technique does have its down side. It doesn't recreate lost details and you will need to degrade your image by making it more noisy before you can dodge and burn. So it can't be considered a magic 'cure all' for problem pictures but it can help you get a little detail into that annoyingly white highlight or that equally frustrating blocked shadow area.

Tinted monochromes

One of the most enduring techniques utilized by photographers the world over is the practice of toning or changing the color of their black and white prints. The Sepia tone (brown) look has come to be linked with quality image production partly because it was a process that increased the longevity of black and white pictures and partly because only committed photographers would take their work through this extra processing step. Digital photographers have the tools at hand to not only 'tone' their black and white images but also to apply this same technique to their color ones.

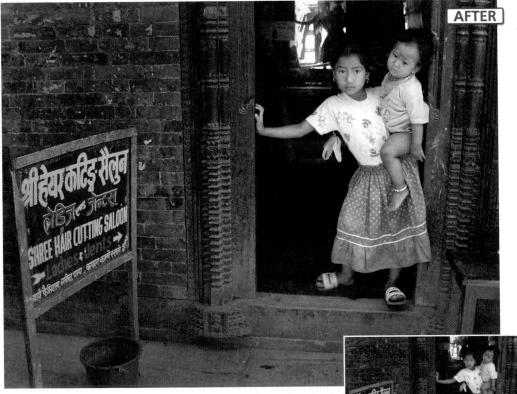

Toning >>> Use the Hue/Saturation control (Enhance > Adjust Color > Hue/ Saturation) to quickly and effectively add a tint to your color images.

6.21 Using Hue and Saturation to tone your pictures

Suitable for Elements – 5.0, 4.0, 3.0, 2.0, 1.0 | Difficulty level – Intermediate | Resources – Web image 6.21 Related techniques – 6.22 | Menus used – Enhance

The simplest and fastest way to add color is to use the Hue/Saturation control (Enhance > Adjust > Color > Hue/Saturation). This can be applied directly to the whole image or as an adjustment layer (Layer > New Adjustment Layer > Hue Saturation). To change the feature into a toning

tool click the Colorize option in the bottom right of the box. The picture will switch to a single color monochrome (one color plus white and black). The Hue slider now controls the color of your tone.

The sepia look in the example is a value of 30 on the Hue slider. The Saturation slider varies the strength of the color. The Saturation value used in the example was 25. The Lightness slider adjusts the brightness of the image but changes of this nature should be left for the Levels feature.

The predictability of this digital toning system means that you can achieve the same tint in each image for a whole series of pictures. The recipes for regularly used tones, or favorite colors, can easily be noted down for later use or

Hue/Saturation		
V Learn more about: <u>Hue/Satu</u>	ration_	OK
Edit: Master]	Cancel
<u>H</u> ue:	30	<u>H</u> elp
-0		
Saturation:	25	
Lightness:	0	
û		6
	9 2 2	Colorize
		E Freedoor

Hue/Saturation toning >> Check the Colorize option to convert the dialog to Toning mode.

if toning using an adjustment layer then the layer can be dragged from one image to another. You can even create a Toning palette like the example on the next page, which provides a range of tint options as well as hue strengths.

Step 1>> Select the Hue/Saturation control from the Enhance menu. For grayscale images change the mode to RGB color first (Image>Mode>RGB Color).

Step 2 >> Place a tick in the Colorize and Preview checkboxes.

Step 3 >> Adjust the Hue slider to change tint color and the Saturation slider to change tint strength.

IMAGE CHANGES -SEYOND THE BASICS

(a) 0, 75, 0 (b) 0, 50, 0 (c) 0, 25, 0

(d) 30, 75, 0 (e) 30, 50, 0 (f) 30, 25, 0

(g) 80, 75, 0 (h) 80, 50, 0 (i) 80, 25, 0

(j) 190, 75, 0 (k) 190, 50, 0 (l) 190, 25, 0

(m) 250, 75, 0 (n) 250, 50, 0 (o) 250, 25, 0

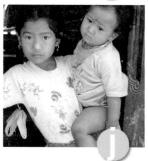

Book resourd

Split toning

Once you have mastered the art of toning your pictures it is time to spread your 'tinting' wings a little. One of my favorite after-printing effects back in my darkroom days was split toning. This process involved passing a completed black and white print through two differently colored and separate toning baths. This resulted in the print containing a mixture of two different tints.

For example, when an image is split toned with sepia first and then blue toner the resultant picture has warm (brown) highlights and mid tones, and cool (blue) shadows. Getting the right toning balance between the two solutions was difficult and then trying to repeat the process uniformly over a series of images was even harder. Thankfully I can replicate the results of split toning in my digital picture with a lot less trouble and a lot more predictability.

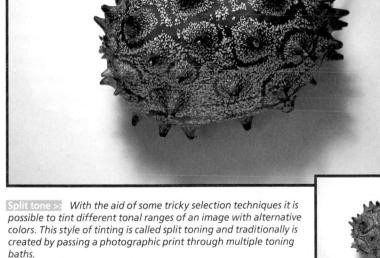

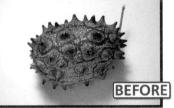

AFTER

6.22 Select and tone

Suitable for Elements – 5.0, 4.0, 3.0, 2.0, 1.0 | Difficulty level – Intermediate| Resources – Web image 6.22 Related techniques – 6.23 | Tools used – Magic Wand | Menus used – Select, Enhance

In order to tint a select range of tones such as mid tones and shadows I must first select these areas of the image. The Magic Wand tool makes selections based on color and tone and so is perfectly placed for this type of selection. Normally we would use this tool with the Contiguous option turned on so that the selection comprises pixels that sit next to each other, but for this

32 Anti-alias Contiguous Sample All Lavers Tolerance:

task turn this option off. The Tolerance value for the tool can range from 0 to 255. This setting determines how close to the selected pixel's tone the other pixels need to be before they too are included in the selection. The 0 setting is used to select other pixels in the image with exactly the same color and tone. whereas a setting of 20 will select other pixels that vary by as much as 20 tonal/color steps from the original.

When using the Magic Wand to select a range of tones in an image be sure to turn off the Contiguous setting, increase the Tolerance value and then select your reference pixel.

With this in mind we can easilv employ this tool to select of an image by setting the tolerance to a value of about 120 and then selecting the darkest part of the image (which we will assume has a value of 0 and therefore is black). The Magic Wand will then search the picture for pixels with a tonal value between 0 and 120. The resultant selection will include both shadows and mid tones. It is then a simple matter of using the Hue/Saturation control to colorize these tones. To tint the rest of the pixels in the picture in an alternative color you must first invert the selection (Select>Inverse) and then repeat the Hue/Saturation toning procedure.

To soften the transition at the split of the two colors apply a feather of 1 or 2 pixels (Select > Feather) after your initial selection.

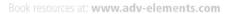

Step 1 >> Select the Magic Wand tool, adjust the Tolerance value and deselect the Contiguous option.

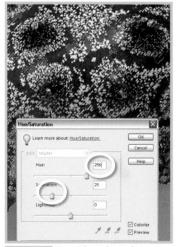

Step 3 >> Tone the selected areas using the Hue/Saturation control.

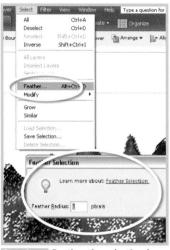

Step 2 >> Feather the selection by a value of 1 or 2 pixels to soften the split between toning colors.

Step 4 >> Inverse the selection and tone the remaining pixels using an alternative color.

6.23 Two-layer erase

Suitable for Elements – 5.0, 4.0, 3.0, 2.0, 1.0 | Difficulty level – Intermediate | Resources – Web image 6.23 Related Techniques – 6.22 | Tools used – Eraser | Menus used – Layer, Enhance

You can extend the split toning idea beyond its darkroom origins by using this technique to create an image where one part of the picture is toned one color whilst the rest is colored in an alternative hue. To achieve this effect duplicate the image layer and then select and tone each layer in turn. Then use the eraser to remove parts of the upper layer to reveal the color of the layer beneath.

Erasing toned layers>> By duplicating the image layer and then toning the two layers it is possible to erase through the upper layer to reveal the alternate colored layer below.

BEFORE

Step 2 >> Select each layer in turn and tone using the Hue/Saturation control set to Colorize.

layer and then choose the Eraser

tool. Use the tool to remove the

IMAGE CHANGES -BEYOND THE BASICS

AFTER

Copacty: 100% 2 Lock: Chica D

Ratgrind a

Step 1 >>> Duplicate the base image layer by dragging it to the New Layer button at the bottom of the Layers dialog.

IMAGE CHANGES -BEYOND THE BASICS

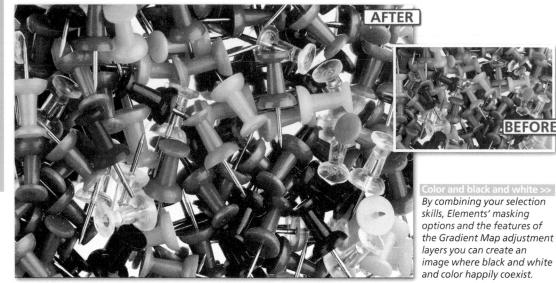

Black and white and color

The same 'two-layer erase back' technique can be used for creating photographs which contain both color and black and white elements, but I prefer to use a different method based around Elements' masking options.

6.24 Layer mask and gradient map

Suitable for Elements – 5.0, 4.0, 3.0, 2.0, 1.0 | Difficulty level – Intermediate | Resources – Web image 6.24 Related Techniques – 6.23 | Tools used – Selection tools | Menus used – Select, Layer

With the color image open make a selection of the objects that will not be converted to black and white. In the example I used a combination of the Magnetic Lasso and the standard Lasso tools to select the three map pins, but you could also use the Magic Selection Brush to achieve the same results. Next, feather the selection (Select > Feather) slightly with a setting of 1 pixel to soften the edge of the effect. Invert the selection (Select > Inverse) so that the background (everything other than the map pins) is now selected. Then, with the selection still active, create a new Gradient Map adjustment layer (Layer > New Adjustment Layer > Gradient Map). When the Gradient Map dialog appears select the map with a smooth transition from black to white and click OK. Elements uses your selection to mask out the adjustment layer effects and restrict them from being applied to the originally selected map pins. You can create a multitude of other effects using the same process but different gradient maps or adjustment layers.

More effects >> You can create other effects using the same masking technique with the Threshold (a), Posterize (b) and Invert (c) Adjustment Layers options.

Book resources at: www.adv-elements.com

Make sure that you save your selections (Select > Save Selection) as you make them. This way you can always reload them later if you need to.

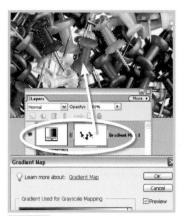

Step 1>>> Make a selection of the parts of the image that you want to remain in color.

Step 2 >> Feather the selection by 1 pixel and then Inverse the selection.

Step 3 >> With the selection still active create a new Gradient Map adjustment layer.

Border techniques

Creating a great border is one of those finishing touches that can really make your images stand apart from the crowd. Using Photoshop Elements you can easily create and apply a variety of different border styles to your photographs.

6.25 Simple borders

Suitable for Elements – 5.0, 4.0, 3.0, 2.0, 1.0 | Difficulty level – Intermediate | Resources – Web image 6.24 Related Techniques – 6.26 | Tools used – Marquee | Menus used – Select, Window, Edit

A basic line border can be created by selecting the whole image (Select > Select All) and then stroking (Edit > Stroke) the selection on the inside with the foreground color. For fancier styles Elements provides a range of Frame and Edge treatments in its Artwork and Effects palette (Window > Artwork and Effects). Some frames require you to make a selection first; others can be applied directly to the picture with no preliminary actions.

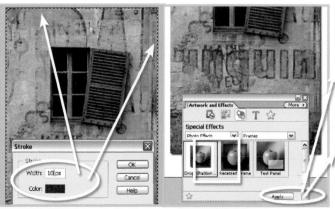

Stroked frame >> Use the Eyedropper tool to select a suitable border color from the image. Select all the picture (Select > Select All). Stroke the selection (Edit > Stroke Selection) on the inside with the foreground color and a width of 10 pixels.

Photo Effects >> Display the Artwork and Effects palette (Window > Artwork and Effects) and then select the Special Effects > Photo Effects section. Choose frames from the drop-down list and then Drop Shadow from the thumbnails. Press the Apply button.

6.26 Sophisticated edges using grayscale masks

Suitable for Elements – 5.0, 4.0, 3.0, 2.0, 1.0 | Difficulty level – Intermediate | Resources – Web image 6.26 Related techniques – 6.25 | Tools used – Paint Brush | Menus used – layer

You can create truly imaginative edges by using a grayscale mask to hide the edges of the picture. Start by using the Elements drawing tools to paint a black shape with rough edges on a white background. This is our grayscale mask. Ideally the dimensions of the painting should be the same as the picture to be framed. With both the picture and the mask open as separate documents, use the Move tool to drag the mask image on top of the picture. The mask will become a new layer. Use the Free Transform tool (Image > Transform > Free Transform) to scale the mask to fit the image precisely.

Grayscale mask borders >> You can use a grayscale mask to produce a creative border effect by stacking the mask on top and then changing the layer mode to Screen.

With the mask layer still active change the layer mode

to Screen. This will cause the image from beneath to show through the black parts of the mask whilst the white areas of the mask hide the rest of the picture below.

This technique can also be used to create an image-filled border by inverting the mask before changing modes. This way the center of the picture is hidden by the white portion of the mask and the edges are filled with the image from below.

Search the web for pre-made grayscale masks that can be downloaded and used directly in Elements.

Step 1>> Create or download grayscale mask. Open image and mask. Drag mask onto image as a new layer.

Step 2 >> With the mask layer selected use the Transformation tool (Image>Transform>Free Transform) to scale the mask to fit the image.

Step 3 >> Switch the mask layer's mode to Screen to create the edge effect. To invert the effect select Image > Adjustments > Invert before changing the mode.

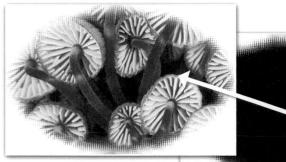

Picture edges >> More sophisticated masks of all manner of shapes, sizes and styles can be created using grayscale masks. By inverting the mask (Image Adjustment > Invert) you can also create an edge filled with a picture rather than a picture surrounded by an edge.

>

Grayscale mask border

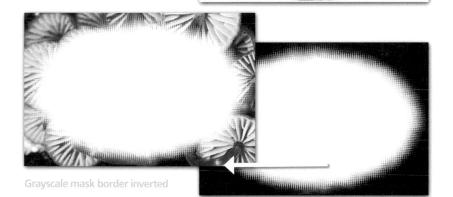

6.27 Creating frames with Frame layers

Suitable for Elements - 5.0, 4.0, 3.0, 2.0, 1.0 | Difficulty level -Intermediate | Resources - Web image 6.26 | Related techniques - 6.25 Tools used - Paint Brush | Menus used - layer

Frame layers are brand new to Elements and have been introduced as part of the new system of creating multi-page themed documents (Photo Creation or .PSE documents). Here, we will just take a quick look at the framing abilities of the new technology, but for a fuller description of how to create and edit PSE files go to Chapter 12.

Frame layers combine both the picture and the frame in a single layer. This a really cool aspect of this technology as it means that not only can the frame and layer combination be sized and rotated as a single composition, but the picture can also be manipulated independent of the frame. Photoshop Elements 5.0 ships with a huge collection of frames that can be quickly and easily added to your pictures.

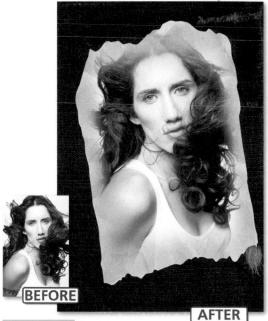

Frame layers >> Frame layers are a new way to dynamically add fancy borders to your photos.

The various designs are collated in the Artwork and Effects palette (under the Frames option in the Artwork section of the palette). To add a frame to a picture that is already open in the Full Edit workspace display the palette first (Window > Artwork and Effects) and then click on the Artwork button (Frame with sun icon) at the top left of the palette. Next choose the Frames option from the left-hand drop-down menu and the Frame grouping from the menu on the right. After locating the frame type you want to add to your photo click on its thumbnail and then press the Apply button at the bottom of the palette.

Elements automatically creates a new Frame layer, adds your photo to it and then provides a small adjustment palette at the top of the framed image containing controls for sizing, rotat-

ing and replacing your photo. Alternatively, extra positioning and sizing options are available from the right-click menu. Click on the photo and then click-drag the corner handles to resize the frame and image together or the rotate handle to pivot the combination. Double-click the Move tool on the photo to select just the picture and use the handles to alter the photo independently of the frame.

Step 1 >> With a photo open in the editing space display the Frames section of the Artwork and Effects palette. Select the Frame Style thumbnail and click the Apply button.

Step 2 >> Elements automatically creates a new Frame layer and places your photo in the frame design. Adjust the size and orientation of the picture using the pop-up adjustment palette.

Step 3 >> More picture controls are available from the right-click menu. In most cases the Fit Frame To Photo option should be selected first and then any fine-tuning added later.

Step 4 >> Single-click the photo to select both frame and photo. Doubleclick to pick the photo only. Use the corner and rotate handles to fine-tune the size of picture and frame.

Step 5 >> To finish add a background to the composition by selecting the Background option from the left-hand menu. Next Choose the background and then click Apply.

Adding texture

Texture is a traditional photographic visual element that is often overlooked when working digitally. All but the highest quality professional films have visible grain when they are printed. This is especially true when the print size goes beyond the standard 6 x 4 inches. In fact we are so familiar with the idea that grain is part of the photographic process that putting a little texture into an otherwise grainless digital picture can lend a traditional 'look and feel' to the image.

Many photographers add a little texture to their pictures as part of their regular image editing process. Some go beyond this and produce photographs with huge clumps of grain that resemble the results often seen with prints made from old style high ISO films.

6.28 Add Noise filter

Suitable for Elements - 5.0, 4.0, 3.0, 2.0, 1.0 | Difficulty level - Intermediate | Resources - Web image 6.28 Related techniques - 6.29, 6.30 | Menus used - Filter

The simplest method for adding texture to your picture is to use the Add Noise filter (Filter > Noise > Add Noise). The feature is provided with a preview dialog which allows you to alter the 'Amount' of noise that is added to the photograph, the style of noise – Gaussian or Uniform - and whether the noise is random colored pixels or just monochrome. As with most filters it is important to use this feature carefully as once the filter is applied and the file saved you will not be able to undo its effects. For this reason, it pays to make a duplicate file of your picture which you can texturize without risk of destroying the original image.

Be sure to preview the image at least 100% when adding noise to ensure that the effect is not too strong. If in doubt, make a test print of sections of the picture with different Add Noise settings to preview the hard copy results.

Filte	View Vindov	v Help Type a quest			
	New Window for 0800h1092.jpg				
	🔍 Zoom In	Ctrl++			
ding Box	🔍 Zoom Out	Ctrl+-			
		Ctrl+0			
C	Actual Pixel	s Alt+Ctrl+0			
The second	Drint Cian				
	Selection	Ctrl+H			
	Rulers	Shift+Ctrl+R			
Marco III	Grid				
	Guide Prese	ts			
	Annotations				
	Snap To				
		State of the second			
	and the second se	and the second se			
-		and the second s			
		Service Se			

Step 1 >> Zoom in so that the picture is at least at 100% view.

Filter	View	Window	Help	Ту	pe a question
Last F Filter	iiter Gallery		Ctrl+F	nnn	Organize
Corre	ct Cam	era Distorti	on		Arrange
Adjus	tments				
Artisti	c			•	Magazin and
Blur				۰I	-
Brush	Stroke	s		۰II	
Distor	t			٠L	STICLE
Noise					Add Noise.
Pixela	te			•	Despectie
Rende	er			•	Dust & Scral
Sketc	h			•	Median
Stylize	е			•	Reduce Nois
Textu	re			1	
Video				•	and the second second
Other					And the second second
Digima	arc				-

Step 2 >> Select the Add Noise filter

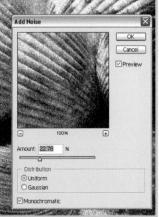

from the Filter menu.

Step 3 >> Adjust the Amount slider to change the strength of the effect and pick the noise type and color.

6.29 Grain filter

Suitable for Elements – 5.0, 4.0, 3.0, 2.0, 1.0 | Difficulty level – Intermediate | Resources – Web image 6.29 Related techniques – 6.28, 6.30 | Menus used – Filter

As an alternative that provides a few more options than the technique above you can use the Grain filter (Filter > Texture > Grain) to add your choice of 10 different grain textures to your picture. Ranging from 'regular' through 'horizontal' to 'speckle' this filter produces a spectacular variety of texture effects. The feature's dialog also provides an Intensity slider to govern the strength of the texture and a Contrast control.

The trick to creating good texture using this feature is the balancing of Intensity and Contrast settings. If the texture is too strong the shape and color of the original subject matter can be lost. If the contrast is too high then shadow and highlight details can be lost.

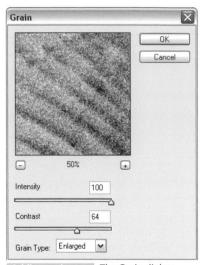

Adding grain >> The Grain dialog provides a preview thumbnail, Intensity and Contrast sliders and a selection of 10 different grain types.

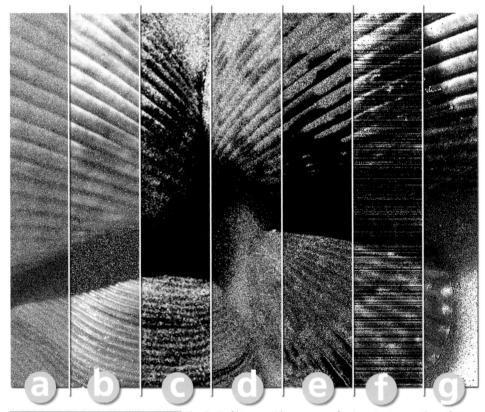

Texture options for the Grain filter >> The Grain filter provides a range of unique texture options that can be applied to your picture. (a) Regular. (b) Sprinkles. (c) Clumped. (d) Enlarged. (e) Stippled. (f) Horizontal. (g) Speckle.

6.30 Non-destructive textures

Suitable for Elements – 5.0, 4.0, 3.0, 2.0, 1.0 | Difficulty level – Intermediate | Resources – Web image 6.30 Related techniques – 6.28, 6.29 | Menus used – Layer, Filter

As we have already seen adjustment layers are a great way to manipulate your pictures without actually altering the original image. This approach to image editing is referred to as 'non-destructive' as the integrity of the starting picture is always maintained. Mistakes or radical manipulations can always be reversed by switching off the adjustment layer leaving the untouched original below. Although there are no such things as Filter adjustment layers it would be handy to be able to use this same approach when making whole non-reversible image changes such as adding texture or noise to your pictures.

Such a technique was used in the following example. Despite the appearance of texture throughout the whole photograph the starting picture is still preserved at the bottom of the layer stack. To get the same results with your own pictures start by making a new layer (Layer > New > Layer) above the image. Next, fill this layer with 50% gray (Edit > Fill Layer) and Add Noise (Filter > Noise > Add Noise) to the layer. Change the mode of the gray textured layer to either Soft Light, Hard Light, Linear Light or Vivid Light. Notice how the texture is now applied to the picture. To soften the effect reduce the opacity of the texture layer.

Using this technique you not only preserve the integrity of the original picture but you can also alter the strength of the effect at any time. In addition, it is also a great way to apply the same amount and style of grain to several layers in a stack without having to individually select and filter each layer.

Pro's Tip

To apply the same texture settings to a series of images of the same size simply drag and drop the gray texture layer into each of the open documents.

1	New Duplicate Layer	Laver She Laver From Backorn
	Delete Layer	Layer via Copy
	Rename Layer	Layer via Cut Shi
	Layer Style	
1	New Fill Layer	 Instant Sector
	New Adjustment Layer	•
	Change Layer Content	
- 3	Layer Content Options	
	Туре	·
	Simplify Layer	
	Group with Previous Ctrl+G	
- 0	Ungroup Shift+Ctrl+G	
	Arrange	•
	Merge Layers Ctrl+E	
8	Merge Visible Shift+Ctrl+E	0.10
	Flatten Image	

Step 1 >> Create a new layer above the image layer or background.

Step 2 >> Fill the layer with 50% gray using the Edit > Fill layer command.

Step 3 >> Texture the layer with Add Noise and switch the layer mode to Vivid Light.

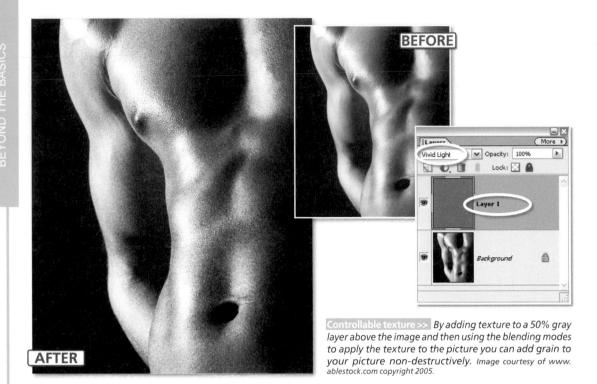

Advanced sharpening secrets

To most of us sharpening is a way of improving the clarity of photos using a single-click option such as Enhance > Auto Sharpen in Elements, but why should we relinquish control when it comes to this final step in the editing process? Here we look a little deeper at some of the more customizable options that allow the user to more easily match the sharpening effect with the subject matter and output destination of their photos.

Sharpening – What are the options?

Photoshop Elements provides a variety of sharpening options designed to increase the clarity of digital photographs. In previous versions these options were listed in the Filter > Sharpen menu and include the Sharpen, Sharpen Edges, Sharpen More and Unsharp Mask filters. In version 5.0 the options are now grouped under the Enhance menu and include Auto Sharpen, Unsharp Mask and Adjust Sharpness filters.

Digital sharpening techniques are based on increasing the contrast between adjacent pixels in the image. When viewed Book resources at: www.adv-elements.com

New sharpen options >> Elements 5.0 groups its sharpening options under the Enhance menu. Unsharp Mask remains but the other filters have been replaced with the one-step Auto Sharpen and the sophisticated Adjust Sharpness options.

150

from a distance, this change makes the picture appear sharper or more defined. So applying a sharpening filter does not, and will never, make a poorly focused picture suddenly appear as if it has been focused correctly. Instead these filters are designed to make your photos appear more sharply defined.

For many users selecting an option such as the Auto Sharpen is about as far as they go when it comes to thinking about how to sharpen their pictures, but this 'one-click' filter fail to take into account the content of the photo and the intended use for the image – two factors that should determine the amount of sharpening you apply. So for the ultimate control of your sharpening use the advanced features in the new Adjust Sharpen filter, or the tried and tested Unsharp Mask filter. Both these options contain controls that allow the user to manipulate the strength of the sharpening effect and adjust which parts of the picture the filters are applied. Let's look at each in turn.

6.31 Unsharp Masking to the rescue

Suitable for Elements – 5.0, 4.0, 3.0, 2.0, 1.0 | Difficulty level – Intermediate | Resources – Web image 6.31 Related techniques – 6.32, 6.33 | Menus used – Enhance

Of the various sharpen filters that Photoshop Elements contains the Unsharp Mask provides some of the greatest control over the sharpening process by giving the user a range of sliders which, when adjusted, alter the way the effect is applied to pictures. Though a little confusing to start with, the Unsharp Mask filter is one of the best ways to make your scans or digital photographs clearer. However, to get the most out of the feature you must understand and control carefully each of the three sliders. So how does the feature work?

Step 1 >> Make sure that your picture is zoomed in or magnified to at least 100% before selecting the Unsharp Mask option from the Enhance menu. Select the Preview option in the dialogue to ensure that the sharpening effects are shown on the full image.

Step 2 >> Start with the radius set to 1 and the Threshold value adjusted to 0. Gradually move the Amount slider upwards watching the sharpening effect as you go. Stop when you find a setting where the picture appears clearer but contains no sharpening 'halos'.

Step 3 >> To restrict the effect from being applied to skin tones, blue skies or other areas of smooth tone gradually increase the Threshold slider until the sharpening is just being applied to the picture's edges.

The **Amount** slider controls the strength of the sharpening effect. Larger numbers will produce more pronounced results whereas smaller values will create more subtle effects. Values of 50% to 100% are suitable for low-resolution pictures whereas settings between 150% and 200% can be used on images with a higher resolution.

The **Radius** slider value determines the number of pixels around the edge that are affected by the sharpening. A low value only sharpens edge pixels. High settings can produce noticeable halo effects around your picture so start with a low value first. Typically values between 1 and 2 are used for high-resolution images, settings of 1 or less for screen images.

The **Threshold** slider is used to determine how different the pixels must be before they are considered an edge and therefore sharpened. A value of 0 will sharpen all the pixels in an image whereas a setting of 10 will only apply the effect to those areas that are different by at least 10 levels or more from their surrounding pixels. To ensure that no sharpening occurs in sky or skin tone areas set this value to 8 or more.

Unsharp Mask Top Tip:

Be careful when you are using the Unsharp Mask filter with your pictures. A little sharpening will improve the look of your photographs but too much sharpening is really noticeable and almost impossible to repair once applied to your picture. If you are unsure of your settings, apply the effect to a copy of the image first.

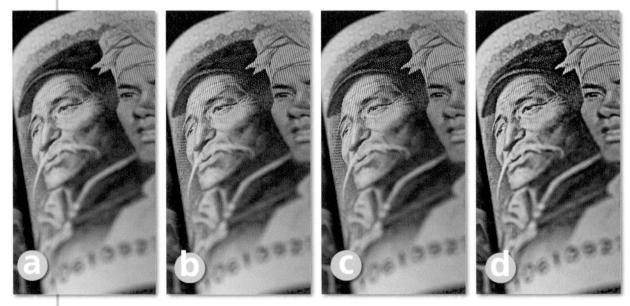

Adding clarity >> Careful sharpening can really add to the clarity of a digital photo, but like most enhancement techniques it is best to make such changes subtly. (a) No-sharpening. (b) After Unsharp Mask. (c) After Adjust Sharpness. (d) High Pass/Blend Light mode approach.

6.32 Adjust Sharpness for the ultimate control

Suitable for Elements – 5.0 | Difficulty level – Intermediate | Resources – Web image 6.31 Related techniques - 6.31, 6.33 | Menus used - Enhance

Until the release of Photoshop Elements 5.0 the best way to take control of the sharpening in your photographs was to use the Unsharp Mask filter. But the most recent release has included a brand new sharpening tool that will easily steal this crown. The Adjust Sharpness filter (Enhance > Adjust Sharpness) provides all the control that we are familiar with in the Unsharp Mask dialog plus better edge detection abilities, which leads to less apparent sharpening halos. The Filter dialog contains a zoomable preview, sliders to control the sharpening plus a drop-down menu where you can choose the type of sharpening to apply. You can control the sharpening effect with the following settings:

Amount – Strength of sharpening effect.

Radius - Determines the extent of sharpening. Higher values equal more obvious edge effects.

Remove – Determines sharpening algorithm used. Gaussian Blur uses the same approach as the Unsharp Mask filter. Lens Blur concentrates on sharpening details and produces results with fewer halos. Motion Blur reduces the effects of blur caused by camera shake or subject movement.

Angle – Sets Motion Blur direction.

I Cancel I Preview

%

pixels

Settings

Amount: 100

Radius: 1.0

More Refined

Remove: Gaussian Blur

Angle: 0

picture is zoomed in or magnified to

sharpening effects are shown on the

at least 100% and then select the

Enhance > Adjust Sharpness filter.

Select the Preview option in the

full image and also tick the More

Refined option unless you are working with a large file or a slow

computer.

dialogue to ensure that the

More Refined – Longer processing for better results.

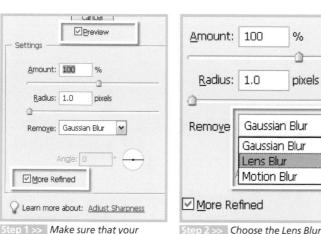

Step 2 >> Choose the Lens Blur entry from the Remove menu. This option provides the best sharpening with least halo artifacts. Choose Gaussian Blur if you want to simulate Unsharp Mask results or Motion Blur if you are trying to get rid of the effects of camera shake.

Remove: Lens Blur Step 3 >> Start with the radius set to 1 and gradually move the Amount

Cancel

New Adjust Sharpness >> The Adjust Sharpness feature in Elements 5.0 extends the customized sharpening ability first started with the Unsharp Mask filter.

slider upwards watching the sharpening effect as you go. Stop when you find a setting where the picture appears clearer but contains no sharpening 'halos'.

Book resources at: www.adv-elements.com

Reset Pre

×

Adjust Sharpness Top Tip:

One of the options for the new Adjust Sharpness filter is the Motion Blur entry in the Remove menu. The options listed in this menu determine the way in which sharpening is applied to the picture or more specifically, the algorithm used when filtering. The Motion Blur option is different to the other choices as it provides a

method of reducing the effects of blur in a photo due to the camera or subject moving during the exposure. When Motion Blur is selected you have the added option of inputting an angle for the blur reducing action. This can be achieved with the dial control by click-dragging the mouse or by inputting a specific angle.

6.33 Another approach

Suitable for Elements – 5.0, 4.0, 3.0, 2.0, 1.0 | Difficulty level – Intermediate | Resources – Web image 6.31 Related techniques – 6.32, 6.31 | Menus used – Layer, Filter

There is no getting away from the fact that sharpening photos with filters alters them irreversibly and forever. For this reason many photographers duplicate their precious pictures multiple times and apply different sharpening options to the copies depending on their intended use. This is not a bad approach, especially if you have plenty of storage space to hand, but what if you could sharpen your photos without altering the original pixels? Well surprisingly the Blending Modes feature located in Photoshop Elements provides the key to just such a technique. In particular, we will use the Hard Light Blend Mode in conjunction with the High Pass filter to create a non-destructive sharpening effect. The High Pass filter provides the mechanism for controlling where the sharpening occurs by isolating the edges in a picture and then converting the rest of the image to mid gray. This is perfect for use with Hard Light blend mode as the mid gray areas will not be affected at all and the sharpening changes will only be applied to the edges of the photo.

Step 1 >>> Make a copy (Layer > Duplicate Layer) of the picture layer that you want to sharpen. Filter the copied layer with the High Pass filter (Filter > Other > High Pass) and press OK.

Step 2 >>> With the filtered layer still selected switch the blend mode to Hard Light. This mode blends both the dark and light parts of the filtered layer with the picture layer, causing an increase in contrast.

Step 3 >> Adjust the opacity of this layer to govern the level of sharpening. Sharpening using this technique means that you can remove or adjust the strength of the effect later by manipulating the filtered layer.

Darkroom Techniques on the Desktop

ADVANCED PHOTOSHOP ELEMENTS 5.0 FOR DIGITAL PHOTOGRAPHERS nce you have mastered the basic editing and enhancement skills and techniques in Elements you will no doubt want to move on to some more challenging tasks that will extend and build upon what you already know. The group of techniques collected together here is loosely based on traditional photographic 'know how' that I have reworked in a digital fashion.

7.01 Diffusion printing

Suitable for Elements – 5.0, 4.0, 3.0, 2.0, 1.0 | Difficulty level – Intermediate | Resources – Web image 701 Tools used – Eraser | Menus used – Filter, Layer

Even though as image-makers we spend thousands of dollars on equipment that ensures that we make sharp photographs, there is something enticing about a delicately softened picture. Especially when this lack of sharpness is contrasted against a well-focused section of the picture. Diffusion printing is one traditional printing technique that played with this idea. Parts of the image were purposely blurred whilst other areas remained sharp.

With non-digital photography adding such an effect meant placing a 'mist' or 'fog' filter in front of the camera lens at the time of shooting. More recently, in an attempt to gain a little more control over the process, photographers have been placing diffusion filters below their enlarging lenses for part of the print's exposure time. This process gave a combination effect where sharpness and controlled blur happily coexisted in the final print.

Gaussian Blur filter >> The diffusion printing technique is based around the careful application of the Gaussian Blur filter.

Step 1 >> Duplicate the original picture by dragging it to the New Layer button or choosing the Layer>Duplicate Layer option.

Step 2 >> Apply the Gaussian Blur filter (Filter>Blur>Gaussian Blur) to the upper, duplicated, layer.

Step 3 >> Control the way that the blurred layer interacts with the one beneath by adjusting the blending mode and/or using the eraser to remove unwanted blurred areas.

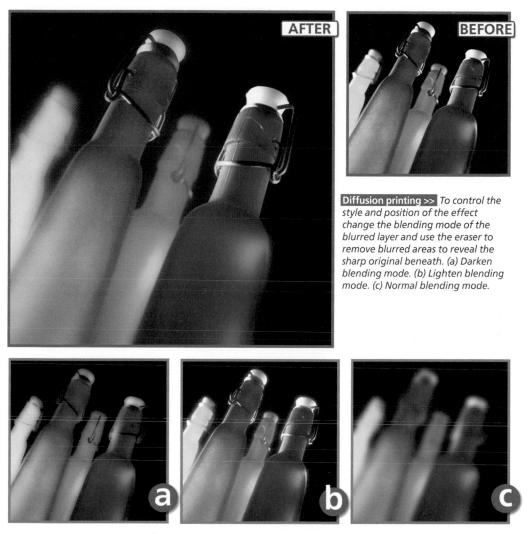

Creating this style of picture using digital processes offers the image-maker a lot more choice and control over the end results. The technique is based around the Gaussian Blur filter, which can be used to soften the sharp details of your photograph. A simple application of the filter to a base image produces a less than attractive result and one that doesn't combine the sharp and blurred imagery. Instead more control is possible if the filter is applied to a copy of the picture stored as a layer above the original image. This blurred layer is then combined with the original by either reducing the opacity of the blurred layer to allow the sharp original to show through, or by changing the blurred layer to a different blending mode such as Darken or Lighten.

Extending the technique

Blending mode or opacity changes provide control over the overall effect of the diffusion, but to fine-tune the results select the blur layer and use the Eraser tool, set to a low opacity, to gently remove parts of the top layer to reveal the sharpness beneath.

DARKROOM TECHNIQUES ON THE DESKTOP

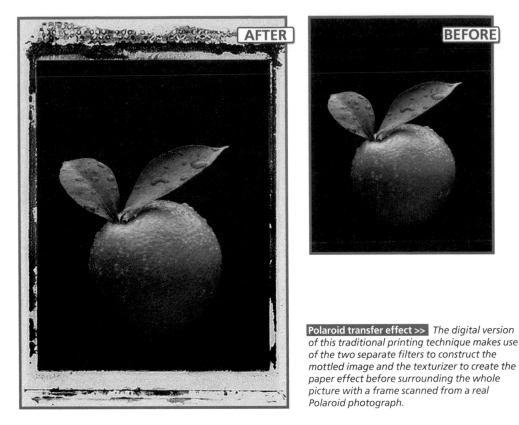

7.02 Instant film transfer effect

Suitable for Elements – 5.0, 4.0, 3.0, 2.0, 1.0 | Difficulty level – Advanced | Resources – Web images 702-1, 702-2, 702-3, Menus used – Filter, Layer, Enhance, Image

Most readers will probably be familiar with Polaroid instant picture products – you push the button and the print is ejected and develops right before your eyes. For many years professional image-makers have been using the unique features of this technology to create wonderfully textured images. The process involved substituting watercolor paper for the printing surface supplied by Polaroid. As a result the image is transferred onto the roughly surfaced paper and takes on a distinctly different look and feel to a standard Polaroid print.

Much acclaimed for its artistic appeal, the technique was not always predictable and, much to the frustration of photographers, it was often difficult to repeat the success of previous results. There were three main problems – dark areas of an image often didn't transfer to the new surface, colors and image detail would bleed unpredictably, and it was difficult to control how dark or light the final print would be. I know these problems intimately as it once took me 16 sheets of expensive instant film to produce a couple of acceptable prints.

A digital solution

This success ratio is not one that my budget or my temperament can afford. So I started to play with a digital version of the popular technique. I wanted to find a process that was more

Book resources at: www.adv-elements.com

158

predictable, controllable and repeatable. My first step was to list the characteristics of the Polaroid transfer print so that I could simulate them digitally.

To me it seemed that there were four main elements: desaturated colors, mottled ink, distinct paper texture and color, and the Polaroid film frame.

If I could duplicate these on my desktop then I would be able to make an image that captured the essence of the Polaroid transfer process.

Step 1 >>> Desaturate the image tones slightly using the Hue/ Saturation feature.

Step 2 >> Duplicate the background layer by dragging it to the New Layers button at the top of the dialog.

Step 3 >> Apply both the Paint Daubs and Palette Knife filters to the upper layer (duplicate).

Step 4 >> Reduce the opacity of the filtered upper layer to allow some of the sharp details of the original image to show through.

anvas Size				
🖓 Learn mo	re about: 🤉	anvas Size		
- Current Siz	0. 2 7044			
current de		8.47 cm		
		10.96 cm		
New Size: (
- New Size, t	Width:	120	perc. nt	-
/	Height:	140	percent	
		Relative	percent 1	1001
	Anchor:	Meauve		
		1	-	
(-	
			•	
			-	
Canvas exter	nsion color:	Backgrou	nd M	

Step 5 >> Check to see that the background color is set to white. Increase the size of the canvas to accommodate the Polaroid edge surround using the Canvas Size command with a setting of 120% for width and 140% for height. Flatten the layers.

Step 6 >> Either use one of the preinstalled textures available in the Texturizer filter or download and install the watercolor paper.psd file (web image 702-2) from the book's website. Use the filter to add the texture to the surround.

Book resources at: www.adv-elements.com

159

Desaturate the image tones

The Polaroid technique requires the watercolor paper to be slightly wet at the time of transfer. The moisture, whilst helping the image movement from paper to paper, tends to desaturate the colors and cause fine detail to be lost. These characteristics are also the result of the coarse surface of the donor paper. So the first step of the digital version of the process is to desaturate the color of our example image. In Elements this can be achieved by using the Hue/Saturation control from the Adjust Color section of the Enhance menu. With the dialog open carefully move the Saturation slider to the left. This action will decrease the intensity of the colors in your image.

Mottle the ink

The distinct surface and image qualities of Polaroid transfer prints combine both sharpness and image break-up in the one picture. To reproduce this effect digitally, I copied the original image onto a second layer. My idea was to manipulate one version so that it displayed the mottled effect of the transfer print whilst leaving the second version untouched. Then, using the blending modes or opacity features of Elements' layers I could adjust how much sharpness or mottle was contained in the final result.

In practice, I started by duplicating the image layer. This can be achieved by selecting the layer to be copied and then using the Duplicate Layer command located under the Layer menu. Alternatively you drag the layer to the Create New Layer button at the top of the Layers palette. With the upper layer selected, I then needed to find a method to simulate the mottle of the transfer print. Though not exactly right, I found that by combining the effects of the Paint Daubs and Palette Knife filters I could produce reasonable results. When using these filters yourself

Step 7 >> In the Levels feature select the blue and red channels separately, dragging in the white Output slider towards the center.

Step 8 >>> Open the edge file as a separate document and drag it onto the original picture.

Step 9 >> Switch the mode of the edge layer to Multiply and use the Scale command to adjust its size to fit the picture below.

160

keep in mind that the settings used will vary with the style and size of your image. This part of the process is not an exact science. Play and experimentation is the name of the game. You might also want to try other options in the Artistic, Sketch or Texture selections of the Filter menu.

The last step in this stage is to combine the characteristics of the two layers. This can be achieved by either changing the Blending mode of the uppermost layer or by adjusting its opacity, or both. For the example image a simple opacity change was all that was needed, but don't be afraid to try a few different blend/opacity combinations with your own work.

Apply a paper texture and color

The paper color and texture is a critical part of the appeal of the transfer print. These two characteristics extend throughout the image itself and into the area that surrounds the picture. For this to occur in a digital facsimile it is necessary to provide some space around the image using Elements' Canvas Size feature. Unlike the Image Size command, this option allows the user to increase the size of the canvas without changing the image size (and all its associated layers). In the example the canvas width was increased by 120% and the height by 140%.

To add the texture to both image and surround I flattened the two image layers and the white background into a single layer. Next, I photographed a section of watercolor paper to use as a customized texture with the Texturizer filter. You can download and use this very file from the book's website (*www.adv-elements.com*). With the texture complete, I played with the overall color of the image using the Levels feature. I adjusted the blue and red channels independently and concentrated on the lighter tones of the image so that rather than the paper being stark white it took on a creamy appearance.

Add the Polaroid frame

The last part of the process involves combining the final image with a photograph of a Polaroid film edge. The edge picture is nothing more complex than a scanned Polaroid print with the image removed. But rather than go to the trouble of making your own, you can download the edge I used for the example directly from the website (web image 702-3). Next, open the file as a separate Photoshop Elements document. Click onto the edge layer and drag it onto your picture. The edge will automatically become a new layer on top of the existing image layer.

With the edge layer selected change the layer's mode to Multiply. Notice that the white areas of the layer are now transparent, allowing the picture beneath to show through. Finally, use the Scale command to adjust the size of the edge to fit the image. Though not an exact copy of the Polaroid transfer print, the digital version displays much of the character of the original and can be achieved for less cost and with more control.

7.03 Using the Unsharp Mask filter to add contrast

Suitable for Elements – 5.0, 4.0, 3.0, 2.0, 1.0 | Difficulty level – Basic | Resources – Web image 703 Tools used – Burning-in | Menus used – Enhance

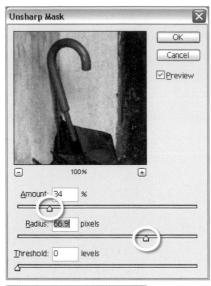

USM local contrast settings >> Instead of using the modest radius settings that we normally associate with the Unsharp Mask filter this technique requires the radius to be set to a high value. Most digital photographers have used the Unsharp Mask filter as a way to add some crispness to pictures that are a little soft. In another application this feature can be used to add some local contrast to flat images in much the same way that multi-contrast printing provides a boost to black and white prints.

The trick with this technique is to forget the way that you have been using the feature. Instead of selecting a high amount and low radius setting you do the opposite. You drag the amount downwards and the radius upwards. This produces a change in local contrast rather than a sharpening of individual pixels. To use the technique as part of your standard enhancement process you would adjust highlight and shadow points to set the contrast of the whole picture first, then employ the Unsharp Mask filter to increase the local contrast and then use the filter a second time, with different settings, to increase the photograph's sharpness.

The new Adjust Sharpness filter also contains Amount and Radius sliders which can be employed to produce similar contrast changing effects.

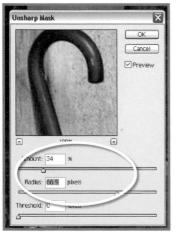

Step 1 >> To change local contrast open the Unsharp Mask filter and select a low Amount value and a high Radius value.

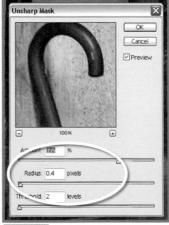

Step 2 >> After adjusting the contrast sharpen the image using the Unsharp Mask filter in the normal fashion.

Step 3 >> The final step in the example image was to darken some of the tones around the door opening with the Burn tool.

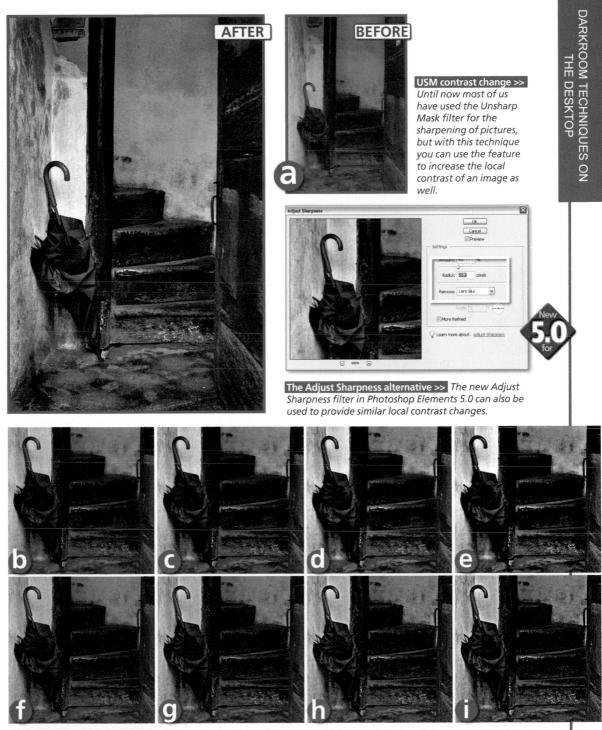

Recipes for USM contrast changes >> (a) Original image, no contrast change.(b) Amount 30, Radius 80, Threshold 0. (c) Amount 60, Radius 80, Threshold 0. (d) Amount 90, Radius 80, Threshold 0. (e) Amount 120, Radius 80, Threshold 0. (f) Amount 30, Radius 20, Threshold 0. (g) Amount 60, Radius 20, Threshold 0. (h) Amount 90, Radius 20, Threshold 0. (i) Amount 120, Radius 20, Threshold 0.

Book resources at: www.adv-elements.com

163

164

BEFORE

DARKROOM TECHNIQUES ON THE DESKTOP

7.04 Lith printing technique

Suitable for Elements – 5.0, 4.0, 3.0, 2.0, 1.0 | Difficulty level – Basic | Resources – Web image 704 Tools used – Dodging, Burning-in | Menus used – Enhance, Image, Filter

Just a few short years prior to the massive uptake of digital photography many professional and amateur image-makers alike were discovering the beauty of a whole range of craft printing processes. There was a resurgence in the techniques involved in the production of high quality black and white pictures and a growing interest in 'alternative' processes that could create stunningly different monochromes.

One such process was lith printing. The process involves the massive overexposure of chlorobromide-based papers coupled with development in a weak solution of lith chemistry. The resultant images are distinctly textured and richly colored and their origins are unmistakable. But rather than head back to the darkroom in pursuit of your first lith print you can use the following steps to recreate the results digitally.

Most lith prints have strong, distinctive and quite atmospheric grain that is coupled with colors that are seldom seen in a black and white print. They range from a deep chocolate, through warm browns, to oranges and sometimes even pink tones. If our digital version is to seem convincing then the final print will need to contain all of these elements.

Select a picture where the composition is strong. It should contain a full range of tones, especially in the highlights and shadows and good contrast will help make a more striking print. The first task is to lose the color. We want to achieve this change whilst still keeping the Book resources at: www.adv-elements.com

AFTER

DARKROOM TECHNIQUES ON THE DESKTOP

Lith printing >> Recreating the highly textured, colored prints that result from the lith printing process involves the following steps:

- losing the color from the image,
- adding some texture and then
- reapplying color to the picture.

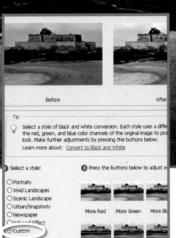

Adjustment Intersity: Loss Dad Loss General Lass Ref Step 1>> Convert your color picture to black and white with the new Convert to Black and White feature.

Step 2 >> Adjust your picture's black and white points and check the spread of tones using the Levels feature.

Step 3 >> Use the Dodging and Burning-in tools to add drama to specific areas of the picture.

Step 4 >> Add some texture to the image using the Add Noise filter set to Gaussian and Monochrome.

Step 5 >> Apply some color using the Hue slider and Colorize option in the Hue/Saturation feature .

picture in a color mode (RGB Color). This way later on we can add color back to the picture. If the original is a color picture use the new Convert to Black and White feature (Enhance > Convert to Black and White) to loose the color. If you are starting the project with a grayscale picture change the color mode to RGB Color (Image > Mode > RGB Color).

Perform all your tonal enhancement steps now. Use the Levels feature (Enhance > Adjust Lighting > Levels) to ensure a good spread of tones and the Burning and Dodging-in tools to enhance specific parts of the picture. Add some texture to the image using the Add Noise filter (Filter > Noise > Add Noise) with the Gaussian and Monochrome options set. The final step is to add some color back to the picture. We can achieve this effect by selecting the Colorize option in the Hue/Saturation feature and then adjusting the Hue slider to select the color of the tint and the Saturation slider to alter the strength.

7.05 Correcting perspective problems

Suitable for Elements – 5.0 | Difficulty level – Basic Resources – Web image 705 | Menus used – Filter

You know the story: you're visiting a wonderful city on holiday wanting to capture as much of the local scenes and architecture as possible. You enter the local square and point you camera towards an impressive three-spired building on the other side of the road only to find that you must tilt your camera upwards to get the peaks into the picture. At the time you think nothing of it and you move on to the next location. It is only when you are back at home about to print your photograph that you realize that the innocent 'tilt' has caused the edges of the building to lean inwards.

Now, to a certain extent this isn't a problem; even though it is not strictly accurate, we all know that most buildings have parallel walls and the majority of people who look at you picture will take this into account – won't they? Apart from a return trip and a re-shoot is there any way to correct these converging verticals? Well, I'm glad you asked. Armed with nothing except Elements 5.0, the new Correct Camera

> Distortion filter and the steps detailed here, you can now straighten all those leaning architectural shots without the cost of the return journey.

Correcting perspective >> When shooting upwards with a wide angle lens the sides of buildings converge inwards rather than remain parallel. You can correct this problem using the new Correct Camera Distortion filter in Elements 5.0.

Book resources at: www.adv-elements.com

166

With the offending image open in the Full Edit workspace select Filter > Correct Camera Distortion. Ensure that the Grid option is switched on via the checkbox at the bottom of the dialog before starting to correct the photo. The dialog contains a variety of controls designed for correcting barrel and pincushion distortion, vertical and horizontal perspective, crooked horizons and the vignetting or the darkening of the corners of the picture frame. The key to using the feature is being able to identify the type of distortion that is present in the photo and then choosing the control to deal with the problem. The presence of a preview window means that you can see the results of the corrections as you apply them. Use the grid to guide your changes.

Step 1 >> With the example image open in the Full Edit space of Elements select Filter > Correct Camera Distortion. Ensure that the Show Grid option at the bottom of the dialog is checked.

Step 2 >> The main problem with the example image is converging verticals which can be corrected by moving the Vertical Perspective control to the left. Unlike the correction techniques in earlier versions of Elements this slider also adjusts the height of the building as well.

Step 3 >> To complete the corrections straighten the photo with the Angle control and scale the results so that they fit within the original canvas area. Click OK to apply the changes and close the dialog – then use the Crop tool to remove unwanted areas of the photo.

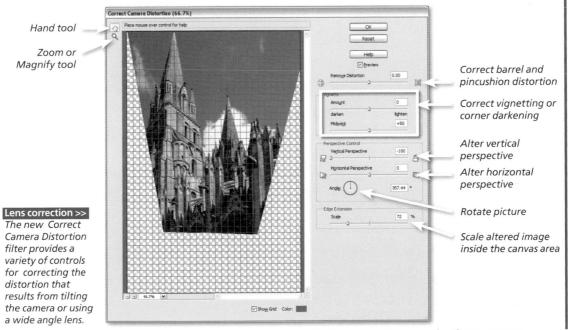

DARKROOM TECHNIQUES ON

THE DESKTOP

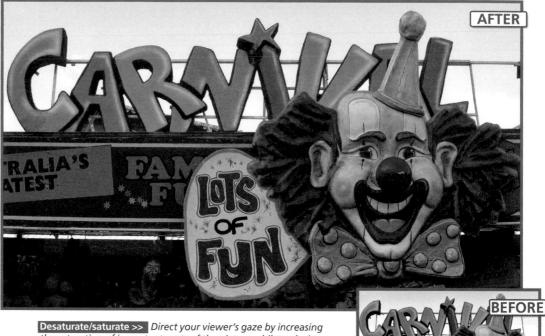

Desaturate/saturate >>> Direct your viewer's gaze by increasing the saturation of important parts of the picture whilst reducing the color vibrancy of the rest of the image.

7.06 Add emphasis with saturation

Suitable for Elements – 5.0, 4.0, 3.0, 2.0, 1.0 | Difficulty level – Basic | Resources – Web image 706 Tools used – Selection tools | Menus used – Enhance, Select

This technique, unlike the ones that we have looked at previously in this chapter, does not draw easy parallels from the world of traditional photography. Until digital came along it was not possible, at least not without a lot of professional smoke and mirrors, to change the vibrancy of the color in one part of the picture whilst maintaining or even boosting it in another part. It certainly wasn't an easy job to combine both black and white and full color in a single picture.

The Hue/Saturation feature has removed such limitations forever. When this tool is combined with a carefully created (and feathered) selection it is possible to desaturate one part of the picture and then, using an inverted selection, increase the saturation of the rest. Like dodging and burning this technique can direct the viewer's interest to a part of the picture that the photographer deems important. In fact it is when these two techniques, dodging and burning and saturation/desaturation, are used in tandem that the desktop photographer can really start to create some dramatic pictures.

In the example image the clown's head was selected using a combination of the Magnetic and standard Lasso tools. Once completed the selection was feathered slightly (1–2 pixels) (Select > Feather) to soften the transition of the effect and saved (Select > Save Selection). With the Book resources at: www.adv-elements.com

168

selection still active the Hue/Saturation feature was opened and the color vibrancy of the clown increased by moving the Saturation slider to the right. To add more contrast, the selection was then inverted (Select > Inverse) and the saturation of the background was decreased almost to the point of just being black and white. An alternative way of working this technique is to create masked Hue/Saturation adjustment layers using the saved selection. This would allow you to readjust the amount of saturation and desaturation at any point later in time and would keep the original picture intact.

Non-destructive version >> Use masked Hue/Saturation layers to produce the same results with fine-tuning options.

Step 1 >> Carefully select the area to saturate/desaturate using your favorite selection tools.

Step 4 >> With the selection still active use the Hue/Saturation feature to increase the saturation of the clown's face.

Select Filter View Window All Ctrl+A Deselect Ctrl+D Reselect Shift+Ctrl+D Inverse Shift+Ctrl+I All Layers Deselect Layers Similar Layers Feather... Alt+Ctrl-D -dify ٠ Grow Similar

Step 2 >> Feather the edge of the selection slightly so that the transition will be smoother.

er	Select	Filter	View	Windov		
	All		Ctrl+A			
	Desele	ect	C	trl+D		
ነቅ	resele	ect	Shift+CtrD			
55550	Invers	se	Shift+Ctrl+			
	All Layers Deselect Layers Similar Layers					
	Feath Modify		Alt+C	trl+D		
	Grow Similar					
	Load Selection					

Step 5 >> Inverse the selection so that the rest of the picture is now selected.

Step 3 >> Save the selection so that you can use it or edit it later.

Step 6 *Wise the Hue/Saturation slider to decrease the saturation and provide color contrast between the two picture parts.*

Book resources at: www.adv-elements.com

169

DARKROOM TECHNIQUES

9N

THE DESKTOP

7.07 Restoring color to faded images

Suitable for Elements – 5.0, 4.0, 3.0, 2.0, 1.0 | Difficulty level – Intermediate Resources – Web image 707 | Menus used – Enhance

Old images, whether they be captured on color films, negatives or slides, are prone to fading and color changes as the dyes they are constructed of break down. It is a source of concern for all photographers who have big collections of images stored away in attics, cupboards or under the bed. After all, many of these photographs, though not valuable in the commercial sense, are irreplaceable as they hold glimpses of a family's history and echoes of days gone by.

Recently a loyal reader and avid Elements user emailed me with exactly this problem. Tom Edwards asked me if I had a solution for restoring the color to the hundreds of fading slides that he had taken in the Orient in the early 70s as they now all appear to be turning red.

The first step in any such restoration work is diagnosing the problem that is causing the color shift and fading. To get a good understanding of the cause I always turn to the Levels feature (Enhance > Adjust Lighting > Levels) for help. It contains a descriptive display of the spread pixels in the image and also includes the tools needed to coax the picture back to life.

When the Levels feature is first opened it displays a graph of the combined red, green and blue pixels. This is signified by the RGB label in the Channels drop-down menu. To really see what is happening to the tones in your picture select and view the graph for each of the individual color channels. The graphs for each channel of Tom's example image can be seen to the right. Notice how the green and blue channels are fairly similar but the red channel has all the signs of being overexposed, that is, all the tones being pushed to the right end of the graph. This is where our problem lies.

To help restore the original color and brightness of the photograph the tones of each of the color channels have to be adjusted individually. Starting with the red channel, drag the black input triangle towards the center of the graph until it meets the first major group of pixels. Do the same for the green and blue channels, but with these also adjust the white point Input slider in the same way.

This action will help to restore the color and contrast of the picture and will give good results for all but the most faded slides or prints. Final adjustments to tone and the removal of any slight color casts that remain can be achieved using levels on the combined RGB channel setting and the Color Variations features.

Restoring faded slides >> When you look at the histogram for each of the red, green and blue channels separately it is easy to see why the faded slide appears so warm.

(a) Red channel.(b) Green channel.(c) Blue channel.

To restore the color in the image work on each channel separately, dragging the white and black points in to meet the first major group of pixels.

This will balance the distribution of the tones in each of the channels and restore the slide's color and contrast.

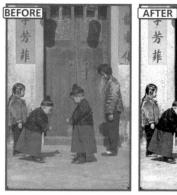

Fading slides >>> Over time traditional color photographs, slides and negatives can show signs of fading and take on a dominant color cast. Using the color correction and tonal change tools in Elements might not be aggressive, or selective enough, to correct these problems. Instead use the steps detailed here to rebalance the tones and colors in your picture. Image courtesy of Tom Edwards © 1972.

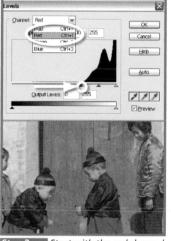

Step 2 >> **Start** with the red channel and drag the black input triangle to meet the first group of pixels.

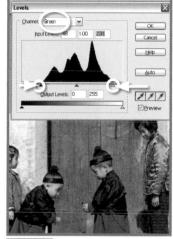

Step 3 >> Next select the green channel and move both the white and black input sliders to the first group of pixels.

from the Enhance > Adjust Lighting

menus.

Step 4 >> Make the same black and white point adjustments for the blue channel as well.

Step 5 >> With the image now balanced you can use the Color Variations feature to remove any slight color casts that remain.

Step 6 >> As a final check of the tones open the Levels feature again and adjust white, middle and black points for the composite channel (RGB).

Book resources at: www.adv-elements.com

171

For those readers who have many images that need this type of color rebalancing and correction it may be worthwhile purchasing the Applied Science Fiction Digital ROC filter. Produced by the same company as the scanner tools that we looked at in Chapter 2, Digital ROC is designed to restore and rebalance the faded color in old slides, negatives and prints.

Supplied with some scanners this technology is also available as a plug-in that installs in the Filters section of Photoshop Elements. Trial versions of the program are available from www.asf.com.

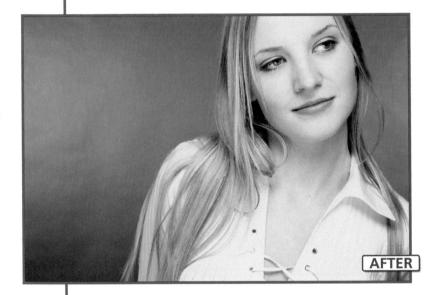

Cross-processing effects >> Made popular because of its use in fashion photography, cross-processing is a traditional technique that takes either print film and processes it in slide chemistry or slide film and develops it in print film chemistry. You can create similar results using the digital version of the process detailed here.

7.08 Cross-processing effects

Suitable for Elements – 5.0, 4.0, 3.0, 2.0, 1.0 | Difficulty level – Intermediate Resources – Web image 708 | Menus used – Enhance

Processing your film in the wrong chemistry sounds like an action that will guarantee disaster, but this is precisely the basis of the cross-processing technique. Print film is developed using slide chemistry or alternatively slide film is processed using print film chemistry. Whichever method you use the process results in distinctly recognizable images that have found their way into many fashion magazines in the last few years. As with many of these alternative techniques the process can be a little unpredictable, with strange color shifts and massive under- and overexposure problems. reducing the number of usable pictures resulting from any shooting session.

Four adjustment layers >> This technique relies on the application of four different adjustment layers being stacked upon the original image.

Martin Evening of 'Adobe Photoshop for Photographers' Focal Press fame created a digital version of this process that uses a series of curve changes to create images that have a similar look and feel to those produced with the chemical cross-processing effect. Here I present an Elementsfriendly version of the technique that provides equally impressive results without using the Photoshop curves feature. In addition, as the technique uses a series of adjustment layers to create the effect, the original picture remains unaltered throughout and the settings for each of the layers can be altered at any time to tweak the final result.

To recreate the look of crossprocessing (print film developed in slide chemistry) we must change the image so that it contains creamy highlights, cyan shadows and is generally reduced in contrast. Start with a standard color image. Create a Levels adjustment layer and select the blue channel. Move the white Output slider to the left to flatten the highlights

Delete Layer	5 Mode: Normal
Rename Layer Layer Style	
New Fill Layer	
New Adjustment Layer	Levels
Change Layer Content	Brightness/Cont
Layer Content Options	Hue/Saturation
Туре +	Gradient Map
Simplify Layer	Photo Filter
Group with Previous Ctrl+G	Invert Threshold
Ungroup Shift+Ctrl+G	Posterize
Arrange +	
Merge Layers Ctrl+E	
Merge Visible Shift+Ctrl+E	
Flatten Image	

Step 1 >> To start the process open a colour image and create a Levels adjustment layer.

Step 2 >>> To make the yellow highlights select the blue channel in the Levels feature and drag down the white Output slider. This adds some yellow to the highlights.

Step 3 >>> Create another Levels adjustment layer, select the red channel and drag down the white input layer. This adds some warmth to the highlights.

Step 4 >> To add cyan to the shadow areas create another Levels adjustment layer, select the red channel and move the mid tone Input slider to the right.

and color them yellow. Create a second Levels adjustment layer and with the red channel selected move the white Output slider to the left as well. This adds some warmth. Next create another Levels adjustment layer and select the red channel again. This time you need to move the mid point Input slider to the right to make the shadows and mid tones cyan. With the Levels feature still open move the white and black Input sliders till they meet the first group of pixels in the histogram. To finetune the overall tones you can add yet another Levels adjustment layer and with the composite of all channels selected (RGB), alter contrast and brightness of the whole picture.

Book resources at: www.adv-elements.com

DARKROOM TECHNIQU

JES

92

THE DESKTOP

Hand coloring >> Digital hand coloring works by applying painted sections of the image to the black and white original using the Color blending mode. This technique preserves the detail of the monochrome picture and tints the surface with the color of the upper layer in much the same way as oil paint was used to tint black and white prints of old.

7.09 Digital hand coloring

Suitable for Elements – 5.0, 4.0, 3.0, 2.0, 1.0 | Difficulty level – Basic | Resources – Web image 709 Tools used – Brush | Menus used – Layer

Before the advent of color film the only way to add a hue to a picture was to apply water- or oilbased paints over the top of a black and white print. Most of us will have old photographs of family weddings that are delicately colored in this way. There is a simplicity and subtlety about this approach that is worth recapturing in the digital age.

If you look at the old images you will notice that the detail of the black and white picture shows through the colored paint. The combination of these details and the applied color creates the hand colored effect. To simulate this technique digitally we can use the Color blending mode in Elements. The color is applied to a separate layer using the paint brush and then the mode of the layer is changed to Color. This allows the details of the image beneath to show through the color above. Using the paint brush in the Normal mode will create large flat areas of color that hide the detail beneath.

Book resources at: www.adv-elements.com

 Linear Burn
 Beckground

 Liphen
 Screin

 Schor Dodge
 Screin

 Linear Dodge
 Schor Dodge

 Overlay
 Soft Liph

 Midd Liph
 High

 Midd Liph
 High

 Midd Liph
 High

 Difference
 Exclusion

 Exclusion
 Step 2 >>

 Step 2 >>
 Select the layer and

change its Blending mode to Color.

✓ Opacity: 100%

Layer 1

Lock:

.

Lavers

arken

Multiply

Color Burn

Step 3 Select the paint brush from the tool box and then select a foreground color to paint with from the Swatches palette.

The color can be removed from any part of the picture with the eraser tool and the

Step 1 >> Open a black and white

RGB color mode. Make a new layer in

picture and make sure that it is in

the document.

vibrancy of the hues can be altered by changing the opacity of the color layer.

For the ultimate control each individual color can be added via a new layer. This approach means that the various colors that make up the picture can be edited individually.

Step 4 >> Paint over the area of the image that you want to hand color. Switch foreground colors and continue to paint.

Step 5 >> Make sure that the colors are being applied to the newly created layer. The strength of the coloring can be altered by adjusting the opacity of the layer.

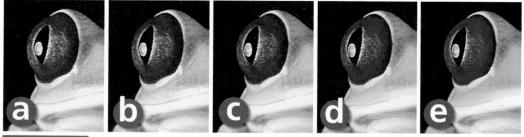

Hand coloring >> Changing the opacity of the color layer will alter the strength of the hand coloring effect. (a) 0% opacity. (b) 25% opacity. (c) 50% opacity. (d) 75% opacity. (e) 100% opacity.

175 DARK

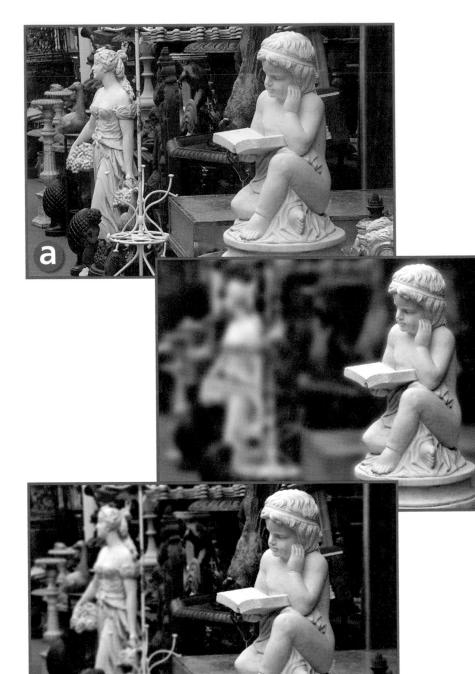

Artificial depth of field effects >>

It is possible to create realistic depth of field effects by making and blurring a series of selections that gradually increase in size. (a) Straight print. (b) Simple selection with Gaussian Blur. (c) Multiple selections with increasing Gaussian Blur values.

Book resources at: www.adv-elements.com

DARKROOM TECHNIQUES ON THE DESKTOP

7.10 Realistic depth of field effects

Suitable for Elements – 5.0, 4.0, 3.0, 2.0, 1.0 | Difficulty level – Advanced Resources – Web image 710 | Tools used – Selection tools | Menus used – Filter, Select

The shallow depth of field effect that is created when you select a small F-stop number (use a long lens or get in very close to your subject) controls the way that a viewer sees your picture. The eye is naturally drawn to the sharpest part of the image and shallow depth of field restricts the sharpness in a photograph to often only a single subject. The Gaussian Blur filter can be used in a similar way to produce results that help to direct the viewer's gaze. Areas of an image can be selected and blurred so that our eyes will be redirected to the sharp part of the print. In a way, by blurring parts of an otherwise sharp picture, this process is creating artificial depth of field.

When the potential of the Blur filter is first discovered many enthusiastic digital photographers take to the task of creating shallow DOF pictures from their sharp originals with gusto. The process they use is simple – select and blur. The results certainly provide a contrast in sharpness, but the pictures lack the sense of realism that is needed for the effect to be truly convincing.

To recreate shallow depth of field more effectively there needs to be a gradual decrease in sharpness as you move in front of, or behind, the main point of focus. Making a single selection doesn't provide the gradual change that is needed. In its place we need to use a series of overlapping selections that gradually move further away from the point of focus. Each selection is feathered to smooth the transition of the effect and then the selected area is blurred using the Gaussian Blur filter. The amount of blur is increased as the selection gets more distant from the point of focus.

Multiple selections >> Convincing depth of field effects are based on the sequential blurring of multiple overlapping selections.

(a) First selection.
(b) Second selection.
(c) Third selection.
(d) Fourth selection.

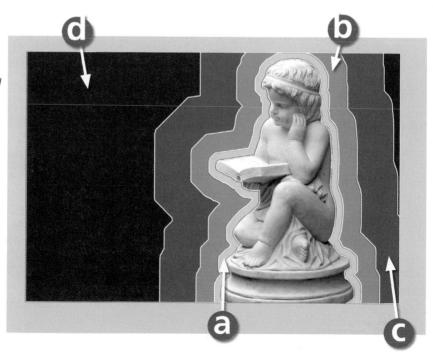

This simulates lens-based depth of field by surrounding the point of focus with the area of least blur and then gradually increasing the out of focus effect as the eye moves further from this part of the picture.

Start the process by creating a selection of the subject area that you want to remain sharp. Inverse (Select > Inverse) the selection so that the rest of the picture is selected. Feather (Select > Feather) the edge slightly to ensure that the transition between blurred and sharp picture parts is less obvious. Apply the Gaussian Blur filter (Filter > Blur > Gaussian Blur) to the selection

Step 1>> Carefully select the part of the picture that is to be your point of focus – the area that will remain sharp.

Step 2 >> Feather (1 or 2 pixels) and then save the selection.

Step 3 >> Use the Inverse command to select the rest of the picture.

Step 4 >>> Apply a small Gaussian Blur to this initial selection. Here I have used a radius of 1.0 pixels.

Step 5 >>> Reduce the area that is selected by selecting the Contract command from the Select menu.

Step 6 >> Feather the new selection by a greater amount. Here I have used 10 pixels. Save the selection.

using a low Radius value of 1 pixel. Now to recede the selection away from the point of focus. Here I have used the Contract command (Select > Modify > Contract) but you could just as easily draw another selection that is further away from the statue. The edge is feathered again, this time by a larger amount, and the whole thing blurred with a larger radius.

This process – contract, feather blur – is repeated as many times as is needed to ensure that the picture's background details are suitably unsharp. In the example image I used four selections to get the shallow depth of field effect.

Step 7 >> Apply a larger Gaussian Blur (2 pixels) to this new section of the picture.

Step 8 >> Create a new smaller selection using the Contract command set to 100 pixels.

Step 9 >>> Feather and save the new selection. Here I have used a radius of 30 pixels.

Step 10 >> Blur the new selection with a higher Gaussian Blur setting.

Step 11 >> Contract the selection by 100 pixels and then again by another 100 pixels before feathering the edge by 60 pixels and saving the selection.

Step 12 >>> Apply the final Gaussian Blur to the selection using a radius of 4 pixels.

Book resources at: www.adv-elements.com

179

DARKROOM TECHNIQUES ON

THE DESKTOP

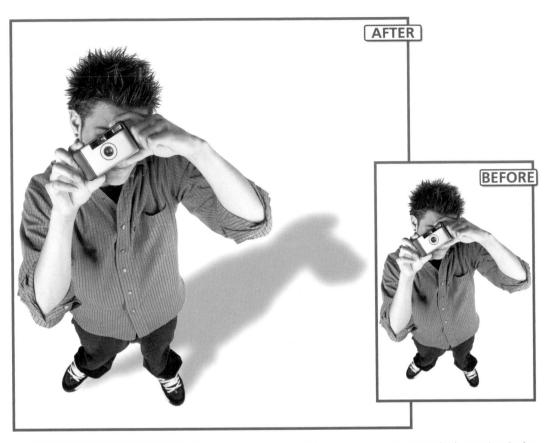

Creating realistic shadows >> Simple shadows can be applied to any layer using the Drop Shadow options in the Elements Styles palette. More complex shadows, like the one in the example that looks like it is falling on the ground, can be created by making a shadow layer beneath the image. Image courtesy of www.ablestock.com. Copyright © 2003 Hamera and its licensors. All rights reserved.

Elements' drop shadow styles >>> Elements provides a range of ready-made drop shadow styles that can be applied directly to any layer. (a) High. (b) Low. (c) Noisy. (d) Hard edge. (e) Soft edge. (f) Outline. (g) Fill/outline. (h) Neon.

Book resources at: www.adv-elements.com

7.11 Beyond the humble drop shadow

Suitable for Elements – 5.0, 4.0, 3.0, 2.0, 1.0 | Difficulty level – Advanced | Resources – Web image 711 Tools used – Selection tools | Menus used – Edit, Filter, Image

The drop shadow effect has become very popular in the last few years as a way of making an image or some text stand out from the background. To coincide with this popularity Adobe created a series of drop shadow styles that can be applied directly to any layer. These options are suitable for many applications and Elements users can even customize the look of the effect by altering variables like the direction of the light and the shadow distance using the Style Settings dialog (Layer > Layer Style > Style Settings).

But what if you want a more sophisticated shadow than these preset choices allow? Well then you will need to create your own shadows. Using the example image let's make a shadow that lies upon the ground that the model is standing on. To do so, we will need to revisit the steps

Lighting Angle:	120	0		
🐨 🗹 Drop Shadow				
Size:			21	px
Distance:			21	рх
Opacity:			75	%
Glow				
Stroke				

Drop shadow style settings >> Alter the look of your drop shadows by changing the value of the options in the Style Settings dialog.

that I used to use to create even the simplest drop shadow before the days of layer styles.

First select the subject with one of your favorite selection tools and copy it to memory (Edit > Copy). Next paste the picture (Edit > Paste) twice to form two new layers. Fill the background layer with white. Next fill the second image layer with black making sure that the Preserve Transparency option is turned on. This creates a silhouette exactly the same size and shape as the main picture. To allow for the shadow we will need to create some more space on the right-hand side of the picture. Use the Canvas Size feature for this (Image > Resize > Canvas Size). Here I have anchored the canvas on the left side and set the option to percent and then increased the width to 150%.

Book resources at: www.adv-elements.com

DARKROOM TECHNIQUES ON

THE DESKTOP

With the shadow layer still selected I used the Distort feature (Image > Transform > Distort) to push the shadow downwards and to the right. Keep in mind that for this type of shadow to be convincing it must be consistent with the lighting in the image generally. In the example the main light is coming from the left and so the shadow should be projected to the right. Also make sure that the shadow is positioned so that it grows from where the subject touches the ground. In the example it is the feet. If need be, use the Move tool and even the Rotate feature (Image > Rotate > Free Rotate Layer) to orientate the shadow so that it meets the shoes.

Next we need to blur the edges of the shadow and adjust its transparency to complete the illusion. With the shadow layer still selected use the Gaussian Blur filter (Filter > Blur > Gaussian Blur) to make the edges of the shadow less sharp. There are no hard and fast rules about the amount of blur to apply. It is a matter of trying a few settings with the Preview option switched on in the Filter dialog until you are happy with the results. To make the shadow a little brighter and more transparent I changed the blending mode from Normal to Multiply and dragged down the opacity of the whole layer.

Although not immediately obvious here, changing the blending mode to Multiply will give a more realistic shadow effect when laid over other picture areas. When used in conjunction with the layer's Opacity slider the density of the shadow can be adjusted to allow the detail from the picture beneath to show through.

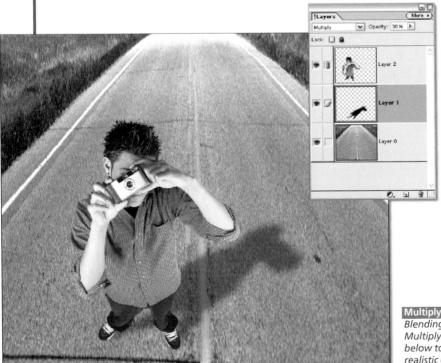

Multiply shadows >> Switching the Blending mode of the shadow layer to Multiply will allow the detail of the layer below to show through, producing a more realistic effect.

Book resources at: www.adv-elements.com

Step 1>>> Carefully select the main subject using your favorite selection tools. Here it was easier to select the uniform background and adjust the selection around the hair region rather than selecting the model.

er	Select Filter	View	Window	
1	All Deselect		rl+A rl+D	ate
ar I	Inverse	Shift+C	trl+I	
	Hii Layers Deselect Lay Similar Layers			-
	Feather Modify	Alt+Ct	rl+D	
	Grow Similar			
	Load Selectio Save Selectio	in		

Step 2 >> Change the selection from the background to the model by inversing the selection.

Step 3 >>> Copy the selected area to the computer memory and then paste the contents twice to form two new image layers containing the copied model picture.

Fill Layer 1 Performed a Fill Layer Contraction of block Fill Layer Contraction of block fill Layer Contraction of block fill Layer Dere Black Luttory "Pitter Blanding Model: Normal Contraction of the block fill Layer Dere re Transparency

Step 4 >> Select the background layer and fill it with white.

Step 5 >> Select the lower of the two new layers and fill this layer with black, this time making sure that the Preserve Transparency option is turned on.

Step 6 >> Increase the size of the canvas to accommodate the shadow by anchoring the image on the left side and increasing the width by 150%.

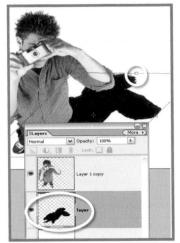

Step 7 >> With the shadow layer still selected use the Distort tool to squash the shadow into the newly created space on the right side of the model.

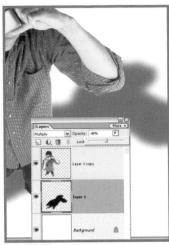

Step 8 >> Blur the edge of the shadow using the Gaussian Blur filter.

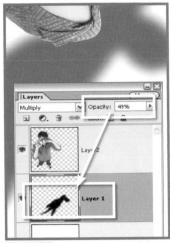

Step 9 >> Switch the mode of the shadow layer to Multiply and adjust the opacity of the shadow until the desired brightness is shown.

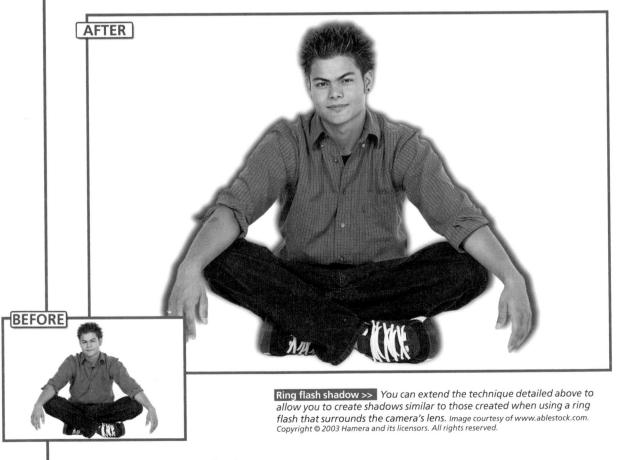

7.12 Ring flash shadow

Suitable for Elements – 5.0, 4.0, 3.0, 2.0, 1.0 | Difficulty level – Advanced | Resources – Web image 712 Tools used – Selection tools | Menus used – Edit, Filter, Image

You can extend the technique detailed above to create a shadow that is similar to those found in pictures created with a ring flash attached to the camera lens. These pictures are characterized by the model having a shadow projected onto the wall behind. As the light is coming from the same position as the camera the shadow is larger but directly behind the subject.

The first few steps are the same as those found in the previous technique. Start by selecting the main subject and copy and pasting it twice to form two new layers. Next fill the background with white. Select the lower image layer and fill it with black, making sure that the Preserve Transparency option is selected. Blur the shadow using the Gaussian Blur filter (Filter > Blur > Gaussian Blur). With the Preview option selected in the Filter dialog, adjust the Blur Radius so that the edge of the shadow is visible as a halo around the top image layer.

With the shadow layer still selected use the Move tool to shift its location upwards by a few pixels. For accuracy you can use the arrow keys instead of the mouse. Each arrow key press moves the shadow one pixel. To finalize the technique change the blending mode of the shadow to Multiply and reduce its opacity.

Step 1>> Select, copy and paste the model twice to create two image layers. Fill the background with white.

Step 2 Select the lower image layer and fill the image area with black. Make sure that the Preserve Transparency option is selected.

Step 3 >> Use the Gaussian Blur filter to blur the shadow so that it shows as a halo around the top image layer.

Step 4 >>> Use the arrow keys to move the shadow gradually upwards so that it shows to the left, right and above but not below the model. Change the Blending mode to Multiply and adjust the opacity.

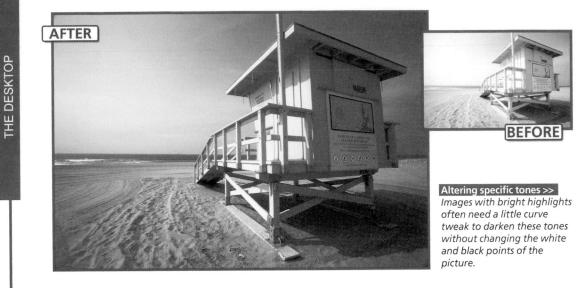

7.13 New Curves features

Suitable for Elements – 5.0 | Difficulty level – Intermediate | Resources – Web image 713 | Menu used – Enhance One of the regular complaints from Photoshop enthusiasts trying to put Elements users in their place is that the program 'doesn't contain curves' and so can't really be considered as a serious photo enhancement package. For the first four versions of the program this was indeed true, but in 5.0 Adobe has included an easy-to-use version of Photoshop's famous Curves feature. This is great news as the Curves feature in Photoshop does offer a great deal of flexibility and creativity over manipulating the tones in your image. In particular, curves provide a great way to lighten shadow areas and darken highlights and it is precisely these two tasks that I use Curves for most.

Adjust Color Curves feature

The new Adjust Color Curves feature contains two different ways to manipulate the tones in your photo. The first is a series of six thumbnail buttons, called Samples, that apply specific curve tweaks to your photos. These adjustments include the options to **Increase Midtones**. **Lighten Shadows, Increase Contrast, Darken Highlights**, create a **Solarize** effect and compensate for **Backlight** in a photo. Clicking on one of these buttons adds the selected adjustment to the photo. Clicking a second thumbnail replaces the first tonal tweak with the second curves adjustment.

The second way to alter the tones in your photo when using the new Adjust Color Curves feature is via a set of four slider controls coupled with a graphical curves display located in the Advanced Options section. The sliders controls include **Adjust Highlights**. **Mid tone Brightness**. **Mid tone Contrast** and **Adjust Shadows** options. Moving any of the sliders directly alters the way that the tones are distributed in your photo and changes the shape of the curve. Using these controls you can fine-tune specific areas of your photo.

186

DARKROOM TECHNIQUES ON

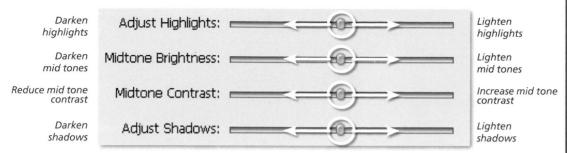

Advanced Options slider controls >>> Moving the position of the sliders in the Advanced Options section of the Adjust Color Curves dialog produce the changes listed above to specific tonal ranges in a photo.

Users can display or hide either or both control sections using the arrows on the left of the dialog. The Reset button removes all curves changes, both thumbnail selections and slider movements, and restores the feature back to the default setting, which is the same as the Increase Mid tones sample.

The easiest and most effective way to use this new Elements' Curves control is to use the Samples thumbnails to select the general correction to apply to the photo first and then use the sliders in the Advanced Options to fine-tune the results.

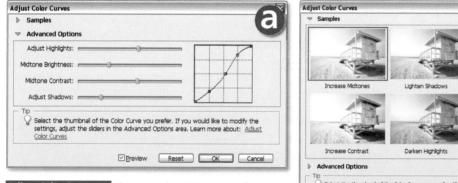

Adjust Color Curves >>> The new Adjust Color Curves feature provides two different ways to tweak the tones in your photo. You can use each set of controls independently but the best results are obtained when the global changes are set by clicking a Sample thumbnail and small fine-tuning to specific tonal ranges added next via the Slider controls.

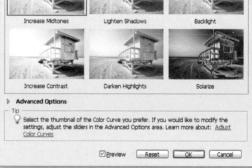

(a) Advanced Options section containing Slider controls for specific tonal ranges.

(b) The Samples thumbnails which apply a set adjustment to the picture when clicked.

(c) Changes in the shape of the curve based on clicking the Sample thumbnails. Left to right: Increase Midtones,

Lighten Shadows, Backlight, Increase Contrast, Darken Highlights and Solarize.

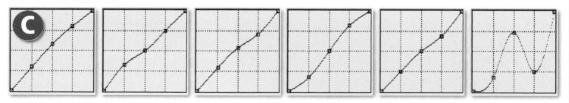

Book resources at: www.adv-elements.com

DARKROOM TECHNIQUES

9 N

THE DESKTOP

188

AFTER

EFORE

Fill Flash effects The Shadows/Highlights option introduced in version 3.0 of Elements also easily lightens the shadows of contrasty photos without affecting the mid and highlight tones in the picture.

Like the new Adjust Color Curves feature, Shadows/ Highlights is useful for lightening the shadows in backlit images such as this beach example.

Both options provide a Fill Flash effect which takes its name from the technique of using an on-camera flash in daylight to lighten the shadows caused by direct sunlight. This way of working is popular with photojournalists who in their haste to capture hard news images have little time to modify the lighting on their subjects.

Shadows/Highlights	×
C Learn more about: Shadows/Highlights	OK Reset
Lighten Shadows: %	Preview
Darken Highlights: %	
Midtone Contrast:	

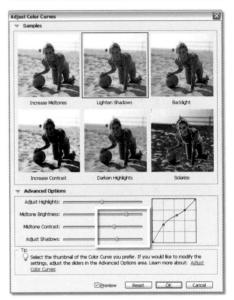

Curves like control via the Shadows/Highlights feature

The Shadow/Highlights tool can also be used to alter specific tonal ranges in your photos. It contains three sliders – the upper one is for lightening shadows, which replaces the old Fill Flash tool (included up to version 2.0), the control in the middle darkens highlights and is a substitute for the old Adjust Backlighting tool (included up to version 2.0) and the final slider adjusts mid tone Contrast. Moving the Shadows control to the right lightens all the tones that are spread between the middle values and black.

Sliding the Highlights control to the right darkens those tones between middle values and white. The beauty of this feature is that unlike the Brightness/Contrast tool, these changes are made without altering other parts of the picture. To fine-tune the tonal changes a third slider is also included in the dialog. Moving this Mid tone control to the right increases the contrast of the middle values and movements to the left decrease the contrast making the image 'flatter'.

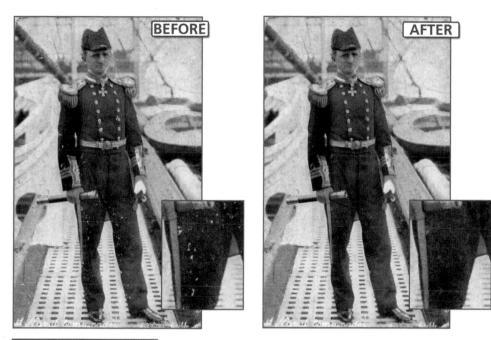

Removing dust automatically >>> One of the most tedious jobs for the digital photographer is the removal of dust and scratch marks from a badly damaged slide or print. Using the Clone Stamp tool to patch each individual mark can take considerable time and effort. A more automated approach that doesn't soften the detail in an image is detailed here. It uses the much besmirched Dust and Scratches filter in conjunction with the Layer blending modes to restrict changes to just the areas where it is needed.

7.14 Dust and scratches be gone

Suitable for Elements – 5.0, 4.0, 3.0, 2.0, 1.0 | Difficulty level – Intermediate | Resources – Web image 714 Menus used – Layer, Filter

The enticingly named Dust and Scratches filter (Filter > Noise > Dust and Scratches) teases us with the promise of a simple solution to repairing the dust and scratches in our scanned pictures. Nearly always the results of using the filter are disappointingly soft or the tones flattened. It is not that the filter doesn't obscure or disguise the problem marks, it is just that in doing so the rest of the image is also filtered. In areas where there is no dust this causes a deterioration of the picture. If only we could restrict the application of the filter to just the areas where the dust marks appear the results would be more usable.

The Lighten and Darken blending modes in Elements can be used for just this purpose. By applying the Dust and Scratches filter to a copy of the background and then blending this filtered layer using the Darken mode, the layer will only change the light dust marks of the original image and will leave the rest of the image unaffected. Similarly a second copy layer also filtered for dust and scratches could also be applied to the original image using the Lighten blending mode to remove the black marks from the picture. If we then control where the effects are applied with a layer mask then it is possible to restrict the changes made by the Dust and Scratches filter to just the areas where it is needed most. Pro's Tips for using the Dust and Scratches filter:

1. Always start with both sliders set to 0.

2. Move the Radius slider first until the marks disappear.

3. Next move the Threshold slider until the texture of the image returns. Do not move this slider so far that the marks start to reappear.

DARKROOM TECHNIQUES ON THE DESKTOP

190

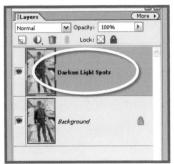

Step 1 >> Start the technique by copying the base layer by dragging the background to the New Layer button at the bottom of the Layers palette. Label the new layer Darken Light Spots.

Step 2 >> With the new layer selected apply the Dust and Scratches filter. Start with both sliders set on 0. Move the Radius slider first until you see the dust spots disappear. Next gradually move the Threshold slider to the right until the texture returns to the picture – not so far that you start to see the spots again.

Step 3 With the Darken Light Spots layer still selected change the mode of the layer to Darken. This will only apply the dust and scratches changes to the areas where this original layer is lighter – the white dust spots.

Step 4 >>> Add a Levels adjustment layer with no changes to the default settings above the background layer. Select the Darken White Spots layer and the choose Layers > Group.

Step 5 Select the layer mask of the Levels adjustment layer and then choose the Edit > Fill Layer option to fill the mask with black. This action hides the upper layer and reveals the unretouched layer beneath.

Step 6 With the layer mask still selected choose white as the foreground color and proceed to paint onto the canvas over the white marks in the photo. The white strokes will reveal the results of the upper layer.

Step 7 >> Create a copy of the background layer and label it 'Lighten Dark Spots'. Apply the Dust and Scratches filter to remove the black marks and change the mode of this layer to Lighten.

Book resources at: www.adv-elements.com

Step 8 >> Create a blank Levels adjustment layer and then group it with the Lighten Dark Spots layer. Fill the Levels layer mask with black to hide the filtered results.

Step 9 >> With white set as the foreground color and the mask still selected paint over the dark marks on the picture with the Brush tool.

7.15 Combining images seamlessly

Suitable for Elements – 5.0, 4.0, 3.0, 2.0, 1.0 | Difficulty level – Intermediate Resources – Web images 715-1, 715-2 | Tools used – Selection tools | Menus used – Select, Layer

One of the most basic yet critical skills for any digital photographer to learn is the art of careful selection of image parts. Whether you need to isolate a portion of a picture so that it is not affected by a filter, or use a selection as a prelude to copying an image section from one photograph to another, being able to manipulate your program's selection tools is a very important skill.

The success of a simple task such as creating a montage from two separate pictures is largely dependent on how well the image parts are isolated and copied. As an example I will add an extra ornament from a separate picture to an existing shadow box image and in the process demonstrate some basic selection and montaging steps that will help you to increase your image editing skills.

With both images open in Elements check to see that they are similar in size by viewing both the images at the same magnification. Make image size adjustments using the Scale feature. This step can also be performed after copying and pasting have occurred. Using the Lasso tool carefully work your way around the edge of the subject to be copied, in this example it is an angel, being sure to pick out as much edge detail as possible. In scenarios where there is more contrast between the edge and the background the Magnetic Lasso could be used instead.

Most selections are not perfect first time round, but rather than scrapping the initial selection try using the modifying keys to adjust your results. To take away part of the selection hold down the Alt key and draw around the area. Increase the image magnification to ensure accuracy around areas or detail. To add to the selection hold down the Shift key and draw around the image part to be included. These keys work with all selection tools and can be used repeatedly to build up a perfect result. Keep in mind that you can switch between any of the selection tools during the modification process; this includes the Magic Selection Brush.

Montaging picture parts >>> Selecting, copying and pasting picture parts from one image to another is a basic skill that most digital photographers should learn. Seamless integration is based on careful selection techniques so it is on developing these skills that you should spend your time.

Book resources at: www.adv-elements.com

At this point a lot of digital photographers would copy the angel and paste it onto the shadow box image, but such an action can produce a very sharp edge to the selection, which is a dead give-away in the final montage. The best approach is to apply a little feathering (Select > Feather) to the edge of the selection before copying. In most cases a value of between 1 and 3 pixels will give a realistic result.

With the feather applied copy (Edit > Copy) the selected portion of the image. This action stores the copy in the computer's memory ready for the Paste command. Switch to the shadow box image and paste the copied angel onto the picture. At this point you should see the object sitting on top of the shadow box picture. Any problems with the relative sizes of the two images will now become obvious. To make small changes in size you can use the Image > Transform > Free Transform tool. When the angel picture was pasted onto the shadow box image a new layer was created. Keeping these two image parts on separate layers means that they can be altered, edited and moved independently of each other; just keep in mind that the changes will only be made to the layer that is selected. Using the Move tool the angel picture is placed in the spare box space in the shadow box. As a final touch of realism a small drop shadow is applied to the angel using the Layer Styles > Drop Shadow options (via the Layer Style menu in the Special Effects section of the Artwork and Effects palette) . The direction and size (shadow distance) of the shadow can be altered via the Layer Styles > Style Settings dialog box. The shadow helps integrate the new picture element with the other ornaments already in the box.

Typically, as your skills increase you will attempt more and more complex selection tasks, some of which may take many minutes to complete. For this reason Adobe has included in version 2.0 of Elements a Save Selection (Select > Save Selection) feature that will allow you to store a copy of your carefully created selection with your image file, ready for later use. Input a name for the selection in the Save Selection dialog. It is good practice to save progress on complex selections as you go. This way if at any point you lose the work you have done you can simply reload the lost selection. Reinstating a saved selection is as simple as selecting the Load Selection option from the Select menu (Select > Load Selection) and choosing the particular selection name from the drop-down menu.

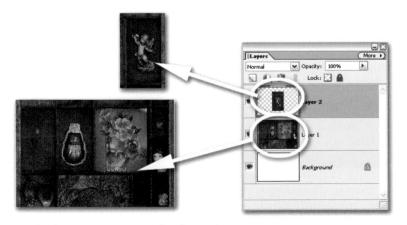

Edit>Paste >> When part of a picture is selected, copied and pasted into a different document, Elements automatically creates a new layer to hold the pasted part. Having the element stored separately means that you can easily move, scale, change brightness or even add texture without altering the background image. In the example I added a drop shadow to the separate layer to help unify the new subject with the background.

Book resources at: www.adv-elements.com

Step 1>> Open both images into the Elements workspace. Check their relative sizes by displaying them at the same magnification rate.

Step 2 >> Carefully select the subject to be copied using your favorite selection tool. Zoom in closer to ensure accuracy.

File	Edit Image Enhance Layer	
3	🍘 Undo Magnetic Lasso	
	🕲 Redo	
19	🥱 Revert	
	Cut	
	Copy	
	Copy Merged	
C	Paste	
	Fusie into Selection	
	🛅 Delete	
	Fill Selection	
	Stroke (Outline) Selection	

Step 5 Click onto the background document to make it active and paste the copied part. Use the Move tool to position it and, if need be, use the Free Transform tool to adjust its size to suit.

Step 3 >> Feather the selection slightly (1–2 pixels) to ensure that the edge of the copied part is not too crisp to appear real.

Step 6 >> To complete the illusion add a drop shadow to the object. Make sure that the size and direction of the shadow are consistent with the others in the background.

7.16 Believable montages – a step further

Suitable for Elements – 5.0, 4.0, 3.0, 2.0, 1.0 | Difficulty level – Intermediate Resources – Web images 716-1 to 716-5 | Tools used – Selection tools, Eraser, Clone Stamp Menus used – Select, Layer, Filter, Enhance

Against the background of the basic montaging skills developed in the last technique let's really test out your abilities to combine disparate images by stepping through the following project that brings together five very different source pictures and with the aid of Photoshop Elements creates a single and hopefully convincing final illustration.

The project has two parts. The first involves creating a background street scene from three different pictures and then unifying the composition by applying a lighting effect. In the second phase of the project a car and bus are added, the street lights are turned on and a little blur is mixed in to create a sense of speed and motion.

DARKROOM TECHNIQUES ON THE DESKTOP

Step 1>>> Open the background images. Be careful to choose pictures with similar pixel dimensions and try to pick photographs with a consistent perspective. Create a new document (File > New) large enough to encompass all three photos and then click-drag the open pictures onto the canvas of the new document.

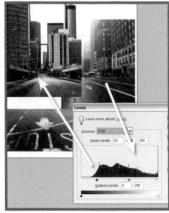

Step 2 >> To match the picture parts select the most different photo and adjust the brightness using the Levels feature. Next alter the color using the Color Variations feature. Finally, make a copy of the right background layer (Layer > Duplicate Layer). This will be used later in the process.

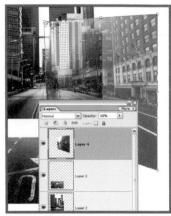

Step 3 >> Using the background as the base match the perspective, size and shape of the other background pieces to fit. Do this by reducing the opacity of the layer to be changed and then using the Free Transform feature to resize, rotate and change layer position. To alter perspective hold down the Ctrl key whilst dragging a corner or side handle.

Step 4 >>> Use the Eraser tool set to Brush mode, low opacity and soft edge to carefully remove the sharp edges of the upper layers to allow them to blend with the lower ones.

Step 5 >> Complete the background by selecting the duplicate layer (Step 2) and flipping it horizontally (Image > Rotate > Flip Horizontal). Use this copy to form the left side of the composition. Size, shape and rotate the layer before blending it into the existing background.

Step 6 >> Make a flat version of the background by selecting all of the document (Select > All) and then choosing the Copy Merged command (Edit > Copy Merged). The merged copy is then pasted (Edit > Paste) as a new layer.

Creating convincing montages:

1. When using a selection tool to cut out an object that will be pasted onto another background always apply a 1-pixel feather to the selection before cutting.

2. Try to ensure that all source images have similar lighting direction and quality.

3. Match the color, contrast and brightness of all picture parts before starting to merge them together.

4. Make sure that all source images are the same (or very similar) size and resolution.

5. Label all layers as you create them as this will help you keep track of the many layers that often make up a complex montage.

7. Don't flatten all the layers and masks that you have used for editing – instead Select > All, then Edit > Copy Merged and finally Edit > Paste a composite of all the detail as a new layer.

Step 7 >> Use the Clone Stamp to even out the textures and tones and the Burn and Dodge tools to darken or lighten areas. Next select white sky area with the Magic Wand tool and fill (Edit > Fill) with black. Use the Lighting Effects filter (Filter > Render > Lighting Effects) to add a yellow hotspot in the center of the picture, fading the edges of the buildings into the newly created black sky.

Step 8 >> Drag the car and bus images onto the background. Flip the bus horizontally (Image > Rotate > Flip Horizontal) and select the bus destination display and flip it back. Using the Free Transform tool (Image > Transform > Free Transform) both the car and bus images are resized and their perspective adjusted to suit the scene.

Step 9 >> Use a low opacity softedged eraser to remove the unwanted areas around the car and bus. Next darken the side of the bus and add a shadow underneath using the Burn-in tool. Apply similar burning-in changes to the car including shadows and darkening the front and wind screen areas. Use the Sponge tool to desaturate vivid color areas that can appear after burningin.

195

THE DESKTOP

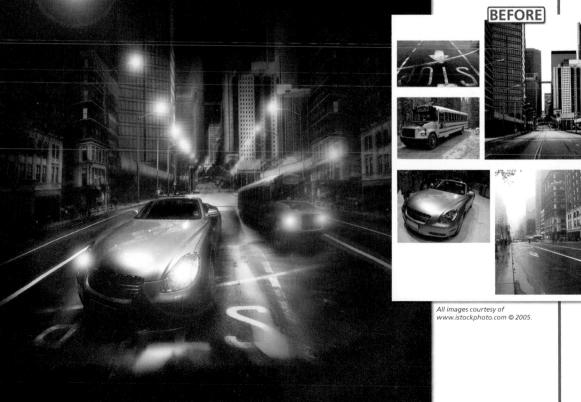

Step 10 >>> Next select the Lens Flare filter (Filter > Render > Lens Flare) and add glows to the headlights of the car and bus and to most of the bigger street lamps using the filter. Because the filter preview window is so small, it is more difficult to apply the changes to the more distant lamp posts. Instead add these with a softedged, slightly transparent brush that is colored white.

Step 11 >> One of the side effects of the Lens Flare filter is a general lightening of shadow areas in the picture. For this reason use the Burn tool to restore some of the depth of tone to the shadow areas. Selecting Mid tone or Shadows as the target range ensures that the highlights remain bright during the changes.

Step 12 >>> Make a copy of the merged layer of the work to date using the technique outlined in Step 6 and then apply the Radial Blur filter (Filter > Blur > Radial Blur), set to zoom and with the centre positioned over the car, to the copy. Reduce the opacity of the blurred layer to restore a little detail and then use a soft-edged eraser to remove layer parts to reveal the detail beneath.

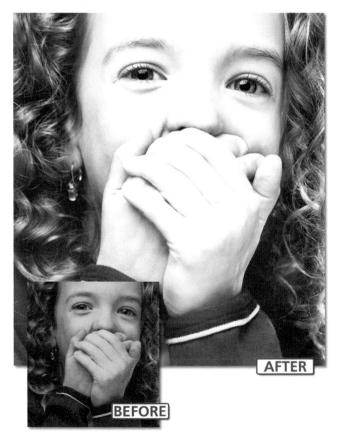

7.17 Producing high-key pictures

Suitable for Elements – 5.0, 4.0, 3.0, 2.0, 1.0 Difficulty level – Intermediate Resources – Web image 717 Tools used – Selection tools Menus used – Select, Layer

When, as a student. I was asked to produce a high-key portrait I can remember the extreme lengths that I went to making sure that my lighting was just right, my exposure perfect and my printing spot on. So finicky was the process that many photographers veer away from making many of these stylized portraits. There is no doubting the beauty of a well-produced highkey portrait. The skin tones become almost white, but still manage to retain just a hint of detail, whilst the shadows keep their depth and the detail throughout remains crisp.

With digital now dominant, what new spin can this technology offer to this old technique? Well I'm glad you asked. This technique takes a standard portrait and with a few basic changes in Photoshop Elements creates a new high-key version. Just like the original technique the digital approach concentrates on lightening the subject's skin tones whilst still retaining depth in the shadows.

Step 1 >> With the image open in Photoshop Elements, the first task is to create a Gradient Map adjustment layer. Do this by selecting the option from the Adjustment Layer button at the top of the Layer's palette.

Step 2 Double-click in the gradient area in the dialog to display the Gradient editor. Now to change the tones that make up the start and end points of the gradient. Start with the left end of the gradient – double-click on the Color Stop box.

Step 3 >> The Color Picker dialog will open. Select a light gray and click OK. This sets this color as the left end of the gradient. Now double-click the color stop on the right end and select white as the gradient end point.

Step 4 >> Select the adjustment layer and change the blending mode to Hard Light. This will produce a much lighter color image but still hold most of your highlight details.

Step 5>> Now add a Levels adjustment layer so that it sits at the top of the Layer Stack. Adjust the Mid tone slider to control the brightness of the subject's skin tones.

Step 6>>> Now to restore the shadow detail. Select the image layer at the bottom of the stack and with the Burn-in tool set to shadow and an exposure of 10% enhance the shadow areas using light overlapping strokes.

Gradient map?

This feature switches the colours in your picture with tones from a gradient. This option is often used to convert colour images to black and white by using a black-to-white gradient map. The colours in your picture are mapped to the grays in the gradient. The feature works just as easily with colours and complex rainbow gradients as well. Try it yourself.

DARKROOM TECHNIQUES

0 Z

THE DESKTOP

7.18 Correcting lens problems

Suitable for Elements – 5.0, 4.0, 3.0, 2.0, 1.0 | Difficulty level – Intermediate | Resources – Web images 718-1, 718-2 | Menus used – Filter, Image

The following techniques are designed to correct two

of the most common lens problems:

• Barrel distortion and

Pincushion distortion.

As we have already seen in technique 7.05 the new Correct Camera Distortion filter that ships with Photoshop Elements 5.0 can quickly and easily correct perspective problems in your photos, but this isn't the end of the feature's abilities. The Remove Distortion slider is designed specifically for removing the barrel distortion or pincushioning effects common with some lenses. For best results this slider can be used in conjunction with the Rotate. Perspective and Vignetting controls to fine-tune the look of your photo. This feature can also be used to intentionally add the effects of each of these lens problems in order to produced bloated or pinched photos.

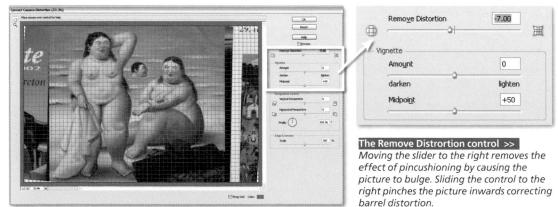

Book resources at: www.adv-elements.com

DARKROOM TECHNIQUES ON

Before Correct Camera Distortion filter

In previous version of Photoshop Elements you could use the Spherize filter (Filter > Distort > Spherize) to help correct the distortion problems in your photos. It contains a preview thumbnail and a slider control that adjusts the degree of barrel or pincushion correction that is applied to the picture. Moving the slider to the right balloons the picture and therefore counteracts the effects of pincushioning. Sliding the control to the left contracts the image and reduces barrel distortion. But simply applying this filter to the problem picture will cause some parts of the photo to be left unchanged (corners) whilst the rest of the image is 'spherized'. To overcome this problem and apply the changes to all the picture, you will need to add some space around the image before applying the filter. Use the steps below to correct the photos you have in your collection that suffer from lens distortion.

Step 1 >>> Open the example image. Next select the Crop tool and clickdrag the marquee so that it covers the whole of the picture. Now click on the marquee corner handles in the top left and bottom right and drag these outwards beyond the edge of the picture. Double-click in the centre of the marquee to add the new canvas space.

Step 2 >>> Open the Spherize filter (Filter > Distort > Spherize) and adjust the magnification of the thumbnail so that all the image can be seen. Drag the Amount slider to the left to remove the barrel distortion. Continue the adjustment until the ballooning effect is no longer evident. Click OK to apply.

Step 3 >> Next choose View > Grid and then select Image > Transform > Free Transform. Click-drag the top corner handles outwards until the building parts that should be vertical are aligned to a grid line. Drag the top handle upwards to counteract the squashing action and then double-click to transform. Use the Crop tool to remove edges.

Step 1 >> Open the example image and as before select the Crop tool and click-drag the marquee so that it covers the whole of the picture. Now click on the marquee corner handles in the top left and bottom right and drag these outwards beyond the edge of the picture. Double-click in the centre of the marquee to add the new canvas space.

Step 2 >>> Open the Spherize filter (Filter > Distort > Spherize) and adjust the magnification of the thumbnail so that all the image can be seen. Drag the Amount slider to the right to remove the pincushion distortion. Continue the adjustment until the edges of the card are no longer bent. Click OK to apply.

Step 3 Select the Crop tool and after drawing the crop marquee around the picture click outside the marquee and drag to rotate the marquee and the edges of the marquee are parallel to the card's sides. Double-click in the centre of the marquee to crop and rotate the photo.

200

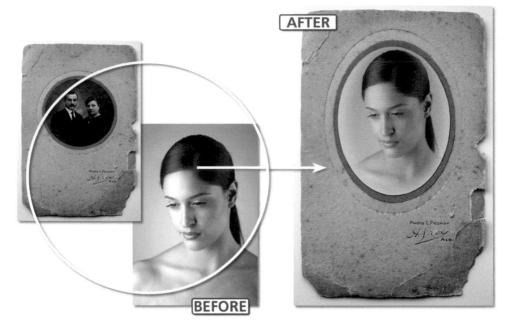

7.19 Change to old

Suitable for Elements – 5.0, 4.0, 3.0, 2.0, 1.0 | Difficulty level – Intermediate | Resources – Web images 719-1, 719-2 | Tools used – Selection tools, Free Transform | Menus used – Select, Layer, Enhance, Filter, Edit Most people would say that old photographs have a certain look and feel about them that can almost be described as magical. It is hard to pin down exactly why we can be so fascinated by these aged images; it may be nostalgia pure and simple, or the knowledge that you are holding a piece of captured history in your hands or it may even be the fact that they look so different from their modern, dare I say it, digital, counterparts. But such is the fascination with old images that many contemporary shooters use a range of digital techniques to recapture this 'look and feel' in their pixel-based photographs. In this section we will gracefully add years of age to a straight portrait with the help of some of the features in Photoshop Elements.

Sepia toned vignettes with old background

In this technique we will take a modern portrait that uses a classic pose, give it an old time treatment and then add it to an original antique background. Such picture surrounds can be easily located at car boot sales or, as with my example, a French brocante shop. The state of the photograph itself is not all that important; it is the surround that we are interested in. The circular cutout won't suit the oval vignette of the example picture so some quick copy, paste and transform steps modify the original to fit our modern portrait. The last part of the process adds some texture and a little unsharpness to the original to ensure that it matches its new (or is that old?) surround.

To see how to create similar results using the new Frame layer technology included in Photoshop Elements 5.0 go to Chapter 12.

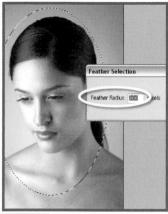

Step 1>>> Start by making an oval selection using the Elliptical selection tool from the Elements tool box. Feather the selection (Select > Feather) to make the transition between the selected and nonselected areas more gradual. Inverse the selection (Select > Inverse) and then press the Delete key to remove the background of the portrait.

Step 2 >>> A digital simulation of sepia toning can be obtained by opening the Hue/Saturation feature (Enhance > Adjust Color > Hue/Saturation), ticking the Colorize option and then moving the Hue slider to a value of about 30. The strength of the color can be changed by sliding the Saturation slider.

Step 3 >> Open the photo-frame picture. This example was photographed using window light directed from the top of the picture. Change the circular cutout to suit the oval picture by making a feather selection of the oval and Edit > Copy and Edit > Paste the selection. Next use the Free Transform tool to make the circle taller. Double-click to apply the transformation.

Step 4 >> Flatten the picture (Laver > Flatten Image) and carefully select the inside of the cutout using one of the Lasso tools. Feather the selection by 1 pixel. Save the selection (Select > Save Selection) just incase you loose it during the next couple of steps. Switch back to the sepia toned portrait and select (Select > All) and copy (Edit > Copy) the whole picture to memory. Click onto the background document and make sure that the cutout selection is still active. Now select the Paste Into Selection option from the Edit menu (not the Paste option).

Step 5 Straight after you paste the portrait into the surround select the Free Transform feature using the shortcut key – Ctrl T. This will place the familiar transformation handles around the pasted picture allowing you to manipulate the size of the portrait to suit the cutout. Be sure to hold down the Shift key whilst resizing to guarantee that the portrait remains in proportion. Double-click to apply the transformation.

Step 6 >> Although the picture now fits the surround well there is an obvious difference between the texture of the two parts. To help match these areas, select a portion of the picture surround and then copy and paste this into a new Elements document. Save the texture as a PSD file. Reload the original selection made for the cutout (Select > Load Selection). Now apply the saved copied texture to the portrait area using the Load Texture option in the Texturizer filter (Filter > Texture > Texturizer).

7.20 Painterly photos

Suitable for Elements – 5.0, 4.0, 3.0, 2.0, 1.0 | Difficulty level – Intermediate | Resources – Web image 720 | Menus used – Filter Before photography was even invented or digital became

the way to take and make pictures, artists had been creating great pictures for centuries using such diverse materials as chalk, pastel, pen and ink, and, of course, paint. Now you can emulate the look of these old

masterpieces by using your very own photographs as the starting point and adding the artistic 'look and feel' with a few well-chosen, but simple, digital embellishments. Here we will recreate four distinct artistic illustrations from a single humble photographic beginning using several enhancement steps and the filters contained in Elements.

Changing to a pen and ink drawing (See a)

Using the Graphic Pen filter it is possible to simulate the effect of making a drawing of a photograph with a thin graphic arts pen. Close overlapping strokes are used for the shadow areas; mid tones are represented by balancing strokes with the paper colour showing through; and highlight details are drawn with a few sparse strokes.

Step 1>> Set the foreground colors to default by clicking the small black and white squares in the bottom left of the toolbar. The Graphic Pen filter uses the foreground color as the 'ink' color and the background color as the 'paper' color. Select the filter from the Sketch menu. Using the preview as a guide adjust the Stroke Length, Light/ Dark Balance and Stroke Direction controls. Click OK.

Step 2 >> To add a little more color to your Graphic Pen 'drawings' select colors other than black and white for the foreground and background values. Double-click each swatch to open the Color Swatch palette where you can select the new color. Here I changed the pen color to brown and the paper color to light cream.

Switching photographic tones with pastel strokes (See b)

As well as the pen and ink approach used above, another favorite with artists is the use of pastels or chalks on a roughly textured paper surface. The tones of the picture are layered upon the paper's texture so that the image detail gradually emerges from the background as a combination of stroke, colour and texture.

Book resources at: www.adv-elements.com

DARKROOM TECHNIQUES ON THE DESKTOP

Step 1 >> To create this effect we make use of the Rough Pastel filter. The feature contains two distinct control sections. The upper two sliders, Stroke Length and Stroke Detail, are used to adjust the way that the photographic tone is converted to pastel strokes. With the preview window zoomed in to 100% move both sliders until you are happy with the mix of detail and tone.

Step 2 >> When drawing with pastels artists often use a heavily textured paper as a base for the picture. The lower section in the Filter dialog is used to apply such a surface texture to your pastel image. Here you can select the texture type (canvas, burlap, sandstone), the size of the texture (scaling), the strength of the texture effect (relief) and the direction of the light that provides shadow for the surface. After making your texture selections, check the preview and readjust the stroke length and detail if necessary before clicking OK to complete.

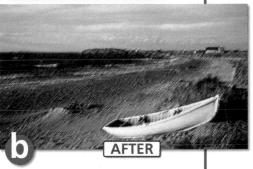

Creating a watercolour painting (See c)

If you want to create the feeling of a painted surface rather than a drawn one then the Watercolor filter in Photoshop or Photoshop Elements is a good place to start. With this feature the tone and hue of the original photograph is converted to daubs of semi-transparent color with the larger areas surrounded by a darker border edge. To make the effect even more convincing I have applied a texture to the picture after the watercolour conversion.

Pop art posters (See d)

Andy Warhol made the technique famous in the sixties and now you can recreate his posterized effect using your own pictures. Warhol's images were extremely graphic and constructed of very few colours, which were then applied in broad flat areas of the picture. Others like Roy Lichtenstein added a cartoon-like feeling to the pop art pictures by including a black line around coloured areas. Here we will use the Cutout and Poster Edges filters to recreate this image style.

203

DARKROOM TECHNIQUES ON

THE DESKTOP

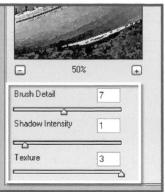

Step 1 >> Start by opening the Watercolor filter from the Artistic option of the Filter menu. Next, with the preview set to 100%, adjust the Brush Detail and Shadow Intensity sliders to suit the picture. The third slider, Texture, is used to control the break-up of the painted areas rather than any simulated paper texture. This comes in the next step. Click OK to filter.

Step 2 Now to add a surface treatment to the picture that will really make the conversion to a watercolor painting complete. For this task we will use the Texturizer (Filter > Texture > Texturizer) filter which has the same controls and options that we looked at in the Rough Pastel filter. We can choose the type, scale, relief and light direction that will be used for the texture. Be sure to preview the effect of the settings at 100% before clicking OK to apply.

AFTER

Step 1 >> To start we will use the Cutout filter (Filter > Artistic > Cutout) to reduce the colors in the picture and to simplify the photographs detail. The feature contains three sliders. The first, No. of Levels, determines the number of colors that will be present in the final picture. Smaller values mean less colors. The Edge Simplicity and Fidelity sliders are used to determine the amount of detail that is retained in the picture. Try several settings to ensure that you have a good balance of detail and flat tone. Click OK to filter.

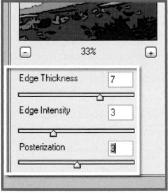

Step 2 >>> The final step in the pop art transformation is to add a black surround to the flat areas of color. For this job we will use the Poster Edges filter (Filter > Artistic > Poster Edges). The Edge Thickness slider adjusts the width of the line drawn around the picture parts, the Edge Intensity slider controls the darkness of the line and the Posterization setting is a further color reduction control. Check how the results of your settings appear when previewed at 100% and then click OK to complete.

204

DARKROOM TECHNIQUES ON

DESKTOP

THE

Professional retouching

ADVANCED PHOTOSHOP ELEMENTS 5.0 FOR DIGITAL PHOTOGRAPHERS

hen it comes to retouching, Photoshop Elements and Photoshop are definitely the royalty amongst image-editors. The programs jointly contain hosts of tools, filters and adjustment options that can help turn ordinary looking portraits into something that is truly dazzling.

The shear power and dominance of the programs in this area is not difficult to see as most glossy magazine covers, family scrapbooks and wedding albums contain a plethora of photos that have been 'shopped' in one way or another. The results, in most cases, are amazing and in a few instances, even a little scary. But for the average photographer (judging by the requests from readers) the interest is not about wanting to recreate the plastic look of celebrity stardom but

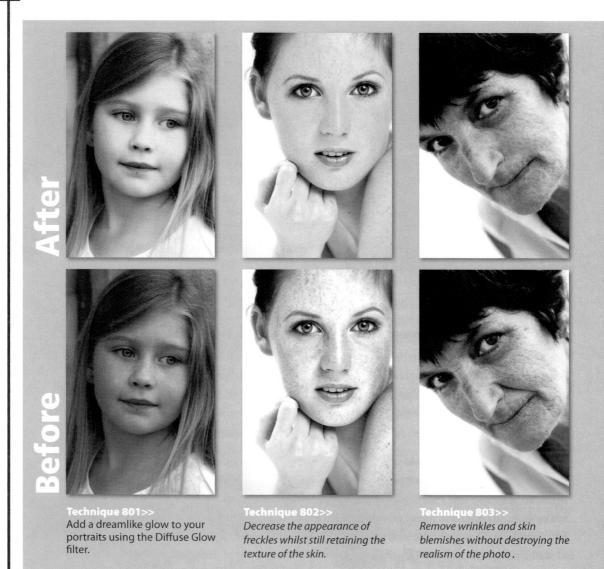

rather it centres around the gentle art of photo enhancement. And in truth, I feel that this is the best use of the retouching power of programs like Elements.

Visual surgery without a hint of anything plastic

So with this in mind, I present here a few of the basic techniques that are used by portrait photographers on a daily basis. Most work with, rather than paint over, the basic structure and texture of the model's face and in so doing they carefully enhance what already exists rather than replace it with something that is manufactured.

Technique 804>> Correct the red skin tones that sometimes appear around noses, cheeks and ears.

Technique 805>> Clean up tired looking eyes with two simple adjustment layers.

Technique 806>> Remove shiny areas of skin and the dark tones beneath the eyes.

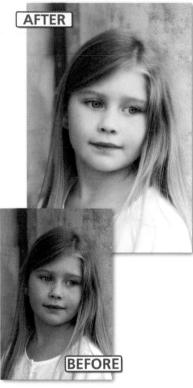

The Diffuse Glow filter adds a glamorous touch to standard portrait images.

8.01 Adding a dreamy effect

Suitable for Elements – 5.0, 4.0, 3.0, 2.0, 1.0 | Difficulty level – Basic Menus used – Filter

The Diffuse Glow filter is one of the Distort group of filters that can be found in Photoshop Elements. The feature creates a highkey (very light), glamorous and slightly grainy glowing version of your picture. The filter is great for smoothing out surface marks on the skin of your subject and is often used to add a Hollywood feel to portraits. Try low settings to start with, keeping an eye on the changes in the filter's preview window to ensure that you are not losing important picture detail in the surface glow.

The Filter dialog contains three sliders and a preview window. The Graininess control alters the dominance of the noise that will be added to the picture. The Glow Amount slider changes the strength of white glow in the picture (and how much detail is lost to it). The Clear Amount slider acts as a counter balance to the Glow Amount restoring detail in the glowing areas of the picture.

As it is often difficult to determine how well the filter will work, applying the changes to a copy of the image layer first and then, with this filtered layer above the original, change its opacity to vary the strength of the final effect.

Step 1 >> Make sure that the default foreground and background colors are selected and then with your picture open select the Diffuse Glow filter from the Distort group in the Filter menu. Alternatively you can also choose the feature from the Artwork and Effects palette (Special Effects > Filters > Distort).

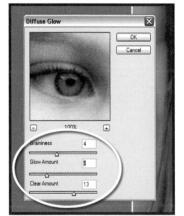

Step 2 >> With the Filter dialog open make sure that the Preview option is clicked and that the preview window is set to 100%. Adjust the three sliders in turn carefully previewing the results. If necessary, drag the visible area in the preview window to examine more closely the changes in other areas of the picture. Click OK.

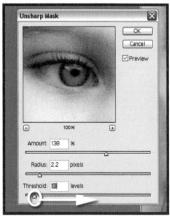

Step 3 >>> As a finishing touch for this example I decided to apply a little sharpening to the eyes to ensure that they stood out from the rest of the scene. Using the Filter > Sharpen > Unsharp Mask feature increase the Levels value to restrict the changes to the areas of the picture with the greatest contrast. Click OK to complete.

PROFESSIONAL RETOUCHING

PROFESSIONAL RETOUCHING

209

ADVANCED PHOTOSHOP ELEMENTS 5.0 FOR DIGITAL PHOTOGRAPHERS

8.02 Softening freckles

Suitable for Elements - 5.0, 4.0, 3.0, 2.0, 1.0 Difficulty level – Intermediate Menus used - Filter | Tools - Brush So many good retouching techniques are not about totally removing or changing the basic structure or makeup of the model's face. Instead. the aim should be to gently enhance the existing skin tones and textures. There is nothing worse, nor more obvious. than an overworked portrait where the skin's original texture and tone are replaced with a flat (or sometimes even shiny) surface that has more in common with plastic appliances than anyone I know.

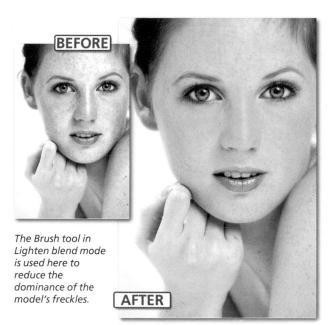

The example image is typical of the sort of photograph that is normally overworked. In an attempt to smooth out the appearance of the model's freckly skin most photographer's completely remove this skin characteristic with the result that the final portrait resembles a computer-generated model rather than an actual living and breathing person. This technique aims to reduce the dominance of the freckles rather than removing them totally. In this way the underlying structure of the face shines through and is complemented with, rather than overridden by, just a hint of the freckles.

Step 1 >> Select the Eyedropper tool and then check to see that the Sample Size (in the options bar) is set to average 3 × 3 or 5 × 5 pixels. Next select a flesh color from the portrait that represents a mid tone of the range available across the face surface.

Pro's Tip: The tone you select at this point in the process will determine which freckles are lightened. Choosing a darker skin tone will change only a few of the darkest freckles whereas a lighter tone selection will alter both mid tone and dark freckles.

Step 2 >> With the skin tone selected the next step is to select the Brush tool and then switch the tool's blend mode to Lighten. Do this by selecting the Lighten option from the drop-down mode list in the tool's option bar.

When the brush is in the Lighten mode Elements compares the paint color with the pixels being painted over. If the pixels are darker then they are replaced with the paint color, effectively lightening the area.

Step 3 >>> The next step is to adjust the opacity of the Brush. Turn again to the options bar and this time reduce the opacity to about 40%. An opacity setting of 100% would produce a result that was too smooth. Reducing the opacity has the effect of allowing a little of the old freckle texture to show through – maintaining the feeling of realism whilst reducing the freckle's dominance. Now paint away, being careful not to paint over details like eyelashes as you go.

8.03 Eliminating blemishes

Suitable for Elements – 5.0, 4.0, 3.0, 2.0, 1.0 | Difficulty level – Intermediate Menus used – Filter | Tools – Spot Healing Brush, Healing Brush, Clone Stamp

Ethical issues aside, Photoshop Elements is a great tool for removing, or at least making less pronounced, a variety of unwanted photo elements. Despite the fact that skin blemishes and wrinkles are a normal everyday occurrence for most of us, photographers are constantly asked to retouch these sections of portrait photos. Like all other techniques discussed here, the secret behind successful retouching of these areas is not to remove them completely but rather to reduce their appearance.

With this in mind let's look at the three tools that Elements offers for blemish removal and then set these tools to work on a typical portrait image.

Clone Stamp tool

The most basic of all the retouching tools is called the Clone Stamp tool (or sometimes the Rubber Stamp tool). The feature selects and samples an area of your picture and then uses these pixels to paint over the offending marks. It takes a little getting used to, but as your confidence grows, so too will the quality of the repairs and changes you make.

There are several ways to use the tool. For starters, it acts like a brush, so changing the tip size allows cloning from just one pixel wide to hundreds across. You can also change the opacity in order to produce a range of subtle clone effects. It can be used in conjunction with any one of the options from the Blend menu and, most importantly, there's a choice between Cloning aligned or non-aligned with the sample area.

Select Aligned and the sample cursor will follow the destination cursor around keeping a constant distance between the two. When the Aligned option is unchecked the sample cursor starts where you left off with all ensuing paint strokes. Both choices have their advantages.

Healing Brush tool

The Healing Brush is designed to work in a similar way to the Clone Stamp tool; the user selects the area (Alt-click) to be sampled and then proceeds to drag the brush tip over the area to be repaired. The tool achieves great results by merging background and source area details as you paint. Just as with the Clone Stamp tool, the size and edge hardness of the current brush determines the characteristics of the Healing Brush tool tip. One of the best ways to demonstrate the sheer power of the Healing Brush is to remove the wrinkles from an aged face. In the step-by-step example image we used here, the deep crevices of the model's face have been easily removed with the tool.

The texture, color and tone of the face remain even after the 'healing' work is completed because the tool merges the new areas with the detail of the picture beneath.

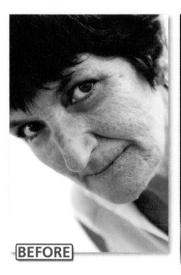

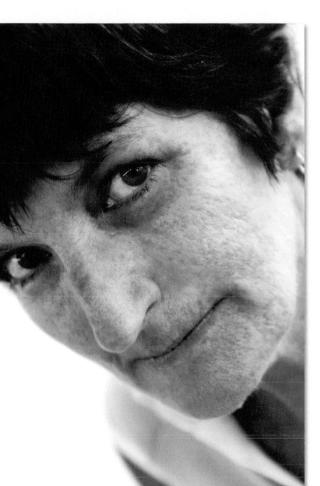

AFTER

By carefully using any of the three retouching tools in Photoshop Elements it is possible to gently remove skin blemishes and signs of age like wrinkles and cracks.

Spot Healing Brush

In recognition of just how tricky it can be to get seamless dust removal with the Clone Stamp tool, Adobe decided to include the Spot Healing Brush in Photoshop Elements.

After selecting the new tool you adjust the size of the brush tip using the options in the tool's option bar and then click on the dust spots and small marks in your pictures. The Spot Healing Brush uses the texture that surrounds the mark as a guide to how the program should 'paint over' the area. In this way, Elements tries to match color, texture and tone whilst eliminating the dust mark.

But don't just use this tool for spot; scratches too can get the treatment by click-dragging the tool's tip across the mark. The results are terrific and this tool should be the one that you reach for first when there is dust to remove from your photographs. PROFESSIONAL RETOUCHING

Clone Stamp tool step-by-step:

Step 1 >>> The Clone Stamp tool works by sampling a selected area and pasting the characteristics of this area over the blemish, so the first step in the process is to identify the areas in your picture that need repair. Then make sure that the image layer you want to repair is selected. Some photographers create a new layer and then apply their cloning to this layer. If this is your approach then also ensure that the Sample All Layers option is selected.

Step 2 >>> Next, locate areas in the photograph that are a similar tone, texture and color to the picture parts that need fixing. It is these sampled areas that the Clone Stamp tool will copy and then use to paint over the model's wrinkles. At this point you can also alter the transparency of the cloning action by adjusting the Opacity slider in the tool's options bar. Values less than 100% will let some of the original texture through the clones areas.

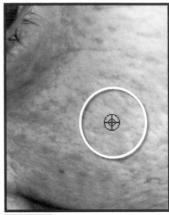

Step 3 >> Now to select the area to be sampled, or the 'Sample Point'. Do this by holding down the Alt key and clicking the left mouse button when the cursor (now changed to cross hairs) is over a part of the image that suits the area to be repaired.

Step 4>>> With the sample point selected you can now move the cursor to the area to be fixed. Click on the blemish and a copy of the sample point area is pasted over the mark. Depending on how well you chose the sample area, the blemish will now be blended into the background seamlessly. Continue to click and drag to repair more areas.

Step 5 ≥> You may need to reselect your sample point if you find that the color, texture or tone doesn't match the surrounds of the blemish. You can also change the brush size and hardness to alter the characteristics of both the sample and stamp areas. A softer edge helps blend the edge areas of the newly painted parts of the picture with the original image. Simply select a different brush tip from the Brush Preset dropdown palette.

Step 6 >> Switching between aligned and non-aligned (when the Aligned option is not selected) can really help when you are rebuilding missing parts of your restoration project. 'Aligned' sets the sample point so that it remains the same distance from the stamped area no matter where on the picture you start to click, and 'Non-aligned' repositions the sample point back to the original sample spot each time the mouse is moved and then clicked.

Healing Brush tool step-by-step:

Step 1 >>> The Healing Brush is also a two-step process. After selecting the tool hold down the Alt/Option key and click a clear skin area to use as the sample for the healing. This action is the same as you would take when using the Clone Stamp tool to select a sample point.

Step 2>> Now move to the area to be repaired and click-drag the cursor over the blemish. The Healing Brush will use the tones, textures and color of the sampled area to paint over the blemish but unlike the Clone Stamp tool, the Brush takes into account the general tone of the repair area and does a great job of seamlessly merging the new detail with the old.

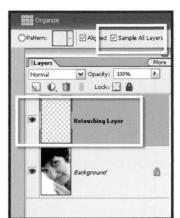

Step 3 is Like the Clone Stamp tool the Healing Brush contains a Sample All Layers option enabling photographers to perform nondestructive editing of their photos by painting the retouched areas onto a separate layer. Using a retouching layer also means that you can interactively adjust the strength of the changes via the layer's Opacity settings.

Spot Healing Brush tool step-by-step:

Step 1 The Spot version of the Healing Brush removes the sampling step from the process. To use the brush you simply select the feature, adjust the brush tip size and harness and then click onto the blemish. Almost magically the Brush will analyse the surrounding texture, color and tones and use this as a basis for painting over the problem area.

Step 2>>> The Spot Healing Brush can also be used for removing marks, hairs, streaks or cracks by click-dragging the tool across the offending blemish.

Pro's tip: If unwanted detail is used to cover the repaired area undo the changes and then draw around the area to be healed with the Lasso tool and apply the brush again. This restricts the area around the blemish that the tool uses to heal.

Step 3 >>>> Like both of the previous tools the Spot Healing Brush also contains a Sample All Layers option enabling photographers to perform non-destructive editing of their photos by painting the retouched areas onto a separate layer. Using a retouching layer also means that you can interactively adjust the strength of the changes via the layer's Opacity settings.

PROFESSIONAL RETOUCHING

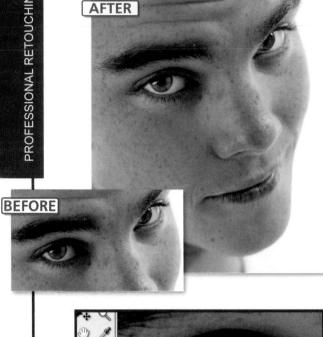

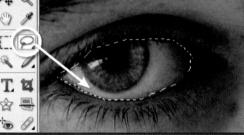

Step 1 >>> Use the Lasso tool to make a careful selection around the main part of the eye. Soften the edge by choosing Select > Feather. Here I used a value of 5 pixels but the setting you use will be determined by the pixel dimensions of your photo. Photos with more pixels will need a larger feather, those with less a smaller amount.

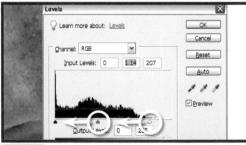

Step 3 >>> The addition of a mask means that the changes made in the Levels dialog will be restricted to the clear part of the mask (the eyes). Add a simple brightening and contrast adjustment by dragging the black and white . Click the OK button to apply the changes. Re-select the eye areas by Ctrl/Command clicking the mask section of the adjustment layer.

Book resources at: www.adv-elements.com

8.04 Brighten Eyes

Suitable for Elements - 5.0, 4.0, 3.0, 2.0, 1.0 Difficulty level – Intermediate Menus used - Laver | Tools - Lasso

No amount of clever photography or tricky lighting can cover the traces of lack of sleep or overindulgence in the eyes of your model. A set of 'sore red eyes' staring back at you can easily ruin an otherwise well-produced photo. Elements certainly has the tools to add back the sparkle and life, but overenhancing can easily lead to sci-fi like results. This technique uses a selection with a couple of adjustment layers for its effect, allowing changes and fine-tuning to the strength of the effect at a later date.

Step 2>>> With the Eyes selections still active, create a new Levels adjustment layer by choosing Layer > New Adjustment Layer > Levels. Notice that because of the active selection a mask has been automatically added to the adjustment laver.

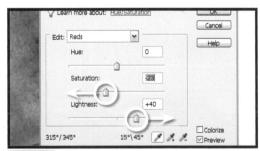

Step 4 >> Now add a Hue/Saturation adjustment layer. Again the changes will be limited to the eyes via the mask. Select Red in the drop-down Edit menu at the top of the dialog and then pull down the Saturation slider and push up the Lighten setting. This will help to lessen the red veins in the eyes. Click OK to apply.

PROFESSIONAL RETOUCHING

8.05 Tone down skin highlights and shadows

Suitable for Elements – 5.0, 4.0, 3.0, 2.0, 1.0 Difficulty level – Intermediate Tools – Brush

The example image has all the attributes of a great portrait but as with a lot of photos of this type there are a couple of places where the model's skin is a little shiny and the area under her eyes is a little dark. Gentle lightening of the dark areas and darkening of the light area are two techniques that, when mastered, you will use often when enhancing your portrait images.

This technique makes use of the Brush tool in both Lighten and Darken blending modes, along with the model's own skin color, to reduce the appearance of these areas in the final image.

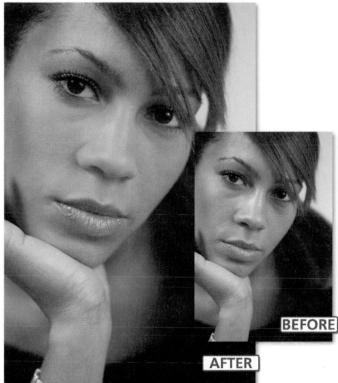

Remove shiny skin areas and bags under the eyes using the Brush in Lighten/Darken modes.

Step 1>> Start by selecting the Brush tool from the tool bar. Next go to the tool's options bar and select Darken as the Brush mode. At the same time I also adjust the opacity of the tool so that a little of the original texture remains after retouching.

Then select a flesh tone that is slightly darker than the highlight areas whilst still using the brush by holding down the Alt key and clicking on the skin color.

Step 2 >> Next gently brush over the shiny areas on the model's nose, forehead and cheek regions. When brushing using the Darken mode, only the pixels that are lighter than the sampled color will be adjusted. For the best results keep selecting different sample colors as you brush.

Pro's tip: For even more control apply the enhancement changes to a separate layer. The strength of the changes can then be adjusted via the layer's Opacity setting.

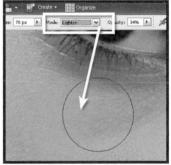

Step 3 ≫ The same technique can also be used to lighten the dark areas under the model's eyes. This time select the Lighten mode before sampling a flesh tone that is slightly lighter than the dark areas you want to fix. Again make sure that you choose a range of sample tones whilst brushing to ensure that the results are not too uniform and plastic looking. If you applied the changes to a separate layer, adjust the opacity of the layer to bring back some of the underlying face structure.

PROFESSIONAL RETOUCHING

8.06 Retouching non-destructively

Suitable for Elements - 5.0, 4.0, 3.0 | Difficulty level - Intermediate

When first starting to retouch your portrait photos it seems logical to apply the changes directly to the photograph or image layer itself, but this is not the way that most professional photographers work. For them the original picture is like the negatives of old and should be carefully maintained and not changed in any way. For this reason you will often hear them talking about employing non-destructive editing techniques as an alternative method for retouching their photos. These techniques produce the same results as editing the original image but employ some advanced Elements options that leave these 'virgin' pixels untouched. Use the non-destructive editing ideas listed here with the techniques in this chapter to maintain the original picture whilst retouching.

Sample all layers:

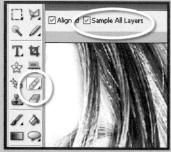

Step 1>> Retouching features such as the Clone Stamp, Spot Healing Brush and Healing Brush tools all contain a Sample All Layers setting on their options bar. Designed to allow the tools to retouch the contents of several layers this option can also be used to protect your original photo pixels.

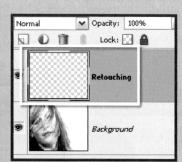

Step 2 >>> To make use of this option for non-destructive retouching firstly create a new blank layer above the image layer. Make this the active layer and then select the retouching tool and choose the Sample All Layers option. Now when you retouch the changes will be stored on the newly created layer.

Use Adjustment layers:

Step 1 >> Many of the editing or enhancement changes that are possible via the options in the Enhance menu can also be applied via Adjustment Layers. Where ever possible use an Adjustment Layer to make a change rather than applying the alteration directly to the image.

Retouch duplicate layer:

Step 1 >>> If the technique you are using can't be applied non-destructively then make a duplicate of the image layer and make the changes to the copied image instead of the original. This also gives you the chance to adjust the strength of the changes with the layer's Opacity slider.

Mask editing adjustments:

Step 1 >> Keep in mind that you can mask the effects of adjustment layers by selecting the layer mask in the Layers palette and then painting onto the image with black to hide the effect and white to apply the change.

Step 2 >>> You can also selectively apply the effects of a duplicate image layer by grouping this layer with a blank (no settings applied) Levels adjustment layer. Once grouped painting onto the Levels layer mask will either hide or apply the changes made in the duplicate layer.

Making Better Panoramas

ADVANCED PHOTOSHOP ELEMENTS 5.0 FOR DIGITAL PHOTOGRAPHERS 217

hen Adobe Photoshop Elements was first released one of the real bonuses of the program was the inclusion of the Photomerge technology. Designed to stitch together a series of overlapping images to form a wide vista print this feature really sets hearts racing amongst those of us with a secret passion for panoramas. There is just something about a long thin photograph that screams special to me. I have often dreamt of owning a camera capable of capturing such beauties, but alas the bank balance always seems to be missing the required amount that would be needed to make such a purchase.

And to be honest, the pragmatist in me also has to admit that the comparatively few shots that I would take in this format would not warrant the expense. It was in the midst of such thoughts

a couple of years ago that I was first introduced to Photomerge, which has proven to be a solution to my 'wide vista' problems that suited both my budget and my infrequent production.

The feature combines several overlapping images to form a new wide angle photograph. Once in this form the panorama can be treated like any other Elements document, providing photographers with the ability to create truly stunning and interesting, wide and thin compositions.

> Photomerge in action >> In this example two separate pictures were joined using Photomerge and the result dodged and burnt before being toned using the Hue and Saturation control.

OK

Cancel

17

0

218

Pho	otomerge Stitching Summary
	Select Photomerge from the File menu (Editor: File > New > Photomerge Panorama) to start a new panorama or select images in the Photo Browser and choose File > New > Photomerge Panorama.
Starting a new panorama	Click the Browse button in the dialog box. If the images are opened already then they will automatically be added to the Photomerge Source Files list.
	Search through the thumbnails of your files to locate the pictures for your panorama.
	Click the Open button to add files to the Source files section of the dialog.
	Version 1.0 only – Set the Image Size Reduction amount to reduce source file sizes. If you are using images greater than 2 megapixels then a setting of 50% or more should be used.
	Version 1.0 only – To get Elements to lay out the selected images check the 'Attempt to Automatically Arrange Source Images' box for manual layout control; leave the box unchecked.
	Version 1.0 only – If you are using the Automatic Arrange option then you can also choose to apply perspective correction across the whole of the composition. Do not use this feature if the panorama covers an angle of view greater than 120°.
	Select OK to open the Photomerge dialog box. Edit the layout of your source images.
Editing in Photomerge	To change the view of the images use the Move View tool or change the scale and the position of the whole composition with the Navigator.
	Images can be dragged to and from the Light box to the work area with the Select Image tool.
	With the Snap to Image function turned on, Photomerge will match like details of different images when they are dragged over each other.
	Ticking the Use Perspective box will instruct Elements to use the first image placed into the layout area as the base for the composition of the whole panorama. Images placed into the composition later will be adjusted to fit the perspective of the base picture.
	The Cylindrical Mapping option adjusts a perspective corrected image so that it is more rectangular in shape.
	The Advanced Blending option will try to smooth out uneven exposure or tonal differences between stitched pictures.
	The effects of Cylindrical Mapping as well as Advanced Blending can be viewed by clicking the Preview button.
	If the source images do not quite line up using the automatic 'Snap to' setting you can manually drag to reposition or rotate any picture by clicking on the Rotate Image and Select Image tools from the toolbar and then clicking on the image to adjust.
Producing the panorama	The final panorama file is produced by clicking the OK button. Also, in Elements 3.0 and above you can choose whether or not to keep the panorama images as separate layers during the save process.

219

Photomerge basics>> For those readers who are new to the feature, use the workflow in the table aside to guide you through making your first Photomerge panorama.

Once you are confident with creating simple wide vista images using the feature, work through the advanced techniques discussed in the rest of the chapter to refine your panoramic prowess.

The technology behind the 'Image Stitching' idea is simple. Shoot a range of images whilst gradually rotating a standard camera so that each photograph overlaps the next. Next, import the pictures into Elements and then Photomerge and proceed to stitch the images together to form a wide, no make that very wide, panoramic picture.

Tips for great panoramas: 1. Panoramas are first and foremost a photographic exercise.

Composition, lighting and point of view are all critical, although they have to be dealt with differently to traditional photography.

2. Elements is your friend. Use it to fix problem areas in your finished panorama.

3. If possible use a special panorama head to capture your pictures. If you can't afford a commercial model search the net for plans of a DIY version for your camera and lens combination. From here the photo could be printed, or if the original series of images covered the full 360° of the scene with the first and last pictures overlapping, a special 'wrap-around view', called virtual reality (VR) panorama, could be produced. Programs like Apple's QuickTime use these 360° panoramas and allow the viewer to stand in the middle of the action and spin the image around. It is like you are actually there.

Despite the comparative ease with which Photomerge stitches images together the best quality panoramas are made when attention is paid to every step of the capture, stitch and print process. The following techniques go beyond the basic steps needed to create a panorama and will help you produce the best pictures possible with the Photomerge system.

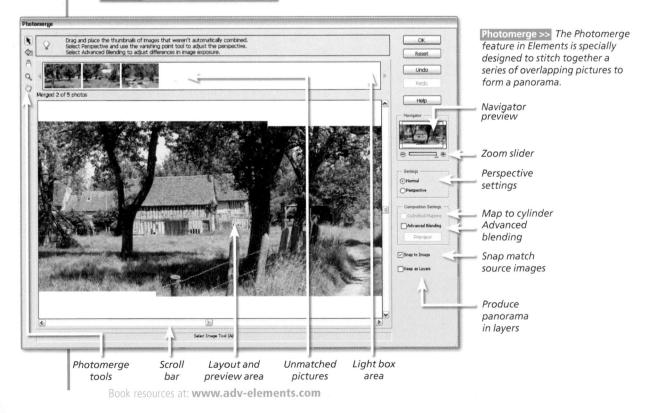

221

ADVANCED PHOTOSHOP ELEMENTS 5.0 FOR DIGITAL PHOTOGRAPHERS

Advanced shooting techniques

When producing great panoramas the importance of the photographic step in the process cannot be underestimated. It is here that much of the final quality of your VR scene is determined. A few extra minutes taken in the setting up and shooting phases will save a lot of time later sitting in front of the computer screen fixing problems.

9.01 Positioning the camera

Suitable for Elements – 5.0, 4.0, 3.0, 2.0, 2.0 | Difficulty level – Basic Related techniques – 9.02

Photographers have long prided themselves in their ability to compose the various elements of a scene so that the resultant picture is dynamic, dramatic and balanced. These aims are no less important when creating panoramic images, but the fact that these pictures are constructed of several separate photographs means that a little more thought needs to be given to the positioning of the camera in the scene. For the best results the photographer needs to try and pre-visualize how the final picture will appear once the single images are combined and then select the camera's position.

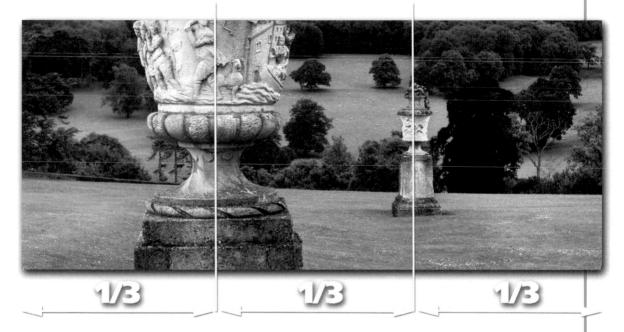

Rule of thirds >>> The same ideas of composition should be followed when making decisions about where to position the camera to capture a panorama sequence of pictures. To ensure that the resultant wide vista picture contains all the drama of a traditional photograph you should ensure that the foreground, mid ground and background details are all present in the final stitched picture.

One common mistake is to move to the center of the environment, set up the equipment and create a sequence of images with most of the subject detail in the mid or background of the picture. This type of panorama provides a good overview of the whole scene but will have little of the drama and compositional sophistication that a traditional picture with good interaction of foreground, mid ground and background details contains.

When deciding on where to position your camera sweep the area whilst looking through the viewfinder. Ensure that the arc of proposed images contains objects that are close to the camera, contrasted against those subjects that are further into the frame.

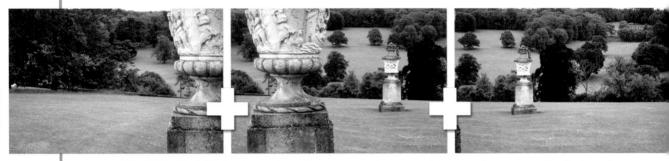

Camera positioning >> Unlike traditional photography the panoramic image-maker must pre-visualize how the stitched picture will appear when considering where to position the camera.

Extend this compositional idea further by intentionally positioning the nearest and most dramatic objects in the scene one-third (or two-thirds) of the way into the sequence of images. This will provide balance to the photograph by positioning this point of focus according to the 'rule of thirds' in the final panorama.

9.02 Camera support

Suitable for Elements – 5.0, 4.0, 3.0, 2.0, 1.0 | Difficulty level – Intermediate | Related techniques – 9.01, 9.09 Though not essential for shooting the odd sequence of images, most panoramic professionals insist on using a tripod coupled with a special panoramic head to capture their pictures. The tripod provides a stable and level base for the camera: the panoramic head positions the camera and lens precisely over the pivot point of the tripod and also contains regular click stops to indicate points in the spin to capture a photograph. Each stop is designed to provide optimum coverage for each frame, taking into account the required edge overlap.

This set up increases the effectiveness of your stitching software's ability to accurately blend the edges of your images. Companies like Kaidan (www.kaidan.com). Manfrotto (www.manfrotto. com) and Peace River Studios (www.peaceriverstudios.com) manufacture VR equipment specifically for particular cameras and lenses. You can purchase a tripod head designed specifically for your camera or choose a head that can be adjusted to suit any camera.

223

Why all this bother with specialized equipment? Photomerge's main task is to seamlessly blend the edges of overlapping images. This is best achieved when the edge details of the two pictures are as similar as possible. Slight changes in the relationship of the objects in the scene will cause problems when stitching, often resulting in 'ghosting' of the objects in the final panorama. Now, for the occasional Photomerge user this is not too big a deal as a little deft work with your Elements editing tools and the picture is repaired (see technique 5.09), but frequent panorama producers will want to use a technique that produces better results

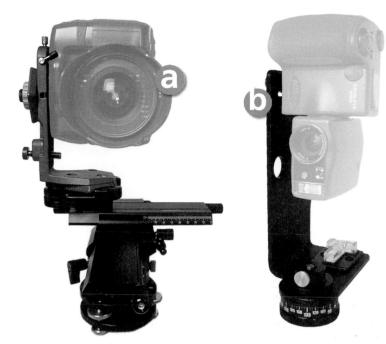

Panoramic tripod heads >> Specialized panoramic or VR (virtual reality) tripod heads are perfect for ensuring that the lens' nodal point is over the pivot point of the tripod. This precision pays dividends at stitching time as Photomerge will produce much better results when the edges of sequential images can be exactly matched. (a) Adjustable Manfrotto VR head suitable for a range of cameras. (b) Camera-specific Kaidan head suitable for a single camera body only.

faster. Using a special VR (virtual reality) or panoramic tripod head produces such results by positioning the 'nodal point' of the lens over the pivot point of the tripod. Images shot with this set up will have edges that match more evenly, which means that Photomerge can blend these overlapping images more successfully and accurately.

Finding the nodal point

If you have a VR head designed specifically for your camera and lens then the hard work is already complete. Simply set up the equipment according to the manufacturer's instruction and you will be taking 'nodal point correct' pictures in no time. If, however, you are using a fully adjustable VR head or you just want to find the nodal point for a specific camera and lens combination you can use the following techniques as a guide.

Some camera or lens manufacturers provide details about the nodal points of their products but, on the whole, this type of data is hard to find and it is up to the shooter to determine the nodal point of his or her own equipment. For this the main method is usually referred to as the 'lamp post' test and is based on a two-step process. With the camera set up and levelled on a panoramic head use the step-by-step guide to find the nodal point. -----

MAKING BETTER PANORAMAS

If the lens' nodal point is rotating over the tripod pivot point then the visual distance (gap) will remain the same throughout the movement. If the distance changes then the lens is not positioned correctly and needs to be moved either forwards or backwards to compensate.

With a little trial and error you should be able to locate the exact nodal point for each of your lenses, cameras and lens zoom points. VR tripod heads, like those made by Manfrotto, excel in this area. The fine-tuning controls and set up scales enable the user to accurately locate and note

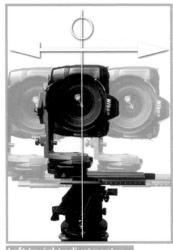

The lens and tripod should be viewed from the front and the lens position adjusted from left to right until it sits vertically above the tripod's pivot point.

You can check your positioning skills by turning the camera 90° down (so that the lens faces the tripod pivot) and confirming that the pivot point is located centrally in the LCD Preview screen. This is the easy part.

Front to back adjustment >> Move the camera back and forward to find the nodal point of the lens. Set camera and tripod up so that there is a vertical object such as a lamp post or sign very near the camera and a similar vertical object in the distance. The closer the foreground object the more accurate the results of the test will be.

Watching the LCD Preview screen (or looking through the viewfinder in an SLR camera) rotate the camera and compare the distance between the foreground and background objects.

the position of the nodal points for a variety of lenses and/or cameras. With the tests complete the results should be recorded and used whenever the same camera set up is required again.

If you don't have a special panoramic head try rotating the camera around the lens rather than pivoting around your body. Also, if you are shooting 'hand-held' use longer focal lengths rather than wide angle lenses; this will help with stitching later.

Handy Guide to Nodal Point Corrections

Use these rules to help you correct nodal point errors:

1. Moving the lens backwards: if rotating the camera away from the foreground object, increases the visual gap, or

2. Moving the lens forwards: if rotating the camera away from the foreground object, decreases the visual gap.

Nodal point errors >>> Many stitching errors are the result of source images being shot with the camera and lens not being centered over the nodal point.

MAKING BETTER PANORAMAS

9.03 Exposure

Suitable for Elements – 5.0, 4.0, 3.0, 2.0, 1.0 | Difficulty level – Basic | Related techniques – 2.03, 9.11

As the lighting conditions can change dramatically whilst capturing the sequence of images you need to make up a panorama, it is important that the camera's exposure be set manually. Leaving the camera set to auto exposure (Program, Aperture priority or Shutter speed priority) will result in changes in brightness of sequential images, especially if you are capturing pictures throughout a full 360° sweep of the scene.

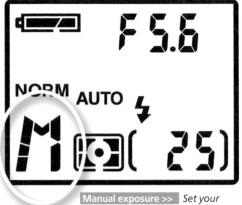

Manual exposure >> Set your camera to manual exposure to ensure consistency across the sequence of images.

Take readings from both the shadow and highlight areas in several

sections of the environment before selecting an average exposure setting, or one that preserves important highlight or shadow detail. Lock this shutter speed and aperture combination into your camera and use the same settings for all the source images. If the scene contains massive changes in brightness this will mean that some parts of the picture are rendered pure white or pure black (with no details): so you may want to consider using the steps in technique 9.11 as a way of capturing more details in these areas. To ensure that you have sufficient picture data to complete the technique capture two or three complete sequences with varying exposures. The exposure for one sequence should be adjusted to record highlights; one for shadows and if required a third can be used to capture mid tones.

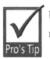

Use your camera's exposure bracketing system to shoot the over-, mid and underexposures automatically.

Average

exposure>> To help ensure that your exposure setting is suitable for all the source images take several readings from all over the scene and then change your camera to the average of these results.

225

9.04 Focus and zoom

Suitable for Elements – 5.0, 4.0, 3.0, 2.0, 1.0 | Difficulty level – Basic Related techniques – 9.05

A similar problem of differences from image to image can occur when your camera is set to auto-focus. Objects at different distances from the camera in the scene will cause the focus to change from shot to shot, altering the appearance of overlapping images and creating an uneven look in your final panorama. Switching to manual focus will mean that you can keep the point of focus consistent throughout the capture of the source images. In addition to general focus changes, the zoom setting (digital or optical) for the camera should not be changed throughout the shooting sequence either.

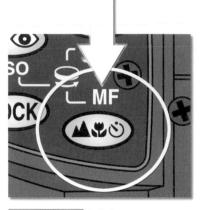

Manual focus>> Switch your camera to manual focus and then set the distance to encompass the subjects in the scene taking into account 'depth of field' effects as well.

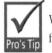

When setting your focus also consider the depth of field that you desire for the image.

Focus and DOF >> Ensure that you consider focus and depth of field at the same time, as both these variables will affect the subject sharpness in your source images. (a) Sharp foreground detail. (b) Background unsharp due to shallow DOF.

Book resources at: www.adv-elements.com

9.05 Depth of field

Suitable for Elements – 5.0, 4.0, 3.0, 2.0, 1.0 | Difficulty level – Basic | Related techniques – 9.04

Despite the fact that cameras can only focus on one part of a scene at a time (focus point) most of us have seen wonderful landscape images that look sharp from the nearest point in the picture right through to the horizon. Employing a contrasting technique, many contemporary food books are filled with highly polished pictures where little of the shot is sharp. I'm sure that you have seen images where only one tiny basil leaf is defined whilst the rest of the food and indeed the plate is out of focus. Clearly focusing doesn't tell the whole sharpness story.

This phenomenon of changing degrees of sharpness in a picture is referred to as the 'depth of field of acceptable sharpness' or 'DOF'. When shooting panoramas it is important to know the factors that control this range of sharpness and, more importantly, how to control them.

226

DOF is controlled by three distinct photographic variables:

Aperture – Changing the aperture, or F-Stop number, is the most popular technique for controlling depth of field. When a high aperture number like F32 or F22 is used, the picture will contain a large depth of field – this means that objects in the foreground, mid ground and background of the image all appear sharp. If, instead, a low aperture number is selected (F1.8 or F2), then only a small section of the image will appear focused, producing a shallow DOF effect.

Focal length – The focal length of the lens that you use to photograph also determines the extent of the depth of field in an image. The longer the focal length (more than 50 mm on a 35 mm camera) the smaller the depth of field will be, the shorter the focal length (less than 50 mm on a 35 mm camera) the greater DOF effect.

Distance from the subject – The distance the camera is from the subject is also an important depth of field factor. Close-up, or macro photos, have very shallow DOF, whereas landscape shots where the main parts of the image are further away have a greater DOF. In other words the closer you are to the subject, despite the aperture or lens you select, the shallower the DOF will be in the photographs you take.

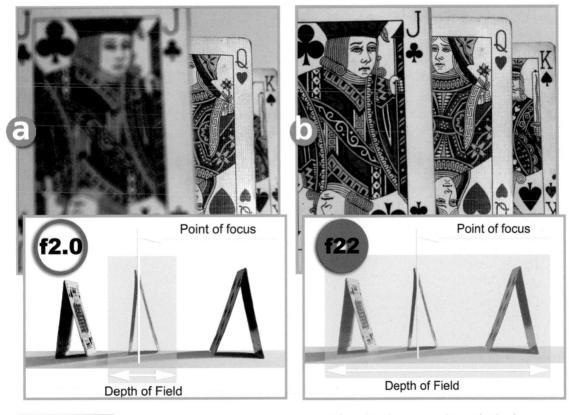

Aperture and DOF>>Most photographers turn to their aperture control first when they want to change the depth of field of sharpness in their images. (a) A small aperture number produces pictures with a shallow depth of field. (b) Selecting a large aperture number produces a larger depth of field.

As most panoramic pictures require sharp details in the foreground, mid and background you should practise setting up your camera for the largest depth of field possible. This means selecting a high aperture number, wide angle lenses and increased camera-to-subject distances wherever possible. It is also good practice to take a couple of test shots of sections of the scene and review these on the LCD monitor on the back of the camera (using the magnification option) to ensure that you have sharpness in the areas of the picture that you desire.

Use the table below as a quick guide for setting up your camera for either shallow or large depth of field effects.

Depth of field effect required	Aperture number	Focal length	Subject to camera distance
Shallow	Low (e.g. F 2.0, 2.8)	Longer than standard (e.g. 120 mm)	Close
Large	High (e.g. F 22, 32)	Wider than standard (e.g. 24 mm)	Distant

9.06 White balance

Suitable for Elements – 5.0, 4.0, 3.0, 2.0, 1.0 | Difficulty level – Basic Related techniques – 2.07

As we have already seen in Chapter 2 the White Balance feature assesses not the amount of light entering the camera, but the color, in order to automatically rid your images of color casts that result from mixed light sources. Leaving this feature set to 'auto' can mean drastic color shifts from one frame to the next as the camera attempts to produce the most neutral result. Switching to manual will produce images that are more consistent but you must assess the scene carefully to ensure that you base your white balance settings on the most prominent light source in the environment.

For instance if you are photographing an indoors scene that combines both daylight through a window and domestic lights hanging from the ceiling then the Auto White Balance feature will alter the color of the captured images throughout the sequence. Switching to manual will allow you to set the balance to match either of the two light sources or even a combination of both using the preset feature (see technique 2.07).

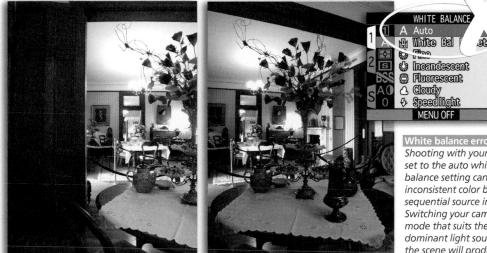

White balance errors >> Shooting with your camera set to the auto white balance setting can cause inconsistent color between sequential source images. Switching your camera to a mode that suits the dominant light source for the scene will produce more even results.

9.07 Timing

Suitable for Elements - 5.0, 4.0, 3.0, 2.0, 1.0 Difficulty level – Basic Related techniques - 9.09

Though not strictly a photographic technique, timing is very important when photographing your sequence of images. Objects that move in the frame or are positioned at the edges of one picture and not the next cause stitching problems when Photomerge tries to blend the edges. The best approach to solving this problem is to wait until the subjects have moved through the frame before capturing the image. A similar solution can be used when photographing in changing

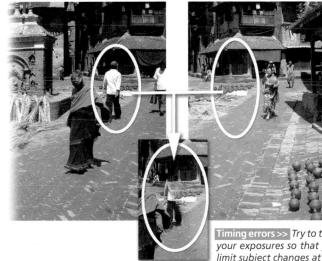

Timing errors >> Try to time your exposures so that you limit subject changes at the edges of your pictures.

lighting conditions. For instance, if you start to capture a sequence of images in full sunshine only to find that halfway through a rouge cloud shadows the scene, then it is best to wait until the sun is shining again before recommencing the capture.

Even though I present some editing techniques later in the chapter that will help you rectify these types of problems the best solution is always to try and capture the most accurate and error-free sequence of source images. In this situation 'prevention is better than cure' and definitely more time efficient as well.

9.08 Ensuring consistent overlap

Suitable for Elements – 5.0, 4.0, 3.0, 2.0, 1.0 Difficulty level – Basic

As you are capturing, ensure that the edges of sequential images are overlapping by between 15 and 40%. The exact number of images needed to complete the sweep of the vista or the full circle

will depend on the angle of view of the lens as well as the amount of overlap that you have used.

A quick way of calculating the pictures needed for 30% overlap is to count the number of images required to complete a full 360° rotation with no overlap and then multiply this value by 3. Or, alternatively, you can use the recommendations detailed in the table below as a starting point for the number of overlap portrait images required to construct a 360° panorama.

Professional VR heads ensure overlap consistency by placing 'click-stops' at regular points on the circumference of the head. On many models this is a variable feature that allows the photographer to change the interval to suit different lenses and/or overlapping amounts. Those on a more modest budget can mark regular intervals on their tripod head using a protractor or use the grid within the camera's viewfinder as a guide.

> Some cameras now provide a special Panorama mode that ghosts the previous shot in the LCD screen so that you can line up or overlap the next picture accurately.

Click-stop heads >> To evenly space sequential image capture points and ensure consistent overlap some companies like Kaidan (www. kaidan.com) produce panorama tripod heads with a built-in 'click-stop' system. The number of stop points is dependent on the angle of view of the lens used to capture the source pictures. (a) Rotating the camera and stopping to capture picture. (b) A variety of click-stop disks designed for use with different camera

(b) A variety of click-stop disks designed for use with different camera lenses or zoom settings.

Focal length in mm (35 mm equivalent)	Number of images required for 360° panorama		
14	12		
18	12		
20	12		
24	18		
28	18		
35	20		
42	24		
50	28		

Number of images for 360° >> Use the table above to calculate the number of overlapping pictures you will need to capture to create a 360° panorama.

V Pro's Tip

9.09 Dealing with the moving subject

Suitable for Elements – 5.0, 4.0, 3.0, 2.0, 1.0 | Difficulty level – Intermediate Related techniques – 9.07 | Tools used – Clone Stamp, Selection tools | Menus used – Filter, Edit

One of the banes of the panoramic photographer's life is the subject that moves during a shooting sequence. These may be people, cars or even clouds but no matter how good your nodal point selection or stitching is, these moving subjects cause very noticeable errors in panoramas. The stitched picture often features half a person, or object, as a result of Photomerge trying to match the edges of dissimilar pictures. These problems can be fixed in one of two ways – either remove or repair the problem area.

(a) Remove – To remove the problem you can use the Clone Stamp tool to sample background parts of the scene and paint over stitching errors. The success of this type of work is largely based on how well you can select suitable areas to sample. Color, texture and tone need to be matched carefully if the changes are to be disguised in the final panorama.

Be careful though as repeated application of the Clone Stamp tool can cause noticeable patterns or smoothing in the final picture. These problems can be disguised by adding a little noise (Filter>Noise>Add Noise) to the image.

(b) Repair – In some instances it is easier to select, copy and paste the damaged subject from the original source image into the flattened panorama picture. This

Step 1 >> Using the Clone Stamp tool (or Healing Brush tool), sample the background around the moving subject and paint over the offending area.

Step 2 >> As repeated stamping can produce a noticeable smoothing of the treated area, disguise the effects by adding a little texture back to the picture with the Add Noise filter.

Step 1>> Using one of the selection tools, outline the problem area in the original source image.

Step 2 >>> Feather the selection by a couple of pixels. This will help blend the selected area when it is added to the panorama.

approach covers the half blended subject with one that is still complete. If you have used the Perspective option in Photomerge or have resized the panorama then you will need to adjust the pasted subject to fit the background. Use the Elements transformation tools such as Rotate, Perspective and Scale to help with this task.

Step 3 >> Copy the selected area (Edit > Copy), click onto the panorama document and paste (Edit > Paste) the selection. Use the Move tool to move the copy into position.

Step 4 >> Use the Eraser tool set to a soft edge and low opacity to help blend the edges of the pasted selection into the background.

Adjusting the opacity of the pasted subject while you are

transforming will help you match its details with those beneath. When the editing is complete, then the opacity is changed back to 100%.

Finishing touches can be applied to the edges of the pasted images to ensure precise blending with the background with the Eraser tool.

Apply a slight feather (Select>Feather) to the selection before copying and pasting. This will help disguise the sharp crisp edge that is the tell-tale sign of so many repair jobs. A setting of 1 or 2 pixels at the most will be sufficient.

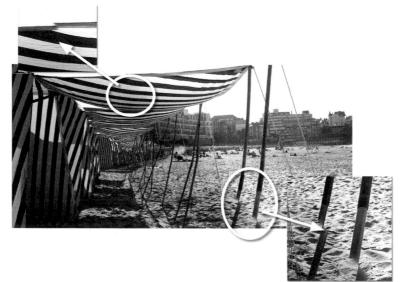

Misalignment >> When capturing source images by hand, or using a standard tripod, slight changes in perspective and position result in Photomerge having difficulty in matching the edges of sequential pictures.

The misaligned picture parts need to be edited and rebuilt using a combination of the approaches outlined in technique 9.09.

9.10 Fixing misaligned picture parts

Suitable for Elements – 5.0, 4.0, 3.0, 2.0, 1.0 | Difficulty level – Intermediate Related techniques – 9.09 | Tools used – Clone Stamp

Shooting your source sequence by hand may be your only option when you have forgotten your tripod or you are purposely travelling light, but the inaccuracies of this method can produce panoramas with serious problems. One such problem is ghosting or misalignment. It is a phenomenon that occurs when edge elements of consecutive source pictures don't quite match. When Photomerge tries to merge the unmatched areas of one frame into another the mismatched sections are left as semi-transparent, ghosted or misaligned.

The affected areas can be repaired using the clone stamp techniques detailed in technique 6.09 but by far the best solution, and certainly the most time, efficient one, is to ensure that the camera and lens nodal points are situated over the pivot of the tripod at the time of capture. A little extra time spent in setting up will save many minutes editing later.

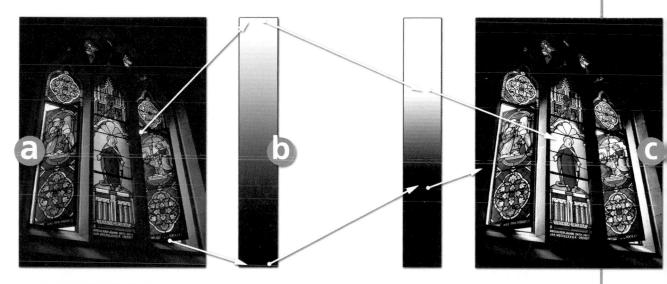

Too much contrast >>> When the contrast range of a scene exceeds the abilities of the camera's sensors, some of the details at the highlight and shadow end of the spectrum are lost. These details are converted to pure white and black. Panoramic pictures that encompass a wide angle of view often suffer from this problem. (a) Range of brightness and detail in the scene. (b) Brightness range of the scene is reduced (clipped) as it is recorded by the sensor. (c) Reduced range of detail and brightness as it is stored in the digital file.

9.11 Coping with extremes of brightness

Suitable for Elements – 5.0, 4.0, 3.0, 2.0, 1.0 | Difficulty level – Intermediate | Resources – Web images 911-1, 911-2, 911-3 | Related techniques – 9.03 | Menus used – Layer

Both film and digital cameras have a limit to the range of brightness that they can capture before details in shadow and highlight areas are lost. For most shooting scenarios the abilities of the average sensor or film is up to the job but in certain extreme circumstances, such as when a panorama encompasses both a view of a sunlit outdoor scene as well as a dimly lit interior, the range of tones is beyond the abilities of these devices.

Book resources at: www.adv-elements.com

233

Rather than accept blown highlights or clogged shadows, the clever panorama photographer can combine several exposures of the same scene to extend the range of brightnesses depicted in the image. The process involves shooting three (or two for less brightness difference) images of the one scene using different exposures. Each exposure is designed to capture either highlight, mid tone or shadow details. The difference in exposure should be great enough to encompass the contrast in the scene. These exposures can be captured automatically using the exposure bracketing technology that can now be found in most medium to high range digital cameras.

Combining the three images: With the three separate image documents open in Elements, hold down the Shift key and drag the background layers of two of the images onto the canvas of the third. Holding down the Shift key will make sure that the new layers are kept in register with

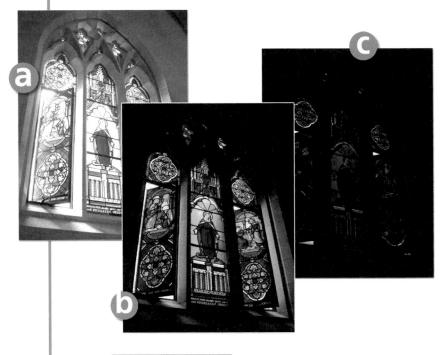

Capturing all the detail >> With your camera fixed to a tripod, shoot three separate images adjusting the exposure settings to: (a) two stops over indicated exposure, (b) indicated exposure and (c) two stops under the settings indicated by your camera.

the existing background. With the Layers palette open, rename and rearrange the layers so that they are ordered top to bottom – underexposed, normal and overexposed.

Changing the overexposed layer: To blend the overexposed image, firstly turn off the topmost layer (underexposed), then change the normal layer's blending mode to Screen. Now select the overexposed layer and choose the Levels function from the Enhance>Adjust Brightness/ Contrast menu. Drag the white Output slider towards the middle of the control. watching the results preview on screen. When the shadow details are visible and vou are satisfied with the effect, click OK.

Changing the underexposed layer: To blend the underexposed image, select its layer and change the blend mode to Multiply. With the layer still selected choose the Levels function and drag the shadow Output slider towards the center of the dialog. When the highlight and shadow details are visible and you are satisfied with the effect click OK. Save a layered version of this image as the original and a flattened (no layers) copy which can be imported into Photomerge as a source image for your stitch.

Step 1>>> Open the images with different exposures. Tile the documents so that all pictures can be seen (Window > Images > Tile).

Step 2 >> Drag two of the pictures onto the third with the Move tool whilst holding down the Shift key.

Step 3 >> Arrange the layers so that from top to bottom they are positioned underexposed, normal and overexposed. Name the layers.

Step 4 >> Hide the top layer by clicking the Eye icon. Change the normal layer's mode to Screen. With the overexposed layer selected, choose the Levels function. Drag the white point Output slider towards the center of the dialog.

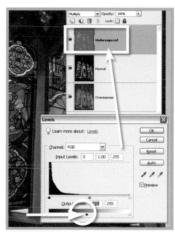

Step 5 >> Change the mode of the underexposed layer to Multiply. Select the Levels feature and move the black point Output slider towards the center of the dialog.

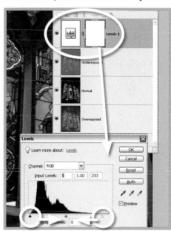

Step 6 >> To fine-tune the process, apply a Levels adjustment layer (Layer > New Adjustment Layer > Levels) to the stack, being sure not to clip newly created highlight and shadows detail.

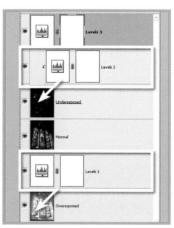

This technique can be applied non-destructively to the layered image by using Levels adjustment layers to change the tonal values of the under- and overexposed layers.

To ensure that the levels adjustment is only applied to a single layer start by inserting the adjustment layer above the layer to be changed.

Next make the tonal alterations and then group the adjustment layer with the changed layer using the Editor: Layer > Group with Previous command. Ξ

235

MAKING BETTER PANORAMAS

9.12 Creating artificially increased DOF

Suitable for Elements – 5.0, 4.0, 3.0, 2.0, 1.0 | Difficulty level – Intermediate Related techniques – 9.06 | Tools used – Selection tools, Eraser | Menus used – Edit

In some environments it may not be possible to gain enough depth of field to extend the sharpness from the foreground details into the background of the picture. In these circumstances you can still simulate this large depth of field by shooting two different sets of source images – one with focus set for the foreground objects and a second set for the background details. Later, at the desktop, the sharp detail from the foreground can be cut out and pasted over the background pictures. As we have seen with other cut and paste techniques, a little feather applied to the selection before cutting helps to ensure a convincing result at the pasting stage.

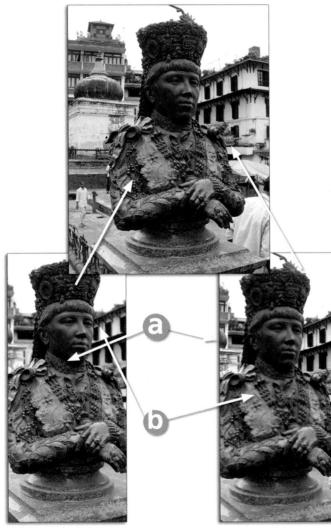

Step 1>> Open the two source files. Carefully select the foreground detail using your favorite selection tool. Feather the selection by 1 pixel.

Step 2 >>> Copy and paste the selection onto the background, using the Move tool to position. Clean up with the Eraser tool if needed.

9.13 Correcting exposure differences

Suitable for Elements – 5.0, 4.0, 3.0, 2.0, 1.0 | Difficulty level – Intermediate Related techniques – 9.03, 9.14 | Tools used – Eyedropper | Menus used – Image, Window

Changes in density from one source image to the next can occur for a variety of reasons – the sun went behind a cloud during your capture sequence or the camera was left on auto exposure and changed settings to suit the 'through the lens' reading. The images that result vary in density. When these images are blended the change in tone is most noticeable at the stitch point in large areas of similar color and detail such as sky or road

surface.

Auto Fixes – Photomerge contains an 'Advanced Blending' feature that tries to account for slight changes in overall density from one frame to the next by extending the graduation between one source image and the next. This 'auto' technique will disguise small variations in exposure and generally produce a balanced panorama, but for situations with large density discrepancies the source images may need to be edited individually.

Manual Fixes – The simple approach to balancing the density of your source images is to open two or more of the pictures

Advanced Blending >> The Advanced Blending option in Photomerge can help to disguise slight differences in contrast, brightness and color.

and visually adjust contrast and brightness using tools like the Levels feature. For a more precise approach it would be useful to know the exact values of the same section of two overlapping images. The Info palette in Elements displays the RGB values of a specific area in a picture. When used in conjunction with the Levels feature it is also possible to display the values before and after density changes. Knowing the RGB values of the first image, you can alter the values in the second to match, thus ensuring a seamless stitch.

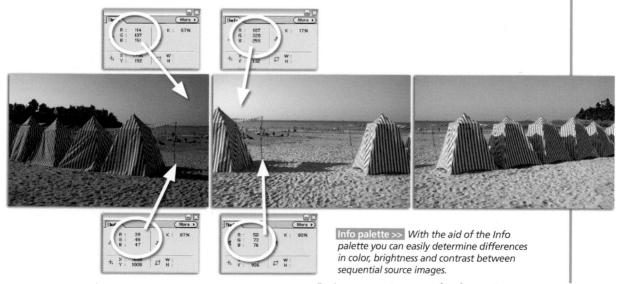

This process is timeconsuming and is a 'work around' for what is essentially a flaw in your shooting technique. So if

your source images continually need this level of adjustment revisit the process you use to capture you pictures and ensure that:

- You have your camera set to manual exposure, and
- You are capturing all the source images under the same lighting conditions.

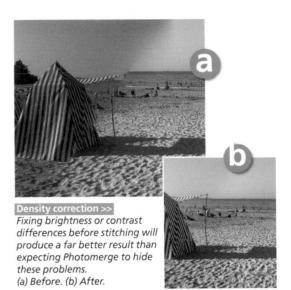

Step 1 >> Open a picture with good brightness and contrast as well as the picture that needs adjusting. At the same time display the Info palette (Window > Info).

Step 2 >>> Click onto several matching points on both pictures taking note of the red (R), green (G), blue (B) and grayscale (K) settings for each.

Step 3 >> Make contrast and brightness adjustments to the problem image checking the changed readings in the Info palette as you go until both pictures display similar values.

9.14 Adjusting for changes in color balance

Suitable for Elements – 5.0, 4.0, 3.0, 2.0, 1.0 | Difficulty level – Intermediate Related techniques – 9.13 | Tools used – Eyedropper tool | Menus used – Image, Window

Slight changes in the color balance of sequentially shot images can result from using the Auto White Balance feature to rid images of casts resulting from mixed light sources. As the color of each frame is assessed and corrected independently, changing subject matter can cause such color shifts. More uniform results are obtained if the white balance is set based on the primary light source in the scene and then kept constant for the rest of the shooting sequence.

238

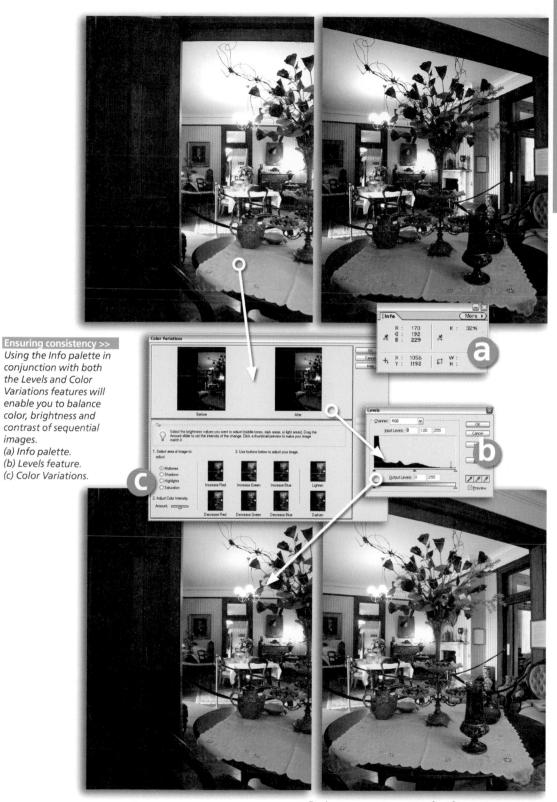

images.

For slight discrepancies in color, tools such as the Auto Color Correction (Enhance>Auto Color Correction) feature will be able to automatically even out some of the changes, but for big changes in color a frame-byframe correction technique similar to the one outlined for exposure differences can be used. This time instead of using Levels to make your adjustments you can employ a color control feature such as Color Variations (Enhance>Color Variations), which can be used in conjunction with the Info palette to match different color values in sequential images.

9.15 Vertical panoramas

Suitable for Elements – 5.0, 4.0, 3.0, 2.0, 1.0 Difficulty level – Basic | Related techniques – 9.16 For most of the time you will probably use Photomerge to make horizontal panoramas of wide vistas, but occasionally you may come across a situation where you can make

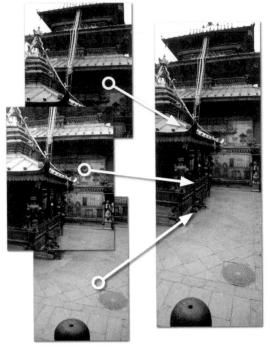

Vertical stitching >>> Don't restrict yourself to only stitching horizontal pictures. Why not also use Photomerge to stitch those very tall shots that you just can't capture in a single photograph?

use of the stitching technology to create vertical panoramas rather than horizontal ones. When capturing the vertical source images be sure to follow the same guidelines used for standard panoramas, i.e. check exposure, focus, white balance, focal length and shooting position.

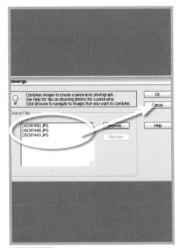

Step 1 >> Add your pictures to Photomerge as you would for a horizontal composition.

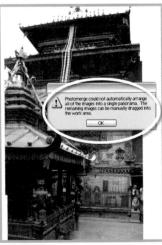

Step 2 >>> Photomerge may display an error message as it tries to automatically arrange the pictures. Click OK.

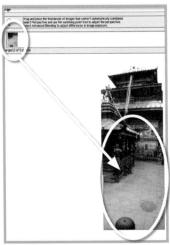

Step 3 >> Manually drag the unplaced pictures into position. Turn on Perspective and Advanced Blending before clicking OK to finish the stitch.

9.16 High-resolution mosaics

Suitable for Elements – 5.0, 4.0, 3.0, 2.0, 1.0 | Difficulty level – Basic | Related techniques – 9.15

Another not so familiar use of the Photomerge technology is the production of high-resolution picture mosaics. In this application, the photographer captures a series of overlapping images, both vertically and horizontally, of the same scene. These images are then stitched together to form a photograph that is both wider and taller and contains more pixels than your camera would normally be capable of.

This approach is particularly suitable for those scenes where you just don't have a lens wide enough to encompass the whole vista, or situations where detail is critical. The higher resolution of the final stitched result also provides the extra digital information necessary to print big pictures (A3, A3+ or even A2) with little or no loss of quality or detail.

Unlike when you are capturing the source pictures for panorama production, high-resolution stitches require pictures that overlap on all sides that are to be stitched. This means that at the time of shooting you need to pay particular attention to edges of the frame and ensure a 20 to 40% consistent overlap.

Pro's Tip: If your camera contains a grid feature that can be displayed in the viewfinder, position the grid line closest to the edge of the frame on a subject that will be present in the overlap. Next turn the camera and make sure that the same subject is present in the frame on the grid line at the opposite side of the viewfinder.

Mosaic stitches >> Create very high-resolution wide angle pictures that contain stunning detail and quality by capturing a series of overlapping pictures and stitching them with the Photomerge feature. (a) Mosaic source images that overlap on all stitching sides. (b) Turn on both the Advanced Blending and Perspective options in Photomerge. (c) Use the Cropping tool to trim away the ragged edges that are the result of the perspective deformation. (d) The final mosaic picture is higher resolution and covers more of the scene than would have been possible with a single camera shot.

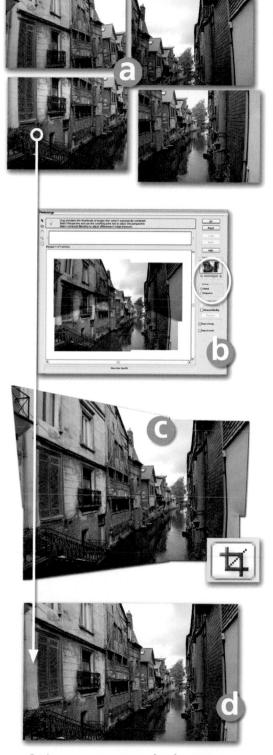

Book resources at: www.adv-elements.com

MAKING BETTER PANORAMAS

9.17 Panoramic printing

Suitable for Elements – 5.0, 4.0, 3.0, 2.0, 1.0 | Difficulty level – Intermediate Related techniques – 10.01 | Menus used – Edit

Given the format of most wide vista photographs, printing on standard inkjet paper will result in much of the printing surface being left unused. Printer companies like Epson now produce pre-cut panoramic paper in a photographic finish. These sheets are convenient to use and their proportions are stored as one of the default paper settings on all the latest model printers.

Another approach is to use the roll paper format that is now available as an option on several different models. This option provides the ability to print both long, thin and standard picture formats on the same paper, reducing the need for multiple paper types. Using these special roll holders the printer can output different image formats back to back and edge to edge, providing cutting guidelines between pictures if needed.

For those of you with just the occasional need to print panoramas, another approach is to cut standard printing papers lengthways. This action produces very usable wide thin stock that is half the usable dimensions of the standard sheet. See the table below for the different paper types and the panorama print sizes that can be output on each.

With the paper organized it is now necessary to set up the printer for the new sizes. If you are using the pre-cut sheet or roll paper, then these options should be available in the drop-down paper menu of the latest printer driver for your machine. If the options are not present, or you are using panorama paper that you have cut yourself, then you will need to set up a custom paper size to suit your needs. On Epson machines you can do this by opening the printer driver, selecting the Paper tab and choosing the User Defined option. The dialog that is displayed will allow you to create, label and save your own paper size. These newly created paper size options will then be available for you to choose when you next open the Elements print dialog. More printing techniques can be found in Chapter 10 of the book, including instructions for making a panorama-friendly Picture Package.

Basic Paper Type	Possible Panorama Print Size
A4	105 x 287 mm (1/2 full sheet)
A3	148 x 420 mm (1/2 full sheet)
A2	210 x 594 mm (1/2 full sheet)
A4 Roll	210 mm x 10 m
100 mm wide Roll	100 mm x 8 m
Panoramic Paper	210 x 594 mm (pre-cut sheet)

Step 1 >> Select the Paper tab from the Epson printer driver and choose User Defined from the drop-down Paper Size menu. Input the paper size in the width and height boxes and then save the settings. Click OK.

Step 2 >>> Once saved the new paper sizes can be found as extra options under the Paper Size menu.

Step 3 >> When it comes time to print a panoramic picture you can now select one of your pre-defined paper sizes and Elements will preview the photograph positioned against the background of the new paper format.

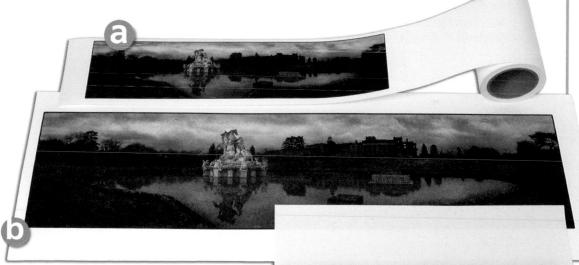

Panoramic print options >>> Because of the wide thin nature of most panoramic photographs, printer companies like Epson have developed special settings for their hardware as well as a range of paper sizes to accommodate the unusual format. (a) Roll paper can be customized to suit both standard print formats as well as wide panoramic prints. (b) Special pre-cut papers in 'photo print' finishes are also available. (c) Panoramas can be printed on standard paper sizes, but much of the sheet is left blank.

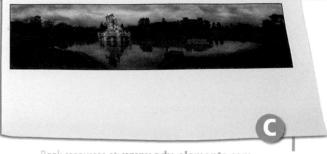

MAKING BETTER PANORAMAS

9.18 Spinning panorama movies

Suitable for Elements - 5.0, 4.0, 3.0, 2.0, 1.0 | Difficulty level - Intermediate | Resources - Web links

Many wide vista photographers choose to present their work in an interactive spinning format rather than as a print. This way of looking at images is often called Virtual Reality (VR) and is used extensively on the internet to give viewers the feeling that they are actually standing in the environment they are seeing on screen. Holiday destinations and real estate previews come to life via this technology. When the VR panorama opens you can navigate around the scene looking left and right with nothing more than simple mouse movements.

Although the ability to output your flat panoramic pictures in a VR format is not an integrated function of the Elements Photomerge feature there are several options for those who want to get their wide vista pictures spinning.

Moving panoramas >> Photomerge users can take their panorama pictures beyond the static print by converting their stitched images to spinning vistas that can be navigated on screen and distributed via the web. For a complete 360° spin overlapping images need to be captured for the whole scene.

Apple QuickTime Viewer >> The QuickTime plug-in is the most well known of all the VR viewers.

Converting flat pictures to spinning movies

The process of getting your flat Photomerge panoramas to spin on screen involves two essential steps:

- Converting the pano photograph to a format that is suitable to be displayed, and
- Linking the converted file to a viewer or presentation utility which actually controls the on-screen display.

The standard QuickTime web plug-in, that can be freely downloaded from Apple and installed, is the most well known of all VR viewers. Along with being able to show movies, play sound and display a variety of still picture files the plug-in can also show panoramic movies that are saved in the QuickTime movie format. The viewer includes buttons to zoom in ('+') and zoom out ('-') of the panorama and the viewer navigates the scene by click-dragging the cursor side to side or up and down in the display window.

244

There are many commercial, shareware and even freeware utilities that will help you convert your flat Photomerge Panorama files to the QuickTime VR movie format (QTVR). Most of the commercial programs contain their own stitching utilities (like Photomerge) and the Conversion to VR movies feature is just one of the many output options offered. As Photomerge users don't need the stitching component of these programs the QuickTime utilities included here and detailed below only handle the conversion process. Once converted to the QTVR format the files can be viewed using the QuickTime plug-in.

There is also a range of non-QuickTime viewers and conversion utilities. Most of these use a small Javascript-based program to provide similar display features to those found with QTVR. Again, most utilities used for creating these non-QuickTime movies are included with stitching features in a fuller program, but the options detailed below use stand-alone software to create spinable movies from basic JPEG panorama picture files.

OPTION 1: Converting Photomerge output to the QuickTime movie format

Elements users can convert their Photomerge output to Apple's QuickTime VR movie format using a free utility available from the Apple website. Both Windows and Macintosh versions of the software are available. Simply save the stitched image as a Macintosh PICT file, rotate it to the left (so that it is tall and thin) and then convert the picture using the Make Panorama utility. The resultant file can be viewed (and navigated) with any QuickTime player and has the added bonus of being able to be uploaded to the web and viewed on-line.

Free convert to QuickTime VR utilities:

Go to developer.apple.com/ samplecode/VRMakePano/ VRMakePano.html and download the VRMakePano utility.

Step 1 >> Rotate the completed Photomerge file to the Left (Image > Rotate > 90° Left before saving as a PICT file (File > Save As).

Step 2 >> Start the VRMakePano utility and open the PICT file via the Test > Make Movie menu. Follow the onscreen prompts and specify image, tile and movie files in the dialogs provided.

Step 3 >> In a new dialog you will be prompted to export the results to a movie file. Here you can adjust the quality and size of the final panorama using the options on this screen.

OPTION 2: Using Pano2Exe

Windows users can make similar spinning panoramas to those destined for displaying in a QuickTime viewer using a small economical utility called Pano2Exe (http://www.change7.com/pano2exe/). The program converts JPEG output from Photomerge to a self-contained EXE file, which is a single easily distributable file that contains the image itself as well as a built-in viewer.

File Edit	Image	Enhance	Layer	Select	Filter	View	Windo	wł
New			Ctrl+N	1	a.	Gy	3 4	2
New fro	m Clipbo	ard) Loof	~		-
Open			Ctrl+C		Reso	lution:		
Browse			ft+Ctrl+C	100345	CONTRACT,	Sectors	-	2005
Open A		A	lt+Ctrl+C				and less	1000
Open R	ecent			•				
Create	Photome	rge						
Close			Ctrl+W	20029				
Sam			2449					
Save A			ft+Ctrl+!	9) <u> </u>				
- ··· Fr	or Web	F.A.st	ft+Ch-1	100	(Calling	-		
Revert	and the second se	many he						
			·					-9/5
Atte	ave As							
Atte	ave As		-					
Atta Cre Sa Onia	ave As	Save in:	0 · 10					
Atta Cre Sa Onli Plac	ave As			eo. too				
Atte Cre Su Onli Plac Imp	ave As		a pp	eg.jpg		20.8		
Atta Cre Sa Onli Plac	ave As)		eg.jpg				
Atte Cre Su Onli Plac Imp	ave As	cent		eg.tpg				
Atte Cre Se Onli Plac Imp Esp	ave As	cent		eg.jpg				
Atte Cre Se Onli Plac Imp Esp Bab Aut	ave As	cent		eg. tog				
Atte Cre Se Onli Plac Imp Esp Bab	Ave As My Re Docum	cent tents		eg.jpg				
Atte Cre Se Onli Plac Imp Esp Bab Aut	ave As	cent tents		eg.jpg				

Step 1 >> Save completed Photomerge

file as a JPEG file (File>Save As or File>

Save for Web).

Step 2>>> Open picture into Pano2Exe program (File > Open Panoramic Image) and set width and height of navigation window.

Step 3 >> Save the spinning panorama as an executable file (.EXE) ready for distribution.

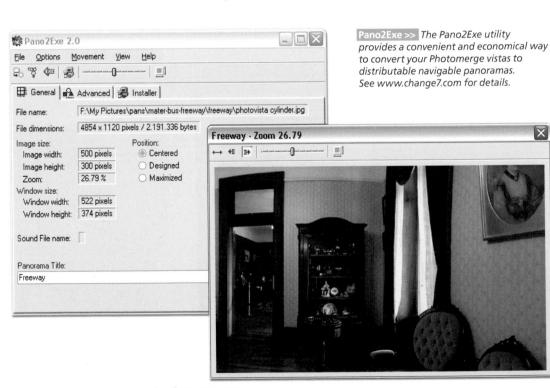

Book resources at: www.adv-elements.com

OPTION 3: Making web pages with a Java Applet-based viewer

For those readers with a good understanding of how to create web pages you can also add your Photomerge panoramas to your website with the aid of a small piece of viewer code. In most cases this code is supplied in the form of a Java Applet. Civic-minded developers like Karl Maloszek at www.panorado.com supply their own applet for free when used on private websites.

The web panorama page is built of three components:

- The HTML page,
- The panorama image file (saved as a JPEG), and
- The viewer applet.

These three files must be present in order for the page to display properly.

To create a panorama page you will need to download the Panorado applet and save the Java archive (Panorado.jar) to your destination folder. Next create a blank web page and insert the HTML code, that controls the viewer and links your panorama photo to the viewer, into the code of the page. To make this process a little easier, for example HTML code can be cut and pasted from the Panorado website directly into your page.

Java applet >> www.Panorado.com provides Java Applet viewer that can be used free of charge for non-commercial websites.

The viewer can be positioned in a scalable pop-up window which also contains HTML-based control buttons or in the middle of a document page (normally in a smaller rectangle or frame).

Creating web pages using a Java-based viewer is not as automated as the other two approaches detailed previously. The process requires that the user understands the basics of HTML coding and how to correctly set parameters in that code.

WWW.PANORADO.COM >>

Karl Maloszek at Panorado produces a non-QuickTime viewer that can be used to create interactive panorama web pages. Along with his applet and viewer software his site also contains a variety of example panoramas that display how this technology works. Images courtesy of www.panorado.com © 2005.

9.19 Panorama workflow

If the 'proof of the pudding is in the eating' then the success of all your careful shooting, stitching and editing work is in the viewing (of the final panorama). Logical planning and execution is the key to high quality wide vista photographs.

In this chapter I have introduced a range of techniques that will help you make great panoramas, but remembering the techniques and order that they should be used can be difficult. Use the steps in the workflow table (aside) to help you sequence your setting up, shooting, stitching, editing and producing activities.

Recommended Panoramic Workflow

	Choose camera position to ensure good foreground, mid ground and background distribution of subject				
Setting up	Sweep the scene looking through the viewfinder to position points of focus using the rule of thirds layout				
		Mount camera on VR tripod head			
	Use camera hand-held	Adjust camera position to ensure nodal point pivot			
		Adjust 'click-stop' setting to suit overlap and lens			
	Coloris Manual Empire	Select Manual Exposure mode			
Shooting	Select Manual Exposure mode	Meter for both highlight and shadow detail			
		Turn off Auto White Balance feature			
	Turn off Auto White Balance feature	Select the White Balance setting that be suits the dominant light source in the scene			
		Select Manual Focus mode			
	Select Manual Focus mode	Preview depth of field to ensure foreground and background objects are sharp			
	Don't alter zoom settings				
	Shoot source sequence ensuring 20–50% overlap	Shoot 2 or 3 source sequences ensuring 20–50% overlap with different exposure settings for highlights, shadows and mic tones.			
		Shoot close-up details to use for artificia depth of field effects			
Stitching and editing		Combine multi-exposure source images			
		Make adjustments for exposure			
	Download and stitch	differences			
	source images using Photomerge	Make adjustments for color difference			
		Import corrected source images and stite using Photomerge			
	Edit misaligned areas				
	Edit moving subject areas				
	-	Add artificial depth of field foreground elements			
Produce panorama	Print panorama or produce spinning VR image				
Image quality	Good Best				

Tools Help

:65

x

Extending Your Web Abilities

ADVANCED PHOTOSHOP ELEMENTS 5.0 FOR DIGITAL PHOTOGRAPHERS

'm old enough to still remember the ubiquitous 'black' folio case. In fact I think my chiropractor remembers it as well; I have been a regular client ever since. It wasn't just the weight of 30–40 matted prints that made the task difficult; it was the unwieldy size of the case that made touting the folder from office to office a daunting task.

I'm happy to say that there is a new set of imagemakers (professionals and amateurs alike) who have no knowledge of my folio-carrying woes. The notion of the folio still exists and remains the stable marketing device of most creative professions, but the black case may be gone forever. In its place is a cyberspace folio, accessible any time, and place, for potential clients or admirers, armed with nothing but a common web browser.

Open 24/7

The web is a 'godsend' for photographers who are eager to display their pictures. An on-line gallery space which contains biographical and résumé details, as well as a folio full of examples of past work, is like having a personal promotions manager on hand 24 hours a day, 7 days a week. Never before has it been possible to share your photographs with such ease or obtain this much exposure of your talent and abilities for such little cost.

Gone are the days where you have to send your precious images to far flung parts of the country in order to share that precious moment of little Johnnie's first step. A few simple clicks from anywhere in the world and Johnnie's agility and prowess can be admired by all.

Photo site styles

Photo sites come in all shapes and sizes and no matter whether you are part of a multinational imaging company or a weekend shooter who wants a few images on a page, a little design thought early on will Book resources at: **www.adv-elements.com**

Photo website styles

The style of the site you make will depend on the nature of your work and the content that you wish to share with the world.

Thumbnail and gallery >>

Prolific image-makers who want to keep an archive of their work on-line will need to use a design that allows many images to be previewed before selecting a single picture to look at in higher resolution. Usually referred to as a 'thumbnail and gallery' design, this is by far the most popular form of photo website on the net today.

Used by photographers, galleries and stock agencies, this design is a great way to provide quick access to a lot of pictures. Because of the size of the thumbnails they download quickly and placing a single image on individual gallery pages also speeds up their display time. The format has proved so popular that packages like Photoshop Elements include automated wizards for creating these type of photo sites.

On-line résumé >>

Professional image-makers saw the potential of the web as a marketing tool very early in the life of the net. They frequently use it to hold CV or résumé information including lists of past and present clients, contact details and, of course, a few of their images. In fact, most shooters who make a living from their pictures probably have a site that is a combination of the thumbnail/gallery type introduced above and the on-line résumé we see here. This type of web presence is now a necessity rather than a nicety for most photographic businesses.

Slide show >>

In an interesting variation of the thumbnail/ gallery folio site, some image-makers have dragged the automated slide show presentation idea of old squarely into the 21st century. Using interactive technologies like the Adobe Flash format and the new animated web templates in Elements, these photographers have created online slide shows that display a changing sequence of their best images.

All on one page >>

The simplest approach to making your own website is to combine your images and text on the one page. Doing so means that there is no need to worry about making and linking extra pages. This approach is handy for those who want to give their audience a taste of their work and then provide contact details for further information, or for the photographer who wants to establish a web presence quickly, before finally linking the thumbnails to a range of gallery pages.

251

make for a better site. Just as there are various styles of digital imaging magazines there are also different forms of the humble photo website.

A little time spent surfing will have you easily identifying different types of sites made by photographers. There are those that are full of shooting information – facts and figures, others that display a design-based approach, and the most popular – the virtual gallery. Time spent on the web will also provide you with the opportunity to see what works and what needs to be avoided when creating your own site.

Using what you learn from your on-line roaming make some decisions about the style of site you want. Are the pages full of information about you, your history and your past work, is the site a sales point for your images or is your web presence designed to 'wow' your friends and family with the vibrancy and energy of your imaging and/ or design skills?

Building websites - the basics

All websites are constructed of several different components or elements. These separate pieces, which include text, images, buttons and headings, are called web assets and are arranged, or laid out, in groups on individual pages. When viewed on screen these pages appear as a single document, much the same as a wordprocessed page. But unlike a typical printed page the components that make up a website remain separately saved files and the web page document itself simply acts as a series of pointers that indicate where elements are to be found and how they look and where they are placed on the page.

You can view the source code or HTML text of any page by selecting the View > Source option in your browser. What you will see is a series of instructions for the location and layout of the page parts and their files. When a viewer looks at the page, the browser software recreates the document, finding the component files and laying them

Website styles >> Most photographers' websites are based around a gallery idea and consist of: (a) a front or home page, (b) an index of thumbnails, and (c) a series of individual gallery pages. www.brittan.demon.co.uk. Courtesy of Philip J Brittan © 2005, UK. EXTENDING YOUR WEE ABILITIES

out as instructed by the HTML code. As you start to make your own pages this is an important concept to remember, as you will need to keep track of all the various files that are used throughout the site and ensure that they are available when requested by the browser.

Creating web pages without writing HTML

Until recently, creating your own web pages required budding net designers to have a good working knowledge of HTML. Now there are many software programs on the market including Elements that allow you to create a web page or site without ever having to resort to HTML coding.

There are essentially two approaches. You can:

- Choose to use a package designed specifically for web page production such as Microsoft FrontPage and use Elements to optimize your pictures and make your buttons and headings, or
- Employ some of the great automated web production features bundled as extras in Elements.

Either way you get to concentrate on the design not the code. Thank goodness! In this chapter we will look at both approaches by firstly creating a multipage website using the newly revised Elements' Photo Gallery feature and then go on to create all the web assets for a second site in the program before laying them out in a web production program.

Website assets

The various components that are used to make up a web page or site can be broken into several main categories:

Images >>

Images form the backbone of any photo site. Creating image assets is a process where the picture is optimized in size and quality so that it can be transmitted quickly over the net. For a photo gallery site both thumbnail and gallery images need to be created.

Headings >>

Headings that are present on every page are usually created and saved as a picture rather than text. For this reason the same optimization process involved in the production of pictures for the net is used to create headings for the site.

Buttons >>

Buttons come in a variety of formats, both still and 'roll-over' or animated. The face of the button is created with an illustration or picture using an image editing package. The Button function, moving the viewer to another page on the site for instance, is controlled by a small piece of code added later in the layout package.

Text >>

Text can be typed directly into position using the layout software or compiled in a word processing package and then imported. In the example site the photographer's information and details may be able to be taken from an already prepared CV or résumé.

Animation, sound and movies >> Animation, Sound and Movie assets are usually created in third-party dedicated production packages and added to the site in the layout part of the process.

HTML code >>> Web pages are constructed of several different parts including text, images, buttons and headings. The position of each of these components is controlled by the HTML code that sits behind the page. The page parts are brought together using these coded settings when you look at the page in your browser.

252

10.01 Elements' Photo Galleries websites

Suitable for Elements - 5.0 | Difficulty level - Basic | Related techniques - 10.02, 10.03 | Menu used - File The Elements Photo Galleries tool (previously called Web Photo Gallery and HTML Photo Gallery tool) is a purpose-built feature designed to take a selection of images and produce a multi-page fully linked gallery site in a matter of a few minutes. The updates of the feature over the last few editions of Elements mean that users now have even more choice and control over the way their site looks and works. You now can choose between basic thumbnail and gallery type sites or new animated or interactive designs. All sites produced by the feature use Adobe Flash technology and so the pages load quickly and the animated components in the productions work smoothly. The feature contains a variety of settings in its two dialogs that allow the user to select the style of the site and then to customize both the look of the pages as well as the information presented. Viewers navigate round the site, from image to image or back to the front page via a series of

arrow buttons or, with some designs, the images automatically change in a slide show format. Once completed the finished site can then be shared with the world; Elements 5.0 is the first version of the program where the often confusing task of uploading to an ISP or web server is also handled inside the feature. So with as little as five mouse clicks it is possible to select, create and upload your very own professionally designed web gallery.

Choose the images

In Elements 5.0 you can multi-select the images to include in the gallery from the Organizer workspace before opening the Photo Galleries feature. Don't panic if you forget an image though as you can also choose to add or remove photos from inside the feature's first dialog. Select your images and then choose File > Create > Photo Galleries.

As no edit or enhancing options are available inside the Website Production feature make sure that the photos that you want to **Pro's Tip** include are already enhanced before starting the process.

Select a website style – screen 1

The Photo Galleries feature contains two wizard based-screens. The first is used for selecting the type of website that you want to create and the second is where you customize the presentation before uploading it to the web. The photos that you selected in the Organizer workspace are automatically imported into the first screen and are listed on the left of the dialog. If you have sourced the photos from an Elements' collection then the sequence of

images is preserved during import, otherwise the images are listed top to bottom in the same order that they were selected (left to right) in the Photo Browser. The order can also be adjusted once the files are in the dialog by click-dragging individual thumbnails up or down the list.

Auto website creation >> The quickest and easiest way to create a website is to use the in-built Photo Galleries feature in Elements 5.0. With a few clicks you will have a fully functioning 'thumbnail and gallerv' website.

Now on to selecting the template to use for the site. Elements 5.0 has a choice of three different types:

Web Galleries – Traditional thumbnail and gallery image sites with plenty of customization of the site's look as well as the option to save your custom changes as a new style for later use.

Animated – Fully animated and themed sites with less customization opportunities but plenty of wow factor.

Interactive – Again less options for altering the look of the design but many of the templates here are truly dynamic and provide the option for the user to control the way that the pictures are viewed. Very cool!

The site type is selected at the top of the screen from the drop-down menu. This choice will alter what is displayed in the rest of the dialog. Selecting Web Galleries will display two sets of thumbnails. The upper ones allow you to choose a Type, or basic look, and the lower set displays color or style variations of this type. Choose the Type first and then the Style. Choosing the Animated or Interactive templates displays a single set of thumbnails as well as a preview of the website in action in the lower section of the dialog. Once you have made your selection click the Next Step button.

Photo Galleries Wizard - screen 2

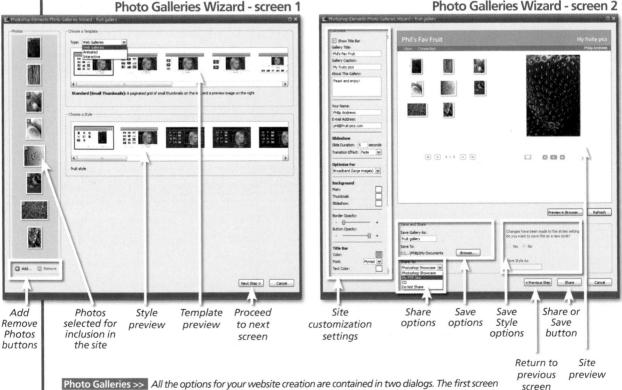

in the Photo Galleries wizard is for selecting the type of website to create and for adjusting the photos selected for inclusion and their order. The second screen provides customization options, a preview of the site as well as Share and Save options.

Step 1>> Multi-select the images to include in the site from those in the Organizer workspace. To pre-order a group of pictures, add them to a collection first and then click-drag them into your chosen sequence.

Step 2 >> Start the feature by choosing the Photo Galleries entry from the Create Shortcut button. Alternatively select File > Create > Photo Galleries.

Step 3 With the first wizard screen open, click-drag photos to alter the order that they will be used. Add new photos to the list or remove existing images using the Add or Remove buttons.

Step 4 >> Choose the website Type from the drop-down menu. Next pick a specific template from the thumbnail list. For Web Galleries templates select a template style. Click the Next Step button.

Step 5 Set the custom options for the website template that you have chosen. Different options are available for different templates. Add in website title and contact details.

Step 6 >> Preview the site and your custom settings by clicking the Preview in Browser button.

Save and Share Save Gallery As: FOUSALED callery Save To: Dt/PSES-Demo-Cat Browse... Photoshop Showcase V

Step 7 >> Insert the saving name for the gallery. This will be used as the name of the folder where the gallery files will be saved as well as the creation file entry in the Organizer space. Also nominate the save directory.

Step 8 >>> Next, select the method for sharing the gallery. To save, choose the Do Not Share option. To make use of the Photo Showcase web space select this option. To distribute the website via disk choose the CD entry.

Step 9 >> To upload to an existing web space, pick My FTP Site. Click the Share button and then add in your ISP settings. These settings are available from your ISP provider.

Adjust the website settings - screen 2

The second screen in the wizard contains custom settings, site preview and share and save options. The number and type of customization options will depend on the website template that you have selected. For all templates you can add in a site title and contact details for the photographer, however when selecting the web galleries you will find that you have many more customization options. With this set of templates you can also adjust site colors, border and button opacity, connection speed optimization, slide show settings, and caption and file name inclusion.

Previewing your site

Once you have completed adding in details and adjusting the site's settings you can preview the results via the preview space in the top right of the screen. You may need to press the Refresh button to display any recent changes. To see how the site will look and function in a real web browser click the Preview in Browser button and a temporary version of your site will be displayed in your computer's default browser. You may also be prompted to download the latest Flash plug-in, if you don't already have it installed in your default browser.

Sharing the site

The only job left now is to share your masterpiece of web design with the world. This used to be a tricky task involving complicated procedures and extra bits of utility software but Elements 5.0 has thankfully streamlined the process. Now the Photo Galleries feature also includes three quick ways to share your website (plus a non-share or purely save option). The choices are listed

in the Share To drop-down menu at the bottom of the dialog and include:

Photoshop Showcase – Upload to a free on-line sharing area provided by Adobe Photoshop Services.

My FTP Site – Transfer to your own ISP or net space provider.

CD – An option for burning the gallery directly to a CD.

C:\\Philip\My Documents	Browse
Share To:	
Photoshop Showcase 🔽	
Photoshop Showcase My FTP Site CD	
Do Not Share	

Share To options >> After completing the design part of the process you can then elect to share your website in a variety of ways.

Do Not Share – The option used for just saving the gallery.

Creating individual web assets using Photoshop Elements

Now that you have seen how to create pages and their assets automatically using the Web Gallery let's take a little more control of the process by manually creating each of the major assets using Elements. We will then lay out the results of our labor in a web production package to create our final site.

Book resources at: www.adv-elements.com

10.02 Optimizing photos for the web

Suitable for Elements – 5.0, 4.0, 3.0, 2.0, 1.0 | Difficulty level – Basic Related techniques – 10.01 | Menus used – File

The skill of making a highly visual site that downloads quickly is largely based on how well you optimize the pictures contained on the pages of the site. The process of shrinking your pictures for web use involves two steps:

- Firstly, the pixel dimensions of the image need to be reduced so that the image can be viewed without scrolling on a standard screen. This usually means ensuring that the image will fit within a 640×480 or 800×600 pixel space.
- Secondly, the picture is compressed and saved in a web-ready file format. There are two main choices here GIF and
 After Compression type

The best way to optimize your pictures for web use is via the Save for Web (Editor: File > Save for Web) option in Elements. This feature provides before and after previews of the compression process as well as options for reducing the size of your pictures, all in the one dialog. Using this feature you can select the file format, adjust compression settings, examine the predicted file size and preview the results live on screen.

IPEG.

Before and associated pixel compression dimensions preview preview settings Save For Wet to include in a Web page. ohs as JPEG and images with I niked colors as GIF. a . Cancel Help JPEG High ~ 0 * Y CC Defle "DSCN0052.100 324.1K 116 sec @ 28.8 Kbps 1 of 1 Preview In: × Zoom Original File size and predicted Preview in Animation New pixel level name and download time after browser settings for size settings GIF format file size compression

To create a typical 'thumbnail and gallery' site you will need two different versions of your images – full screen size images suitable for use as gallery pictures and small Save for Web >> The best way to ensure that you are using the best balance between file size and image quality is to preview your compression and file type choices in the Save for Web feature.

thumbnails that can be laid out together on an index page. To make these resources you will need to size and compress each image twice and then save the finished files into two separate folders titled 'thumbnails' and 'gallery'. Make sure that the gallery images are no bigger than one full screen and that the thumbnails are small enough to fit several on the page at the one time.

File formats for images on the web

The standard PSD or Photoshop Elements file format is not suitable for web use; instead several different picture types have been developed especially for on-line work. The two most common are JPEG and GIF.

257

EXTENDING YOUR WEB

Original

ABILITIES

1. **JPEG**, or JPG, or Joint Photographic Experts Group, is a file format specially developed for photographic web images. It uses a lossy compression technique to reduce files to as little as 5% of their original size. In the process some of the detail from the original picture is lost and 'tell-tale' artifacts, or visual errors, are introduced into the picture. The degree of compression and the amount of artifacts can be varied so that a balance of file size and image quality can be achieved. More compression means smaller file sizes, which in turn means poorer image quality. On the other hand less compression gives larger files of better quality JPEG images that can contain millions of colors rather than the comparative few available when using GIF. The format has massive support on the net and is the main way that photographers display their web pictures.

2. **GIF**, or the Graphics Interchange Format, has had a long (in internet terms) history with web use. It has the ability to compress images mainly by reducing the numbers of colors they contain. For this reason it is great for headings, logos and any other artwork with limited colors and tonal graduation. It can also display pictures that contain areas of transparency and can be used for simple 'cell-' based animation. This format is not suitable for most photographic images.

How big is too big?

When you are producing your first web pages there is always the temptation to keep as much image quality in your pictures as possible, resulting in large file sizes and a long wait for your site visitors. Use the table aside to help you predict how long a web picture will take to download to your recipient's computer.

Balancing Compression and Image Quality >>

Photographers wanting to display their images on the net are caught between the two opposing forces of image quality and image file size. When Adobe created Elements they were well aware of these difficulties and, to this end, they have included sophisticated compression features that give the user a range of controls over the process.

The Save for Web feature contains a Preview option that allows you to view the original image after the compression and conversion to web format has taken place. In addition, the dialog also displays predicted compressed image sizes that will allow you to ensure that your web files are not too cumbersome and slow to download.

File size	Download Speed					
	14.4 Kbps (modem)	28.8 Kbps (modem)	56.6 Kbps (modem)	128 Kbps (Cable)		
30KB	24 secs	12 secs	6 secs	3 secs		
100KB	76 secs	38 secs	19 secs	9 secs		
300KB	216 secs	108 secs	54 secs	27 secs		
1000KB (1MB)	720 secs	360 secs	180 secs	90 secs		

Step 1 >>> Open the original image and select the File >Save for Web feature. Input the image size into the New Size section, being sure to keep the pixel dimensions less than 640 x 480. Click Apply. Set previews to 100%.

Step 2 >> Try different file format, compression setting or numbers of colors. Determine the best balance of file size and image quality. Check the download times. Click Save to store the image.

Step 3 >> After creating the gallery images you can repeat the process using smaller pixel dimensions to generate the thumbnail versions of the pictures. Thumbnails should be between 60 x 60 or 100 x 100 pixels.

EXTENDING YOUR WEB ABILITIES

258

Generally, a delay of 10–15 seconds for large gallery images is acceptable, but download times longer than this may cause your audience to surf elsewhere.

Pro's Tips for good image compression:

- Always use the Save for Web compression tool to preview the side-by-side images of the original and compressed picture.
- For GIF images try reducing the number of colors to gain extra compression.
- Always view the compressed image at 100% or greater so that you can see any artifacts.
- For JPEG images carefully adjust the Quality slider downwards to reduce file size.
- Do not sharpen the photos to be compressed. Non-sharpened pictures compress to smaller sizes.
- Take notice of the predicted file size and predicted download time when compressing images.

10.03 Button creation

Suitable for Elements – 5.0, 4.0, 3.0, 2.0, 1.0 | Difficulty level – Basic | Tools used – Shape tools, Type tools Menus used – Layer, File,

In their simplest form, the buttons on a web page are nothing more than a small graphic or picture file similar to those that we created as thumbnails in the last technique. The same process of careful sizing and compression used to help keep image files small is employed to ensure that buttons take up very little space and download extremely quickly – so in this regard they should be treated exactly the same as any other image. It is the step after these simple buttons are placed on a web page that makes them different from just another graphic.

During the web page assembly process the button images are positioned onto the page. Each image is then selected and linked to a web page or HTML file. This simple step converts the graphic from a static picture to a working button. When the page is displayed and the mouse pointer moved over the linked button, the standard 'arrow' cursor will change to the familiar 'pointing finger' to indicate that a link can be clicked at this section of the page. In essence, buttons are just hyperlinked graphics.

Simple buttons >> Buttons are small pictures that when clicked perform an action or transport the viewer to new web pages.

Step 1 >> Using the Rounded Rectangle tool a button shape was drawn and a layer style added to it.

Step 2 >> A text layer was also added; the color and layer style changes to suit the button.

Step 3 >> The image was then saved as a web picture using the Save for Web feature.

Step 1 >> Using the button created in the previous technique as a base change the button color.

Step 2 >> Resave the optimized picture as the 'gall-but-over' state.

Step 3 >> Change the button bevel and embossing by applying an inset style. Save as 'butt-down'.

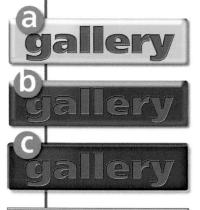

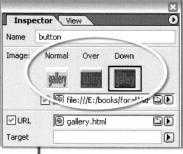

Rollover buttons >> After making the three button states – (a) normal, (b) over, and (c) down – use the Rollover button feature in your web layout package to assign each graphic to each button action. Here the graphics are combined using the Inspector dialog in Adobe GoLive.

Animated buttons - 'rollovers'

Not all sites contain simple buttons. In fact there are many pages that make use of animated or rollover buttons. Designed so that the button image changes as the mouse moves over it, this button style requires a little more planning and design. A new graphic needs to be created for each of the different mouse actions or button states and then these images need to be integrated into the web page via some simple 'java scripting'. Don't panic, there is no coding needed here as in most web layout packages. Simply input the file names of the different rollover button states into the dialog and the program handles the rest.

10.04 Effective headings

Suitable for Elements – 5.0, 4.0, 3.0, 2.0, 1.0 | Difficulty level – Intermediate Tools used – Type tools | Menus used – Layer, File

Headings, which are usually placed at the very top of the screen, provide a title for the page, or site, and sometimes include a series of buttons called a menu or button bar. Like buttons this web asset is usually created as a graphic and then positioned on the page using a layout program such as Adobe GoLive. Text and images are often combined to create the heading and even though the text remains editable in the original file, the final design is saved as a picture in JPEG or GIF format. In either of these two forms the text becomes just another picture element.

Keep in mind that just as much care needs to be taken when making and optimizing headings as with any other graphics, as the speed that your page will display will be based on the combined file size of all the page's assets.

Animated headings

In addition to creating static headings it is also possible to make animated banners using the Save As GIF features in Elements. Adobe has merged

Book resources at: www.adv-elements.com

traditional techniques with the multi-layer abilities of its PSD file structure to give users the chance to produce their own animations. Essentially the idea is to make an image file with several layers, the content of each layer being a little different from the one before. The file is then saved in the GIF format. In the process each layer is made into a separate

Animated headings >> Create your own animated text headings by using the Warp Text feature to add a wave to multiple text layers. Saving the file as an animated GIF will loop the text layers, creating the illusion of movement.

frame in an animated sequence. As GIF is used extensively for small animations on the net, the moving masterpiece can be viewed with any web browser, or placed on the website to add some action to otherwise static pages.

The GIF file is saved via the Save for Web feature. By ticking the Animate checkbox you will be able to change the Frame Delay setting and indicate whether you want the animation to repeat (loop) or play a single time only. This dialog also provides you with the opportunity to preview your file in your default browser. Keep in mind when you are making your own animation files that GIF formatted images can only contain a maximum of 256 colors. This situation tends to suit graphic, bold and flat areas of color rather than the gradual changes of tone that are usually found in photographic images. So rather than being disappointed with your results, start the creation process with a limited palette; this way you can be sure that the hues that you choose will remain true in the final animation.

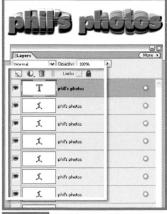

OK ⊙Horizontal ○Vertica Cancel Bend +31 Horizontal Distortion: tical Distortion (More) Cipacity: 100% 2 0. 1 1 Т phil's photos 1 1

Step 1 >> Start by inputting some base heading text. Adjust color and style. Create multiple copies of the finished layer.

Step 2 >> Select each layer in turn and apply slightly different settings in the Warp Text (wave) feature.

Step 3 >> Select the GIF and Animate options. Adjust the settings in the Animation section, then click OK to produce the animation.

10.05 Making seamless backgrounds

Suitable for Elements – 5.0, 4.0, 3.0, 2.0, 1.0 | Difficulty level – Intermediate Tools used – Selection tools, Clone Stamp | Menus used – Filter, File

The HTML language has a specific feature designed for including backgrounds with your pages. As you can imagine, using a full size image for a background would greatly increase the file size and therefore the download time of your pages, so in their wisdom, the early web

Book resources at: www.adv-elements.com

EXTENDING YOUR WEE

ABILITIES

engineers included the ability to tile a small graphic pattern over the whole of the background of each page. Using this method, a small, highly optimized picture can be repeated in a grid over the expanse of the whole screen, giving the appearance of a seamless background with little download time cost. Using the Offset filter (Filter>Offset) in Elements you can create

a special background graphic containing matched edges that will seamlessly tile across a whole web page. Select a section of a suitable image. Copy and paste the selection as a new document. Apply the filter using offset settings that are exactly 50% of the dimensions of the image and choose the Wrap Around option. This displays the edges of the tile in a cross in the center of the image. Use the Clone Stamp tool to disguise the joins by merging similar areas and textures together. To finish save the file in JPEG format using the Save for Web feature. With the tile made you can now select it as the background image in your web layout program.

Repeating background tiles >> The tiles that you make using the Elements Offset filter can be used to create repeating backgrounds by selecting them as the background image in your web layout program. The GoLive dialog above shows how the tile image can be used for creating seamless web backgrounds.

Step 1 >> Select an area of an image to use as a base for the tile. Copy and paste the selection into a new document.

Step 2>>> Select the Offset filter and input width and height values that are 50% of the image size. Select the Wrap Around option.

Step 3 >> Use the Clone Stamp or Spot Healing Brush tools to disguise the joins in the picture. Save as a JPEG using the Save for Web feature.

10.06 Using background matting

Suitable for Elements - 5.0, 4.0, 3.0, 2.0, 1.0 | Difficulty level - Basic | Menus used - File

Most photos that are optimized for use on the internet are saved in the JPEG format. As part of the construction process of a web page, the pictures are placed on top of a colored background. The JPEG format does not contain a transparency option and so when an irregularly shaped graphic is saved as a JPEG and placed onto a web page it is surrounded by a plain colored box, usually white. Background matting is a technique for adding the web page color to the background of the object at the time of web optimization. When the matted object is then used to create the web page, it appears to be sitting on the background as if it was surrounded by transparency. The transparent pixels surrounding the object are replaced with the matte color and the semi-transparent pixels are blended. The Matte option is located in the settings area of the Editor: File > Save for Web feature.

Preserve Obtomin Preserve Obtomin Propressive Image Site Original Site Wedbi: 2026 pixels Height: 3325 pixels New Site Widdh: 1000 pixels Height: 1335 pixels] ()

Step 1 >> Choose the web page color by double-clicking the foreground swatch to show the Color Picker and then selecting the Only Web Colors option. Next create a picture with a transparent background. **Step 2** >>> Choose Editor: File > Save for Web feature and the JPEG option. Select the same color for the Matte by double-clicking the swatch and selecting from the Color Picker. Click OK to save.

10.07 Creating downloadable slide shows

Suitable for Elements – 5.0, 4.0, 3.0, 2.0, 1.0 | Difficulty level – Basic Menus used – File

Version 2.0 of Elements introduced a PDF slide show making option. The feature proved so popular that Adobe introduced two slide show features in version 3.0 for Windows – Simple and Custom. Elements 5.0 continues this development and the program now contains a common Slide Show Editor interface which can produce multiple different types of slide shows. The feature contains a host of options that allow users to create true multimedia slide shows, complete with music, narration, pan and zoom effects, transitions, extra graphics and backgrounds and titles.

Step 3>>> Now construct the web page with the same color in the background and add in the new matted graphic. When the page is displayed the object will seamlessly merge with the page color.

Your own on-line slide show >> The final PDF file can be linked to a button in your website, allowing the show to be displayed in the browser via the free Adobe Acrobat plug-in. Here the slide show file is linked using the Inspector palette in Adobe GoLive.

Step 1 >>> Preselect the photos to include in the show from within the Photo Browser and then select Photo Browser: File > Create > Slide Show. Set the defaults for the presentation in the Slide Show Preferences dialog and then click OK to proceed to the main Slide Show Editor window.

Step 2 >> Adjust the slide sequence by click-dragging thumbnails within the storyboard or Quick Reorder workspaces. Insert transitions by clicking the space in between slides and selecting a type from the menu in the Properties pane. Add graphics and text by click-dragging from the Extras pane.

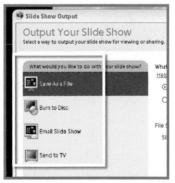

Step 3>> Record voice-over by selecting a slide and then using the narration option in the Extras pane. Add existing audio by clicking the sound-track bar at the bottom of the storyboard. Produce the slide show by selecting File > Output Slide Show and picking the type of presentation to produce from the Slide Show Output dialog.

Book resources at: www.adv-elements.com

EXTENDING YOUR WEE

ABILITIES

Photoshop Elements 5.0 contains a new workflow for creating slide shows. Previously you had to choose the type of presentation you wanted to create from the onset; the new approach centers all slide show activities around a single editor interface and it is only at the time of outputting that you choose the type of slide show that you want to create. In this way you can create (and save) a single slide show project and then repurpose the presentation in many different forms (on-line, DVD, PDF slide show or direct to TV) by simply selecting different output options. For more details on how to use the Slide Show Editor see Chapter 13.

10.08 Assembling the site

Suitable for Elements – 5.0, 4.0, 3.0, 2.0, 1.0 | Difficulty level – Intermediate Related techniques – 10.02, 10.03, 10.04, 10.05, 10.06

Using the last few techniques you will have created images, thumbnails, page heading, buttons for navigation and a background tile. It is now time to bring all these parts together with the aid of a web page layout program.

The most well known of these types of software packages are Adobe's Dreamweaver or GoLive and Microsoft's FrontPage. They work in a similar way to desktop publishing programs in that they allow the user to lay out images and text before publication. Unlike DTP software though, the

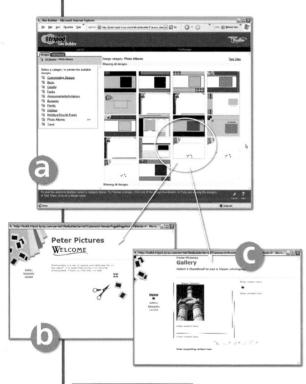

ISP page creation tools >> Some internet hosting companies provide a web-based layout feature that can have your site up and running in a matter of minutes. The features are normally template-driven (a) and are more than capable of creating linked front (b) and gallery (c) pages. Courtesy of www.tripod.com.

Book resources at: www.adv-elements.com

end designs are meant to be viewed on the web rather than the printed page.

Even though these big name packages lead the field, there are more economical options and even some free programs that provide the basic functions needed to construct the pages. In particular Netscape Composer, which is part of an older release of Netscape browser programs called the Communicator Suite, is an example of a simple web layout package that contains all the features needed to create a simple multi-page website. What's more it can be downloaded and used for free. Alternatively you may find that your well-used word processor is now so 'web aware' that it is more than capable of laying out and linking the files and pages in your site. Some of the larger hosting companies such as www.tripod.com supply basic layout and design features on-line to their subscribers. Using their step-bystep screens you can create and lay out a series of linked pages and then publish the whole site in a single setting. This feature is great for first-time web producers as the template-driven interface takes a lot of the guesswork out of the process. You can customize text, headings and images but the basic design elements and layout are fixed.

Step 1 >> Collect the web assets that you have created and place them into a simple folder structure with different directories for thumbnails, gallery images, pages and common elements like the buttons, background and heading graphics. Ensure that all the files are well labelled and that each file name is 8 characters long or less.

Step 2 >>> To create the home page start the Netscape Composer program. The package automatically creates a new page when opened. Next select Format > Page Colors and Properties and under the General tab input the title, author, description and keywords for the page. Under the Colors and Background tab select the background tile that you made earlier. Click the 'Leave image at the original location' and 'Save these settings for new page' boxes and click OK.

Step 3 >> Click on the Insert Image button. Under the Image tab find the heading Graphic and select OK. Select the heading Graphic and click the Center alignment button. Deselect the graphic and hit the Enter key to move the cursor to the next line under the heading. Using this process insert the button graphics one by one. Save this page as index.html.

Step 4 >> Create a thumbnails, or picture index, page and add the small versions of all the photographs that you want to include in the site. Save as thumb.htm.

On a series of new gallery pages insert the larger images, one per page, saving each using the name of the picture as the file name (pict1.htm).

Step 5 To add interactivity to the site double-click on a button graphic and click on the Link tab from the Image Properties dialog that appears. Select the Choose File option and locate the page file that relates to the button, i.e. thumbnail button linked to thumb.htm. Complete this linking action for each of the buttons in the site.

Step 6 >> With the site now complete it is essential that you test all the links and image insertions. Do this by opening the index.htm file and clicking the Preview button on the Netscape menu bar.

265

EXTENDING YOUR WEE ABILITIES

10.08 Uploading the site

Suitable for Elements – 5.0, 4.0, 3.0, 2.0, 1.0 | Difficulty level – Intermediate Resources – Web link to www.tripod.com | Related techniques – 10.08

With pages created it is now time to put your site on the web. You will need to secure drive space on a machine that is permanently connected to the internet. Such space is provided by specialized businesses called Internet Service Providers (ISP). They host the files that make up your site. You will also need to obtain a web address. This is used to enable web surfers the world over to locate and view your pages.

Before going out and buying the space and web address check to see if the company you are currently using for access to email and web browsing includes some free space as part of the monthly dial-up charge. Most of the bigger ISPs provide 10–20 Mb as part of their dial-up services as well as a web address which combines their domain and your name, usually in a form such as 'www.isp.com/ philipandrews'. If you don't have an internet connection, or you browse via a network at work or school, then you can obtain an address and some storage space from any of the many free hosting companies. Simply search the net using a 'free hosting' as your subject to get a list of candidates. Most provide a few different products at various prices along with their free hosting plan. These companies pay for their free provision by including banner advertisements at the top of your web pages.

With your space and address secured, it is now time to transfer your site, with all its images, buttons and pages, to the host computer. Until recently this task was handled by an FTP or File Transfer Protocol program. This utility connected your computer with the ISP machine. Files and folders could then be copied from one machine to the other. Most of the larger ISP companies now provide a web page interface for transferring or uploading your files. You simply locate the Upload option in the File Management section of the members' pages for your ISP and then browse and select the files to be transferred. Click the Upload button and a few moments later the files appear on the ISP's computer.

inor

Step 1 >> As a registered Tripod member you will be able to log into your own web space. Use the File Manager option to see a file view of your space. Here select and change the Upload via setting to 'Single Files'.

Step 2 >> In the Upload browser select the files you want to transfer. Click the Upload button. Be sure to duplicate the exact file and folder structure of your site. This may mean that you will have to make the Image and Page folders before transferring files to them.

Step 3 >> As the last step in the process, check that all components of the site have been transferred and are working properly by viewing your pages in your browser. Check to see that your pages display correctly on a variety of machines and browsers.

Producing Effective Graphics

ADVANCED PHOTOSHOP ELEMENTS 5.0 FOR DIGITAL PHOTOGRAPHERS

s well as providing us with a suite of features and options that can be used to edit and enhance photographic images, Adobe Photoshop Elements also contains a variety of painting and drawing tools. These can be used to create new pictures from scratch or to add original artwork to your photographs. The following techniques are designed to take you beyond the basic painting and drawing tasks so that you will be able to create professionallooking graphics that can work in conjunction with your professionally edited and enhanced photographs.

Revisiting painting and drawing basics

Although the names are the same the tools used by the traditional artists to paint and draw are quite different from their digital namesakes. The painting tools (the Paint Brush, Pencil, Eraser, Paint Bucket and Airbrush) in Elements are pixel based. That is, when they are dragged across the image they change the pixels to the color and texture selected for the tool. These tools are highly customizable and in particular the painting qualities of the Brush tool can be radically changed via the More Options or Brush Dynamics palette (located in the Brush tool options bar).

The drawing tools (the Shape tools) in contrast are vector or line based. The objects drawn with these tools are defined mathematically as a specific shape, color and size. They exist independently of the pixel grid that makes up your image. They usually produce sharp-edged graphics and are particularly good for creating logos and other flat colored artwork.

Painting and drawing tools >> Drawing and painting tools are used to add non-camera or scanner-based information to your pictures. (a) Drawing tools (from the top) – Rectangle, Rounded Rectangle, Ellipse, Polygon, Line, Custom Shape. (b) Painting tools – Airbrush (an option for the Brush tool), Brush, Pencil, Eraser, Impressionist Brush, Paint Bucket tool.

11.01 Controlling brush characteristics

Suitable for Elements – 5.0, 4.0, 3.0, 2.0, 1.0 | Difficulty level – Intermediate Tools used – Painting tools | Palettes used – Brush Presets, Brush Dynamics

Elements provides users with the ability to change a range of brush options quickly and easily. Color, Size, Mode and Opacity are the most accessible options.

The color of the brush can be altered by changing the currently selected foreground color. Do this by clicking the foreground swatch located at the bottom of the program's toolbar. Select a new color from the Color Picker that is displayed and then click OK to exit the palette. Any drawing or painting from this time forward will be in the new color.

Brush size, blending mode and opacity / / / B & / Size To px & Mode Normal are altered by the values set in the Brush's option bar. The size of the brush is measured in pixels with higher values producing a brush with a larger diameter. The Brush's Blending mode controls the way that the color that is being applied interacts with the color already in the document. Notice that the options you have here are the same as the Blending modes available in the Layers palette – with the exception that when painting on a layer, two extra options, Behind and Clear, are also available as Blend modes. The Opacity

setting controls how transparent the painted color will be.

Elements also comes packaged with a host of pre-designed brushes that can be acessed by clicking the Presets button to the right of the Brush Preview thumbnail in the options bar. The designs are grouped under headings that indicate the style of brush calligraphic, special effect, faux finish. Even though these brushes are supplied with all the major characteristics pre-designed, you can customize any brush by altering one or more of its settings.

In addition to the basic changes of size, color, Blend mode and opacity many more brush characteristics can be altered via the Brush Dynamics palette. The palette is opened by clicking the More Options button located in the Brush's options bar. Here vou will find controls for a further seven brush characteristics. At first the options and their effects may seem a little strange and confusing. To help you get to know the way that each setting will

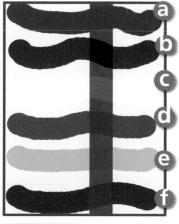

Blend modes >> Controls how the brush's color interacts with existing colors. (a) Normal. (b) Darken. (c) Lighten. (d) Hard Light. (e) Difference. (f) Luminosity.

Book resources at: www.adv-elements.com

269

PRODUCING EFFECTIVE

GRAPHICS

alter your brush, try drawing a series of brush strokes, changing a single option as you go. This exercise will make the setting's effect more obvious. When you feel confident then try changing the settings for multiple options to provide a mix of different effects.

The More Options palette

- **Spacing** determines the distance between paint dabs, with high values producing dotty effects.
- The **Fade** setting controls how quickly the paint color will fade to nothing. Low values fade more quickly than high ones.
- **Hue Jitter** controls the rate at which the brushes' color switches between foreground and background hues. High values cause quicker switches between the two colors.
- **Hardness** affects the amount of softness or hardness of the edge of the brush. Lower values produce soft brushes.
- The **Scatter** setting is used to control the way that strokes are bunched around the drawn line. A high value will cause the brush strokes to be more distant and less closely packed.
- Angle controls the inclination of an elliptical brush.
- The **Roundness** setting is used to determine the shape of the brush tip. A value of 100% will produce a circular brush, whereas a 0% setting results in a linear brush tip.

Version 1.0 users have a more limited set of brush controls accessed by clicking the thumbnail of the currently selected brush, in addition to pressing the More Options button. Completely new brushes can be added to the palette, in either version of the program, by selecting the side arrow in the Brush palette and choosing the New Brush option. For the truly creative among us, extra custom-built brush sets are available for download and installation from websites specializing in Elements resources.

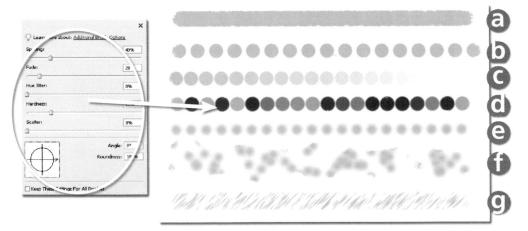

Brush Dynamics >>> The Elements brush engine provides a range of Brush Dynamics settings that allow users to completely control the behavior and characteristics of their brushes. (a) Normal. (b) Spacing increased. (c) Fade introduced. (d) Hue Jitter increased. (e) Hardness decreased. (f) Scatter increased. (g) Angle = 45°, Roundness = 0%.

Book resources at: www.adv-elements.com

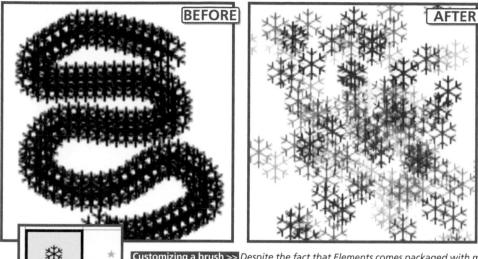

Customizing a brush >> Despite the fact that Elements comes packaged with many varied preset brush designs there will always come a time when you will need to alter the way that the existing brush works. By altering the settings detailed in the Brush Dynamics palette you can drastically change the look and feel of the brush.

11.02 Changing an existing brush

Snowflake

Suitable for Elements – 5.0, 4.0, 3.0, 2.0, 1.0 | Difficulty level – Intermediate Related techniques – 11.01 | Tools used – Brush

With the basics now under your belt let's stretch those newly found skills by following the steps needed to customize an existing brush shape. At first the most notable differences between the preset brushes that come packaged with Elements will be the shape of the brush itself. Ranging from simple round or square tips to those that are based on pictures such as flowers or even the humble rubber duck, these shapes form the basis for the brush stoke itself. One click of the mouse button will paint the shape of the brush tip, but click and drag the mouse and you will see a brush stroke made up of a repeating pattern of the brush tip shape.

The way that the tip repeats is controlled by the options in the Dynamics palette. It is here that you can force the brush to space out the painted shape and change its color, position and opacity dynamically as you stroke.

If when you first select a preset brush shape you find that you don't like the way that it paints then you may find that with a few changes to the brush's dynamics it will be more suited to your needs.

Simply select the brush you wish to change from the Presets palette. Now you can make the changes to the new brush using the slider controls in the Brush Dynamics palette. To check your progress make practice strokes onto a blank document that you have open in the workspace. Next save the brush as a new brush using the Save Brush option in the fly-out menu of the palette. Custom brush sets can be saved and shared using the Save and Load Brushes, also located in the Presets fly-out menu which is displayed by clicking the sideways arrow located at the top of the Brushes Presets dialog.

Book resources at: www.adv-elements.com

PRODUCING EFFECTIVE GRAPHICS

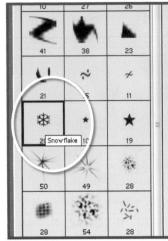

Step 1>>> Select the brush tip shape that you wish to customize from the Brush Presets palette.

Step 2 >> Select the New Brush option from the fly-out menu displayed when you click the side arrow at the top right of the presets screen.

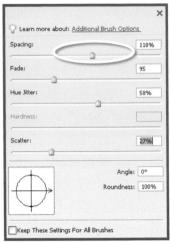

Step 3>>> Click on the More Options button on the right of the Brush options bar and alter the settings in the Brush Dynamics palette. Your brush is now ready to use.

Sharing your custom brushes >> If you want to share the brushes that you have customized with other Elements users then you can save your changes using the Save Brushes option in the fly-out menu of the Presets palette. To only save a selection of the brushes in the palette hold down the Shift key whilst you click onto the brushes, then choose Save Brushes.

Your fellow Elements users can then copy the resultant .abr file into the Elements/Presets/Brushes folder and then load your custom brushes using the Load Brushes option in the same fly-out menu.

11.03 Creating a new brush

Suitable for Elements – 5.0, 4.0, 3.0, 2.0, 1.0 | Difficulty level – Intermediate Resources – Example brushes 1103-1, 1103-2, 1103-3 | Related techniques – 11.01, 11.02 | Tools used – Brush If modifying existing brush shapes (presets) still doesn't provide the level of creativity that you

need for that all-important illustration, then why not create your own completely new and original brush shape? Elements provides users with a way that they can create brush tips from

A new brush from old images >>> You can take your creativity one step further by making your own brushes rather than altering those supplied with Elements. Simply select an area using any of the selection tools, define the brush using this option in the Edit menu and then set the brush dynamics. (a) Original image. (b) New brush shape.

Book resources at: www.adv-elements.com

272

PRODUCING EFFECTIVE

GRAPHICS

sections of photographs or original artwork. It is a two-part process - define and save the area that will be used as the basis of the new brush and then, using the newly defined brush shape, set the brush dynamics to suit your application.

The success, quality and style of the brush you make will be based on the selection of the artwork at the start of the process. Image parts that are high in contrast work best when used as a brush. Any selection tool can be used to isolate the area of the photograph that will be converted to a brush shape. If you don't want the edge of the selection to act as part of the overall brush shape then make sure that the picture part that you use is surrounded by white. Dark or black sections of the source picture will convert to a strong color when your brush is used, mid tones will correspond to lighter areas and white parts will paint no color at all.

Once you are satisfied with your selection then you will need to convert the image to a brush format. Do this by choosing the Define Brush from Selection (Edit > Define Brush from Selection). This process changes the picture to a gray and stores the image as a brush tip in the current Brushes Preset palette. Now you can adjust the brush dynamics of your newly created brush using the processes detailed in the previous technique.

Step 1 >> Define an area of the source image to be used for the brush using one of the selection tools.

Step 2 >> With the selection active choose the Define Brush from Selection option from the Edit menu.

Learn more about

Spacing

Fade

Hue Jitter

Scatter

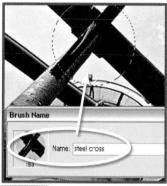

Step 3 >> A dialog appears that shows a preview of your brush shape and provides a space to enter a new brush name.

Step 5 >> Open the Brush Dynamics palette and make changes to the settings that control how the new brush paints.

Step 6 >> With the shape and style of brush now designed you can choose your colors, size, opacity and blend mode and paint away.

Book resources at: www.adv-elements.com

Step 4 >> The brush is saved to the current Presets palette. To customize, select your new brush from the Presets palette.

11.04 Text

Suitable for Elements – 5.0, 4.0, 3.0, 2.0, 1.0 | Difficulty level – Basic | Tools used – Type tools

Combining text and images is usually the job of a graphic designer or printer but the simple text functions that are now included in most desktop imaging programs mean that more and more people are trying their hand at adding type to pictures. Elements provides the ability to input type directly onto the canvas rather than via a Type dialog. This means that you can see and adjust your text to fit and suit the image beneath. Changes of size, shape and style can be made at any stage by selecting the existing text and applying the changes via the options bar. As the type is saved as a special type layer, it remains editable even when the file is closed so long as it is saved and reopened in the Elements PSD, TIFF or PDF formats.

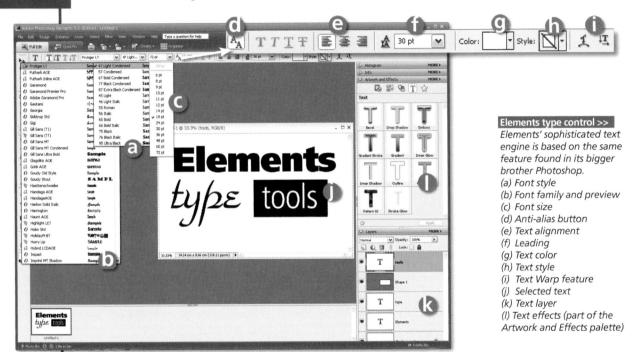

Creating simple type

Two new type tools were added to Elements in version 2.0, over and above the two that were present in the initial release of the program. In version 5.0 you can select from Horizontal and Vertical Type tools, as well as Horizontal and Vertical Type Mask tools. Of the standard type tools, one is used for entering text that runs horizontally across the canvas and the other is for entering vertical type. To place text onto your picture select the Type tool from the tool box. Next, click onto the canvas in the area where you want the text to appear. Do not be too concerned if the letters are not positioned exactly where you want as the layer and text can be moved later. Once you have finished entering text you need to commit the type to a layer. Until this is done you will be unable to access most other Elements functions. To exit the Text Editor, either click the Tick button in the options bar (version 2.0 or later) or press the Control+Enter keys in Windows or Command + Return for a Macintosh system.

Book resources at: www.adv-elements.com

PRODUCING EFFECTIVE

GRAPHICS

Creating paragraph text

Elements version 4.0 added the Paragraph Text options to the simple type ones detailed above. To create a paragraph, select the Type tool and then click and drag a text box on the surface of the picture. Automatically Elements positions a cursor inside the box and creates a new layer to hold the contents. Typing inside the box will add text that automatically wraps when it reaches the box edge. When you have completed entering text, either click the Tick button in the options bar, or press the Control + Enter keys.

You can resize or even change the shape of the box at any time by selecting a Type tool and then clicking onto the area where the paragraph text has been entered. This action will cause the original text box to display. The box can then be resized by moving the cursor over one of the handles (small boxes at the corners/edges) and click-dragging the text box marquee to a new position. The text inside the box will automatically re-wrap to suit the new dimensions.

Basic text changes

All the usual text changes available to word processor users are contained in Elements. It is possible to alter the size, style, color and font of your type using the settings in the options bar. You can either make the selections before you input your text or later by highlighting (click-dragging the mouse across the text) the portion of type that you want to change.

In addition to these adjustments, you can also alter the justification or alignment of a line or paragraph of type. After selecting the type to be aligned, click one of the justification buttons on the options bar. Your text will realign automatically on screen. After making a few changes, you may wish to alter the position of the text. Simply hold down the Ctrl key (MAC – CMD key) whilst you drag outside of the type area to move it around. If you have already committed the changes to a text layer then select the Move tool from the tool box, making sure that the text layer is selected, then click-drag to move the whole layer.

Reducing the 'jaggies'

One of the drawbacks of using a system that is based on pixels to draw sharp-edged letter shapes is that circles and curves are made up of a series of pixel steps. Antialiasing is a system where the effects of these 'jaggies' are made less noticeable by partially filling in the edge pixels. This technique produces smoother looking type overall and should be used in all print circumstances and web applications, the only exceptions being where file size is critical (as anti-aliased web text creates larger files than the standard text equivalent) and when you are using font sizes less than 10 points for web work. Anti-aliasing can be turned on and off by clicking the Anti-aliased button.

Anti-aliasing >>> Anti-aliasing smooths out the jaggies that result from trying to depict curved edges with rectangular pixels. (a) Without anti-aliasing. (b) With antialiasing. PRODUCING EFFECTIVE

GRAPHICS

PRODUCING EFFECTIVE GRAPHICS

The left align, or justification, feature will arrange all text to the left of picture. When applied to a group of sentences the left edge of the paragraph is organized into a straight vertical line whilst the right-hand edge remains uneven or ragged. Right align works in the opposite fashion, straightening the right hand edge of the paragraph and leaving the left ragged. Selecting the center text option will align the paragraph around a central line and leave both left and right edges ragged. Af align, or justification, feature will arrange ext to the left of picture. When applied to a group of sentences the left edge of the paragraph is organized into a straight vertical line whils the right-hand edge remains uneven or ragged. Right align works in the opposite fashion, straightening the right hand edge of the paragraph and leaving the left ragged. Selecting the center text option will align the paragraph around a central line and leave both left and right edges ragged. C

eft align, or justification, feature will arrange all text to the left of picture. When applied to a group of sentences the left edge of the paragraph is organized into a straight vertical line whilst the right-hand edge remains uneven or ragged. Right align works in the opposite fashion, straightening the right hand edge of the paragraph and leaving the left ragged. Selecting the center text option will align the paragraph around a central line and leave both left and right edges ragged.

Text alignment>> Text is aligned with a straight edge on the left, right or by centring each line around its middle. (a) Left align. (b) Center align. (c) Right align.

Alignment and justification

These terms are often used interchangeably and refer to the way that a line or paragraph of text is positioned on the image. The left align, or justification, feature will arrange all text to the left of picture. When applied to a group of sentences the left edge of the paragraph is organized into a straight vertical line whilst the right-hand edge remains uneven or ragged. Right align works in the opposite fashion, straightening the right-hand edge of the paragraph and leaving the left ragged. Selecting the Center Text option will align the paragraph around a central line and leave both left and right edges ragged.

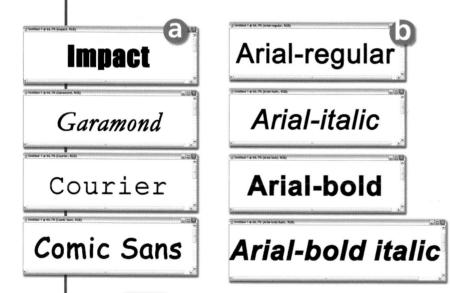

Font family and style

The font family is a term used to describe the way that the letter shapes look. Most readers would be familiar with the difference in appearance between Arial and Times Roman. These are two different families each containing different characteristics that determine the way that the letter shapes appear. Arial is a sans-serif font meaning that the letter shapes are more streamlined than the serif-based Times Roman design. The font style

Fonts >>> You can achieve changes in the way that your text looks by altering either the font family (a) or the font style (b).

refers to the different versions of the same font family. Most fonts are available in regular, italic, bold and bold italic styles. You change the style of a font by selecting an option from the drop-down menu in the Type options bar. Pressing the style buttons on the bar produces a 'faux' version of these styles for those typefaces with limited style options.

Leading

Originally referring to the small pieces of lead that were placed in-between lines of metal type used in old printing processes, nowadays it is easier to think of this term as referring to the space between lines of text. Unlike earlier versions of the program, Elements 4.0/3.0 includes the ability to alter the leading of the type input in your documents. Start with a value equal to the font size you are using and increase or decrease from here according to your requirements.

Delit dio corem iriusci psuscilit augait, quisl ea feugue consed exerostrud molent nim autate facidunt il lucmodo lorper

Delit dio corem iriusci psuscilit augait, quisl ea feugue consed erostrud

molent nim

Leading >> Leading is the space between lines of text. 24 pixel type with: (a) 18 pixel leading and (b) 48 pixel leading.

11.05 Adding styles to text layers

Suitable for Elements - 5.0, 4.0, 3.0, 2.0, 1.0 | Difficulty level - Basic | Related techniques - 11.04 | Tools used -Type tools | Menus used – Layer, Edit

Elements' Layer Styles can be applied very effectively to type layers and provide a quick and easy way to enhance the look of your text. Everything from a simple drop shadow to complex surface and color treatments can be applied using this single-click feature. A

collection of included styles can be found under the Artwork and Effects palette (previously the Styles and Effects palette) or you can view the dialog by selecting the Artwork and Effects option from the Window menu. A variety of different style groups is available from the drop-down list and small example images of each style are provided as a preview of the effect.

Additional styles can be downloaded from websites specializing in resources for Elements users. These should be installed into the following folder:

C:\Documants and Settings\All Users\Application Data\Adobe\Photoshop Elements\5.0\Photo *Creations**special effects**layer styles*

This folder is hidden by default and you will need to follow the steps in technique 12.08 to reveal it before being able to copy the new styles. You will also need to ensure that the .asl file is in its own separate folder or it will be added to the Bevels subcategory. Note that this action will only add the new styles to the Artwork and Effects palette. If you want to access them from the Style pop-up palette in the options bar for the Type or Shape tools, you need to also copy the .ASL file to:

C:\Program Files\Adobe\Photoshop Elements 5.0\Presets\Styles

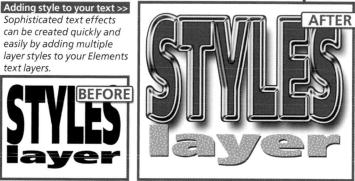

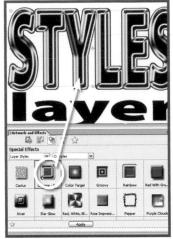

Step 1 >> With the text layer selected click onto a layer style and then press the Apply button.

Step 4 >>> Adjusting the options in the Style Settings alters the appearance of the style.

Step 2 >> Add a second style by selecting and applying another style from the Artwork and Effects palette.

Step 5 >>> Changes to the Lighting Angle are reflected across all layer styles present in the document.

Step 3 >> Different sets of styles can be applied to other text layers in the image by selecting the layer first.

Step 6 >> Use the Scale Layer Effects to change the size settings for all styles applied to a single layer.

To apply a style to a section of type make sure that the text layer is currently active. Do this by checking that the layer is highlighted in the Layers palette. Next select the Layer Styles option from the drop-down menu in the top left of the Special Effects section of the Artwork and Effects palette and then use the second menu to choose the styles group you wish to use. Click on the thumbnail of the style you want to add and then the Apply button. The changes will be immediately reflected in your image. Multiple styles can be applied to a single layer and unwanted effects can be removed by using the Undo command (Edit > Undo Apply Style). To remove all styles, choose Layer > Layer Styles > Clear Layer Style. The settings of individual styles can be edited by double-clicking on the starburst icon in the text layer and adjusting one or more of the available style settings.

Book resources at: www.adv-elements.com

278

PRODUCING EFFECTIVE GRAPHICS

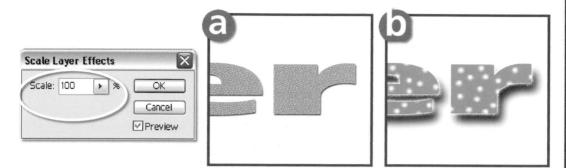

Scaling effects >> Layer styles settings do not change proportionately when you enlarge or reduce text to fit a composition or design idea. This can mean that the styles become too overpowering for the text or too subtle for the design. You can solve this problem by using the Slider control in the Scale Effects feature (Layer > Layer Style > Scale Effects) to adjust the look of all styles interactively. (a) Scale Effects set to 50%. (b) Scale Effects set to 200%.

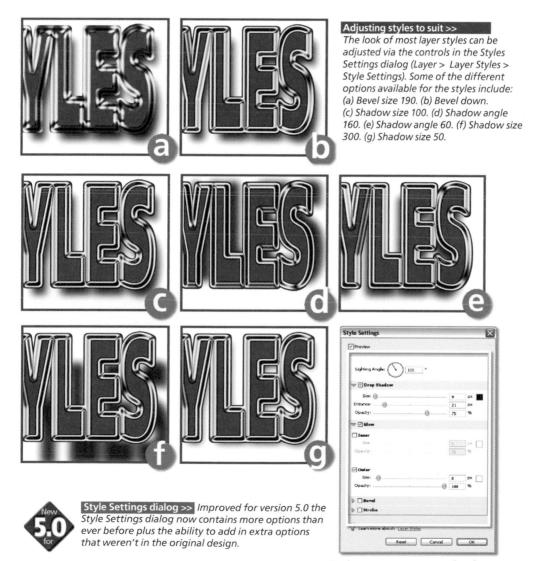

Book resources at: www.adv-elements.com

279

PRODUCING EFFECTIVE

GRAPHICS

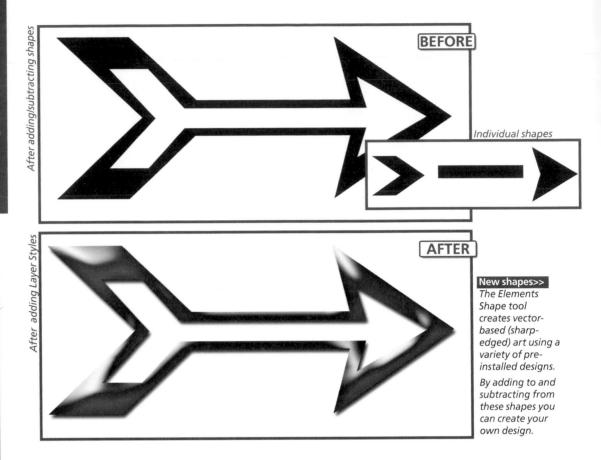

11.06 Customizing shapes

Suitable for Elements – 5.0, 4.0, 3.0, 2.0, 1.0 | Difficulty level – Intermediate Related techniques – 11.05 | Tools used – Shape tools | Menus used – Layer

Photoshop Elements' drawing tools, such as the rectangle, ellipse, polygon and line, give users the option to create vector-based graphics which are stored as separate layers in their Elements document. These tools create their content independent of the pixels that are the base of photographic images. Being vector based means that these graphics can be scaled up and down with no loss in quality. It also means that no matter what printer is chosen for output the shapes will be printed at the best quality available, keeping the sharp edges of the graphics sharp.

As well as the predefined shapes such as rectangle and ellipse, Elements also ships with a range of custom shapes that are also vector-based graphics. Though the program does not offer the option of creating your own custom shapes you can customize those available by interactively adding extra parts to and subtracting areas from these shapes.

This process is very similar to that used to modify a selection. To start we draw a base shape. Automatically Elements creates a new layer to store the shape. By default each shape that you draw is kept on a separate layer. If you want to add a shape to an existing shape make sure that

Book resources at: www.adv-elements.com

PRODUCING EFFECTIVE GRAPHICS

Step 1 >> To help ensure the accuracy of the drawing process, start by displaying the Grid in the workspace.

Step 4 >>> Click the Add to Shape button in the tool's option bar or press the '+' key.

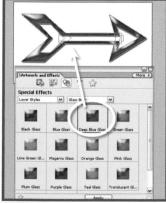

Step 7 >> The newly constructed shape can now be treated just as any other shape. Here I applied a layer style to the completed graphic.

Step 2 >> Select the first custom shape that the other shapes will be added to.

Step 5 >> Draw the other shapes making sure that they are positioned correctly. If not, select Edit > Undo and redraw the shape.

Step 3 >>> Click-drag the shape until it is the right size. Use the Move tool to reposition the graphic.

Step 6 >> Change the mode to Subtract from Shape by selecting this button in the bar or press the '-' key. Draw the shapes that are to be subtracted from the original.

the shape layer is selected, choose the shape and click the '+' or Shift key before drawing the new shape. To remove sections from the shape click the '-' or Alt key before drawing.

Both these options can also be accessed from the drawing tool's option bar along with selections to 'Intersect' or 'Exclude' the newly drawn shape from the existing graphic. By working with the drawing tools and these modifying options it is possible to construct very complex vector shapes on a single layer. PRODUCING EFFECTIVE GRAPHICS

Images and shapes together >> Included with the Elements program is a group of frame designs that can be used with the Custom Shape feature to surround your photographs.

11.07 Adding pictures to shapes

Suitable for Elements – 5.0, 4.0, 3.0, 2.0, 1.0 | Difficulty level – Intermediate | Resources – Web image 1107 Tools used – Selection tools | Menus used – Layer, Edit, Select

The graphic quality of shapes makes them perfect additions to many photographic compositions. They can be used as a title plate, a border, or, as is the case in this example, a picture frame. For the technique to be convincing though, it is important to try to match the scale, texture and coloring of the shape with the photograph. In essence the frame should match the mood of the picture. The example image used here, a sepia nautical photograph, contains an old world charm that needs to be echoed in the frame itself. The best way to achieve this is to add texture, color and pattern to the shape layer using the Layer Style options (Artwork and Effects palette). In this example I used a standard custom shape from the Frames group of shapes to surround the boat picture. To help match the frame to the 'look and feel' of the photograph I added a combination of layer styles and modified their settings to suit. The picture was then copied and pasted into the document as a new layer and dragged beneath the Shape layer. Finally, the shape was simplified and then used as the basis for a selection to trim away the unwanted excess (corners) of the picture so that the image then looked like it was sitting within the drawn frame.

Step 1 >> Select the desired shape from those in the Custom Shape palette. Click and drag to draw.

Book resources at: www.adv-elements.com

Step 2 >> View the Artwork and Effects palette and select the base style from the group. Here I used Stucco.

 Style Setting:
 Image: Control of the set of the

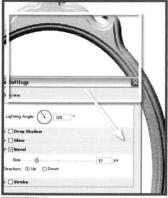

Step 4 >> Apply a second layer style for the bevels and adjust the setting for this style as well.

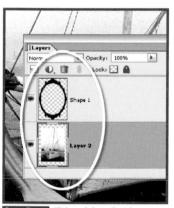

Step 5 >> Select all (Ctrl + A) of the nautical picture and then choose Copy from the Edit menu.

Step 8 >> With the frame layer selected use the Magic Wand to select inside the frame. Click OK to simplify the shape layer in the process.

Step 6 >> Switch to the frame document and paste the picture as a new layer.

Step 9 >> Expand the selection by half the width of the frame and then inverse the selection. Choose the image layer and press the Delete key to remove the image corners.

Step 1 >> After opening the photo to be framed create a separate new document and apply a frame to it.

Step 2 >> Now drag the picture from the Photo Bin to the frame area in the new document. Use the right-click menu options to fine-tune.

New for Elements 5.0

But let's not forget the special framing capabilities that are introduced in this release (see Chapter 12). To add a simple frame to a photo just create a new document and then apply a new frame to the page via the Frames menu in the Artwork section of Artwork and Effects palette. Now drag the open picture from the Photo Bin to the frame and use the options in the right-click menu to fine-tune the frame and photo combination.

PRODUCING EFFECTIVE GRAPHICS

CDH-C CDH-C CDH-C CDH-C CDH-Y +CDH-Y +CDH-Y +CDH-K +CDH-K

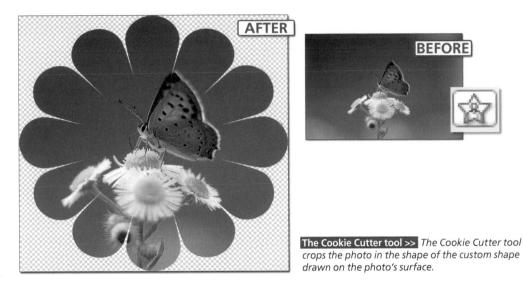

11.08 Using shapes as borders

Suitable for Elements – 5.0, 4.0, 3.0 | Difficulty level – Intermediate | Resources – Web image 1108 Tools used – Cookie Cutter

The Cookie Cutter tool was added to Elements in version 3.0. Though not strictly a drawing tool, the feature works in a very similar way to the Custom Shape tool as it too allows users to select and draw a range of pre-designed shapes in the workspace. It is after the drawing step that the two tools differ. The shape drawn with the Cookie Cutter is used to define the edges of the current image. In this way the feature functions as a fancy Crop tool, providing a range of graphic designs that can be used to stamp out the edges of your pictures.

The feature is a great way to add interesting edge effects to your pictures.

Step 1 >>> Open an image to crop and select the Cookie Cutter tool from the tool box. Click the Shape button in the options bar to reveal the pop-up menu of cookie shapes. Select the shape to use.

Step 2 >> To soften the edge of cookie cutter crop, add a Feather value in the options bar. Click and drag the tool over the surface of the picture. Let the Mouse button go and click-drag the edge handles to adjust the size of the cookie shape to suit the picture.

Step 3 >> If you want Elements to automatically crop the area outside the shape after it is applied select the Crop option in the tool's options bar. Double-click inside the cookie shape or click the Tick icon at the bottom of the crop marguee.

284

Book resources at: www.adv-elements.com

11.09 Customizing the shapes you use

Suitable for Elements – 5.0, 4.0, 3.0, 2.0, 1.0 | Difficulty level – Intermediate | Resources – Web link Tools used – Custom Shape, Cookie Cutter

Photoshop Elements ships with a vast range of shapes that can be used in conjunction with the Custom Shape or the Cookie Cutter tools. New shape sets can be added to those already visible as thumbnails by clicking the side arrow button in the Custom Shape Picker palette. If you can't find a favorite here then why not try some of the extra shape sets that can be downloaded from specialist Elements resources websites? You can download the '.CSH' or custom shapes file directly to your computer and then transfer it to a new folder in the C:\Documents and Settings\All Users\Application Data\Adobe\Photoshop Elements\5.0\Photo Creations\artwork\shapes directory where it will automatically register as a new shape set in Elements when the program is restarted. The Artwork folder is hidden by default and you will need to follow the steps in technique 12.08 to reveal it before being able to copy the new shapes. Note that this only adds the new shapes to the Artwork and Effects palette. If you want to access them from the Shape pop-up palette in the options bar for the Cookie Cutter or Shape tools, you need to copy the .CSH file to: C:\Program Files\Adobe\Photoshop Elements 5.0\Presets\Custom Shapes.

Step 1 >> Enter 'Photoshop Custom Shapes' as a search item in your favorite internet search engine to locate downloadable shape sets. The set featured here can be found at graphicssoft.about.com.

Step 2 >>> Most shape sets that you download from the internet are saved in a compressed file format. Clicking Save at the pop-up window will transfer the file from the server space to your computer.

Step 3 >> After expanding the compressed file you should see a shapes file (title ends in .CSH). Reveal the hidden Shapes folder and then move this file to it.

 Full Edit
 Participation

 Shape:
 Shape:

 Shape:
 Shape:

Step 4 >> If Elements is open, close down the program and restart it again to register the new shape set. To access the shapes click the side-arrow at the top right of the Custom Shape picker and select the set.

Step 5 >> After making the selection the new shapes will appear in the Custom Shape Picker palette ready for use.

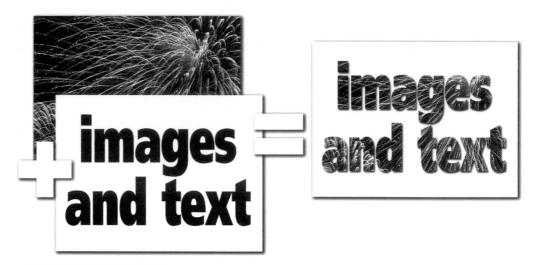

Combining text and images>> One way to add another dimension to the pictures you create is to skillfully combine the images and text together. Text can be used as a container to hold a picture or as a template used to cut away parts of the image itself.

Text and pictures

It doesn't take too long before most Elements users want to combine text with their pictures. To start with they simply add a text layer on top of their picture layer and maybe alter the color of the type so that it stands out from the picture background. Those users with a little more adventure in their soul may even add a layer style to the text to really make it jump out.

Nothing wrong with this approach. This is precisely how I started and much of my text and image work still fits into this category, but occasionally there are times when I need to create a text effect that is a little different. The following three techniques are ones that often fit the 'different' bill.

First I will show you how to fill your text with an image (technique 11.10), then I will demonstrate the reverse, extracting the text from the picture (technique 11.11), and finally I will go 'all out', merging text into an existing picture by creating shadows and lighting effects similar to those that already exist in the scene (technique 11.12).

11.10 Images in text

Suitable for Elements – 5.0, 4.0, 3.0, 2.0, 1.0 | Difficulty level – Intermediate | Resources – Web image 1110 Related techniques – 11.11 | Tools used – Type tools | Menus used – Select, Edit, Layer We have already been introduced to this technique way back in Chapter 7 when we were

reviewing the various masking options that are available in Elements. I think that it is worth revisiting the process in this context as we look at the various ways that we can combine text and images. The technique makes use of the Group with Previous command to place the image into the text. This command uses the text layer as a mask. The black region of the type displays the picture whilst the transparent area allows the white from the background to show through. Book resources at: **www.ady-elements.com**

PRODUCING EFFECTIVE GRAPHICS

Step 1 >> Open a suitable image document and create a new document to size for the text.

Step 4 >> Complete the effect by adding a drop shadow Layer Style to the text layer.

Alternative – Step 1 >> Start by simplifying the text layer (Simplify Layer). Then select all of the picture and copy to memory.

Step 2 >>> Select all, copy and paste the image onto the text document so that it forms a new layer.

Step 3 With the Image layer selected and above the text layer choose the Group with Previous option from the Layer menu.

An alternative approach requires you to simplify (Layer > Simplify layer) the text layer first. This converts the text layer to a standard image layer. It is no longer an editable text layer so make sure that you don't need to alter font, style or spelling.

Next switch back to the picture document, select all (Select > All) and copy (Edit > Copy) the image to the computer's memory. Now switch back to the text document and select the type. A quick way to do this is to hold down the Ctrl key (Mac – Command key) whilst clicking into the type layer thumbnail. Now you can paste the picture from memory into the letter shapes using the Paste Into (Edit > Paste Into Selection) command.

Alternative – Step 2 >> With the Ctrl key pressed and any Selection tool active click into the text layer thumbnail to select the type only.

Alternative – Step 3 >> Now use the Paste Into command to fill the selected text with the picture.

Book resources at: www.adv-elements.com

287

PRODUCING EFFECTIVE

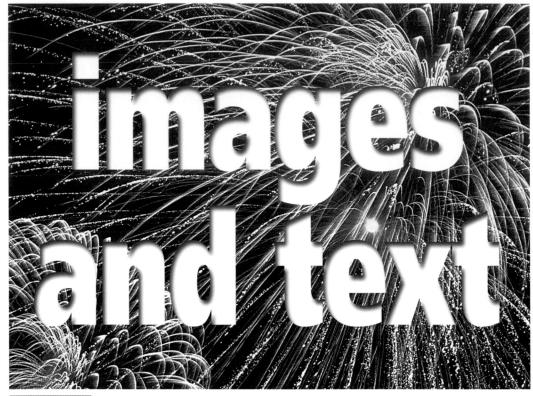

Cut away text >> The text that you input can be used as a basis for cutting away image parts. In this way the words remain visible as a hole in the picture.

11.11 Text in images

Suitable for Elements – 5.0, 4.0, 3.0, 2.0, 1.0 | Difficulty level – Intermediate | Resources – Web image 1110 Related techniques – 11.10 | Tools used – Type tools | Menus used – Select, Edit, Layer

In a contrasting text technique we will use the text as a basis for a 'cutout' in the image itself. Before you begin be sure that the picture is not stored as a background layer. If you have just downloaded the file from your camera or scanner then double-click the layer's name ('background') in the Layer palette, rename the layer and click OK. Alternatively select the background layer and pick Layer > New > Layer from Background. Either process will convert the background to a standard image layer ready for your text work.

Now, to add the text select the standard horizontal Type tool from the tool box. Select a foreground color that will contrast against the picture. Click onto the image area and input the words that will be the basis for the cutout. A new text layer appears in the layer stack. With the text layer selected choose a selection tool and whilst holding down the Ctrl (Mac – Command) key click into the thumbnail of the text layer. As we saw in the previous technique this action automatically selects all the type in the layer. Next select the image layer and cut (Edit > Cut) or press the Delete key. This will remove a portion of the image in the same shape as the selection.

Step 1 >> With a picture document already open select the Type tool and add some text to the image.

Step 2 >> Whilst pressing the Ctrl key click into the type layer thumbnail.

Step 3 >> Now select the image layer and cut (Edit > Cut) away the picture in the shape of the selection.

As the text layer will be obscuring the image layer beneath, the results of your actions may not be immediately obvious, so drag the text layer to the Dustbin icon in the bottom right of the Layer's palette to delete the layer. To finish the technique and make sure that the cutout looks realistic, select the image layer and add a drop shadow layer style. This gives the deleted area real depth.

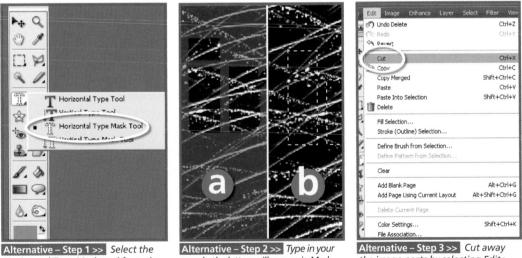

Horizontal Type Mask tool from the Type options in the toolbar.

words, the letters will appear in Mask mode (a). Press the numeric pad Enter key to switch to Selection mode (b).

the image parts by selecting Edit > Cut or pressing the Delete key. Add drop shadow.

An alternative approach that achieves the same results uses the Horizontal Type Mask tool to create the type selection. Simply select this Text option from the Type tool choices and input your words directly onto the image layer. Press the Enter key on the numeric pad to change from the Mask (red) mode to the Selection (marching ants) mode. Cut the selection from the image using the Edit > Cut command and to finalize add the drop shadow to the cutout.

PRODUCING EFFECTIVE

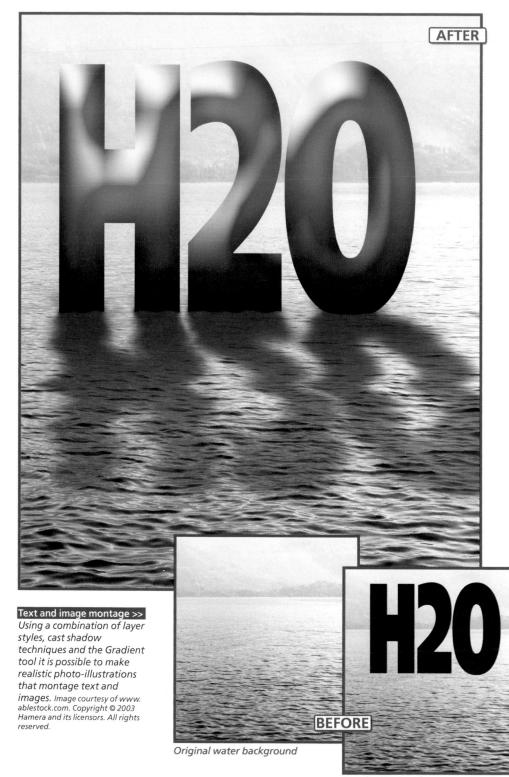

290

Book resources at: www.adv-elements.com

Standard text and water combination

11.12 Realistic text and image montages

Suitable for Elements – 5.0, 4.0, 3.0, 2.0, 1.0 | Difficulty level – Intermediate | Resources – Web image 1112 Tools used – Type tools | Menus used – Select, Edit, Layer

The previous two techniques concentrated on combining text and images in a graphic way. In contrast this section aims to seamlessly merge some text into an existing picture. As we have already discussed the success or failure of montage work often relies on matching the texture, light and color of the two components. When combining segments of photographs this means ensuring that the lighting direction and overall contrast are similar for all picture parts that will be used to form the montage. Many of the same concerns are true when you want to add text to an existing picture, the difference being that rather than photographing under the same conditions you must use Elements to recreate these lighting, color and contrast effects in the text.

The example background image of water and mountains has both distinctive color and light. To successfully montage some text into the composition, it too must reflect these qualities. To start the process I added the text to the image and then applied a layer style that matched the color of the background picture. I then proceeded to adjust the position of the highlights in the bevel of the style, using the Lighting Angle control in the Style Settings, so that they matched the direction of the light in the scene, that is from the back left. This created type of the right color and surface texture.

At this point the text feels and looks like it is floating in mid-air over the water. To make the letters look like they were sitting on, or a little under, the water I decided to add a shadow to the text. A simple drop shadow Layer Style would not give the desired effect so instead a directional shadow was added using the duplicate layer, distort and blur technique that we encountered in Chapter 7. To add the sense that the shadow was falling on water the opacity was reduced to allow the water texture to show through and a Wave filter was applied.

Step 1 >> Add suitable layer styles to type. Copy the layer by dragging it to the New Layer button.

Step 2 >> Select the type copy and convert to a standard image layer with the Simplify Layer command.

Step 3 >> With the copied layer still selected flip the layer vertically.

Step 4 >> Click on the Move tool and drag the copied layer down so that it reflects the type layer.

Step 5 >>> Pick the Eyedropper tool and select a dark blue color from the background.

Step 6 >> With the Preserve Transparency option ticked, Edit > Fill the copied layer with the foreground color.

Step 7 >> Distort the filled layer to form a cast shadow using the Image > Transform > Distort feature.

Step 8 >> Blur the edges of the shadow layer using the Gaussian Blur filter.

Step 9 >>> Reduce the opacity of the shadow layer to allow some of the water texture to show through.

Step 10 >> Break up the edges of the shadow using the Filter > Distort > Wave filter.

Book resources at: www.adv-elements.com

Step 11 >> Simplify the text layer and make feathered wave-like selections at the bottom of the type. Delete these sections.

Step 12 >> Select the text then switch mode to Intersect and make a rectangular selection of the bottom of the type.

Step 13 >> Using a foreground to transparent gradient set to Darken, fill the selection with a linear gradient.

Step 14 >> Select the shadow and apply the same gradient from the letter base outwards.

This provided a broken edge texture to the shadow that made it appear to fall more realistically on the water's surface.

The text layer was converted to a standard image layer using the Simplify Layer command (Layer > Simplify Layer). To give the illusion that the letters are partially submerged at their base, a series of curved

selections were made at the bottom of each letter shape. The selection was feathered a little (1-2 pixels) and, with the text layer selected, these sections of the letter were then deleted (Edit > Cut).

To complete the technique some minor adjustments were made to the color and tone of both the letter shapes and their shadow. The bottom of the letters needs to be made darker and the effect

gradually reduced as you move up the letter. To achieve this change the letters were selected first and then with the Intersect Selection mode highlighted, a rectangular selection was then drawn over the lower section of the letter shapes. This creates a selection of just the bottom half of the letters.

The gradient tool was selected and the mode turned to Darken. A color to transparent gradient was chosen and the color changed to a dark blue, sampled from the background using the Eyedropper tool. A linear gradient was drawn from the bottom of the selection upwards, with the effect that the letters became darker at the bottom than the top. The same gradient technique was applied to the shadow layer, this time making the area closest to the base of the letters the starting point for the linear gradient. The overall effect of the combination of layer styles, cast shadow, wave filter and gradient darkening has produced a text/picture montage that merges the type more convincingly with the background image.

Gradient Editor >> The Gradient Editor can be used to alter the color, style and type of gradient that you draw. In the example I sampled the background to ensure that the color in the gradient was consistent with those in the scene.

Book resources at: www.adv-elements.com

11.13 Hand drawn logos

Suitable for Elements – 5.0, 4.0, 3.0, 2.0, 1.0 | Difficulty level – Intermediate | Resources – Web image 1113 | Tools used – Drawing tools | Menus used – Select, Image, Layer There will be times when the particular project that you are working on requires a graphic element that can't be sourced from a photograph or created using the Custom Shape tool. In these circumstances there is no escaping trying your hand at a little drawing. No need to panic though as Elements contains a few tools that can make even the most elementary artist's work very presentable.

For example, let's create a dollar sign symbol that could be used as part of a business presentation. Using the paint brush, set to a soft-edged tip, roughly draw the symbol making sure the basic shape is correct. To clean up the edges of the drawing convert the picture to just black and white (no grays) using the Threshold command (Image > Adjustments> Threshold). With the Threshold dialog still open you can alter the point at which a gray tone is changed to white or black

Pro's Tip: Graphics tablets to the rescue If you regularly need to draw freehand shapes then you will quickly find that the mouse, though good for general screen navigation, is quite clumsy for drawing. For years professional artists have forsaken the humble mouse for a drawing tool that is far more intuitive and easy to use – the stylus and tablet.

Working just like a pen and pad these devices are more suited to many drawing and painting tasks. They not only provide a way of working that is familiar but they also allow you to use an extended Elements function set designed to take advantage of the pressure settings of the device. Pushing harder with the stylus as you draw can change the density or thickness of the line or if you are using the Dodging tool, for example, changing pressure will alter the degree of lightening.

Drawn symbols >>> Using the Selection tools in Elements along with a tricky manoeuvre with the Threshold command you can turn a rough hand drawn symbol into a graphical element that you can use in your publications.

Step 1 >> With a soft-edged brush draw the base artwork for the dollar symbol.

Step 2 >>> Convert the drawing to a flat graphic using the Image> Adjustments > Threshold command.

Step 3 >>> Trim unwanted areas from the graphic by selecting first with the polygonal lasso and then deleting.

Step 6 >> Drop in a background image and use a copied version of the graphic as a shadow to complete.

Step 4 >> Smooth the edges by selecting the symbol, contracting (Select > Modify > Contract) and then smoothing (Select > Modify > Smooth).

Step 5 *Inverse* (Select > Inverse) the selection and delete (Edit > Cut) the unwanted edges. Apply a layer style to the finished graphic to give the symbol some depth.

B 10

*

100

by sliding the threshold arrow in the middle of the graph. Click OK to convert. Now the symbol has a hard edge but some of the areas where lines meet are too rounded. Use the Polygonal Lasso tool to trace the preferred outline for these areas and then delete (Edit > Cut) the unwanted edge sections. The basic shape is ready but some edges are still a little rough. Make them smoother by firstly selecting the shape and then reducing (Select > Modify > Contract) and smoothing (Select > Modify > Smooth) the selection. Next inverse (Select > Inverse) the selection and delete (Edit > Cut) the unwanted edges. Your basic symbol is now complete. You can add a layer style and a background, like the Euro notes used in the example, to complete the illustration.

PRODUCING EFFECTIVE

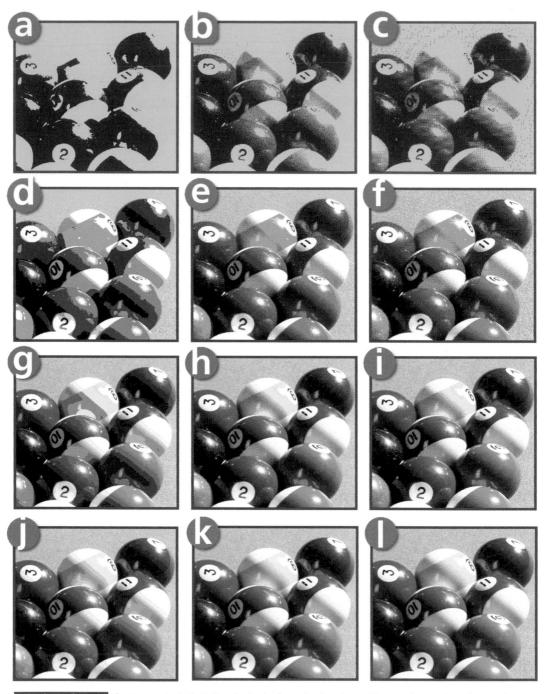

 Using less colors >>
 The two controls that alter the look of your 'reduced-color' images the most are the total number of colors and the type of dithering used to simulate lost hues.

 (a) 2 color, no dither.
 (b) 2 color, diffusion dither.
 (c) 2 color, pattern dither.

 (a) 2 color, no dittier.
 (b) 2

 (d) 8 color, no dither.
 (e) 8

 (g) 64 color, no dither.
 (h) 6

 (j) 256 color, no dither.
 (k) 2

(b) 2 color, diffusion dither.
(e) 8 color, diffusion dither.
(h) 64 color, diffusion dither.
(k) 256 color, diffusion dither.

(c) 2 color, pattern dither.
(f) 8 color, pattern dither.
(i) 64 color, pattern dither.
(l) 256 color, pattern dither.

Image courtesy of www.ablestock.com. Copyright © 2003 Hamera and its licensors. All rights reserved.

Book resources at: www.adv-elements.com

11.14 Reducing your picture's colors

Suitable for Elements – 5.0, 4.0, 3.0, 2.0, 1.0 | Difficulty level – Basic Resources – Web image 1114 | Menus used – Edit

For most of us when we consider the colors in our digital images we think about trying to capture and use the most hues possible. After all, the accuracy and quality of digital pictures are based, at least in part, on the number of colors use to construct them. Hence the push of scanner and camera manufacturers towards creating devices that capture in 24-, 36- and even 48-bits. This said, there are still times when for aesthetic or technical reasons there is a need to reduce the numbers of colors present in your images.

Limiting the numbers of colors in a picture is one way to make files small enough to display quickly on web pages. The GIF (Graphics Interchange Format) format is a file type suitable for web use that can also store images with different numbers of colors (up to a maximum of 256). A GIF image with 8 colors, for instance, takes up much less space and displays more quickly than one that contains 200 hues. In addition to the small file sizes, 'reduced-color' images have a distinctive look that can suit situations when large areas of flat color are needed.

Elements, in its Save for Web (Edit > Save for Web) feature, provides a GIF format option which enables you to interactively reduce the number of colors in your image. This feature can be used to convert a full color image (16.7 million colors) to one that contains as few as two different hues. At the same time you can also make decisions about how Elements will make the reduction. The 'No Dither' selection will create an image made up of flat colors only, whereas selections of 'Diffusion', 'Pattern' or 'Noise' will try to recreate the removed colors and tones by mixing together various proportions of those hues that are left. Deciding on which combination of settings works best for your application often requires a little experimentation. Use the example images below as a guide to how the number of colors and the dither settings alter the way a 'reduced-color' image looks.

GIF	~		Interl	aced
GIF		Colors:	2	~
JPEG	1	Dither:	100%	5
PNG-24		Matte:		~
	1000 pi×e			
– Original Si Width: Height:				
– Original Si Width: Height: – New Size	1000 pixe 665 pixels			
– Original Si Width: Height:	1000 pi×e		Та	
– Original Si Width: Height: – New Size	1000 pixe 665 pixels	-]®	
- Original Si Width: Height: - New Size Width:	1000 pixe 665 pixels 1000 665	pixels]®	

Step 1 >> With an image open, select the Save for Web feature from the File menu. Choose the GIF setting from the File Type dropdown menu.

GIF	~	[Interlaced
Perceptual	~	Colors:	* A V
lo Dither	~	Dither:	2
Transpar	ency	Matte:	4
Animate			16
			32
mage Size - - Original Si	ze		128
	1000 pix	els	256
Height:	665 pixel	s	-
New Size			
Width:	1000	pixels	٦
Height:	665	pixels	8

Step 2 >> Pick the number of colors from the presets in the Colors dropdown menu or input the precise number into this space.

Step 3 >>> Now choose the Dither Type from the drop-down menu on the left of the dialog. Click OK to save the newly created GIF file.

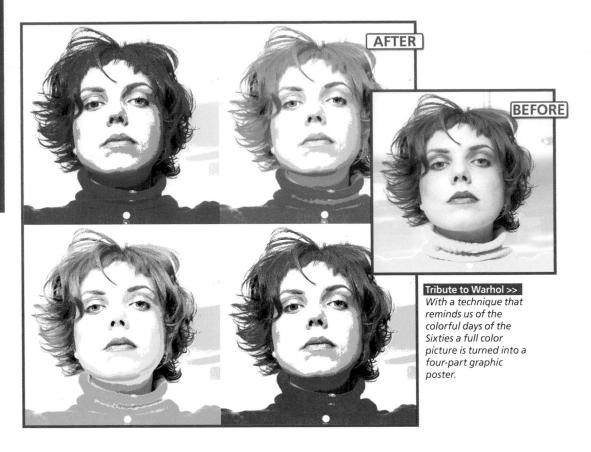

11.15 Posterized pictures

Suitable for Elements – 5.0, 4.0, 3.0, 2.0, 1.0 | Difficulty level – Intermediate | Resources – Web image 1115 Related techniques – 11.14 | Menus used – Enhance, Image, Layer

Andy Warhol made the technique famous with his 'Campbell Soup Cans' and now you can recreate the sixties and this posterized effect using Elements and your own digital camera. Warhol's images were extremely graphic and were constructed of very few colors, which were applied in broad flat areas of the picture. Following on from the previous technique, here I pay tribute to Warhol by creating flat color images using a reduced color set created with a single filter in Elements.

In the example I started with a standard portrait, increased its contrast and then reduced the numbers of colors used to make up the image with the Posterize feature. To make different color combinations I adjusted the Hue and Saturation sliders in the Hue/Saturation feature.

To start the process the picture will need to contain a little more contrast than normal. I enhanced the contrast with the Levels feature (Enhance>Adjust Lighting>Levels) but you could easily use the Contrast slider (Enhance > Adjust Lighting>Brightness/Contrast). To increase contrast you need to click-drag the black point and white point triangles towards the center of the Levels histogram.

Book resources at: www.adv-elements.com

298

PRODUCING EFFECTIVE GRAPHICS Next I reduced the number of colors in the picture using the Posterize feature. Select the feature from the Adjustments section of the Image menu (Image > Adjustments > Posterize). Input the numbers of levels you wish to use for the picture into the Posterize dialog. The smaller the number the less colors in the final picture. Here I used a setting of 4 levels.

This gives you your base colored image. To alter the color mix I employed the Hue and Saturation control. Select the feature from Adjust Color section of the Enhance menu (Enhance > Adjust Color > Hue/Saturation). You can create many different color combinations by moving the Hue slider in the Hue/Saturation dialog. If the new colors are a little strong then reduce their vibrancy by dragging down the Saturation slider.

You can extend the idea into a poster using four different posterized versions of the original portrait by copying and pasting the picture onto a bigger canvas and then selecting each copy in turn and adjusting the colors.

Step 1 >> The contrast of the original portrait is increased by dragging in the white and black Input sliders in Levels.

Step 4 >> The background layer was converted to a standard image layer by double-clicking its label.

Step 2 >> The Posterize feature was set to 4 levels to reduce the colors in the picture.

Step 5 >> To accommodate the three other pictures the canvas size was increased by 200% in width and height.

Step 3 >> The color combination was altered by moving the Hue slider in the Hue/Saturation control.

Step 6 >> The base image was copied three times, the colors in the copies adjusted and then each picture placed in the corners of the composition.

Book resources at: www.adv-elements.com

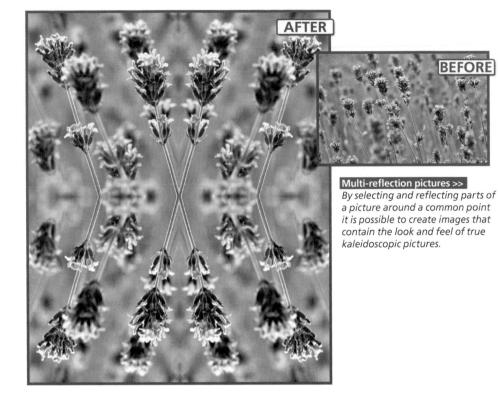

11.16 Kaleidoscopic images

Suitable for Elements – 5.0, 4.0, 3.0, 2.0, 1.0 | Difficulty level – Intermediate | Resources – Web image 1116 Tools used – Crop, Move tools | Menus used – Layer, Image, Edit

I can still remember saving my pocket money for weeks to buy my first kaleidoscope. I was fascinated by the way that the images would change and move as they refracted, or is that reflected, inside the small metal tube. Apart from a brief and largely embarrassing period in my imaging career when I owned, and happily used, a 'multi-imaging' filter on the front of my camera, I have not rekindled my interest in these types of images until recently when I started to play with a few photographs in Elements. I found that by copying and pivoting the main image I could create an interesting and dynamic picture that contained several of the kaleidoscope qualities I valued in my youth.

Real kaleidoscope pictures are made with a tube, an eyepiece and a series of carefully arranged mirrors. The distinctive images that we see are produced by the scene at the end of the tube reflecting from the surface of a series of mirrored surfaces. The positioning and number of mirrors alter the style and complexity of the image. The digital version of this technique detailed here repeats an image around a common point allowing the edges to interact, using layer flips to reflect the picture and one-pixel cursor movements to ensure that pictures are precisely placed. Though not strictly a kaleidoscope technique, the pictures that are produced do contain similar shapes and textures that we would expect from a picture created traditionally.

....

300

Book resources at: www.adv-elements.com

Step 1 >> Crop the image to a section that contains good color, contrast and shapes.

Step 2 >>> Convert the background layer into a standard image layer by double-clicking on the layer label.

Step 3 >>> Open the Canvas Size dialog, anchor the picture in the corner and increase by 200%.

Step 4 >> Duplicate the layer three times so that you have four versions of the original picture.

Step 7 >>> Select the right-hand layers one at a time and flip them horizontally.

Step 5 >> Use the Move tool to position the three copies in the vacant corners of the canvas.

Step 6 >> Select the bottom layers one at a time and flip them vertically.

Which images are suitable?

The pictures that work best for making striking multifaceted images are those that contain contrasting color and texture, along with dominant graphic shapes. Strong lines too can provide a basis for making dynamic and exciting designs in your final compositions.

You shouldn't let any preconceptions deter you from trying a range of different images with this technique. You will be surprised at how amazing a photograph, that you would normally discard, can appear as a kaleidoscope montage. 301

PRODUCING EFFECTIVE GRAPHICS

The process outlined above will give you simple, but stunning, images and with a little more effort you can create truly dynamic compositions from your photographs. Use the picture created above as the basis for further copying, flipping and positioning. By repeating the original picture several times you will end up with a multi-image kaleidoscope pattern.

Step 1 >> Merge the four layers in the kaleidoscope picture created in the previous technique.

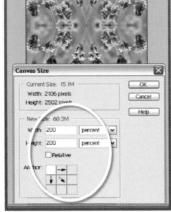

Step 2 >> Open the Canvas Size dialog, anchor the picture in the corner and increase by 200%.

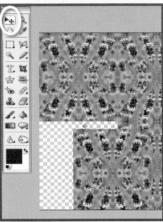

Step 3 >> Duplicate the image layer three times and position the copies in the corners of the canvas.

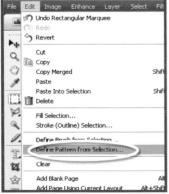

Step 1 >> Create a selection with the rectangular marquee and then choose Define Pattern from Selection in the Edit menu.

Book resources at: www.adv-elements.com

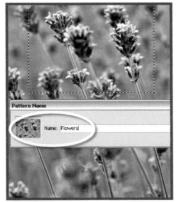

Step 2 >>> Name the new pattern. The pattern will be stored in the Elements patterns folder.

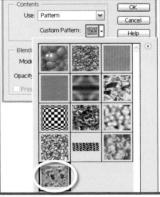

Step 3 >> Choose Edit > Fill, selecting the Pattern option as the content. Select the pattern from the thumbnails.

PRODUCING EFFECTIVE

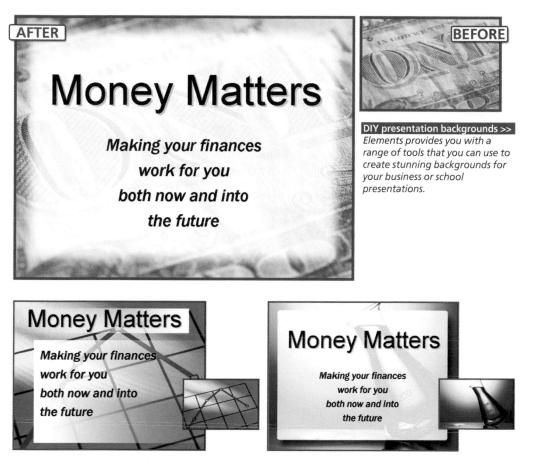

11.17 Presentation backgrounds

Suitable for Elements – 5.0, 4.0, 3.0, 2.0, 1.0 | Difficulty level – Intermediate | Resources – Web images 1117-1, 1117-2, 1117-3 | Tools used – Selection, Gradient, Crop | Menus used – Select, Layer, Image

One of the most common ways that ideas and information are communicated in the business world today is via the PowerPoint presentation. This program is the digital platform that replaces both the slide and overhead transparency projectors. It is used to sequence a series of 'slides' that can contain text, pictures, sound, video and tables.

People spend many hours putting together the content for these multi-slide extravaganzas but, too frequently, little attention is paid to the background images that are used in the show. These pictures provide a context for the information that is being presented and what better way to emphasize your point than to create and include background graphics that relate specifically to the ideas that you are presenting? Don't reach for the 'clip art backgrounds' that come with the program – think about what type and style of pictures would suit the content of your presentation and either shoot them yourself, or source them from a stock company like www.ablestock.com. With images in hand you can now create your own backgrounds that are customized for your presentation.

Step 1 >> Set the Width, Height and Resolution values in the Crop tool options bar to suit your slide.

Step 4 >> Feather the selection so the edge will not be hard and sharp.

(a) Lightening a soft-edged selection

To start we must make sure that the background image is the size suitable for the presentation. This value is usually determined by the default resolution of the digital projector you use. Here I used a standard 800 x 600 pixel slide. With the image open I select the Crop tool and input the height and width into the option bar. Now the tool will only allow me to crop with a shape that suits the slide size. With the image now sized, I make a rectangular selection just inside the edges of the picture. This area is where the text of the slide will be placed. The selection is then softened using the Feather command (Select > Feather). I then use the Levels feature (Enhance > Adjust Brightness/Contrast > Levels) to lighten the text area of the picture. To achieve this I drag the black Output slider towards the right. This converts the dark tones to lighter ones and creates a good area where text can be placed. The picture is then saved as a high quality JPEG file ready for use in the presentation. An extended version of this technique uses a Levels adjustment layer in Step 5. This approach provides the same results but doesn't change the base image in the process. It also allows you to resize or move the lightened area without affecting the base image.

Book resources at: www.adv-elements.com

Step 2 >>> Click and drag out the crop area that you want to use as a background. Press Enter to complete.

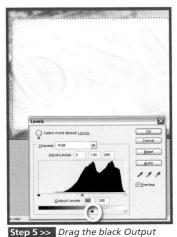

slider of the Levels feature to the right to lighten the selected area.

Step 3 >>> Make a rectangular selection just inside the image.

Elements is perfectly suited for the creation of PowerPoint graphics and in this technique I will demonstrate how to create three different background styles with images that you can take yourself. All the procedures are based on the idea that the picture needs to be visible but not so apparent that it makes the text difficult to read.

PRODUCING EFFECTIVE

(b) Fade to white

The second technique uses the Gradient tool set to 'Foreground to Transparent' and 'Linear' to create the text space. The gradient is applied separately to two different rectangular selections to create a place for a heading as well as an area for main points. If not enough lightening is provided by the gradient to make the text readable, apply a levels adjustment, like the one described in the technique above, to the selections as well.

Step 1 >> To make the heading area create a long thin rectangular selection from the left border to just short of the right border.

Step 2 >>> With a white to transparent gradient selected use the Linear Gradient tool to fill the selection.

Step 3 >>> Reverse the gradient fill then create and fill a larger selection lower on the page for the presentation points.

(c) Dropped shadow text box

The last technique creates a text area based on a drawn rectangle filled in white that is slightly smaller than the overall slide dimensions. A drop shadow Layer Style is then applied to the white box to make it stand out from the background. As a finishing touch the opacity of the box layer is reduced to allow some of the background image to show through.

Step 1 >> Draw a rectangle slightly smaller than the size of the background using the Rounded Rectangle tool.

ILayers Norma Shape 1 Background

Step 2 >> With the rectangle layer selected apply a drop shadow Layer Style to the shape.

Step 3 >>> Lower the opacity of the rectangle by moving the Opacity slider in the Layers palette.

Book resources at: www.adv-elements.com

PRODUCING EFFECTIVE

306

		Ø 🔅 Silde Layout Apply silde layout
	1	Test Layouts
	Click to add title	
	Click to add subtitle	
	ALC: No.	Test and Content Layout
2010/02/02/02/02		Concession (Concession)

Microsoft PowerPoint >> PowerPoint provides an easy way to bring together images, text, tables and videos into a digital slide show format.

Adding your backgrounds to a PowerPoint slide With your backgrounds now complete you can import them into your PowerPoint presentation. When formatting slides in the

program the background and the presentation information such as tables, text and pictures that sit on the background are treated separately. It is possible to construct your whole presentation and then apply a single background image to all the slides or even apply different images for each slide.

To add your newly created background images to an existing slide select Background from the PowerPoint Format menu. Next choose the Fill Effects option from the drop-down menu at the bottom of the Background dialog. Choose the Picture tab from the Fill Effects dialog and click the Select Picture button. Navigate your way through your folders to find the slide backgrounds that you saved as JPEG files. Select the background you want to use for this slide and click Insert and then OK. In the Background dialog click Apply to use the picture for just a single slide or Apply to All to make this image the default background for all slides in the presentation.

Step 1 >> Choose Background from the Format menu and then pick Fill Effects from the drop-down list.

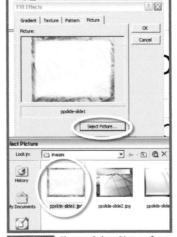

Step 2 >>> Choose Select Picture from the Picture tab of the Fill Effects dialog and then find your background pictures.

Step 3 With the backgrounds now inserted add the content of the presentation.

Book resources at: www.adv-elements.com

Free Form Photo Layouts

ADVANCED PHOTOSHOP ELEMENTS 5.0 FOR DIGITAL PHOTOGRAPHERS

Photoshop Elements 5.0 has a range of great new tools designed to tease upgrade money from the digital photographer's wallet, none of which is more exciting than the new Photo Layout feature. Far from being a 'one trick pony' the feature brings with it a host of new technologies that will change the way that Elements users create picture montages and layouts for ever.

Adobe has created a new layer type, **Frame layers**, a new file format, the Photo Creations or **PSE** format, a new design system that uses special matched frames and backgrounds sets called **Themes**, a new set of **Photo Creation** projects that makes use of all this new technology and, finally, a new layout workflow.

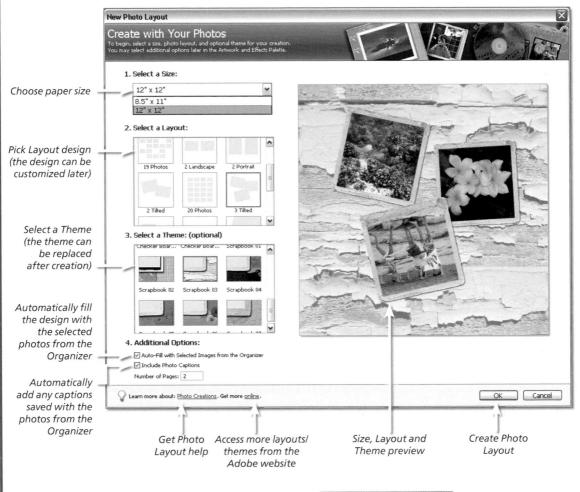

The Photo Layout feature >>> The new Photo Layout dialog groups together the options that govern the way that your multi-page photo layout document is created. The documents produced with this process are editable later inside the Full Edit workspace where extra images, text, graphics, effects and pages can be added to or removed from the design.

Book resources at: www.adv-elements.com

FREE FORM PHOTO LAYOUTS

Sound confusing, well it is new, and it is different, but once you begin to play with Photo Layouts, the process seems so logical and familiar that it isn't long before you will start to feel at home with the new workflow. So to get you started this chapter will look at the the basic technology and techniques that are involved in the new layout workflow. In the next chapter we will then see how this revolutionary way of working has impacted on the production of other Photo Creations projects in Elements 5.0.

Before you start - edit then layout

The production of Photo Layouts, or any of the other Photo Creation projects, in Photoshop Elements is essentially a presentation exercise for photos that have already been enhanced. For this reason it is a good idea to complete any preliminary editing work such as color and tonal correction, spotting and retouching changes and the application of sharpening before including the picture in a new Photo Layout.

This is especially true when working with the special framed picture elements of a Photo Layout as these visual components are stored in a special Frame layer which has to be simplified before it can be edited. The act of simplification, which is also called rasterization, converts the Frame layer to a standard image layer and in the process removes the layer's ability to scale, rotate and distort repeatedly without image quality loss.

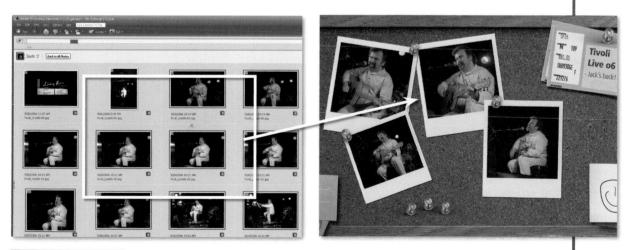

FREE FORM PHOTO LAYOUTS

12.01 Basic steps for layout creation

Suitable for Elements – 5.0 | Difficulty level – Basic | Resources – Web image 1201-1, 1201-2, 1201-3 Related techniques – 12.02, 12.03, 12.04

Using the new Photo Layout feature, one of the new Photo Creation options in Elements 5.0, is a simple multi-step process with the creation options centered around the new Photo Layout dialog.

Step 1 >>> The process of creating a Photo Layout, one of the new Photo Creation options, will generally start in the Organizer workspace. Here you can multi-select the photos that will be used in the layout. To choose a series of images click on the first thumbnail and then hold down the Shift key and click the last picture in the series.

Step 2 >>> To pick non-sequential photos, select the first and then hold down the Control key whilst clicking on other thumbnails to be included in the selection. With the images highlighted the next step is to choose File > Create > Photo Layout or pick the heading from the Create Shortcut Key menu.

Step 3 >> Using an Elements' collection as a starting point you can alter the order or sequence that the photos appear in the multi-page document. After rearranging the position of photos in the collection, multi-select those to be included in the layout.

Step 4 >>> Alternatively a blank document can be created by selecting the File > Create > Photo Layout option in either the Editor or Organizer spaces. Photos that are already open can then be dragged into the blank document from the Photo Bin area of the Editor. Nonopened pictures can be added by clicking onto the Click Here to Add Photo section of the newly created frames and then choosing the image from the file browser that is displayed.

Step 5 After selecting to create a multi-page document Elements displays the new Photo Layout dialog. The window contains a preview area and four sections for adjusting the characteristics of the document. At the top you can select the Size of the photo layout from those contained in the drop-down list.

Note: For a more detailed look at this dialog see the illustration on page 308.

Step 6 >>> Next the Layout design is chosen. This option controls the number and general position of the pictures on the document pages. The Theme options provide the chance to refine the way that the layout looks. Here you can choose background and frame treatments. The last section provides the Additional Options of auto filling the pages created with selected photos, adding caption details and altering the total number of pages created. The choices you make will change the example preview to the right of the dialog.

310

Book resources at: www.adv-elements.com

Step 7 >>> Extra pages and images can be added or removed after the Photo Layout has been created from inside the Full Edit workspace. The frames, backgrounds and themes can also be changed by applying an alternative design from those listed in the Artwork and Effects palette.

Step 8 >>> Once the Photo Layout or other Photo Creation's characteristics are set then clicking the OK button at the bottom of the dialog will instruct Elements to create the free form multi-page document. This process can take a little while as the program creates the pages and then sources, sizes and inserts the pictures into the new Photo Layout.

Step 9 *Each photo is stored on a separate Frame layer which is indicated by a small plus icon in the bottom right of the layer's thumbnail.*

Step 10 >>> Frame layers are unlike other image layers in that they contain both the photo as well as its surrounding frame. These picture parts are stored separately and remain editable even though they appear as a single layer. When the creation process is finished you can flip between pages by clicking on the next (or previous) page in the Photo Bin or pressing the Forward and Back buttons in the Organizer space.

Step 11 >>> Unlike the album pages in earlier versions of Elements, Photo Layouts and the other Photo Creations, and their contents, remain editable after they have been saved and reopened. To enable this new ability Adobe created a completely new file format for the multi-page editable documents. Called the Photo Creation Format it has an extension of .PSE as opposed to the . PSD that is associated with standard Photoshop and Photoshop Elements documents.

Step 12 >> When saving a newly created Photo Layout the file format in the Save dialog automatically changes to .PSE. By default the Include in the Organizer option is also selected ensuring that the new document is catalogued and displayed in the Organizer space. A small Multi-page icon is displayed at the top right of the thumbnail of each Photo Layout document displayed in the Organizer.

Quick change layouts using Themes The new Photo Layout feature in Photoshop Elements 5.0 can be used to quickly create a series of photo album pages using photos selected in the Organizer workspace. A variety of layout designs are shipped with the program with other variations promised as downloads in the future. Changing a design (a specific background and frame) is as simple as Applying a new Theme from the Artwork and Effects palette.

12.02 Editing existing Photo Layouts

Suitable for Elements – 5.0 | Difficulty level – Basic | Related techniques – 12.01, 12.03, 12.04

As we have seen, the Photo Layout feature can create a multi-page document complete with photos in frames on a background. In producing this design Elements will make decisions about the size and position of the frames and the pictures within them. On many occasions you will probably want to use the pages the feature produces with no alterations, but there will be times when you will want to tweak the results. At these times use the following techniques to edit the automatically produced designs.

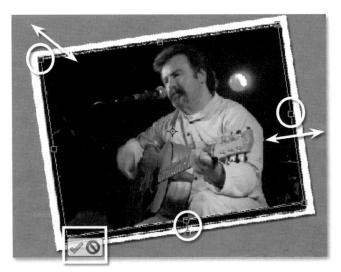

Basic adjustments >>

To move the picture and frame combination to a new position on the canvas just click and drag the combination.

The size and orientation of the Frame/Picture can be altered by clicking on the picture and frame first, to select it, and then using the corner, edge and rotate handles to scale or pivot.

Click on the Commit button (green tick) at the bottom of the selected picture to apply the changes. To disregard the changes click the Cancel button (red circle with diagonal line through it) instead.

Book resources at: www.adv-elements.com

FREE FORM PHOTO LAYOUTS

Frame and picture combination changes summary

Other adjustment options are available via the right-click menu when the Move tool is selected. Selections in this menu allow you to:

Rotate 90° Right or Left – Pivot the frame and picture by a set amount.

Position Photo in Frame – Switch to Picture Select mode to allow scaling, rotating and moving the photo within the frame.

Fit Frame to Photo – Automatically adjust the frame size to accommodate the dimensions and format of the place photo. Use this option if you don't want to crop the photo with the edges of the frame.

Replace Photo – Displays a file dialog where you can select a new photo for the frame.

Clear Photo – Removes the photo but keeps the frame.

Clear Frame - Removes the frame but keeps the photo.

Altering the picture only >>

As well as being able to alter the characteristics of the frame by selecting the photo you can perform similar changes to the picture itself. Doubleclicking with the Move tool or choosing the Position Photo in Frame option from the right-click menu selects the photo and displays a marguee around the picture. A small control panel is also displayed at the top of the marguee. To move the position of the photo in the frame simply click and drag on the image, releasing the mouse button when the picture is correctly placed. You can alter the size of the photo within the frame by moving the Scale slider (in the control panel) or by dragging one of the handles of the marguee.

Moving a corner handle will scale the photo proportionately, whereas dragging a side handle will squish or stretch the image. The picture can be rotated in 90° increments (to the left) by clicking the Rotate button in the control panel. Alternatively, you can rotate the image to any angle using the rotate handle (middle of the bottom edge of the marquee) or by click-dragging the cursor outside the boundaries of the marquee.

The photo can be replaced with a new picture by clicking the Replace button in the control panel and then selecting the new picture from the file dialog that is displayed.

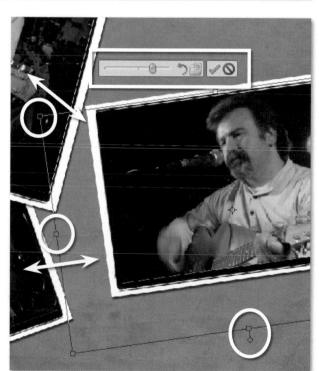

FREE FORM PHOTO LAYOUTS

Altering the Picture Only summary

Extra image adjustment options are available from the right-click menu. The actions available are:

Free Transform – The default mode where dragging the corner of the marquee scales proportionately and dragging the edges squashes or stretches the picture. The following keys alter the action of dragging a handle when in this mode:

Shift + corner handle – Scales proportionately (this option is set by default when first scaling so it may not be necessary to hold down Shift unless you moved an edge handle),

Ctrl + any handle - Distorts the picture,

Ctrl + Shift + middle edge handle - Skews the picture, and

Ctrl + Alt + Shift + corner handle – Applies perspective.

Scale – Resizes in the same manner as the Free Transform mode.

Free Rotate Layer - Rotates the image when click-dragging outside of the marquee.

Skew – Skews the photo when dragging an edge handle.

Distort – Distorts the picture when moving any handle.

Perspective – Applies a perspective effect when dragging a corner handle.

12.03 Adding, removing and replacing photos

Suitable for Elements - 5.0 | Difficulty level - Basic | Related techniques - 12.01, 12.03, 12.04

Photo Layouts do not become static documents once they are created. In the previous section we saw how it is possible to adjust the size, position and orientation of both the photo and frames that were added during the initial creation process, but the feature's flexibility doesn't end there. You can also add new photos, replace existing pictures with alternative choices and even remove images that you no longer want to keep. Here's how.

Adding new photos >>

All editing of Photo Creations occurs in the Full Editor workspace. So to add new photos to an existing layout you need to add a new blank frame to the composition. Do this by clicking on the selected frame in the Artwork section of the Artwork and Effects palette and pressing the Apply button. A new frame will be created on the current page of the document. To add a photo to the frame, click-draq

one from the Photo Bin to the frame, click-drag one from the Photo Bin to the frame or click the text in the empty frame and select a photo from the file browser that opens. Using this approach you can add a photo without it first having to be open in the Photo Bin. When moving the photo make sure that the frame is highlighted with a blue rectangle before releasing the mouse button to insert the picture.

Book resources at: www.adv-elements.com

Getting new photos to fit >>

The last part of the process is to fine-tune the picture by adjusting size, orientation and position within the frame. Use the techniques in the previous section to make these alterations.

A good starting place is to select the Fit Frame to Photo option from the rightclick menu. After the image and frame are the same size you can then scale, rotate and move the combination.

Replace existing photos >>

It is just as easy to replace existing photos with different images whilst still retaining the frame. Select the frame first and then click-drag a picture from the Photo Bin to the frame.

This action swaps the two pictures but you will need to have the replacement image already open in the Full Editor workspace beforehand. If this isn't the case, then an alternative is to select the Replace Photo entry from the right-click menu and choose a new picture via the file dialog that is displayed.

Switching photos >>

You can also switch photos between frames on a page by dragging the content of one frame over another. You will see a special Cursor icon when the image is in position and the content will be switched.

Removing photos >>

Pictures inserted into frames can be removed whilst still retaining the frame by selecting the Clear Photo option from the right-click menu. The frame will then revert back to a blank state providing the opportunity to add a new image to the composition.

If you want to remove both the frame and the photo it contains then select the frame first and click the Delete key. A warning window will display asking you if you want to delete selected layers. Answer yes to remove the frame and picture from the composition.

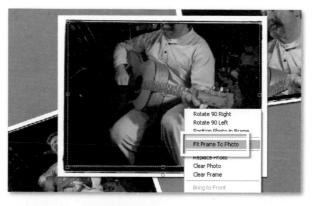

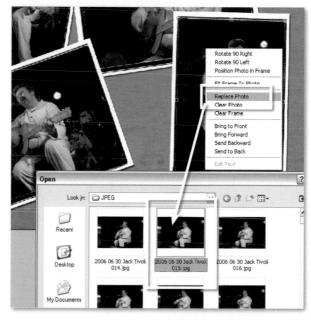

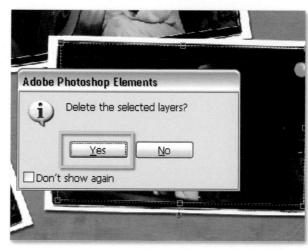

Book resources at: www.adv-elements.com

PHOTO LAYOUTS

FREE FORM

12.04 Adding, moving and deleting pages

Suitable for Elements – 5.0 | Difficulty level – Basic | Related techniques – 12.01, 12.02, 12.03 If you selected the Auto Fill option when first creating your Photo Layout then Elements will have generated enough pages to insert the photos that were initially included. If you want to add images, some text or graphics later on then you will need to add some extra pages. The new Photo Creation file format (.PSE) was developed especially to handle multi-page documents and to ensure that tasks such as adding, deleting and moving pages was as easy as possible.

All page management activities are centered around the PSE document in the Photo Bin. The document can be displayed collapsed, where all the pages are grouped together on top of each other, or expanded, where each of the thumbnails representing a single page can be viewed separately.

Adding Pages >>

All new pages in a PSE document are added after the current selected page. So start by expanding the multi-page document in the Photo Bin and then selecting the thumbnail of the page before the position where the new page is to be created.

So to add a new page you choose either the Add Blank Page or Add Page Using Current Layout option from the Edit menu.

The new page is then added to the document and a new thumbnail is displayed in the Photo Bin to the right of the selected page.

These Add Page options are also available from the right-click menu when you select a page in the Photo Bin.

Adding pages options:

In Elements you have two options for creating new pages:

Add Blank Page – Use this option to add a white page with no frames, backgrounds or themes present. Once the page is created then text, graphics, shapes, frames, backgrounds and special effects can be added from the Artwork and Effects palette.

Add Page Using Current Layout – This feature duplicates the layout settings of the selected page when creating the new one. Use this option to add new pages to a group of pages that already contain a background and frames as it will help to keep the look of the whole document consistent.

Moving pages >>

The position of pages (from left to right) in the expanded view of a multi-page document in the Photo Bin indicates the page's location in the production. The first page in the document is the one position furtherest to the left, the second page is the next one along to the right and so on. Changing the position of the page thumbnail in the Photo Bin preview alters the page's actual position in the document. Moving pages is a simple task – just click on the page to move and drag it to a new location in the document, release the mouse button and the page is relocated.

Delete Current Page

Add Blank Page Add Page Using Current Layout

Auto-hide

Deleting pages >>

Pages, and the frames and photos they contain, can be deleted from a multi-page document by selecting the page thumbnail in the Photo Bin and then choosing Edit > Delete Current Page. Alternatively, the Delete Current Page entry can also be selected from the right-click menu.

Viewing pages >>

Navigate between the different pages of your PSE document by selecting the thumbnail of the page that you want to display from the Photo Bin. Alternatively you can move from one page to the next using the Forward and Backward buttons located at the bottom of the document window.

33.33% 27.94 cm x 21.59 cm (220 ppi)

PSE document shown collapsed

PSE documents in the Photo Bin >>

Multi-page Photo Creation (.PSE) documents are displayed in the Photo Bin with a shaded background. The document can be expanded or collapsed via the sideways arrow button on the right of the last thumbnail on the right.

Selected page

PSE document shown expanded

Collapse/Expand button

37.2296

27.94 cm x 21.59 cm (22

Book resources at: www.adv-elements.com

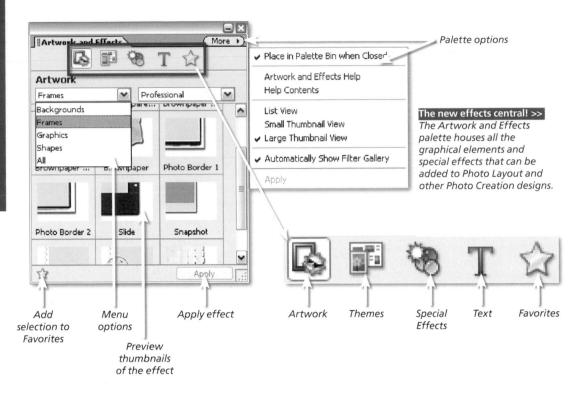

12.05 Using the Artwork and Effects palette

Suitable for Elements – 5.0 | Difficulty level – Basic | Related techniques – 12.01, 12.02, 12.03, 12.04 The Artwork and Effects palette replaces the Style and Effects palette of version 4.0 and is the central place for the storage of a variety of a design components that can be used to enhance the look of your Photo Layout compositions.

Once a multi-page document is created it is the various components that are housed in this palette that can be used to add to or alter the look and feel of your design The palette contains five separate sections which are accessed via the buttons at the top of the palette frame.

The Artwork section contains backgrounds, frames, graphics and shapes. The themes area houses prebuilt and fully styled layout designs for a variety of projects including scrapbook pages, CD/DVD jackets and greetings cards. Many of the frame and theme options featured in these sections are also available in the Photo Creations dialogs. The Special Effects group includes filters, layer styles, and photo effects. The Text section contains a variety of one-click text effects that can be added quickly and easily to type. The Favorites group holds user selected favorites chosen from the other areas.

To add a theme, frame, background or any other entry from the palette select the entry and then click the Add to Favorites button. To apply a style, effect or add artwork to a document select the Palette entry and click the Apply button. Extra palette options and preferences are available via the More button at the top of the palette.

Book resources at: www.adv-elements.com

318

FREE FORM PHOTO LAYOUTS

rk and Effects 马阿哈T 公 Y

bum Par Cd Dvd Label

vd Jacket

to Layou

01

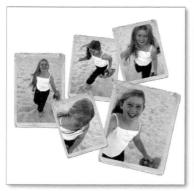

More +)

0.02

319

Old Style Pa ating Card (large) ing Card (small) Appla

Multiple designs in seconds >>

You can change both frames and backgrounds of an existing layout with just two clicks – one to select the new theme (combination of frame and background) and two to apply it to the design. All the designs here were created in this way. If you drag the design from the palette and drop it on the document, then you can make the change with only one click. Cool!

FREE FORM PHOTO LAYOUTS

Artwork and Effects > Artwork section >>

The Artwork section of the Artwork and Effects palette contains backgrounds, picture frames, graphics and shapes that can be added to your layouts. Backgrounds, graphics and shapes all create their own layers when added. Frames, on the other hand, are applied to existing layers. To add a piece of artwork click on the thumbnail in the palette and then press the Apply button. To add a picture to a frame drag the image from another open document to the frame. All artwork except Backgrounds can be scaled and rotated via the corner, middle edge and rotate handles. Click the image layer to activate the handles.

Book resources at: www.adv-elements.com

Artwork and Effects > Text section >>

The Text section contains a variety of text effects that you can apply to the type in your Elements documents. The effects include bevels, drop shadows, glows and gradients, and only work with text layers. To apply a text effect select the text layer in the Layers palette first, then the thumbnail of the effect that you want to apply before finally clicking the Apply button. In addition you can also click Apply to create a new type layer. Like layer styles the attributes of the text effects (size of drop shadow, colour of stroke, etc.) can be adjusted via the Layer > Layer Style > Style Settings. Text effects can be removed by selecting the Layer > Layer Style > Clear Layer Style entry.

Artwork and Effects > Special Effects section >>

The Special Effects section of the Artwork and Special Effects palette groups together filters, layer styles and photo effects.

The Filters group contains many of the options that are listed under the Filter menu. To apply a filter select the layer to change, then the thumbnail in the palette and click Apply. Lavers styles add effects such as drop shadows, outer glows and strokes to selected layers. These can be applied to text, image and shape layers and the characteristics of the styles can be customized via the Layer > Layer Style > Style Settings dialog. Photo effects alter your photos via a series of automatic editing steps. Options include convert to black and white, create a photo frame and add soft focus. Some Photo effects are applied to standard image layers, others only work with background layers. After selecting the effect to apply, a pop-up dialog will indicate if you are working with the wrong layer type. To correct, simply convert image layers to background, or vice versa, and apply the effect again.

Artwork and Effects > Favorites section >>

The Favorites section of the Artwork and Special Effects palette lists all the artwork, effects, themes and styles that you have nominated as favorites. This area is a great place to store the Artwork and Effects entries that you use time and time again. For instance when you find a layer style or filter that you particularly like then, rather than have to search for it each time you want to use it, simply click the Add Favorites star at the bottom of the palette to store the style in the Favorites area.

Remove items from the Favorites by right-clicking on the thumbnail of the Favorites entry and selecting Remove from Favorites entry in the pop-up menu.

Artwork and Effects > Themes section >>

The Themes section lists a variety of pre-designed backgrounds and matched frame sets that can be applied to your Elements' document. A document page can only have one theme at a time so trying to apply a second theme will replace the existing background and frames. A multi-page document can have many differently themed pages though. Themes are a great place to start when you want to provide a consistent look and feel to your album or scrapbook pages. Commencing your project with themes doesn't mean that you can't add other frames, graphics, shapes or text later. Just choose and apply the selected frame style from the Artwork and Effects palette as you would normally. You can also change the theme's background by picking and applying a new background. Different frame styles can be substituted by dragging the new style over the existing frame and letting go when the layer border turns blue.

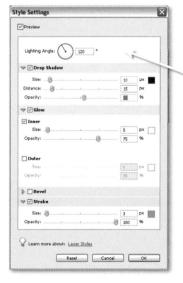

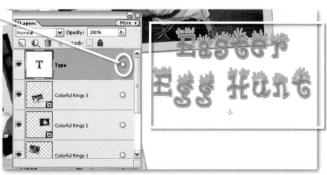

12.06 Align, arrange and distribute your frames

Suitable for Elements – 5.0 | Difficulty level – Basic | Related techniques – 12.01, 12.02, 12.03, 12.04 The Auto Fill option within the Photo Layout feature is a great way to get your photos into a layout quickly and easily. In the previous sections we have looked at how to adjust the pictures and the picture and frame combinations; now lets look at how to change the way that each of the picture elements relate to each other.

Photoshop Elements contains three specialist controls designed for this purpose. They are located on the options bar of the Move tool and are divided into Arrange, Align and Distribute headings. When clicked each shortcut button displays a variety of composition options in a drop-down menu.

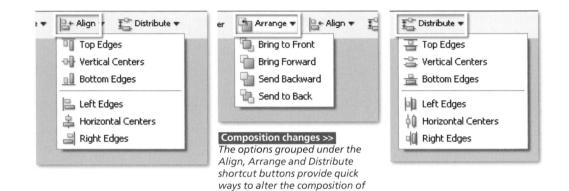

your framed photos.

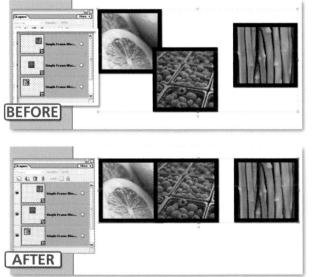

Align >>

The Align option is one of three new arrangement features designed to work with the contents of layers. After multi-selecting several layers in the Layers palette, the picture content of these layers can be composed according to the options in the Align menu.

Top and Bottom Edges align the picture via the top or bottom extremities of layer content. The Vertical Centers option arranges the picture parts around a horizontal line or axis. Left and Right Edges move the picture content to either side aligning the edges of the detail. The Horizontal Centers feature arranges all the content of the selected layers around a vertical axis.

In the example, the three pictures are aligned using the top edge of the frame. Do this by selecting the layers first and then choosing Align > Top Edges.

.

AFTER

Arrange >>

The Arrange option is one of three new layer organization features contained on the Move tool's options bar. Unlike the Align and Distribute features, Arrange moves a selected layer (or group of layers) up or down the layer stack rather than moving the contents of these layers around the canvas area.

To use the feature select a layer, or layers, in the Lavers palette and then choose one of the options in the drop-down Arrange menu in the Move tool options bar. In the example document the green leek picture (top laver) was selected and then the Send Backward option chosen. This moved the layer one position down in the order of the stack changing the picture so that the leek now sits behind the red pepper. The Arrange options include - Bring Forward and Send Backward which moves the layer up or down one position and Send to Back which pushes the layer to the bottom and Bring to Front which places the layer on the very top of the stack.

Distribute >>

The Distribute option also arranges the content of layers within the canvas space. After multi-selecting several layers in the Layers palette, the picture content of these layers can be arranged according to the options in the Distribute drop-down menu. This feature can be used very successfully to evenly space picture parts within the canvas area.

The Distribute > Horizontal and Vertical Centers options arrange the picture parts so that the axies of the objects are evenly spaced. The Top and Bottom Edges base the spacings on the upper or bottom most part of the object. The Left or Right Edges option distributes the objects using the side boundaries as the reference point for the spacing.

In this example an even space was placed between the three photos by first selecting all three layers and then choosing the Distribute > Horizontal Centers option.

12.07 Printing your Photo Layouts

Suitable for Elements – 5.0 | *Difficulty level – Basic* | *Related techniques – 12.01, 12.02, 12.03, 12.04* As part of the technology behind the new Photo Layout feature the folk at Adobe created a new file format called the Photo Creation Format. The files saved in this format differ from traditional Photoshop Elements files in that they can include multiple pages. The format has a file extension of .PSE. If a layout document consists of only one page then you can choose to save the file in either the Photoshop Elements format (.PSD) or the Photo Creations format, but once you have multiple pages in the layout then you can only save the document in the PSE file type.

This new file type also brings with it different possibilities when it comes to output. You can now choose to print any single page from the document, all pages from the layout, a contact sheet, picture package, or label set of the pages or even order a Kodak Photo Book of the complete project all from inside Photoshop Elements 5.0.

All printing options, except the on-line photo book ordering, are handled by either the Print Preview (for single prints) or Print Photos (for multiple prints) dialogs. Print Preview is accessed from inside the Full Edit space by selecting File > Print. The Print Photos dialog is displayed by either selecting File > Print Multiple Photos from the Full Edit space or File > Print from the Organizer (the Photo creation thumbnail must be selected first). You can also proceed to the Print Photos screen from the Print Preview dialog by clicking the Print Multiple Photos button.

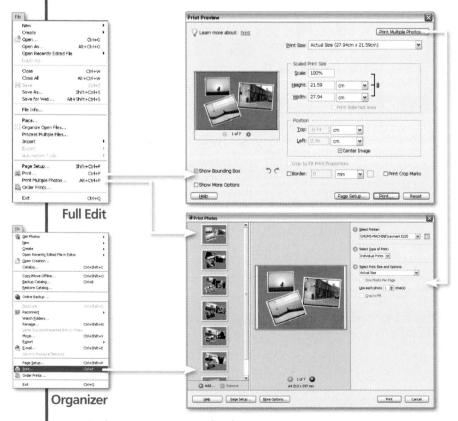

Printing PSE documents >>

Multi-page PSE, or Photo Creation documents that are open in the Full Edit workspace, can be printed either a page at a time via the File > Print option or as a group of prints with the File > Print Multiple Photos. The Photo Creation project can also be printed directly from the Organizer space without the need to open the document by electing the project's thumbnail and then choosing the File Print option.

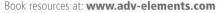

Print Preview

There is no need to display the individual page you want to print before moving to the Print Preview screen as a pair of Navigation buttons now appear below the preview thumbnail in the window. Use these to flip through the pages in your document to select the page to output. If you decide that you want to print more than one page then click onto the Print Multiple Photos button at the top of the dialog to display the Print Photos screen.

Print Photos

Once inside the Print Photos dialog you will notice that the pages of your Photo Creation are listed as individual prints on the left side of the screen. Here you can choose to remove any pages that you don't want to print by clicking on the thumbnail and then choosing the Remove button at the bottom of the screen. It is important to know that this action only removes the page from the print list and doesn't make any changes to the Photo Creation document itself. As well as the Individual Print Type setting, the Print Photos dialog also provides the ability to output the pages as a contact sheet, picture package or label set. See Chapter 14 for more details on these options.

Order a Kodak Photo Book

As well as these many options for desktop printing, you can also opt for getting your multi-page Photo Layout produced as a Kodak Photo Book. Simply select the completed creation project thumbnail in the Organizer space and then choose the Order Kodak Photo Book option from the Print On-line shortcut button. This action will take you to a two screen wizard where you can add or remove pages (or photos), rearrange the sequence of the pages and then, in the second screen, preview each individual page. Once this is completed and you click the Done button your project will be uploaded to Kodak where you will need to register, select the cover finish, add in delivery and payment details and finally confirm the order. A few days later a professionally printed and bound book will arrive at your door.

12.08 Adding your own backgrounds and graphics

Suitable for Elements – 5.0 | Difficulty level – Advanced | Related techniques – 12.01, 12.02, 12.03, 12.04 Not satisfied with the graphics or backgrounds supplied by Adobe with Elements 5.0? Well why not make your own. It is not difficult to create your own graphics and background artwork. After all these are just pictures that Elements treats in a special way. Careful copying of the customized files you produce to a specific Elements folder will then see your designs appear as an entry in the Artwork and Effects palette.

Before you start

Custom graphics and backgrounds are added to a settings folder that is usually hidden from view in the Windows file browser. Before you can start to add your own content you must first make these hidden folders visible. Do this by displaying the Windows' Control Panel (select Control Panel from the Start menu). Next choose the Appearance and Themes option and in the following screen the Folder Options. Choose the View tab in the Folder Options dialog that is displayed. Scroll down the options to locate the Hidden files and folders heading. Select the 'Show hidden files and folders' option. Click the OK button to apply the changes to your folders. You should now be able to view the Application Data folder in the *C:\Documents and Settings\All Users* directory.

WARNING: Be careful adding to and deleting files from any of the hidden directories that are now displayed. These folders are generally hidden from the user's view because they contain settings that affect the way that your programs function. And yes, just in case you are wondering, you proceed from this point onwards at your own risk. Deleting, overwriting or adding a file to the wrong area can cause Elements to stall when opening. If this occurs then backtrack your changes and if all else fails you may have to reinstall the program to fix the problem. Scared? Well don't be. Just be careful and all should be fine.

Adobe InDesign CS2	My Computer My Network Places Control Panel Set Printers and Printers and Defailes Printers and Faxes Plate and Support	Pick a category	Folder Options Image: Control of the second se
All Programs 📡	Search	Pick a task Compile counter's there Compile distribution Compile distributions Compile distributions	Hidden files and lodies Hidden files and lodies
1	aling the Artwork directo	Comparison control Part ison	Show and suanage the pair as a single file Show both pasts and snange them individually Show both pasts but manage as a single file Remember each folder's view settings Restore previous folder windows at logon
By der direct Graph	fault Windows hides the ories where Backgrounds nics files are kept. Your fir eveal these folders.	s and	Restore <u>Defaults</u> OK Cancel <u>Apply</u>

Background DIY

Backgrounds in Photoshop Elements are nothing more than a digital photograph or illustration that is 2572 x 1871 pixels in size, has a resolution of 220 pixels per inch and is saved in the JPEG format. To create your own Elements' background create a new document of the exact dimensions and resolution above and then either create an illustration on the canvas or cut and paste a photo onto the document. Create a new folder in the directory listed below and then save the picture as a high quality JPEG into the folder:

	Name:	Background file			ОК
Preset:	Custom		~	1	Reset
	Width:	2572	pixelis	-	
	Height:	1871	pixels	~	
	{ esolution:	220	pixels/inch	-	
	Color Mode:	RGB Color 🔍	j		
Backgrou	nd Contents:	White		~	Image Size: 13.8M

Background size >> Use the File > New > Blank File option to create a new document 2572 x 1871 pixels in dimension.

C:\Documents and Settings\All Users\Application Data\Adobe\Photoshop Elements\5.0\Photo Creations\artwork\backgrounds

Now close and restart Elements. The program will automatically rebuild the thumbnails in the Artwork and Effects palette to include your new additions.

Step 1 >> Start by selecting the File > New > Blank File command. Insert the 2572 pixels and 1871 pixels for the Width and Height values of the new document. Change the pixels per inch setting to 220 – the default Elements value for quality printing. Click the OK button to create the new document.

Step 2 >> Next you need to fill the document with the picture detail for the new background. To do this you can open an existing image that is preferably larger than the background and click-drag it from the Layers palette onto the new document. You can then use the Free Transform tool (Ctrl T) to resize the image to suit. Alternatively you can create a background illustration using the drawing and painting tools in Elements.

Here I added a custom gradient to the document and then placed some text that will appear on every page of my Photo Layout.

Step 3 >> Once created, the new background needs to be saved as a high quality JPEG file into the folder detailed above. To keep track of your custom additions, make a new folder and add the custom background to it. Elements is then closed and restarted; the folder becomes a new heading in the Background is loaded into the Artwork and Effects palette ready for use.

FREE FORM PHOTO LAYOUTS

Adding your own graphics

In a similar way you can add your own customized graphics to those pictures listed in the Artwork section of the Artwork and Effects palette. Rather than saving your picture elements in the JPEG format this time we will use the PNG or Portable Network Graphics file type. This format has the added ability of being able to save images that are partially transparent. This creates graphics that fit more easily on the background of Photo Layouts.

To create your own graphics start with a photo that contains the picture element to include. Change the background layer to a standard image layer by double-clicking on the layer in the Layers palette and adding in a layer name to the dialog that appears. Next, carefully select the outside or background of the picture part and then Edit > Cut the detail from the layer. This should leave the surrounds as transparent (gray checkerboard pattern). Now create a new folder in the directory listed below and save the newly created graphic as a PNG file into the folder. Close and restart Elements to display the graphics.

C:\Documents and Settings\All Users\Application Data\Adobe\Photoshop Elements\5.0\Photo Creations\artwork\graphics

Custom graphics >>> Create your own set of custom graphics that you can freely add to your Photo Layouts using the steps detailed here.

Step 1 >> Start by using your favorite selection tool to outline the edges of the picture part that you want to include in Elements. Here I use a small picture frame that I captured by scanning. If you have selected the object then you will need to inverse the selection before the next step.

Make sure that you change the layer from Background to a standard Image layer before selecting Edit > Cut. This will mean that the deleted area will end up transparent and not the background color.

Save As			
Save jn:	D Philips		• O
Recent	graphics01	png	
Desktop			
My Documents			
My Computer			
0	File name:	Graphics01.png	
My Network	Eormat	PNG (".PNG)	

Step 2 >>> After isolating the picture part on a transparent background save the image in the PNG format in the directory indicated above. Unlike JPEG this format retains the transparent areas of the image and so is perfect for creating graphics that blend into the background. Close down Elements and restart the program. During the restart Elements will rebuild the Artwork and Effects and at that time will include your new graphic.

ditor - Untitled Slide Show

Add Media - Add Blank Slide

Start

H M A P H

B

Click Here to A

5 sec *

rder Select All Slides Fit Slides to Audio

5 sec

B

Photo Creations

ADVANCED PHOTOSHOP ELEMENTS 5.0 FOR DIGITAL PHOTOGRAPHERS

N ewly introduced in Photoshop Elements 3.0 and revamped for 4.0 and 5.0, Photo Creations are a common starting point for the production of many different photo projects. Each of the imaging projects is set up in a wizard format, which enables users to quickly and easily produce professional-looking end results.

With Photo Creations you can produce slide shows, greeting and photo cards, calendars, web photo galleries, album pages, bound books and calendars and Video CD (VCD) presentations. Whole catalogs, or even several individually selected files from the Organizer, can be used as a basis for these projects.

The Photo Creations can be accessed from the Organizer and Full Edit spaces by selecting the option from the File > Create menu or the Create button in the shortcuts bar. These actions will take you to the first screen of the Photo Creations wizard.

Photo Creations >> Photo Creations provide wizard-based production of a range of photorelated products. For instance the Bound Photo Book can be used to create professionally laid out books that are then uploaded to an on-line provider that prints and binds the pages before returning the finished book to you in the mail.

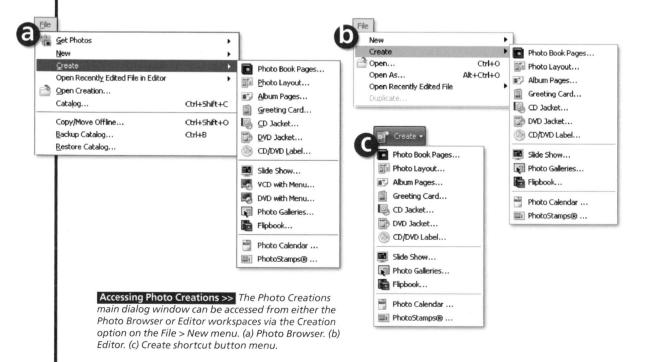

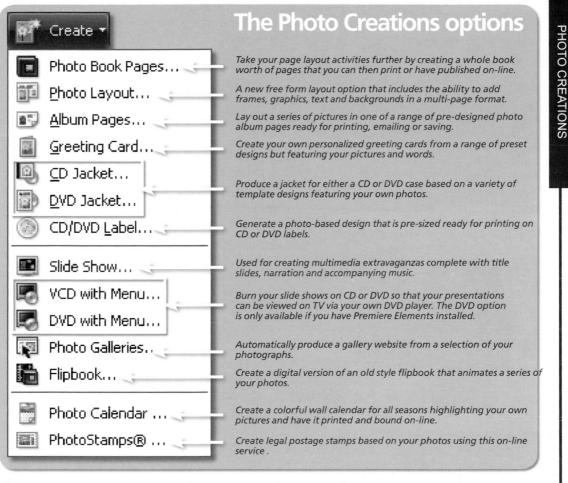

The Create menu contains a range of project options that you can feature your pictures in. Some projects, like the Slide Show and Photo Galleries, will already be familiar to Elements users as basic forms of these features were contained in previous editions of the program, but others such as the Flipbook and Photo Layout items create new and exciting ways to share your pictures with others. Each project requires you to have some basic resources prepared before starting out. For the most part this means that you should have selected, enhanced and edited any pictures you wish to include before commencing the creation process.

As you need to have all your pictures edited and enhanced before adding them to your Photo Creation projects, start by enhancing your pictures then save the finished file back to the browser. Now select the pictures to include and then select the Photo Creations project. The selected images will now appear in the Project dialog.

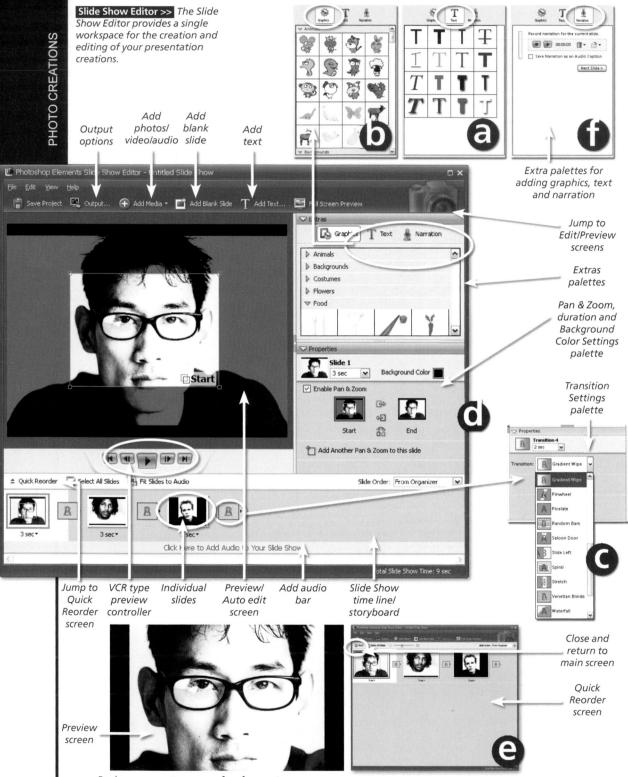

Book resources at: www.adv-elements.com

13.01 Multimedia slide shows

Suitable for Elements – 5.0, 4.0, 3.0 (Windows) | Difficulty level - Intermediate | Menus used - File > Create One of the most popular features in Photoshop Elements has always been the Slide Show creator. Each new release of the program contains a new and improved version of the utility. Version 5.0 continues this development and Elements now contains a common editor interface which can produce no less than five different types of slide shows. The main dialog contains a host of options that allow users to create true multimedia slide shows, complete with music, narration, pan and zoom effects, transitions, extra graphics and backgrounds and titles. The finished presentations can be output as a file. burnt to CD or DVD, emailed as a slide show, displayed as an online presentation or even sent directly to your television (Windows XP Media Center Edition users only).

Static Duration: 5 sec Transition: Fade Transition Duration: 2 sec Background Color: Apply Pan & Zoom to All Slides	ell's
Background Color:	e l ii
Background Color:	
Apply Pan & Zoom to All Slides	
✓ Include Photo Captions as Text	
Include Audio Captions as Narration	
🔽 Repeat Soundtrack Until Last Slide	
Crop to Fit Slide: 🔽 Landscape Photos 🗌 Portrait Photo	s
Preview Playback Options	
Preview Quality: Medium	
Land Land Land Land Land Land Land Land	

The version 5.0 Slide Show Editor in action

Though the redesigned Slide Show Editor may at first seem a little complex, having all the controls in one place certainly means that you can create great multimedia presentations more easily and efficiently. In addition, for the revised Editor the following features have been included:

Automatic editing: Rotate, size, change to sepia, black and white or back to color and apply Smart Fix and Red Eve Fix to your photos without leaving the Slide Show Editor. Click the preview image to display the Edit options in the Properties palette (if the image was selected from the Catalog).

(a) Styled text: Select from a range of text styles with click, drag and drop convenience. Text is always placed on top of any graphics that have been added and cannot be rearranged.

(b) Add graphics: The Slide Show Editor now includes a variety of clip art that can be added to vour presentations. Double-click or click-drag to place a selected graphic onto the current slide. The graphics are layered in the order in which they were applied. You can rearrange their order using the options in the context menu. It is not always easy to select graphics that have been sent behind other picture parts.

(c) Transitions: Add individual transitions between slides by clicking the area in the middle of the slides in the storyboard and then selecting the transition type from those listed in the Properties pane. (d) Pan and Zoom: Add movement to your still pictures by panning across or zooming into your photos. Simply select the slide in the storyboard and the check the Enable Pan & Zoom option in the Properties pane. Click on the left thumbnail (Start) and set the starting marquee's (green) size and

PHOTO CREATIONS

position, then switch to the right thumbnail and adjust the ending marquee's (red) size and position.

(e) Quick Reorder: This new sequencing screen enables you to quickly and easily adjust the position of any one photo (or groups of mulit-selected photos) in the presentation sequence using click and drag. You can also use cut and paste to reorder individual slides.

(f) Music and narration: Add music and extra audio to the show using the Add Media button and incorporate narration using the built-in slide show recorder.

Step 2 Adjust the slide sequence by click-dragging thumbnails within the storyboard or Quick Reorder workspaces.

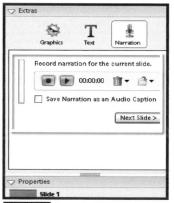

Step 5 >>> Record voice-over by selecting a slide and then using the Narration option in the Extras pane.

Step 3 >>> Insert transitions by clicking the space in between slides and selecting a type from the menu in the Properties pane. Change the duration using the options in the Properties pane.

Step 6 >> Add existing audio by clicking the soundtrack bar at the bottom of the storyboard.

Step 1 >>> Choose the photos in the Organizer and then Select Slide Show from the Create menu. Set the defaults for the presentation in the Slide Show Preferences dialog.

Step 4 >>> Alter any of the secondary options for transitions (such as Direction for Saloon & Zig Zag). Add graphics and text by click-dragging from the Extras pane.

Step 7 >>> Produce the slide show by selecting File > Output Slide Show and picking the type of presentation to produce from the Slide Show Output dialog.

13.02 Producing a VCD with a menu

Suitable for Elements – 5.0, 4.0, 3.0 (Windows) | Difficulty level – Intermediate | Menus used – File > Create The VCD with Menu project converts your Elements slide shows to VCD format ready for viewing on most DVD players or computers with a DVD drive, but to be sure that your machine is compatible check the equipment manual first. In Elements 5.0 slide shows can be written directly to VCD or DVD with the output options found in the revised Slide Show Editor; however, DVD burning does require Premier Elements to be installed alongside Photoshop Elements.

PHOTO CREATIONS

Step 1 >> Before you can create a VCD with a menu you must have at least one slide show saved into the Organizer. If you don't have a candidate slide show then start the process by selecting the Slide Show option and creating a multimedia presentation complete with sound. Save the project to the Photo Browser.

Step 2 >> Select the shows to include in the VCD from the Organizer and then pick VCD with Menu from the Photo Creations menu. Add or Remove slide shows from the thumbnail list if you are unhappy with your selection. Click-drag slide shows to new positions in the list to adjust where they will be placed in the menu of the VCD. The small number in the top left of each thumbnail indicates the sequence. Click Burn when you are happy with the arrangement.

Step 3 The burn step is a two-part process. First, any slide show not in the Windows Media Video file will be converted to that format. The conversion can be quite lengthy if you are burning slide shows containing many high-resolution files. If you want to speed up this section of the process, convert your shows to WMV beforehand from inside the Slide Show Project dialog.

Burn		
- Select Dest	ination Drive	
	on drive(D: AOPEN_COM4824)	
Burn VCD c	on drive (E: MP DVD Writer 300n)	
- Select Drive	- Second	
	s speed	
-46x		
Progress		
	scoding video: Phils slide show.wmv	No. of Concession, Name
		4196
	OK.	Cancel
Dis	C CREATION	
hA by S	onic Solutions	
u A		

Step 4 >>> The second part of the burn process is writing the CD itself. After converting the slide shows to WMV files a Burn dialog will appear. Make sure that a new blank CD is inserted into the CD writer and click the OK button to create the VCD.

Book resources at: www.adv-elements.com

Making a photo book is fast becoming one of the most popular ways to collate and share your photographs with friends and relatives and the new Photo Layout feature, along with the revamped Photo Book Pages and Album Pages projects, is a terrific way to produce the pages that make up one of these publications.

As with the other Photo Creations options the user selects the images to be included in the publication and then works their way through a series of steps to lay out the pages, which can then be printed at the desktop or sent via the internet to an on-line book publisher. The publisher will then print, bind and trim the pages, add a cover and return the completed book via the post or courier.

13.03 Creating pages for printing and publishing

Suitable for Elements – 5.0, 4.0, 3.0 (Windows) | Difficulty level – Intermediate | Menus used – File > Create Photoshop Elements offers three different ways to produce your own picture or scrapbooks. For publications that are destined to be printed at home then choose either Album Pages or the Photo Layout option. For books that are to be produced by an on-line publishing company select the Photo Book Pages option. Both pathways provide the ability to incorporate pictures into predesigned templates and both make use of the new themes, background and frame content. In this technique we step through Album Page creation.

Step 1 Select the pictures that you want to include from the Organizer and then choose the Album Pages option from the Creations menu. Choose the page size and then determine the number of pictures you want per page via the Layout menu and the text to include via the options at the bottom of the screen. Finally, choose a page style from the theme thumbnails. Click the OK button to continue to create the pages and open them in the Full Edit space.

Step 2 >>> If you selected the Auto Fill option in the initial Wizard screen Elements will automatically create multiple pages and photos in the Frame layers. Add extra images by selecting a frame from the Artwork section of the Artwork and Effects palette and then clicking the Apply button. Now either drag a new picture from the Photo Bin to the frame or click on the frame and choose a new picture from the file browser that is displayed. To remove picture and frame combination click on a frame and press the Delete key.

Step 3 >> To add a new background or replace the existing one, choose another option from Backgrounds menu in the Artwork section of the Artwork and Effects palette. Click the Apply key to insert the new background. To add the same background to all pages, select each page in turn (in the expanded view of the document in the Photo Bin) and apply the same background design. Adjust the frames and/or pictures using the detailed guidelines in the last chapter.

Print Learn more about: Print nt Size: Actual Size (27.94cm x 21.59cm) Scale: 100% Height: 21.59 - 8 Width: 27.94 -Top: -0.74 1 cm * 0 5 of 7 0 Left: il cm × Center Image Show Bounding Box 30 Border: 0 mm -DP Show More Options Help Page Setup... Print.

Step 5 >>> As with most Photo Creation projects you have a choice of the

way that it will be produced. You can elect to print the pages out (and

bind them into a book form) with the File > Print command or you can

even send the project as an email attachment by selecting the project in

Organizer and then selecting the Email option from the Share shortcut

Step 4 >> Next save the project in the new PSE or multi-page Photo Creation format. Saving the Album Pages project means that it will be possible to edit your layouts later. Select the option to Include in the Organizer and then click the Save button.

menu.

If you want to have the pages that you make printed and published as a bound book create a Photo Book Pages project instead of a Photo Album Pages project. Alternatively, you can also create your pages using the Photo Layout option if you select the correct page size in the project's Wizard screen.

13.04 Publish a photo book

Suitable for Elements – 5.0, 4.0, 3.0 (Windows) | Difficulty level – Intermediate | Menus used – File > Create Taking the creation of photo album pages idea a little further, the Photo Book Pages project allows you to lay out the pages and then upload the whole project to an on-line publisher. Using the set-up wizard, your own images and one of the many template designs in the feature, you can quickly and easily produce a series of pages (yes, including a title page) that look like they have been professionally laid out. The finished pages are then uploaded directly to the publisher, where the files are printed on a digital press using standard CMYK inks, the sheets are bound, trimmed and a cover is added. The completed book is then shipped via post or courier. The print production time for most companies is 3–5 days with shipping times varying depending on the level of service selected (airmail, express post, international courier).

Book resources at: www.adv-elements.com

337

PHOTO CREATIONS

Step 1 >>> Creating pages that are suitable for on-line publishing involves the same initial steps that are outlined in the previous step-bystep project with a couple of differences: Photo Book Pages are a set size preferred by the publisher, the first image in the book is used for the cover design and the minimum book size is 20 pages.

Step 2 >>> Once you have completed laying out the pages in your book, save the book design as a Photo Creations file (.PSE). Make sure that the file is cataloged in the Organizer workspace. Close the file and switch back to the Organizer.

With the project file selected choose the Order Kodak Photo Book option from the Online shortcut menu.

Step 3 This action will take you to the first screen of the Book Ordering wizard. Here you can clickdrag pages to rearrange their sequence, choose to add page numbers and even add or remove pages (called photos in the dialog). This is a good place to check that you have placed a suitable cover image at the beginning of the sequence. Click Next to proceed to the second screen.

Step 4 >>> In this, the second of the wizard screens, you can preview the look of each page by clicking the forward and back buttons on the sides of the preview area. When you are happy with your results click the Done button to start the uploading process. At this point your file is passed to the book publishing company.

Step 5 >> Once the book is uploaded you will be prompted to register for the service. If you are already a member then you will be taken straight to the Order Book wizard, which contains a number of screens with options for cover type, print numbers, recipients details, billing details and confirmation of the order.

Step 6 >>> If you can't connect directly to an on-line photo book publisher (the default provider is Kodak EasyShare Gallery, formerly www.ofoto.com) from within Elements, some companies will print a book from individual pages of the file saved as separate JPEG images. Create these files by selecting the project file in the Organizer workspace and then choosing File > Export. Pick the format to save the files in and press the Export button. Check with your photo book provider for their file format preference.

Designing with Templates >>

At first, the idea of using a pre-designed layout may seem a little restricting but the Album Pages and Photo Book Pages wizards are just the starting point of the design process. Don't forget that you can change backgrounds, frames and even whole themes with the click of a few buttons once you are in the Full Edit space. Add to this the ability to add text, graphics and custom shapes and apply a series of special effects, filters and layer styles and the possibilities are endless.

PHOTO CREATIONS

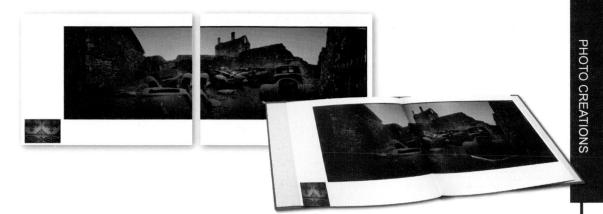

13.05 Book publishing without using Photo Creations

Suitable for Elements – 5.0, 4.0, 3.0, 2.0, 1.0 | Difficulty level – Intermediate | Tools used – Crop | Menus used – File, Image, Edit

Using the wizard/template-based approach in Elements is fine, but if you seek the ultimate in creative control over every page then a company like www.SharedInk.com can create a book from individually designed spreads produced in Elements and saved as a JPEG file.

Simply create a new document the size and format of the printed page and add your pictures directly to the document. You can size the individual photos using the Free Transform command and with the grid displayed it is easy to ensure consistent spacing between individual photos.

Step 1 >> Select the book size and orientation from those provided by your chosen publisher. Use the recommended settings for width, height and resolution for creating a new custom page. Alternatively download pre-made

templates for your book size from the publisher's website. In this example I used the Photoshop templates (which can also be used for Elements) provided by www.SharedInk.com as the base size for my book pages.

Step 2 >> Open the template to suit your design. There are options for left and right pages and also a design for double-page spreads. As the example book contains a variety of panoramic pictures the latter choice was used.

Open one of the pictures that you want to include on the page and click-drag the file onto the template background. Use the included template guides to help position the photo or alternatively align the image with the aid of the grid (View > Grid).

Step 3 >> To resize the photo on the page, make sure that the laver is selected and then select the Image > Transform > Free Transform feature. To ensure that the picture stays in the same aspect ratio or proportions, hold down the Shift key whilst dragging the corner handles. Add and size other images to suit and when the laying out of the page is complete save the document with a file name that includes the page number (as a two digit number i.e. 'page01'). Keep in mind that all left-hand pages are evenly numbered and right-hand pages have odd page numbers.

339

Step 4 >> Next save another version of the document as a level 10 JPEG. Save all the book page files as a single compressed (zipped) file. These files are the ones that will be uploaded and printed.

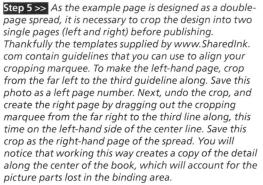

Step 6 Now that the pages are created go to the SharedInk website and create a new book by pressing the Create a New Book link at the top of the page. Choose the book size and then the Full Bleed Book template. Next you will be taken to the upload page where you can upload your ZIP file (of all the pages).

After the uploading is complete, press the Order Now button and proceed through the Publish and Payment options making sure that you carefully preview the finished book before completing the order.

13.06 On-line publishing options

Suitable for Elements – 5.0, 4.0, 3.0, 2.0, 1.0 | Difficulty level – Intermediate Menus used – File, Image, Edit

The easiest way to publish your photo books is via the on-line publisher in the Bound Photo Books option of the Photo Creations workspace. But this isn't the only option for picture book aficionados. There is a variety of other on-line publishers who will happily print and bind your masterpieces. Of those listed here only Kodak Gallery is linked directly to Photoshop Elements; the others provide various layout options including web-based utilities or the ability to accept PDF books or JPEG-saved pages produced by Elements.

As an added bonus these companies also provide a variety of other photo products including such diverse offerings as photo coffee mugs, ties and dog bowls.

Kodak Gallery (www.kodakgallery.com)

Formerly called Ofoto, Kodak Easy Share Gallery is an online photo products provider that has sites in the USA and Europe as well as the UK. At the moment photo books are only produced via the US website but the company welcomes international customers and ships the completed books worldwide. You can create a Kodak Easy Share Gallery photo book in a couple of different ways. Firstly, there is a standard

web wizard production approach that requires you to create an album of images that you have uploaded first and then step through a series of screens that selects the style, type finish and layout of your book. But it is the second option that has digital photographers buzzing. Kodak Gallery has struck a deal with Adobe to be the on-line provider of web print services for its software. This means that Photoshop Elements users can create their books on their desktop, using a familiar software package and then upload the project directly to Kodak Gallery who will produce the book. This way of working has the advantage of being much faster and more convenient than on-line production because there is no need to create an album on-line first – all the layout process is handled on your own machine and publishing occurs from within Elements itself. Once you are registered with Kodak Gallery, publishing books or printing on-line is just a menu selection away.

SharedInk (www.sharedink.com)

SharedInk isn't like the other providers listed here. To start with, it isn't as big as the others and secondly it operates on a membership basis (you need to pay a one-off fee with free-trial memberships available for new customers for 45 days). This structure enables the company to provide a more specialized and personalized service. For instance, this is the only company listed that runs its own members' forum full of tips, tricks and helpful advice for the new photo book creator. Add to this the fact that

SharedInk supplies ICC profiles of their printers to their customers, can add foil stamped letters to the front of your book, are prepared to output test prints of important images before creating a whole book and you know that this is a company that is concerned with quality of production. There is even an option to supply your completed book in a padded case for a tiny US\$5.00 per book.

SharedInk uses a system where photographers lay out their own pages in a third-party program like Elements using templates supplied in the download section of the website. The designs are then saved and uploaded as 'full-bleed' pages ready for book production. In addition to this approach, SharedInk recently introduced the ability to upload the PDF books produced by Photoshop Elements directly to their server where they are automatically made print-ready.

PhotoWorks (www.photoworks.com)

PhotoWorks provides seven different photo books amongst the many photo products they offer to the film and digital customer. The book designs are broken into two different sections – the Everyday range, that features a hard cover with a die-cut hole in the front, and the Metropolitan series that has a solid cover with foil-stamped or screen-printed designs. Different cover colors and internal designs are available with each book type, with the

Everyday-Expandible and Metropolitan-Oversized options providing a level of flexibility beyond the normal offerings.

Books are produced using the aid of a step-by-step web wizard. Through the process you select an interior style, input book details such as title and description, drag and drop photos from your on-line albums to include in the book, design the layout of the pictures and then preview the final result before placing your order.

SnapFish (www.snapfish.com)

husband's tie.

 Image: state in the state i

Two photo book options are also included in their product range. Flipbooks are similar to the spiral-bound photo books

SnapFish.com boasts over 12 million users worldwide and provides options for both film and digital users to get their pictures on a truly mind-boggling array of photo products. Yes, you can have your favorite photo on everything from your baby's nappy bag and your dog's food bowl to your

that local laboratories have been offering for years except with SnapFish you can add a colored or patterned background to your photos before they are printed and bound.

The second option is the Memory Book product which comes with a cloth-bound hard cover and a minimum of 20 pages. One standard die-cut style is available but inside you can choose from single- or double-sided printing, captions or no captions and a range of page designs.

To create a book you must first create an on-line album and upload your pictures. The album (or albums if you have uploaded more than one) then becomes the centre of your SnapFish production. Images are selected from the album to be included in the book, which you can organize and design manually or get the web wizard to automatically produce for you (this option is called Express).

MyPublisher (www.mypublisher.com)

MyPublisher is a dedicated book publisher that provides the widest range of photo book sizes of all our candidate companies. They range from the small pocket books $(6 \times 8 \text{ inches})$ to the mammoth Deluxe books $(12 \times 16 \text{ inches})$ with full bleed available).

The company uses a production approach that is based

around a free layout utility called BookMaker which is downloadable from their website. Images are sourced directly from your hard drive, arranged and laid out in book form before your purchasing details are added and the whole project uploaded to the net.

34

13.07 Creating a greeting card

Suitable for Elements – 5.0, 4.0, 3.0 (Windows) | Difficulty level – Intermediate Menus used – File > Create

The Photo Creations Greeting Card project uses the same basic approach for the set up, production and editing of the card as we have already seen with the creation of Photo Book pages with the difference being the size of the final result. Two card sizes are available, 6×4 inch for home printing and 5×7 inch for production on-line.

Step 1 Select the picture you want to feature on the card from the Organizer. Select the Greeting Card option from the Create menu. Choose a card size from the Wizard screen. The 4 x 6 inch option is designed for home printing and the 5 x 7 inch card is for on-line production.

Step 2 >> Next select a card layout and theme from the thumbnails displayed. Remember that the frame and its accompanying background can be changed later when the project is in the Full Edit space. Click the OK button to produce the project.

Step 3 >> Unlike previous versions of the Greeting Card project the wizard no longer produces a design that is suitable for folding into a card format that opens like a book. The greeting card design has a single front face onto which you can add images, text, backgrounds, shapes and other graphical elements.

Step 4 >> Once produced you will be able to manipulate the photo and frame combination as well as the background just as you would any other Photo Layout. If you are producing the card on-line then you can also add a title and text in the Order wizard.

Step 5 To produce the card with the aid of an on-line publisher save the file in the Photo Creation format (.PSE) and ensure that the document is added to the Organizer. Close the document and switch to the Organizer space. Select the Greeting Card project and then choose the Order Photo Greeting card option from the On-line shortcut menu. Follow the instructions in the Order wizard to produce your cards.

Step 6 >> If you want to output the file to a desktop prnter insert the correct sized card and then choose File > Print from inside either the Full Edit or Organizer workspaces.

13.08 Making a CD or DVD Jacket

Suitable for Elements – 5.0 | Difficulty level – Intermediate | Menus used – File > Create

CD and DVD jackets are the sheets of paper or thin card that wrap around the outside of the CD/DVD case. The inclusion of a Photo Creation option for the creation of these jackets is new for Elements 5.0. There is no real difference between the two choices except for the size of the finished creation document. After creating a jacket with a combination of your images and one of the themes provided in the Creation dialog, the final design is printed, the edges trimmed and the paper inserted into the cover space of the case.

Step 1 >>> Start by multi-selecting photos from the Organizer workspace before choosing CD or DVD Jacket from the File > Create menu. Depending whether you are creating a CD or DVD jacket the size option will be different. DVDs are 11 × 7.5 inches and CD jackets are 9.75 × 4.75 inches.

Step 2 >> Next choose the layout for the jacket. Select the number of photos to include in the Layout section and then choose a theme (matched Frame and Background design) before pressing OK to create the document.

Step 3 >> A new Creation document is produced with the selected images inserted into the frames and placed onto the background. If more images were selected than the places available in the document then Elements creates a second page and places the extra photos there. Each framed image is stored on its own layer.

Step 4 Right-click on each image in turn and choose Fit Frame To Photo. Next adjust the size and orientation of the photo and the frame using the side and corner handles. For more details on how to manipulate frames see the previous chapter.

Step 5>>> With the images in place we can now turn our attention to adding other details to the design. Here extra text is inserted over the main photo and a layer effect is added (drop shadow and stroke). The color of the text is matched with the background in the design. After saving the completed composition the CD/DVD jacket is then printed using the Actual Size setting to ensure that the jacket fits the case.

13.09 VCD/DVD with Menu

Suitable for Elements - 5.0, 4.0 | Difficulty level - Intermediate | Menus used - File > Create

This project converts your Elements slide shows to VCD format ready for viewing on most DVD players or computers with a DVD drive but, to be sure that your machine is compatible, check the equipment manual first. In Elements 5.0 slide shows can be written directly to VCD or DVD with the output options found in the revised Slide Show Editor; however, DVD burning does require Premier Elements to be installed alongside Photoshop Elements.

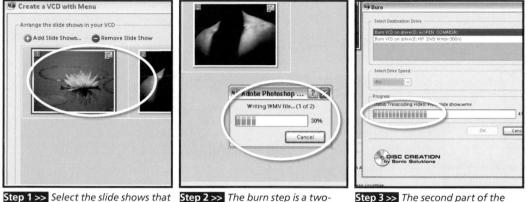

Step 1>> Select the slide shows that you want to include in the VCD from the Photo Browser and then pick VCD with Menu from the File > Create. Add or Remove slide shows from the thumbnail list if you are unhappy with your selection. Clickdrag slide shows to new positions in the list to adjust where they will be placed in the menu of the VCD. The small number in the top left of each thumbnail indicates the sequence. Click Burn when you are happy with the arrangement.

Step 2>>> The burn step is a twopart process. First, any slide show not in the Windows Media Video file will be converted to that format. The conversion can be quite lengthy if you are burning slide shows containing many high-resolution files. If you want to speed up this section of the process, convert your shows to WMV beforehand from inside the Slide Show project dialog. **Step 3** The second part of the burn process is writing the CD/DVD itself. After converting the slide shows to WMV files a Burn dialog will appear. Make sure that a new blank CD/DVD is inserted into the writer and click the OK button to create the VCD.

13.10 Flipbooks

Suitable for Elements – 5.0 | Difficulty level – Intermediate | Menus used – File > Create

Unlike the animations produced in GIF format where each layer of the Elements document becomes a frame in the movie, the Flipbook feature uses a series of different images that have been selected in the Organizer space as the basis for the animation. This approach makes the feature particularly good for creating snippets of action from sequences of photos captured on the Burst or Continuous Shooting mode with your digital camera.

Select the images to be included in the book from a collection or the Organizer and choose the File > Create > Flipbook option. The Flipbook dialog is then displayed. Here you can set the playback speed in frames per second (FPS), the order the sequence is played and the pixel dimensions of the output. Click the Output button to create the movie.

Book resources at: www.adv-elements.com

PHOTO CREATIONS

13.11 Your pictures month by month

Suitable for Elements – 5.0, 4.0, 3.0 (Windows) | Difficulty level – Intermediate | Menus used – File > create In version 5.0 the two calendar options (one for on-line printing and one for producing at home) that were included in the previous edition of the program have been replaced with a single Photo Creation project. Images are selected in the Organizer space, the Photo Calendar option selected and then the files are uploaded to the Kodak Easy Share Gallery website. Here you can select the style and color of the calendar and choose if you want the wizard to auto fill the image spaces with your photos or allow you to add the images page by page. The final step is to order the calendar and then Kodak does the rest, producing and binding the project and then shipping it directly to you.

Step 1 ≫ Make sure that all 13 photos (12 months plus cover) to include in your calendar have been carefully enhanced before starting the process. A calendar, just like a website and flipbook, has a defined sequence of images as part of the project itself. It is also a good idea to add the photos to a collection as well. When the collection is displayed you can reorder the sequence of photos so that feature images match the months they are illustrating. When complete multi-select the photos and choose File > Create > Photo Calendar.

Step 3 With the pictures now uploaded you will be presented with a small pop-up screen that asks if you want the images to be automatically placed on the calendar pages (Auto Fill) or if you would prefer to make the decision page by page (Manual). Next you select a template design and color and then choose the starting date for the calendar and the number of images each page will feature. Click Next to continue.

Step 2 >> After selecting the Photo Calendar option, Elements contacts the Kodak Easy Gallery website and displays a Registration screen. First time users will need to fill out a simple registration section and nominate a login email address and password. Returning visitors only need to supply their log-in and password details. After successfully logging in, the selected images will start to upload to the site. This process can take a while, especially if you are using high-resolution photos or have a slow internet connection. Click Next to continue.

Step 4 With the images in place you can now preview the calendar design, edit any pages that you are not happy with and finally order the finished project. After the order is confirmed Kodak prints, binds and ships the calendar.

Finely Crafted Output

ADVANCED PHOTOSHOP ELEMENTS 5.0 FOR DIGITAL PHOTOGRAPHERS

t is one thing to be able to take great pictures with your digital camera and quite another to then produce fantastic photographic prints. In the old days of film most photographers passed on the responsibility of making a print to their local photo store. Most, that is, except for a few dedicated individuals who spent their hours in small darkrooms under stairs or in the attic.

Digital has changed all this. Now more shooters than ever before are creating their own prints. Gone are the dank and smelly darkrooms. Now the center of home print production sits squarely on the desk in the form of a table-top printer.

Printing basics

There are several different printer technologies that can turn your digital pictures into photographs. The most popular, at the moment, is the Ink Jet (or Bubble Jet) printer, followed by Dye Sublimation and Laser machines.

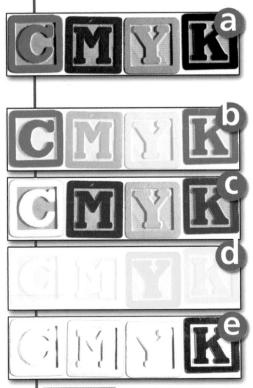

CMYK color >> Most printing systems are based on breaking the full color picture (a) down into several color parts. Here the picture is separated into cyan (b), magenta (c), yellow (d) and black (e), which correspond to the inks of the printer.

Book resources at: www.adv-elements.com

Creating millions of colors from as little as four

Each of the printing technologies creates the illusion of millions of colors in the photograph by separating the picture into four separate base colors (some systems use six or seven colors). In most cases, these colors are Cyan, Magenta, Yellow and Black. This type of separation is referred to as CMYK (where K stands for the black component), which has been the basis of newspaper and magazine printing for decades.

Once the picture is broken into these four colors, the printer lays down a series of tiny colored dots in a specific pattern on the paper. Looking at the picture from a distance, our eyes mix the dots together so that we see an illusion of many colors rather than just the four that the picture was created from.

Tones and colors made of dots

To create darker and lighter colors the printer produces the colored dots at varying sizes. The lighter tones are created by printing small dots so that more of the white paper base shows through. The darker tones of the photograph are made with larger dots leaving less paper showing. This system is called halftoning. In traditional printing, such as that used to create the book you are now reading, different dot sizes, and therefore tone, are created by 'screening' the photograph. In desktop

digital printing different shades are created using 'simulated halftones'.

This process breaks each section of the image into minute grids. Then as part of the separation process, the printer's software will determine the tone of each image part and decide how to best balance the amount of white space and ink dots in the grid in order to simulate this tone. Sound confusing? Well let's use a simple example.

We are printing a black and white picture with a printer capable of five levels of tone:

- White,
- Light gray (25% gray),
- Mid gray (50% gray),
- Dark gray (75% gray) and
- Black (100% black).

We are using black ink only. Let's say that one part of the image is represented by a grid of two dots by two dots.

If this part of the picture was supposed to be white then the software would print no dots in the grid. If the area was light gray then one dot (out of a possible four) would be printed. If the image was a mid tone then two dots would be printed. If the shade was a little darker then three dots would be laid down and finally if this part of the photograph was black then all parts of the grid (that is, all four dots) would be printed.

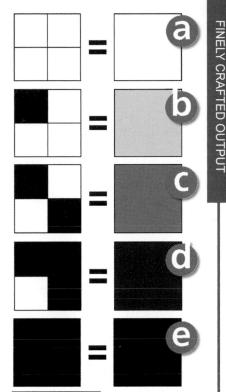

Simulated tones >> Digital printers represent tones in a similar fashion using small grids containing areas of ink color and sections where the paper shows through. (a) White. (b) 25% gray. (c) 50% gray. (d) 75% gray. (e) Black.

Keep in mind that modern photographic inkjet printers are capable of many more levels of tone than the five used in our example. Also remember that different colored dots are being laid

Color from dots >>

The separate colors are laid down on the paper surface in the form of minute dots which, when seen at a distance, mix together to simulate all the other colors in the photograph.

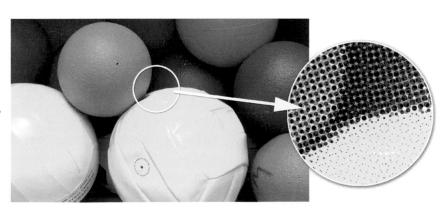

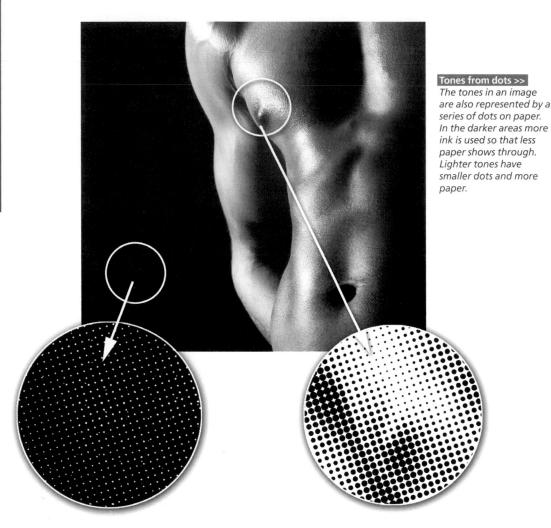

down at the same time. In this way both simulated tone and color are created by drawing the picture with a series of dots using a small set of printing inks. The fact that all the current crop of desktop printers handle this type of separation and the creation and application of the dots with such precision and speed is nothing short of a technological miracle. Now let's look at the three main desktop printing technologies in turn.

The inkjet printer

Costing as little as US\$100 the inkjet printer provides the cheapest way to enter the world of desktop printing. The ability of an inkjet printer to produce great photographs is based on the production of a combination of fineness of detail and seamless graduation of the color and tone. The machines contain a series of cartridges filled with liquid ink. The ink is forced through a set of tiny print nozzles using either heat or pressure. Different manufacturers have slightly different

systems but all are capable of producing very small droplets of ink (some are four times smaller than the diameter of a human hair!). The printer head moves back and forth across the paper laying down color whilst the roller mechanism gradually feeds the print through the machine. Newer models have multiple sets of nozzles which operate in both directions (bi-directional) to give faster print speeds.

The most sophisticated printers from manufacturers such as Canon, Epson and Hewlett Packard also have the ability to produce ink droplets that vary in size. This feature helps

create the fine detail in photographic prints. Most photographic quality printers have very high resolution approaching 6000 dots per inch, which equates to pictures being created with very small ink droplets. They also have 6, 7 or even 8 different ink colors enabling these machines to produce the highest quality prints. These printers are often more expensive than standard models but serious photographers will value the extra quality they are capable of.

Printers optimized for business applications are often capable of producing prints faster than the photographic models. They usually only have three colors and black, and so do not produce photographic images with as much subtlety in tonal change as the special photo models.

One of the real advantages of inkjet printing technologies for the digital photographer is the choice of papers available for printing. Different surfaces (gloss, semi-gloss, matt, iron-on transfer, metallic, magnetic and even plastic), textures (smooth, water color and canvas), thickness (from 80 gsm to 300 gsm) and sizes (A4, A3, 10 x 8 inch, 6 x 4 inch, Panorama and even roll) can all be fed through the printer. This is not the case with laser printing, where the choice is limited in surface and thickness, nor Dye Sublimation printing, where only the specialized paper supplied with the colored ribbons can be used.

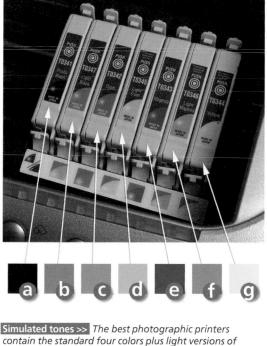

Simulated contessor in the best photographic printers contain the standard four colors plus light versions of black, cyan and magenta to help create truer colors and smoother graduation of tones. (a) Black. (b) Light or Photo black. (c) Cyan. (d) Light cyan. (e) Magenta. (f) Light magenta. (g) Yellow. 351

Laser

Though most laser printers you see are used for black and white business prints more and more are capable of producing good quality color output. These devices use a modified version of photocopier technology to produce their crisp hard-edged prints.

They work by drawing the image or text to be printed onto a photo-sensitive drum using either a laser or a series of LEDs (light emitting diodes). This process changes the electromagnetic charge on the drawn sections of the drum. The drum is then passed by a dispenser and the oppositely charged toner (the 'ink' used by laser printers) is attracted to the drum, which then is passed by electrostatically charged paper where the toner is deposited. Color laser printers use four different

Laser printers >> Laser printers use photocopier-type technology to produce crisp output. Some models can even produce full color prints.

drums for each of the separation colors - cyan, magenta, yellow and black.

The strengths of laser printers are their speed, cost per printed page and the sharp-edged clarity of the prints they produce. For businesses that regularly produce short runs of color brochures a color laser may be a cost-effective alternative to printing outside, but for the dedicated digital photographer, inkjet printers provide a cheaper way to produce photographic quality prints.

Dye Sublimation

Where laser and inkjet technology printing prowess is based on the creation of tone and color via discrete dots, Dye Sublimation printers use a different approach. Often called a continuous tone printing system, 'Dye Sub' machines create prints by laying down a series of overlapping transparent dyes to build up the picture.

Expensive when the technology was first released, these printers have gained more popularity as newer models have dropped in price and increased in speed and image quality. Rather than using a set of inks, color is added to the picture using a heating element to transfer dye from cyan, magenta, yellow and, in some machines, black ribbons onto a specially treated paper.

Dye Sublimation printers >>> **Dye Sublimation printers** use a multi-colored donor ribbon which is heated to transfer the color to a special receiving paper.

The dyes are absorbed into the paper surface leaving a slightly blurred edge which blends with adjacent colors and tones. This gives the image a continuous tone (non-dotty) appearance at relatively low resolutions (300 dpi) compared to inkjet technology equivalents.

The dyes are layered on a full paper size ribbon and each color is added in turn. With some machines a protective clear coating is also applied at the last stage in the process. Accurate registration is critical throughout the whole printing process.

Other printing processes

Though less well known, the following processes are also being used to produce photo images:

Thermal wax transfer – Initially designed for use in the graphic design and printing industries this technology uses very small heating elements to melt and transfer color wax from donor sheets onto the printing paper. These printers produce very strong and vibrant colors but sometimes struggle to create truly photographic prints.

Pictrography – Developed by Fuji, this system uses a three-color laser (red, green and blue) to draw the picture onto a donor paper at a resolution of about 400 dpi. The donor paper is then placed in contact with a printing paper and the image transferred using heated water. The final print is very similar to standard photographic paper.

Offset lithography – Used for printing newspapers and magazines. Typically a color image is separated into the standard four base colors (CMYK) and a halftone version of the image created at the same time. This produces four separate versions of the picture, one for each color, which are used to create four different printing plates. The color inks (called process colors) are applied to each plate and the printing paper is fed past each plate with the ink being laid down in registration.

Inkjet media >> One advantage of creating your photographs with an inkjet machine is the large range of paper stocks available for printing.

Image resolution vs printer resolution

As we have already seen from our discussions in Chapter 2 the true dimensions of any digital file are measured in pixels, not inches or centimeters. These dimensions indicate the total number of samples that were made to form the file. It's only when an image's resolution is chosen that these dimensions will be translated into a print size that can be measured in inches or centimeters.

The image resolution determines how the digital information is spread over the print surface. If a setting of 100 dpi is chosen then the print will use 100 pixels for each inch that is printed. If the image is 800 pixels wide then this will result in a print that is 8 inches wide. If the image resolution is set to 200 dpi then the resultant print will only be 4 inches wide because twice as many pixels are used for every inch of the print. For this reason the same digital file can have many different printed sizes.

With this in mind, the following table shows the different print sizes possible when the same picture is printed at different resolutions:

Pixel dimensions:	Print size at 100 ppi:	Print size at 200 ppi:	Print size at 300 ppi:
640 x 480 pixels	6.4 x 4.8 inches	3.2 x 2.4 inches	2.1 x 1.6 inches
1440 x 960 pixels	14.4 x 9.6 inches	7.2 x 4.8 inches	4.8 x 3.2 inches
1600 x 1200 pixels	16 x 12 inches	8.0 x 6.0 inches	5.3 x 4 inches
1920 x 1600 pixels	19.2 x 16 inches	9.6 x 8 inches	6.4 x 5.3 inches
2304 x 1536 pixels	23 x 15.4 inches	11.5 x 7.7 inches	7.6 x 5.1 inches
2560 x 1920 pixels	25.6 x 19.2 inches	12.8 x 9.6 inches	8.5 x 6.4 inches
3000 x 2000 pixels	30 x 20 inches	15 x 10 inches	10 x 6.6 inches

Printer resolution refers to the number of ink droplets placed on the page per inch of paper. Most modern printers are capable of up to 5600 dots per inch. This value does not relate to the image resolution discussed above. It is a measure of the machine's performance not the spread of picture pixels.

Keep in mind that different printing technologies have different optimum resolutions. For example, perfectly acceptable photographic images are produced on Dye Sublimation machines with a printing resolution as small as 300 dpi, whereas the same appearance of photographic quality may require a setting of 1440 dpi on an inkjet machine.

Step 1 >> With your image open in Elements select Print from the File menu.

14.01 Basic steps

Suitable for Elements – 5.0, 4.0, 3.0, 2.0, 1.0 | Difficulty level – Basic Related techniques – 14.04–14.08 Menus used – File

Let's revisit the basic steps used in printing from Elements before introducing some advanced techniques that will really help you to produce top quality images from your desktop printer.

Make sure that your printer is turned on and your image is open in Elements. Select the Print option from the File menu (File > Print). If your print was too big for the page in earlier versions of the program then a Clipping Warning will appear indicating that part of your image will be truncated if you proceed. You could choose to squeeze the picture onto the paper by checking the Scale to Fit Media box, click preview

ge Setuj Printer	
Name:	EPSON Stylus Photo R310 Series
Status:	\\ANDREWS-SERVER\EPSON Stylus Photo R Acrobat Distiller
Туре:	Auto Family Laser on MUMS-MACHINE
Whe-	TEPSON Stulus Photo 890
C. mmeni	EPSON Stylus Photo R310 Series
Network	

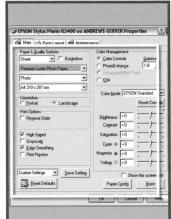

Step 2 >> **S**elect the printer that you want to use from the drop-down list displayed via Page Setup and Printer buttons.

Step 3 >> Choose the media type and Quality mode from the main section of the printer driver.

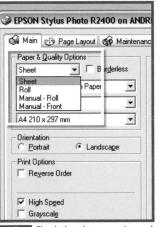

Step 4 >> Check that the paper size and source are correctly set in the Paper section of the printer driver. Click OK.

Step 5 As a final step adjust the size of the photo on the page using the corner handles in the preview. Be careful though as increasing the size of the photo here reduces image quality by printing at a lower resolution.

Print Clipping Warning	×
The image is larger than the paper's printable area; some clipping will occur.	OK
Scale to Fit Media	Preview

Print Clipping Warning >>> The Print Clipping Warning appears when your image is too big for the default paper size set for your printer.

Book resources at: www.adv-elements.com

FINELY CRAFTED OUTPUT

to take you directly to the Print Preview dialog or select OK to continue printing the trimmed image. This will open up the printer's control panel, often called the Printer Driver dialog. The type and style of dialog that you see will be determined by the printer manufacturer and model that you own. Here I have shown a dialog box or printer driver typical for Epson machines.

A little more sophistication

Thankfully in version 5.0 of Photoshop Elements the whole process has been simplified. Now choosing the File > Print option takes you directly to the Print Preview option. With this dialog you preview your picture as it will appear on the printed page. This thumbnail snapshot of picture on page means that problems with sizing and picture orientation are immediately obvious. You can choose to let the program adjust the picture size to suit the paper automatically by employing the Scale to Fit option you can manually position and size the image. Simply deselect the Scale to Fit and Center Image options and choose the Show Bounding Box feature. Now you can drag the picture around the paper surface and scale the printed image using the corner handles in the thumbnail. To adjust paper size and orientation or change the printer you are using to output your image select the Page Setup button and input the values you require in the Page Setup dialog.

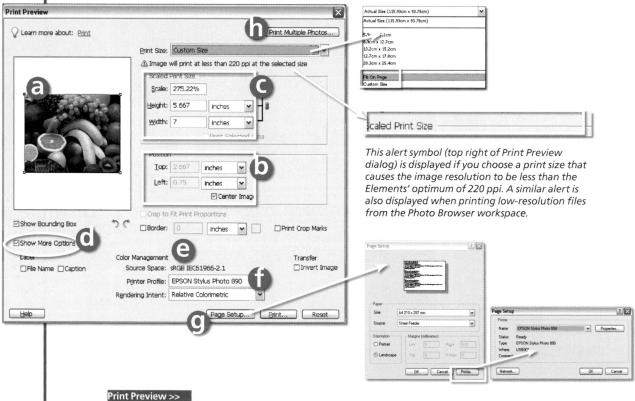

The Print Preview dialog provides a more comprehensive and visual approach to adjusting printing variables than what was available with the Print command in previous versions. (a) Preview image on paper. (b) Image position. (c) Image size. (d) Show More Options tick box. (e) Color Management selection. (f) Printer profile. (g) Page Setup dialog. (h) Print Multiple Photos dialog.

The Print Preview feature also provides the option for users to better control the way that Elements communicates how the colors in the picture will output to the printer. By ticking the Show More Options box and selecting the Color Management item from the drop-down list you can define the precise color profile to use when printing. Most photo-quality printers now include generic profiles that are copied to your system when you install your printer drivers. To ensure the best color reproduction from your printer select the precise profile for your model from the drop-down list. With the color management, paper size and orientation as well as image size and position set, pressing the Print button will start the output process.

Basic settings

PIM and EXIF Print?

Exif Print

Select Printer:

All the basic printer settings are controlled via the Printer Driver dialog. This is different for each printer model but generally contains similar controls (even if they are named slightly differently). Check to see that the name of the printer is correctly listed in the Name box. If not, select the correct printer from the drop-down menu. Click on the Properties button and choose the 'Main Tab'. Select the media type that matches your paper, the Color option for photographic images and Automatic and Quality settings in the mode section. These options automatically select the highest quality print settings for the paper type you are using. Click OK.

Select the Paper tab to alter the paper size and its rotation. Also nominate if the paper is being loaded from the sheet feeder or via a roll. Click OK. Select the Main tab once more and input the number of copies you want to print. Click OK to start the print process. Depending on the size of your picture and the quality of the print this part of the process can take a few minutes before you will see any action from the printer.

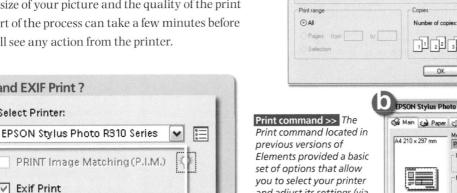

Print

Printe

Name

Status

Type:

Where

Commen

Ready EPSON Stylus Photo 890

LISBOOT

Epson printer users will find two extra options in the Print dialog (detailed above) when outputting their JPEG photos from the Photo Browser workspace. Called PIM (PRINT Image Matching) and Exif Print, enabling these options when printing will generally provide better results than when they are left unchecked.

Both these technologies aim to match the photo picture characteristics more closely with the printer's abilities. These print options are lost when photos are edited outside the Photo Browser in either the Standard or Quick Fix Editor workspaces.

and adjust its settings (via the Properties button).

When the File > Print option is selected in Photoshop Elements 5.0 the Print Preview dialog is displayed. (a) Printer selection. (b) Printer Properties dialog. (c) Media type (paper type). (d) Printing mode. (e) Number of prints.

? X

Print to file

14.02 Creating contact sheets

Suitable for Elements – 5.0, 4.0, 3.0 | Difficulty level – Basic | Related techniques – 8.03 Menus used – File

With the one simple Contact Sheet command Elements can create a series of small thumbnail versions of photos in a catalog or those that were multi-selected before opening the tool. These small pictures are automatically arranged on pages and labelled with their file names. From there it is an easy task to print a series of contact sheets that can be kept as a permanent record of the folder's images. The job of selecting the best pictures to manipulate and print can then be made with hard copies of your images, without having to spend the time and money to output every image to be considered. This is a real bonus for digital photographers as it provides a quick tactile record of their day's efforts. Elements 5.0 contains a version of the feature that is part of the

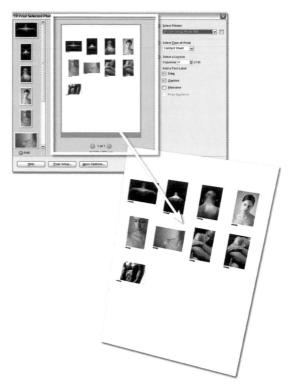

Contact sheets >>> Create prints of thumbnail versions of your images using the Contact Print feature in Elements.

Print Multiple Photos dialog and is easier to use than the File > Contact Sheet II version that was found in earlier versions of the program.

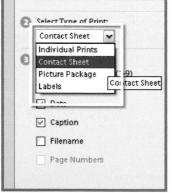

Select Printer:
EBSON Stylue Photo R310 Series
Select Type of Print:
Contact Sheet
Contact Sheet
Columns: 4 (1-9)
Add a Text Label
Date
Caption
Filename
Page Numbers

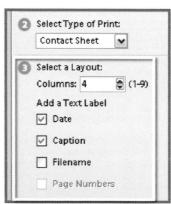

itor open the
therwiseStep 2 >>Use the Add and Remove
Photos buttons to adjust the list of
pictures to be included. Select the
printer from the drop-down list in
section 1 of the dialog and adjust the
hardware settings by clicking the
Printer Preferences button.

Step 3 >> In the final section (3) choose the number of columns to use (and therefore the total number of thumbnails to place on a single sheet) and select the content of the label text to be included. Click Print to output the contact sheet.

Step 1 >> From the Editor open the images to be printed, otherwise multi-select the pictures from inside the Photo Browser. Select File > Print Multiple Photos and choose Contact Sheet from the Select Type of Print menu.

358

14.03 Multiple prints on a page

Suitable for Elements – 5.0, 4.0, 3.0, 2.0, 1.0 | Difficulty level – Basic | Related techniques – 14.02 | Menus used – File The Picture Package option extends the contact sheet idea by allowing you to select one of a series of predestined multi-print layouts that have been carefully created to fit many images neatly onto a single sheet of standard paper. Previously located in the Print Layouts section of the File menu where the Contact Sheet command was also placed, the revamped Picture Package has now been integrated into the Print Multiple Photos dialog. Macintosh users can access the feature via the File menu in the Editor or under the Automate menu in the file browser.

There are designs that place multiples of the same size pictures together and those that surround one or two larger images with many smaller versions. The feature provides a preview of the pictures in the layout. You can also choose to repeat the same image throughout the design by selecting the One Picture per Page option. There is no option to add labels as there was in version 2.0 of the feature, but you can

Picture Package >> As well as the Contact Sheet feature the Picture Package option also provides the ability to print multiple images of different sizes on the one sheet of paper.

select a frame from one of the many listed to surround the photos you print. Whichever layout and frame design you pick, this feature should help you to keep both family members and football associates supplied with enough visual memories to make sure they are happy.

Step 1 >>> Open images in the Editor or multi-select pictures in the Photo Browser. Select Editor: File > Print Multiple Photos or Photo Browser: File > Print and then Picture Package. Use the Add and Remove Photos buttons to adjust the list of pictures to be included in the contact sheet.

		×	
0	Select Printer:		
	EPSON Stylus Photo 890		
5	EPSON Stylus Photo R310 Series	F I	
P	EPSON Stylus Photo 890		
10	Auto Family laser on UPSTAIRS		Dhata 000
	Auto Family Laser on MUMS-MAC	som stylus	Photo 690
0	Acrobat Distiller		
	\VANDREWS-SERVER\EPSON Stylus Ph	×	Concentration of
	Select a Fram <u>e</u> :		
	Antique Oval		
	Fill Page With First Photo		
	Crop to Fit		
			TIS TABLE
			Constanting of the

Step 2 >> Drag the photos to alter the layout. Add more pictures from the film strip by dragging them to the preview area. Select the printer from the drop-down list. Click the Printer Preferences button to adjust the hardware settings.

Step 3 >>> In the final section choose the Layout and Frame design to be included. To repeat a single image on a page click the One Photo per Page option. To add many different pictures to the same page leave this item unchecked. Click Print to output the Picture Package pages.

Book resources at: www.adv-elements.com

359

Ensuring color consistency between devices

One of the biggest problems faced by the digital photographer is matching the color and tone in the scene with what they see on screen and then with what is output as a print. This problem comes about because when working digitally we use several different devices to capture, manipulate and output color photographs – the camera, or scanner, the monitor or screen, and the printer. Each of these pieces of hardware sees and represents color in a different way. The camera converts a continuous scene to discrete digital tones/colors, the monitor displays a full color image on screen using phosphors or filtered LCDs and the printer creates a hard copy of the picture using inks on paper.

One of the earliest and most complex problems facing manufacturers was finding a way to produce consistent colors across all these devices. As many readers will attest too, often what we see through the camera is not the same as what appears on screen, which in turn is distinctly different to the picture that prints. These problems occur because each device can only work with a small subset of all the possible colors. This set is called the color gamut of the machine. As the gamut changes from device to device so too does the range of colors in the picture. For example, the range of tones and colors the camera recorded may not be visible on screen and the detail that can be plainly seen on the monitor may be outside the capabilities of the printer.

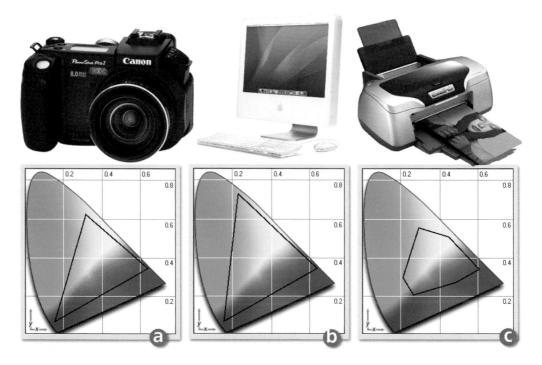

Color and digital devices >> The devices used to capture, process and output color pictures all respond to color in a different way. Each piece of hardware is only capable of working with a subset of all possible hues. This range of colors is called the device's color gamut. (a) Camera gamut. (b) Screen gamut. (c) Printer gamut. Graph images generated in ICCToolbox, courtesy of www.icctools.com.

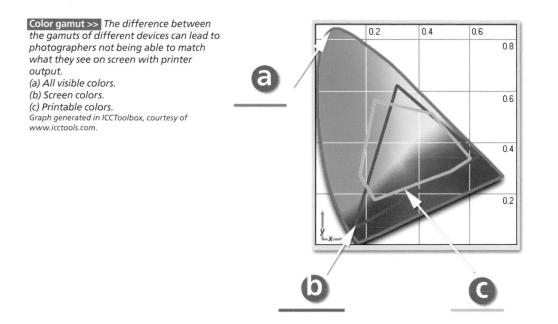

Add to this scenario the fact that if I send the same image to three of my friends it will probably appear differently on each of their screens. On one it may be a little contrasty, on another too blue and on the last screen it could appear overexposed. Each of the monitors is interacting with the digital file in a slightly different way.

So with all these complexities are digital photographers condemned to poor color consistency? The answer is a resounding NO! Through the use of a color-managed system we can maintain predictable color throughout the editing process and from machine to machine.

Essentially color management is concerned with describing the characteristics of each device in the editing chain. This description, often called an ICC profile, is then used to translate image detail and color from one device to another. Pictures are tagged, when they are first created, with a profile and when downloaded to a computer, which has a profiled screen attached, the image is translated to suit the characteristics of the monitor. With the corrections complete the tagged file is then sent to the printer, where the picture is translated, again to suit the printer's profile.

A similar scenario occurs when viewing files on different machines. As the picture is passed around, the profile for each monitor translates and accounts for individual hardware and color changes. The result is a picture that appears very similar on all devices.

Pro's Tip: To ensure that you get the benefits of color management at home, be sure to turn on color management features for your camera, scanner, monitor, software and printer. Always tag your files as you capture them and then use this profile to help keep color consistency as you edit, output and share your work.

FINELY CRAFTED OUTPUT

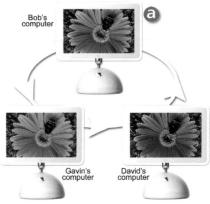

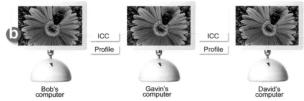

Color-managed workflows >>> When color management is not used the same digital photograph can display differently on different screens (a). When a tagged picture is displayed on several profiled monitors in a color-managed environment the image will appear similar despite the different characteristics of each computer and screen set up (b).

Color management and printing

So how does color management impact on our printing workflow? Well as we have already seen when dealing with resolution, so much of how we start the digital process determines the quality of our outcomes. Color management is no different in this respect. It is a fact that the digital photographer who considers color management at the point of shooting (or scanning), and then again when editing, will output better quality (and more predictable) printed images than one who doesn't. So at each stage of the digital process – capture, manipulation (editing) and output – your pictures should be color managed.

Color-managed capture – When shooting we should make sure that any color management or ICC profile settings in the camera are always turned on. This will ensure that the pictures captured will be tagged with a profile. Those readers shooting film and converting to digital with scanners should search through the preference menus of their scanners to locate, and activate, any inbuilt color management systems here as well. This way scanned pictures will be tagged as well.

Color-managed manipulation – When setting up Elements we should make sure that one of the color management options is selected in the Color Settings dialog of the program. This ensures that tagged pictures coming into the workspace are correctly interpreted and displayed ready for editing and enhancement. It also guarantees that when it comes time to print, Elements can correctly translate your on-screen masterpieces into a format that your printer can understand.

Color-managed output – The final step in the process is the printer and it is critical, if all your hard work to this point is going to pay off, that you load and use the printer's profile in the Print Preview > Show More Options settings. This step means that the tagged file exiting Elements will be accurately translated into the colors and tones that the printer is capable of creating.

Think of the whole system as a chain. The strength of your color management and therefore the predictability of the process is based on both the integrity of the individual links and their relationship to each other. The ICC profiles are the basis of these relationships. They ensure that each device knows exactly how to represent the color and tones in an image.

Book resources at: www.adv-elements.com

FINELY CRAFTED OUTPUT

- CAPTURE

EDIT &

OUTPUT

14.04 Setting up a color-managed workflow

Suitable for Elements – 5.0, 4.0, 3.0, 2.0, 1.0 | Difficulty level – Intermediate Related techniques – 14.05, 14.06, 14.07, 14.08 | Menus used - File

Now that I have convinced you that a color-managed system has distinct quality advantages over a 'hit and miss' non-managed approach, you will, no doubt, be eagerly wanting to make sure that you are working this way at home. So here are the steps that you will need to follow to put in place a full ICC profile color-managed system for capture, manipulation and print.

Scanners and cameras

Start by searching through the manuals for your digital camera and scanner to find references for 'Changing Color Spaces' or 'Tagging your Scanned File'. Most cameras automatically tag the images they make with the sRGB ICC profile. Even if there is no mention of attaching profiles to pictures in the camera documentation, don't assume that the file is being imported without a profile. It may be that this function is occurring in the background and that your particular camera does not offer the facility to change or manipulate the camera's color profile.

To check to see if your pictures are tagged, open the file in the Elements Editor and click the sideways arrow at the left of the status bar (at the bottom of the picture window) to reveal a fly-

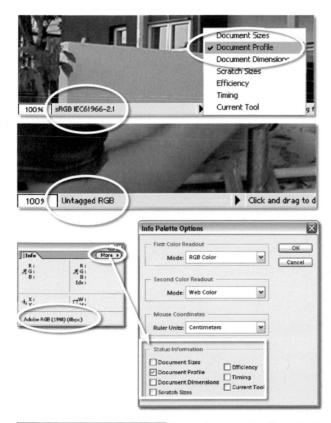

Checking profiles in Elements >> Use the Document Profile option in the Info palette on the document's status bar to check what profile is attached to your pictures.

out menu. Choose the Document Profile option from the list. Now to the left of the arrow you will see the profile name attached to your file. If the picture is not tagged then it will be labelled 'Untagged RGB'. Alternatively, you can also display the profile as part of the Info palette (Editor: Window > Info) by selecting the setting from the More Options button.

Some more expensive cameras contain the ability to alter the default profile settings, allowing the user to select different color spaces. For the moment just make sure that the camera is attaching a profile to your images. We will discuss 'which profiles are best to use when' later in this chapter.

Do the same type of investigation for your scanner. Unfortunately you will probably find that most

entry level scanners don't seem to have color profile options, but this situation is changing. Many more budget models are 'profile aware' so make sure you search the preferences part of your scanner driver carefully to ensure that all color management options are turned on.

Step 1 >> The color settings, for cameras with this option, can usually be found in the Set Up or Preferences menu.

Step 1 >>> Look for the area of your scanner driver that contains the settings for attaching profiles to your scans.

Step 2 >> For example, Nikon D100 users can access these settings via the Color Mode option located in the Shooting Menu.

Step 3 >>> In this menu Nikon provides three options for attached color spaces.

	rences riew Scan Scanner Color Settings
¢	Recommended
C	Canon ColorGear
	Target
	I Monitor
c	None
2	Always perform the auto tone

Step 2 >>> Once in the settings or preference area locate the Color Settings defaults.

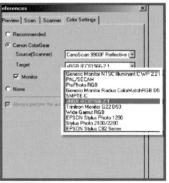

Step 3 >>> Activate the scanner's Color Management features and then select the profile to attach.

Monitors and screens

Now let's turn our attention to our screen or monitor. Most manufacturers these days supply a general ICC profile for their monitors that installs with the driver software when you first set up your screen. The default profile is generally the sRGB color space. If you want to check what profile is set for your monitor then Windows users will need to view the options in the Advanced settings of the Display control panel. If you are working on a Mac computer using OSX then you will find a similar group of settings in the Color section of the Display control panel which is located in the System Preferences.

At this stage, simply ensure that there is a profile allocated for your screen. In the following techniques I will show you how to create specific profiles for your screen using either the monitor calibration utility that comes with Elements, Adobe Gamma, or using a hardware tool called a Spyder.

play Properties	Default Monitor and NVIDIA GeForce4 MX 440 (Micros ?)
hemes Desktop Screen Saver Appearance Settings	General Adapter Monitor Troubleshoot Color Management
Display: Default Monitor on NVIDIA GeForce4 MX 440 (Microsoft Corporation)	These settings let you select the default color profile for your monitor. This affects the colors that your monitor displays. Current monitor: Default Monitor Default monitor profile: Phil's Default Monitor 06-27-03 Ador profiles currently associated with this device: Phil's Default Monitor 06-27-03 phil's Monitor 06-27-03
Screen resolution Less More Highest (32 bit)	
1280 by 1024 pixels Troubleshoot Advanced	Add Remove Set As Default
OK Cancel Appy	

Checking monitor profiles >>> Windows users can check the profile that is being used for the monitor via the Settings > Color Management section of the Display control panel. Mac OSX users will locate the default monitor profile in the Color section of the Display control panel.

Step 1 >> Windows users should select the Control Panel option from the Start menu.

Step 2 >> Click on the Display icon from those listed.

Step 3 >> Select the Settings tab and then the Advanced settings. Click Add to install a new profile.

Image editing program – Photoshop Elements

In previous versions of the program Elements offered three options for color management – *No color management, Limited color management* and *Full color management.* Users could nominate the option that they wished to use for an editing session by clicking on a Radio button in the Color Settings dialog (Edit > Color Settings). To use a fully managed workflow you needed

Color Settings

- Choose your color management: --- No color management
- O Limited color management optimized for Web graphics ③ Full color management - optimized for Print

Checking Elements' color management >> You can check the Color Management settings for Elements by selecting the Color Settings option from the Edit menu. Users of versions 1.0, 2.0 and 3.0 have three options.

Book resources at: www.adv-elements.com

365

FINELY CRAFTED OUTPUT

to pick the Full color management option as this is the only choice that made use of a complete ICC profile workflow.

From version 4.0 of Elements Adobe revamped the color management system to make it easier to understand and more logical to use. You now have four options to choose from in the Color Settings dialog. In addition to these settings you also have the ability to change the profile attached to your photo or even remove it totally.

Rotate	+	
Transform	•	
🕻 Crop		
Divide Scanned Photos		
Resize	۲	
Mode	+	
Convert Color Profile	•	Remove Profile
		Apply sRG8 Profile

Color management options >> *Elements 4.0 introduced new color management options including clearer options in the Color Settings dialog and the ability to switch the profiles attached to photos.*

lor Settings	
Clearn more about: Color Settings	OK
Choose how to manage color in your images:	Reset
Always Optimize Colors for Computer Screens	
Computer screens are capable of reproducing all the colors within the sRGB color range. This setting will keep all the colors you see on screen within that range, ensuring an accurate display for any device that supports the sRGB color space.	
O Always Optimize for Printing	
This setting will display your photos based on the colors within the AdobeRGB color space, commonly used for printing images.	
O Allow Me to Choose	
This setting assumes sRGE, but will allow you the flexibility to pick AdobeRGB iF a profile is not present; when you save the file, the profile will be saved with the image.	
iole: The "No Color Management" setting will ignore and discard embedded color profiles if they xith. The other settings will utilize embedded profiles or convert to sRGB or AdobeRGB, if the moded of profiles cannot be supported.	1

To ensure that Elements is operating with a color-managed workflow think about how you would normally view your work and then choose between Screen Optimized and Print Optimized options. If you need image-by-image control over what profile is used then select the Allow Me To Choose setting.

New Options for Color Settings

No Color Management – This option leaves your image untagged, deletes attached profiles when opening images and doesn't add a profile when saving.

Always Optimize Colors For Computer Screens – Attaches sRGB to photos without a profile and uses sRGB as the working space but maintains any attached profiles when opening images.

Always Optimize For Printing – Attaches AdobeRGB to photos without a profile and uses AdobeRGB as the working space but maintains any attached profiles when opening images.

Allow Me To Choose – Maintains all attached profiles but allows the user to choose between sRGB and AdobeRGB when opening untagged files (Editor workspace only).

dissing Profile	>
Color Settings	
This file does not have a color profile associat	ted with it. What would you like to do?
- How do you want to proceed?	
O Leave as is(don't Color Manage)	
O Optimize colors for computer screen of	display (use sRGB IEC61922-2.1)
Optimize colors for Print output(use A	AdobeRGB)
Always take this action, and don't show m	ne again
	OK Cancel

Missing Profile >> When opening an untagged file after first having selected the Allow Me To Choose option in the Color Settings a new Missing Profile dialog is displayed. Here you can choose which profile is attached to the photo.

Assigning rather than converting profiles

Selecting one of the options in the Image > Convert Color Profile menu will convert the picture's color to the selected color space. However if you press Ctrl when selecting a new profile, it will apply the profile without converting. This gives the image the appearance that it has been converted but maintains the underlying colors of the original. This option is the same as Photoshop's Assign Profile command.

Book resources at: www.adv-elements.com

366

sRGB versus Adobe RGB

The two color space options available in Photoshop Elements 4.0 are widely used industry standards. AdobeRGB encompasses a range of colors (color gamut) that more closely matches the characteristics of both desktop and commercial printers, whereas sRGB is a profile that is very closely aligned with the gamut of the average computer screen. Choosing which profile to use as your standard will depend largely on what will be the final outcome of the majority of your work.

Printer

The photo quality of desktop printers is truly amazing. The fine detail and smooth graduation of vibrant colors produced is way beyond my dreams of even just a few short years ago. As the technology has developed, so too has the public's expectations. It is not enough to have colorful prints; agement options for Elements now the digital photographer wants these hues to be closely

×+		
0	Cut	Ctrl+X
0	Сару	Ctrl+C
2	Copy Merged	Shft+Ctrl+C
*	Paste	Ctrl+V
-	Paste Into Selection	Shift+Ctrl+V
13	Delete	
3	Fill Layer	
	Stroke (Outline) Selection	
1	Define Brush	
	Define Pattern	
	Clear	
	Add Blank Page	Alt+Ctrl+G
	Add Page Using Current Layout	Alt+Shift+Ctrl+G
	A.L.C. A.L.C. A.L.	
100	Color Settings	Shift+Ctrl+K
	File Association	
Legenne .	Preset Manager	

Step 1 >> To set up the color manchoose Color Settings from the Edit menu.

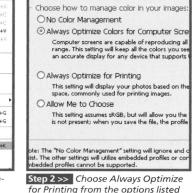

for a print based ICC-managed

workflow

matched with what is seen on screen. This is one of the reasons why a lot of printer manufacturers are now supplying generic, or 'canned', printer profiles. Using such profiles at the time of printing greatly increases the predictability of your output.

To check that you have a printer profile installed on your system open the Color Management section of the printer driver and search the list of installed profiles for one that matches your machine. If one is not listed then check the manufacturer's website for the latest drivers or profile updates. The general nature of these profiles means that for most pictures, on most surfaces, you will get a good result, but for the best prints you will need a different set up for each paper stock that you use. Some manufacturers provide matched profiles for all the media they supply, which makes the job of choosing a suitable profile much easier. Later in this chapter I will show you how to customize your printer's output specifically for output on different speciality papers.

a printer profile installed, open a

Print from the File menu.

picture in Elements and then select

Top: Left: 0.514 Crop to Fit Prin Show Bounding Box 20 Border: 0 Show More Options Color Management File Name Caption Source Space: sRGB I Printer Profile: Same Help

- 10 C	Color Hanaganan	on an	Transfer Pri
me Caption	Source Spaces	Adobe RGB (1990)	Invert b
and shirts	Printer Profile:	Same As Source	
	endering takeb	NEC Multisync Monitor G22 D93	^
		NTSC (1953) PAL/SECAM	
		Phase One - PC Monitor PhaseOne RGB(Trinkron G1.8 D50) ProPhoto RGB	
		ROMM-RGB SDTV (PAL)	
		SDTV (Rec. 601 NTSC) SMPTE-C	
		SPR2400 Archival Matte SPR2400 D-S Matte Paper	
		SPR2400 Enhanced Matte SPR2400 Matte Paper - HW	
		SPR2400 Photo Qity LIP SPR2400 Premium/Bossy	1
		SPR2400 Premium/uster	

Step 2 >> Tick the Show More **Options feature in the Print Preview** dialog to display the printer Color Management settings.

Step 3 >> Click the down arrow in the Profile section of the dialog and locate your printer profile.

14.05 Calibrating your screen – Adobe Gamma

Suitable for Elements – 5.0, 4.0, 3.0, 2.0, 1.0 | Difficulty level – Intermediate Related techniques – 14.04–14.08 | Tools used – Adobe Gamma

The profile that is included with your screen drivers is based on the average characteristics of all the screens produced by the manufacturer. Individual screens will display slightly different characteristics even if they are from the same manufacturer and are the same model number. Add to this the fact that screens' display characteristics change as they age and you will start to understand why Adobe packaged a monitor calibration utility with Elements.

Designed to account for these age and screen-to-screen differences the Adobe Gamma utility provides a way for users to calibrate their monitor and in the process write their own personal ICC screen profile. The program provides a step-by-step wizard that sets the black and white points of the screen, adjusts the overall color and controls the contrast of the mid tones. When completed these settings are saved as an ICC profile that Adobe Gamma loads each time the computer is switched on.

In Windows Adobe Gamma is located in control panels or the Program Files/Common Files/ Adobe/Calibration folder on your hard drive. For Macintosh users with OS9 and Elements 1.0 and 2.0, select the option from the Control Panels section of the Apple menu. OSX users should use Apple's own Display Calibrator Assistant as Adobe Gamma is not used in the new system software. Regular calibration using this utility will keep the output from your workflow consistent and will also help to ensure that what you see on screen will be as close as possible to what others with calibrated systems also see. Keep in mind though that for the color management to truly work, all your friends or colleagues who will be using your images must calibrate their systems as well.

Before you start the calibration process make sure that your monitor has been turned on for at least 30 minutes to warm up.

Step 1 >> Check that your computer is displaying thousands (16-bit) or millions (24-bit) of colors.

Step 2 >> Remove colorful or patterned backgrounds from your screen.

Step 3 >>> Ensure that light from the lamps in the room, or from a nearby window, is not falling on the screen surface.

368

Step 4 >> Use the monitor's built-in controls to select the color temperature/ white point (eg, 6500 K). Locate and open the Control Panel menu. Doubleclick the Adobe Gamma icon to start.

Step 5 >> Select the Step-by-Step Wizard (win) or the Assistant (Mac) option and click Next.

Step 6 >> Input a description for the ICC profile. Include the date in the title. Click Next.

Step 7 >> Set the screen's contrast to the highest setting and then adjust brightness. Click Next.

Step 8 >> Select the Phosphors that suit your screen. Check with manufacturer for details. Click Next.

Step 9 With Windows default set, adjust the Gamma slider until the square inside matches the out-side in tone. Uncheck single Gamma and do the same for each R, G, and B slider. Then recheck single gamma and check it again. Click Next.

Step 10 Click the Measure button and calibrate the screen's white point using the '3 squares' feature. Click Next.

Step 11 >>> Choose the Same as Hardware option as per Step 4 above. Click Next and then Finish.

Step 12 >> Save the completed profile with a file name the same as the profile description.

369

FINELY CRAFTED OUTPUT

14.06 Calibrating your screen – ColorVision Spyder

Suitable for Elements – 5.0, 4.0, 3.0, 2.0, 1.0 | Difficulty level – Intermediate Related techniques – 14.04–14.08 | Tools used – ColorVision Spyder

For more accuracy when calibrating their screens professional photographers often use a combined hardware/software solution like the well-known Spyder2 from ColorVision (www. colorvision.com). Like Adobe Gamma the system will calibrate your screen so you can be sure that the images you are viewing on your monitor have accurate color, but unlike the Adobe utility this solution does not rely on your eyes for calibration accuracy.

Instead the ColorVision option uses a sevenfilter colorimeter attached to the screen during the calibration process. This piece of hardware samples a range of known color and tone values that the software displays on screen. The sampled results are then compared to the known color values, the difference calculated and this information is then used to generate an accurate ICC profile for the screen. Unlike the Adobe Gamma approach this method does require the purchase of extra software and hardware but it does provide an objective way for the digital photographer to calibrate their screen. The ColorVision Spyder2 system works with both CRT (standard) and LCD (flat) screens.

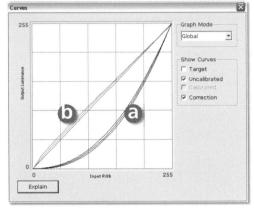

Corrected monitor curves >>> ColorVision's Spyder2 provides a combined hardware and software solution that measures the inconsistency in a monitor's display and creates correction curves to account for it. (a) Uncalibrated curves. (b) Corrected red, green and blue curves.

In previous versions of the program the calibration process contains two steps handled by two separate utilities:

1. *PreCAL*, which is used to set the white and black points of your screen as well as balance the red, green and blue components of the display, and

2. *OptiCAL*, designed to calibrate the screen and create a monitor profile that will ensure that colors and tones will be displayed accurately.

In the latest release these steps have been combined into a single step-by-step wizard.

Before you start...

ï

1. Set the screen to 24-bit color and a resolution of at least 640 x 480 pixels or greater and and ensure that the screen has warmed up for at least 30 minutes.

2. Make sure that you know how to change the Color, Contrast and Brightness settings of your monitor. This may be via dials or on-screen menus.

3. Ensure that no light source is shining on the screen during the calibration process.

4. Once the calibration process has started don't move the on-screen calibration window.

Target settings for general digital photography:

Color temp. – 6500 Gamma – 2.2 (Windows) Gamma – 1.8 (Mac)

Step 1 >>> Start by selecting the display type that needs calibrating. Here I have chosen an LCD screen.

Step 4 >> Review the Target Display settings to check that they are correct.

Step 7 >> Check that four separate white blocks can be seen in the scale. Adjust with the contrast control.

Step 10 >> Attach the Spyder and check to see that it is set up correctly for your screen type.

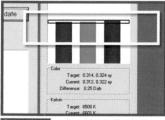

Step 13 >> Adjust the individual Red, Green and Blue controls to balance the screen color.

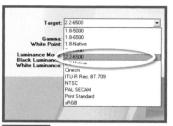

Step 2 >>> Now select the target color temperature and gamma from those listed in the drop-down menu.

Step 5 >> Indicate which controls are present on the monitor.

Step 8 >> Check that four separate black blocks can be seen in the scale. Adjust with the brightness control.

Step 11 >> Attach the Spyder to the monitor ensuring no other light sources are reflecting on screen.

Step 14 >> Press the Continue button and let the Spyder read the color and tone swatches displayed.

Step 3 >>> Choose the Luminance mode between Visual (single screen) and Measured (multiple screens).

Step 6 >> Return all settings to their factory default. Check with the monitor manual for instructions.

Step 9 >> Choose the way that the monitor adjusts color from the three options listed.

Step 12 >> The sensor will initialize and then several colors will be displayed and tested.

Step 15 >> When the program is finished, save the new profile.

Book resources at: www.adv-elements.com

371

Getting intimate with your printer

With the screen now well and truly calibrated and our scanner, camera and printer all ICC profiled terrific prints should be certain to follow, and in most cases this is true. But despite the use of a fully profiled system there are still those annoying occasions where the print doesn't meet our expectations. As long as you keep to standard papers and paper surfaces these occasions won't be too frequent, but the more that you experiment with different paper types and finishes the more you will be presented with unexpected results.

The culprit is the generic print profile supplied with your machine. By definition it is designed to provide good results with average images, surfaces and paper types. For those of you who want a little more than 'average' results you can fine-tune your printer profile for different paper and surface types.

As was the case with screens, here too we have a couple of different approaches. The first makes use of the extra color controls hidden away in the printer driver to modify your output and the second uses another ColorVision hardware/software solution to create separate print profiles for each paper type and surface that you use.

14.07 Calibrating your printer – resolution, color, tone and sharpness tests

Suitable for Elements – 5.0, 4.0, 3.0, 2.0, 1.0 | Difficulty level – Intermediate Resources – Web text images 14.07-1, 14.07-2 | Related techniques – 14.04–14.08

Good prints are made from good images and, as we know from previous chapters, digital image quality is based on high image resolution and high bit depth. Given this scenario, it would follow that if I desire to make the best prints possible, then I should at first create pictures with massive pixel dimensions and huge numbers of colors. The problem is that such files take up loads of disk space and, due to their size, they are very, very slow to work with, to the point of being practically impossible to edit on most desktop machines.

The solution is to find a balance between image quality and file size that still produces 'good prints'. For the purposes of this book 'good prints' are defined as those that appear photographic in quality and can be considered visually 'pixel-less'. As we have also seen the quality of all output is governed by a combination of the printer mechanism, the ink set used and the paper, or media, the image is printed on. To find the balance that works best for your printer set up and the various papers that you use, you will need to perform a couple of simple tests with your printer.

Quality printing >> Quality printing is based on paper, ink and machine all working together. Changing any of these components can alter the color, shadow, highlight or mid tone rendition of the print. For the best control different set ups or profiles are necessary for each of the paper/ ink/printer combinations you work with.

Book resources at: www.adv-elements.com

372

Testing tones

There are 256 levels of tones in each channel (red, green and blue) of a 24-bit digital image. A value of 0 is pure black and a value of 255 is pure white. Desktop inkjet machines do an admirable job of printing most of these tones but they do have trouble printing delicate highlight (values of between 230 and 255) and shadow (values between 0 and 40) details. The absorbency of the paper in combination with the inkset and the printer settings means that some machines will be able to print all 256 levels of tones whilst others will

Quality printing >>> When using some paper, ink and printer combinations delicate highlight and shadow details are lost. Being able to account for these output characteristics makes for better prints. (a) Lost highlights. (b) Lost shadows.

only be able to output a smaller subset. Being able to predict and account for lost shadow and highlight tones will greatly improve your overall print quality.

To test your own printer/ink/paper set up make a stepped grayscale that contains separate tonal strips from 0 to 255 in approximately five-tone intervals. Alternatively, download the example grayscale from the book's website (www.adv-elements.com). Print the grayscale using the best quality settings for the paper you are using. Examine the results. In particular, check to see at what point it becomes impossible to distinguish dark gray tones from pure black and light gray values from white. Note these values down for later use as they represent the range of tones printable by your printer/paper/ink combination.

Step 1 >> Download and print the tone-test.jpg image using your favorite settings and paper type.

Step 2 >> **Examine the print after** 30 minutes drying time to locate the values where you cannot distinguish shadow and highlight detail.

Step 3 >>> Input these values as the black and white output points in the Levels dialog when next printing with this paper, ink and printer combination.

373

When you are next adjusting the levels of an image to be printed, move the Output sliders at the bottom of the dialog until black and white points are set to those you found in your test. The spread of tones in your image will now meet those that can be printed by your printer/paper/ink combination.

Step 1 >> Create a high-resolution composite image and print the picture at several different imageresolution settings.

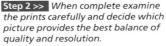

Parl Dimensions: 9.45M Width: 240 pixels Height: 1376 pixels Wigth: 30.66 cm w] Wigth: 30.66 cm w] Besolution: 380 r elsvinch w] Constraint Proportions Resample Image: October w

t: Image Size

Step 3 >> Use this image resolution as the basis of your prints using this ink, paper and printer combination.

Testing resolution

Modern printers are capable of incredible resolution. Some are able to output discrete dots at a rate of almost 6000 per inch. Many users believe that to get the utmost detail in their prints they must match this printer resolution with the same image resolution. Although this seems logical, good results can be achieved where one pixel is printed with several printer dots. Thank goodness this is the case, because the result is lower resolution images and therefore more manageable, and smaller, file sizes. But the question still remains – exactly what image resolution should be used?

Again a simple test can help provide a practical answer. Create a high-resolution file with good sharp detail throughout. Using Image > Resize > Image Size make a series of 10 pictures from 1000 dpi to 100 dpi reducing in resolution by a factor of 100 each time. Alternatively download the resolution examples from the book's website. Now print each of these pictures at the optimum setting for your machine, ink and paper you normally use. Next examine each image carefully. Find the lowest resolution that you should use if you want your output to remain photographic quality. For my set up this setting varies from between 200 and 300 dpi. I know if I use these values I can be guaranteed good results without using massive file sizes.

Testing color

For the majority of output scenarios, using the ICC profile that came with your printer will provide good results. If you do happen to strike problems where images that appear neutral on screen continually print with a dominant cast then most printer drivers contain an area where individual colors can be changed to eliminate casts.

374

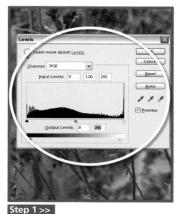

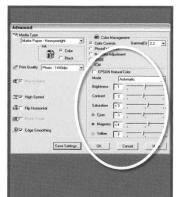

Print a full color test image using the Tonal and Resolution values derived in the two previous tests.

Step 2 >> Assess the color of the dominant cast and with the printer driver open, alter the color settings to remove the cast. Save the settings.

Wayward color casts often occur when non-standard papers are used for printing. The cause can be the base color of the paper itself, the absorbency of the paper or the type of surface being printed upon. Eliminating all-over casts is possible using the Color Adjustment sliders found in the Printer dialog.

Determine the exact settings you need for a specific paper type by running a series of print tests, carefully adjusting the color settings until the resultant output is cast-free. Save the corrective settings for use whenever you want to output using the same paper, ink and printer combination.

Plat Press Image: State State

Step 3 >> Reprint the example image using the new color settings. Assess the results and make adjustments if necessary.

Removing color casts with the printer driver >> Use the following guide when customizing the output from your printer using the color sliders in your printer driver:

- To subtract red from the print add cyan
- To add red to a print subtract cyan
- To add blue to a print subtract yellow
- To subtract blue from a print add yellow
- To add green to a print subtract magenta
- To subtract green add magenta

Testing sharpness

Often overlooked but definitively just as important is the amount of sharpness that is applied to the photo. Unfortunately most image-makers apply a standard degree of sharpening to all their photos irrespective of the final printed size, subject matter and the stock that they will be reproduced upon. And just like other settings when it comes to sharpness, one size definitely does not fit all.

To find what works best for your set up, copy an indicative section of you image and duplicate it several times (at 100%) in a new document. Open the Adjust Sharpness filter selecting each duplicate in turn and filtering the picture part using successively more aggressive settings. Note down each of the settings for use later. Now print the test file using the same set up that you use for making final prints. Carefully examine the printed results using the same lighting conditions and viewing distance that will be used to display the print and select the best overall sharpness. This part of the process is pretty subjective but most viewers can pick over- and under-sharpened images when confronted with several versions of the same image sharpened to different degrees,

375

FINELY CRAFTED OUTPUT

making the task of selecting the best sharpness much easier. Now to apply the sharpness to the original print photo. Rather than applying the filter directly to the document it is best to sharpen a copy and save this duplicate with a name that includes it's intended outcome, i.e. 'portrait-A3-Epson2400-sharpened'.

14.08 Calibrating your printer – ColorVision PrintFIX

Suitable for Elements – 5.0, 4.0, 3.0, 2.0, 1.0 | Difficulty level – Intermediate Related techniques – 14.04–14.08 | Tools used – ColorVision PrintFIX

Want to take your printer calibration one step further? The dream printing set up for most photographers is a situation where they have a profile created specifically for each of their paper, ink and printer combinations. Until recently this way of working has indeed been a dream, as the hardware and software system needed for creating high quality printer profiles could cost well over \$1800. But ColorVision (www.colorvision.com) now produces a more economical option designed specifically for the digital photographer. Just like the Spyder, ColorVision's PrintFIX comprises a hardware and software solution that takes the guesswork out of calibrating your printer's output. The process involves three easy steps (illustrated below):

(a) Output a set of color test patches from your printer using the ink and paper you want to calibrate,

(b) Read the patches using a modified scanner supplied with the system, and

(c) Use the supplied calibration utility to generate an ICC printer profile based on the scanner output.

Using this system you can build a complete set of profiles for all the papers that you use regularly. The system saves you time and money by reducing the waste normally associated with getting the perfect print on varying paper stock.

Elements' Print dialog:

- Source Space Document Document
- Print Space Profile the one you
- create with PrintFIX
- Print Space Intent Saturation

Printer Driver dialog:

- Color No Color Adjustment
- Paper Enhanced Matte or Photo Quality Ink Jet

Step 1 >> Select the PrintFIX option from the Automation Tools section of the File menu.

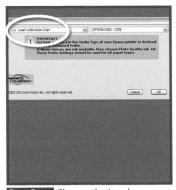

Step 2 >>> Choose the Load Calibration Chart option and then select the printer model in the PrintFIX dialog.

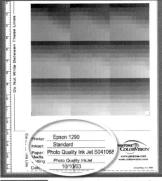

Step 3 >> Input the details into the spaces provided on the test print image.

376

Step 4 >> From the Print dialog click the Show More Options section and select the Same As Source item.

Step 1 >> Wait 5 minutes for drying then cut out the test print, insert it in the plastic sleeve and preload it into the scanner.

Step 5 >> Proceed to the printer driver and choose Photo Quality Ink Jet paper.

Step 6 >> Select 'No Color Management' and choose the Print Quality required. Print the test.

Step 2 >> Select the PrintFIX option from the Import section of the File menu.

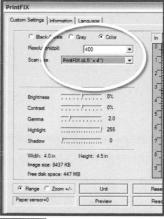

Step 3 >> Set scanner for Color, 400 dpi, 0% Brightness and Contrast, 2 Gamma, 255 Highlight and 0 Shadow. Click Read.

? X

.0000.

2100-wat-col-pap-r

adod6522.icn

Save As

Save in: D colo

1290-Epson PQIJ-504168.ic 2100-archival-matte-s04134

Step 1 >> Use the Cropping tool to isolate the color patches from the rest of the scan.

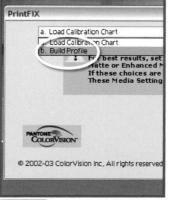

Step 2 >> Select PrintFIX from the Automation Tools options and select Build Profile.

printer profile using a name that combines printer, paper and inkset.

FINELY CRAFTED OUTPUT

377

14.09 Making great black and white prints

Suitable for Elements – 5.0, 4.0, 3.0, 2.0, 1.0 | Difficulty level – Intermediate Resources – Web image 14.9 | Menus used – File

Photography has had a long history of fine black and white print making. Practitioners like the famed Ansel Adams took the craft to dizzy heights, inventing the Zone system along the way. It wasn't too long ago that digital prints were judged not by their visual quality but by their ability to disguise their pixel origins. Thankfully, shooting and printing technology has improved to such an extent that we are now released from the 'guess if I'm digital' game to concentrate on more important things, like making great images. After all, this is the reason that most of us got into photography in the first place. But producing high quality black and white prints digitally, even with a fully color-managed system, does have its problems. In my experience making great monochrome prints relies heavily on choosing the right paper and inks to print with.

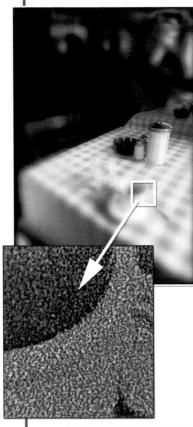

Black and white in color >> When printing a black and white image using a standard inkjet printer many of the gray tones are produced using a combination of colored ink droplets.

Choosing paper and inks

There is now an incredible range of papers and inks that are suitable for use in desktop printers. The combination you choose will determine the 'look and feel' of your prints. One of the first things that screams quality is the type of stock that your images are printed on. Fiber-based papers have always held a special place within the photographic community. Images produced on this type of paper ooze quality and demand respect. Professionals and amateurs alike take a lot of time, and spend a lot of money, choosing the right paper for their photographs.

Selecting which paper to use when you are digital printing is no different. Surface, weight and base tint should all be carefully considered and tested before making your final decision. The papers supplied by your printer manufacturer provide the easiest way to obtain predictable and reliable quality output. The surfaces of these papers are often specially designed to work in conjunction with the inks themselves to ensure the best balance of archival stability and image quality. But this is not the limit of your choices: there is a myriad of other papers available from photographic companies such as Kodak and Ilford as well as paper manufacturers like Somerset. Often specialist suppliers will sell you a sample pack containing several paper types so that you can test the papers that work best for you.

There are also decisions to be made about the inks to use to make your prints. The cartridges supplied and recommended by your printer's manufacturer are specifically designed to work in conjunction with your machinery. These ink sets provide the quickest way to get great photo-realistic images. But along with standard four- or five-color inksets you now also have a choice of

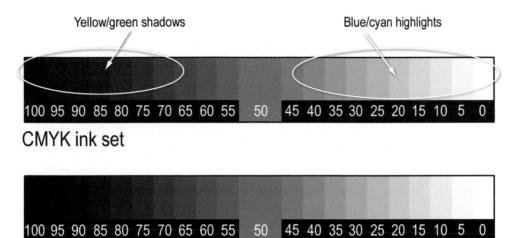

Multi-black Neutral ink set

Neutral grays >>> Because many of the gray tones in a monochrome print are created with colored dyes it can be almost impossible to produce completely neutral tones throughout the whole of a grayscale when printing with standard ink sets. Neutral grays are possible, however, if the black and white print is produced using a dedicated multi-black ink set.

printers that make use of multiple blacks (black plus varying shades of gray) as well as cyan, magenta and yellow (CMY). The mid tone and light gray inks are used to create the tones in monochrome pictures and replace the colored dots that have previously been employed for the same job. Using this approach, digital photographers can produce the rich and smoothly graduated monochrome output they have preciously created traditionally, without any of the problems of strange and unwanted color casts creeping into their black and white prints.

Why use monochrome inks?

Most photo-quality inkjets use the three colored inks as well as black to produce monochromes. Using the four inks (sometimes six – five colors plus black) provides the greatest range of tonal levels. With dot sizes now being so small it is only under the closest scrutiny that the multi-colored matrix that lies beneath our black and white prints is revealed. Balancing the different colors so that the final appearance is neutral is a very tricky task. Too many dots of one color and a gray will appear blue, too few and it will contain a yellow hue. For most users slight color variations are not a problem, but for image-makers with a monochrome heritage to protect, nothing less than perfection is acceptable.

Too often the black and white prints produced using a color ink set contain strange color casts. For the most part these errant hues are the consequence of mixing different ink types and paper products and can be rectified with a little tinkering of the printer driver's color settings or by using a custom-made profile. One paper I use, for instance, continually presents me with magentatinged black and white prints. But as the cast is consistent across the whole of the tonal range, I am able to rid the pictures of this tint by adjusting the Magenta/Green slider in the printer settings. I saved the set up that produced a neutral image and now use it each time I print to this surface.

Book resources at: www.adv-elements.com

FINELY CRAFTED OUTPUT

Paper types >>

There are many papers on the market that are suitable for inkjet printing. Most can be divided into two groups – 'coated' and 'uncoated'. The coating is a special ink receptive layer that increases the paper's ability to produce sharp 'photo-realistic' results with a wide color gamut and a rich maximum black (high D-max). Uncoated papers can still be used with most printing equipment but changes in the printing set up may be necessary to get good results.

Apart from coatings, paper surface is the other major factor that discriminates between paper types. The general categories of surface are:

Glossy Photographic – Designed for the production of the best quality photographic images. These papers are usually printed at the highest resolution that your printer is capable of and can produce either 'photo-realistic' or highly saturated colors.

Matt/Satin Photographic – Papers designed for photographic images but with surfaces other than gloss. Surfaces specially coated so that, like the gloss papers, they can retain the finest details and the best color rendition and often produce the best archival results.

Art Papers – Generally thicker based papers with a heavy tooth or texture. Some coated products in this grouping are capable of producing photographic quality images, but all have a distinct 'look and feel' that can add subtle interest to images with subject matter that is conducive. Unlike other groups this range of papers also contains examples that contain colored bases or tinted surfaces.

General Purpose – Papers that combine economy and good print quality and are designed for general usage. Different to standard office or copy papers as they have a specially treated surface designed for inkjet inks. Not recommended for final prints but offer proofing possibilities.

Specialty Papers – Either special in surface or function. This grouping contains papers that you might not use often but it's good to know that on the occasion that you do need them they are available. The range in this area is growing all the time and now includes such diverse products as magnetic paper, back light films and a selection of metallic sheets.

It is not these consistent casts that cause much concern amongst the critical desktop printing fraternity, rather it is the way that some printers produce a different cast for highlights and shadows. As we have seen already in this chapter, as part of my printer set up procedure I always output a grayscale to help me determine how the machine handles the spread of tones from highlights to shadows. The test prints remain fairly neutral when they are made with the manufacturer's recommended papers, but as soon as I start to use different stock, the gray tonal scale ceases to be so gray. For the occasional print, I can put up with the strange colors present in my black and white masterpiece, but for the dedicated monochrome producer it is enough to send them screaming back to the darkroom. Well almost!

Specialist ink sets – the solution for monochrome printing

With just this type of situation in mind several of the bigger printer manufacturers are now producing specialist machines that are much more suited to monochrome printing. The system they use is simple – rather than trying to create grays from three or more colors, these printers use extra gray inks for the task. So, in addition to the standard colors – CMY, the manufacturers have added in extra gray inks to create a seven- or even eight-color cartridge. All gray inks are derived from the same pigment base as the black, so prints made with these cartridges contain no strange color casts. That's right, no color casts! That's no overall magenta tint with my favorite paper, or strange color changes in the shadows and highlights of my grayscales.

Printing with a specialist monochrome printer is the closest thing to making finely-crafted fiber-based prints that the digital world has to offer. Not only are your images cast-free, they also display an amazing range of grays. With pictures that have been carefully adjusted to spread image tones and retain shadow and highlight details, the multi-black system produces unparalleled quality prints on a wide range of gloss, satin, matt and fine-art stock.

Ink types >>

Not all inks are created equal. Different printers use different inks sets, which in turn have their own characteristics. They generally fall into two categories:

Dye-based Inks - Most standard cartridges use this type of ink. They are generally easy to use with fewer problems with streaking, long drying times and puddling than pigmented inks. Some varieties are also capable of a greater range of colors.

Pigment-based Inks - These products last longer than most dye-based inks. They are also more water resistant. But be warned, these ink sets can be more difficult to print with and some particular brands do not have the same color or density range as their dye-based equivalents.

14.10 What about permanence?

Suitable for Elements - 5.0, 4.0, 3.0, 2.0, 1.0 Difficulty level - Intermediate So with the availability of such great products that produce fantastic images most photographers believe that we are living in Desktop Printing Navarna. To some extent this is true. The tools for the creation of great looking prints are well within the reach of most of us, but the youth of the technology in conjunction with our haste to embrace all that is digital, has us forgetting, or at the very least overlooking, some of the lessons of the past. Many photographic enthusiasts still see the 50s. 60s and 70s as golden years of print production. Then, just like now, countless image-makers were taking control of the print production process by setting up their own darkrooms and churning out high quality black and white prints.

The best crafted prints made during this period exhibit many of the characteristics we still value today. They are sharp, show good

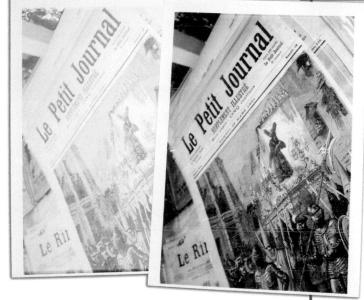

Prints that fade >> The print emerges from the machine crisp, clean and brilliantly colored but in as little as a few weeks of standard display the same image is no more than a faded ghost of its former self. Image permanence is the hidden quality factor to consider when choosing a print system.

gradation and exhibit an exceptional range of gray tones, from deep blacks through to delicate highlights. In addition to the presence of these obvious image-quality characteristics, many of the prints made in this period also boast exceptional permanence characteristics. Put simply, if well cared for, these prints will last a long time, no make that a very long time, with little or no fading. Much time and effort was spent by companies and practitioners alike establishing archival print processing systems that would ensure that the images we created would last a lifetime. It was against this historical background that the first color print processes were introduced and, more recently, the first digital print systems invented.

381

New doesn't always mean better

In embracing these new printing possibilities it seems that sharpness, gradation and gamut were held up as the quality characteristics to be cherished and poor old permanence 'faded' into the background. For a few rocky years image-makers were teased with the release of new printer models that boasted better resolution, tonal gradation and color gamut, but these advances were coupled with permanence characteristics that were well short of expectations. Thankfully this is no longer the case. All the major printer companies have spent the last few years chipping away at the print permanence issue and now we are blessed with a range of machines that not only produce a great looking print but also one that will last.

Print systems are more than a sum of their parts

By combining specialist inksets with matched papers and customized print heads, companies like Epson and Hewlett Packard have been able to achieve substantial increases in the projected life of their prints, without sacrificing the other image qualities that we all hold so dear. This revolution started in the high end or pro range of printers but now has filtered down to entry level machines. Permanence ratings beyond four score years is now a regular occurrence, with several ink, paper, printer combinations breaking the 100 year barrier.

The extended print life is directly related to the interaction of the matched papers and inks. Despite what you read in advertising campaigns, or even on the packets of ink and paper produced by third-party vendors, not all inks and paper combinations will provide this same level of permanence. Sure, the print might look the same when it exits the machine with sharpness, color, tonal range and brightness all equivalent to a photo produced with OEM (Original Equipment Manufacturer) supplied materials, but it is only further down the track that the differences in permanence become apparent. So if the image quality is comparable for photos produced with a variety of inks and paper combinations (both OEM and third-party) how do we tell if a print is going to last the distance? By testing its permanence.

Testing permanence

Thankfully the major players in the world of inkjet printing markets, Epson, Hewlett Packard, Canon and Lexmark also uphold permanence as a key component of print quality. Over the last few years these companies have been instrumental in improving the longevity of their own print systems. In addition they have taken the permanence bull by the horns and have been testing the life of their products and publishing these results so the consumer can make informed decisions about their purchases.

But judging print permanence is a tricky proposal. After all how do you really know how long a print will last unless you are there to view it after the 100-year predicated life? Most industrybased tests are predictions based on light, humidity and temperature levels of an average display location. Rather than expose the print to these variables over a long period the photos are given a shorter exposure to a much brighter light source and the results then extrapolated back to the standard viewing conditions. With these results it is possible for manufacturers to predict the performance of individual printer, ink and paper combinations and for consumers to have confidence in the longevity of the prints they make.

Comparing 'apples with apples'

Most manufacturers have settled on average display light levels of between 450 or 500 lux per 12-hour day as the basis of their predicated permanence ratings. I say most because there are still some players in the third-party media and ink market who either don't publish their permanence findings at all or who use lower daily light exposure values to generate higher-

How long will my prints last?

Photo printers	Print	Ink	Paper	WIR Perm.
	type	Туре		Rating*
Epson PictureMate Personal Photo Lab	Inkjet	Pigment	PictureMate included with cartridge	104 years
Epson Stylus Photo R1800	Inkjet	Pigment	Epson matt paper heavyweight	>150 years
			Epson Glossy Photo paper	104 years
Epson Stylus Photo R800	Inkjet	Pigment	Epson matt paper heavyweight	>150 years
			Epson Glossy Photo paper	104 years
Epson Stylus Photo R300	Inkjet	Dye	Epson ColorLife Photo Paper	36 years
			Epson matt paper heavyweight	30 years
Epson Stylus Pro 9800	Inkjet	Pigment	Epson Premium Gloss Photo paper	85 years
			Epson Ultrasmooth Fine Art paper	108 years
Epson Stylus Pro 2100	Inkjet	Pigment	Epson Premium Gloss Photo paper	85 years
			Epson Ultrasmooth Fine Art paper	108 years
Epson Stylus Pro 2000p	Inkjet	Pigment	Epson Premium Semi-Gloss Photo Paper	>100 years
			Epson Enhanced (Archival) Matt Paper	>100 years
Hewlett Packard Photosmart 8750	Inkjet	Dye	HP Premium Plus Photo Paper High Gloss	108 years
			HP Premium Plus Photo Paper Soft Gloss	108 years
Hewlett Packard Designjet 130	Inkjet	Dye	HP Premium Plus Photo and Proofing Gloss	82 years
			HP Premium Plus Photo Paper Soft Gloss	82 years
HP Photosmart 325 and 375 Compact Photo Printers	Inkjet	Dye	HP Premium Plus	82 years
			HP Premium Photo High Gloss	82 years
Olympus p-10 Digital Photo Printer	Dye-sub	Dye-sub ribbon	Dye-sub paper	8 years
Canon S800 Photo Printer	Inkjet	Dye	Canon Photo Paper Pro	27 years
Kodak Edge Generations/Royal Generations papers	Traditional photo	Color couplers	Silver halide paper	19 years
Agfacolor Sensatis/Splendex Paper	Traditional photo	Color couplers	Silver halide paper	22 years
Fuji Crystal Archive type one paper	Traditional photo	Color couplers	Silver halide paper	40 years

*How were the tests conducted?

All print permanence ratings detailed here are drawn from data provided by the Wilhelm Imaging Research. The full articles and information sheets from which the information is extracted can be accessed via the company's website – www. wilhelm-research.com. These ratings are based on accelerated light stability tests conducted at 35Klux with glass-filtered cool white fluorescent illumination with the air temperature maintained at 24°C and 60% humidity. Data was extrapolated to a display condition of 450 lux for 12 hours per day using the Wilhelm Imaging Research 'Visually Weighted End Point Criteria' and represents years of display for easily noticable fading, changes in color balance and/or staining to occur.

predicted print life figures. As you can expect, this leads to much confusion when it comes time to purchase media and inks, with claims and counter claims of predicted print life featuring prominently on packaging of competing products.

To solve this problem many companies submit their products for testing and evaluation to Wilhelm Imaging Research, a well-respected independent testing company, to provide comparative results produced under the same stringent conditions. This process has worked quite successfully for the last few years with consumers 'in the know' seeking out the valuable testing results that are freely published on the company's website – www.wilhelm-research.com. The information is then used to inform print system purchasing decisions or provide data about predicted life expectancy of specific printer, ink and paper combinations.

> **Testing print life** >>> Wilhelm Imaging Research, Inc. (www. wilhelm-research.com), conducts research on the stability and preservation of traditional and digital color photographs and motion pictures. The company publishes brand name-specific permanence data for desktop and large format inkjet printers and other digital printing devices.

Henry Wilhelm is co-founder, President, and Director of Research at Wilhelm Imaging Research, Inc. and appears frequently as a speaker on inkjet printing technologies and print permanence at industry conferences, trade shows, and museum conservation meetings.

In 2005 Epson, Hewlet-Packard, Canon and Lexmark endorsed the Wilhelm Imaging Research independent permanence testing program which provides consumers with standardized print longevity ratings.

The WIR certification program

Taking the idea further, in 2005 the top four manufacturers of inkjet printers, inks, and inkjet photo papers worldwide – Epson, Hewlett-Packard, Canon and Lexmark – endorsed an independent image permanence testing program that includes a certified seal for print and ink packaging. With testing data supplied by the Wilhelm Imaging Research center the WIR certification program will provide customers with standardized print longevity ratings. The program has three components:

(1) *The WIR Certified Tests* – A comprehensive set of test methods developed by Wilhelm Imaging Research to evaluate image permanence,

(2) WIR Test Data – Permanence data generated with the WIR Certified Tests, and
(3) The WIR Seal – Signifies that the product has been tested by WIR, and that detailed image permanence data is available on the WIR website.

The standardized image permanence test methods and specifications undertaken by WIR provide consumers throughout the world with 'apples-to-apples' comparisons for a wide range of inks and photo papers. The testing program and associated seal will help us all differentiate between printer manufacturers' papers that have been optimized for that company's inks, and

Book resources at: www.adv-elements.com

384

third-party and store-label 'universally compatible' papers that may use less demanding test methods or supply no image permanence information at all about this critical – but initially hidden – aspect of total product quality. For example, WIR gave one leading third-party inkjet paper a WIR Display Permanence Rating of 11 years when printed with an HP printer and the HP No. 57 inkjet cartridge. The paper's manufacturer rated the display life of the same paper at 162 years by using far less rigorous tests, with 120 lux UV-filtered illumination and measurements made at only a single density point rather than the two that is the standard with the WIR tests.

To qualify for use of the Seal, a product must have a minimum WIR Display Permanence Rating of 25 years and a WIR Album/Dark Storage Rating at least equal to the display rating. Complete results and details of WIR test methods are available at www.wilhelm-research.com. You will start to see the WIR seal appearing on the packaging of your favourite print products over the coming months but until then, for the latest information on print permanence, check out the WIR website.

14.11 Preparing your images for professional outsourcing

Suitable for Elements - 5.0, 4.0, 3.0, 2.0, 1.0 | Difficulty level - Intermediate

Professional lab services are now expanding into the production of large and very large prints using the latest inkjet and piezo technology as well as digital images on color photographic

paper. Now that you are part of the digital fraternity you too have the choice of outputting your humble Photoshop Elements images on these 'big printing beasts'.

Outputting to color print paper via machines like the Lambda and Pegasus has quickly become the 'norm' for a lot professional photographers. Adjusting of image files that print well on desktop inkjets so that they cater for the idiosyncrasies of these RA4 machines is a skill that most of us are continuing to learn. The reeducation is definitely worth it – with image quality and archival permanence of our digitally generated imagery finally meeting that of traditional prints as well as

the expectations of photographers and their clients. But just when you thought that you could become complacent with your new skills the wide format printing market has really started to take off.

With improved quality, speed and competition in the area, the big players like Epson, Kodak and Hewlett Packard are manufacturing units that are capable of producing images that are not only stunning, but also very, very big. Pictures up to 54 inches wide can be made on some of the latest machines, with larger images possible by splicing two or more panels together. You can now walk into a bureau with a CD containing a favorite image and walk out the same day with a spliced polyester poster printed with fade-resistant all-weather inks the size of a billboard. Not that everyone wants their output that big but the occasional poster print is now a very real option.

Getting the set up right is even more critical with large format printing than when you are outputting to a desktop machine. A small mistake here can cause serious problems to both your 48 x 36 inch masterpiece as well as your wallet, so before you even turn on your computer talk to a few local professionals. Most output bureaus are happy to help prospective customers with advice and usually supply a series of guidelines that will help you set up your images to suit their printers. These may be contained in a pack available with a calibration profile over the counter, or might be downloadable from the company's website. Some companies will check that your image meets their requirements before printing, others will dump the unopened file directly to the printer's RIP assuming that all is well. So make sure that you are aware of the way the bureau works before making your first print.

Outsourcing guidelines

The following guidelines have been compiled from the suggestions of several output bureaus. They constitute a good overview but cannot be seen as a substitute for talking to your own lab directly.

Ensure that the image is orientated correctly. Some printers are set up to work with a portrait or vertical image by default; trying to print a landscape picture on these devices will result in areas of white space above and below the picture and the edges being cropped.

Make sure the image is the same proportion as the paper stock.

This is best achieved by making an image with the canvas the exact size required and then pasting your picture into this space.

Don't use crop marks. Most printers will automatically mark where the print is to be cropped. Some bureaus

will charge to remove your marks before printing.

Convert a layered image to a flat file before submission. Most output bureaus will not accept layered PSD (Photoshop Elements) files so make sure that you save a flattened copy of the completed image to pass on to the lab.

Use the resolution suggested by

the lab. Most output devices work best with an optimal resolution. Large format inkjet printers are no different. The lab technician will be able to give you details of the best resolution to supply your images in. Using a higher or lower setting than this will alter the size that your file prints, so stick to what is recommended.

Use the file format recommended by the lab. The amount of time spent in setting up a file ready to print is a big factor in the cost of outsourced printing. Supplying your file in the wrong format will either cost you more, as a lab technician will need to spend time converting the picture, or will have your print job rejected altogether.

Keep file sizes under the printer's maximum. The bigger the file, the longer it takes to print. Most bureaus base their costings on a maximum file size. You will need to pay extra if your image is bigger than this value.

Watch out for fancy fonts. Elements does not have 'preflight' features to insure that all fonts associated with the document are included when submitted. So if you supply a PSD file to a printer and they do not have the same fonts on their system that you used in your picture they will get a message about updating fonts when the document is opened. To avoid this only supply flattened files in TIFF or JPEG formats.

387

ADVANCED PHOTOSHOP ELEMENTS 5.0 FOR DIGITAL PHOTOGRAPHERS

14.12 Shoot small print big

Suitable for Elements – 5.0, 4.0, 3.0, 2.0, 1.0 Difficulty level – Intermediate | Menus used – Image You know the scenario. You hand over what in a lot of countries amounts to a year's salary for a snazzy new digital camera with all the bells and whistles and a modest three megapixel sensor only to be told by someone like me in the preceding chapters of this book that you can now print great photoquality images – but only up to 10 x 8 inches. Wrong, Wrong, Wrong.

The thinking behind such a statement is sound. As we saw earlier in this chapter the recommended image resolution for most inkjet and professional digital output is between 200 and 400 dots per inch. So if we divide the pixel dimensions of the sensor the recommended resolution for inkjet output (200 dots per inch) we will get the maximum print size possible. For example, if we divide an image produced by a chip that is 2000×1600 pixels by a resolution of 200 dpi then the maximum print would be 10×8 inches. If a higher resolution of 400 dpi was used then the final print size would be reduced to a mere 5×4 inches. Right? Wrong!

In truth, this is still the way to achieve the absolute best quality from your digital files. But for the average camera owner the promise of superb image quality is no consolation if all you want is a bigger

What is interpolation anyway?

Interpolation is a process by which extra pixels are generated in a low-resolution image so that it can be printed at a larger size than its original dimensions would normally allow. Interpolation, or as it is sometimes called, Upsizing, can be implemented by increasing the number of pixels in the width and height fields of the Photoshop Elements Image > Resize > Image Size dialog.

This approach works by sampling a group of pixels (a 4 x 4 matrix in case of Bicubic interpolation) and using this information together with a special algorithm as a basis for generating the values for newly created pixels that will be added to the image.

The sophistication of the algorithm and the size of the sampling set determine the quality of the interpolated results.

The interpolated results are never as sharp or clear as an image made with the correct pixel dimensions to start with, but when you need a big print from a small file this is a great way to go.

Interpolated big prints >> To create big prints images can be resized in Elements using the Image Size dialog (Image > Resize > Image Size). (a) Original test print 5.3 x 3.2 inches. (b) Interpolated print 32 x 24 inches. print. When faced with this problem those 'nonprofessional' shooters amongst us have been happily upscaling their images using the Resample option in the Image Size feature of Elements, whilst those of us who obviously 'know better' have been running around with small, but beautifully produced, prints. After all it is common knowledge that increasing the numbers of pixels in an image by resampling or 'interpolating' the original data can only lead to unsharp, and more importantly, unacceptable, albeit large, pictures. Right! Well, sort of!

Book resources at: www.adv-elements.com

Quietly over the last few years and right under our very noses it seems, a small revolution in refinement has been happening in the area of interpolation technologies. The algorithms and processes used to apply them have been continuously increasing in quality until now they are at such a point that the old adages such as

• Sensor dimension / output resolution = maximum print size

don't always apply. With the Bicubic option set in the Image Size dialog it is now possible to take comparatively small files and produce truly large prints of great quality. This process, often called interpolation or upscaling, artificially increases the number of pixels in an image so that with more image data in hand, bigger prints can be made.

Upscaling techniques

So what are the steps involved in increasing the size of my pictures. Here I will demonstrate two approaches to upscaling (see page 389). The first is the simplest and involves inputting new values into Image Size dialog (a) and the second, called Stair Interpolation (b), uses the same technique but increases the size of the picture incrementally rather than in one jump. Stair Interpolation is the preferred approach by many professionals, who believe that the process provides sharper end results. Both approaches use the Image Size dialog and are based on the Bicubic interpolation option.

From version 4.0 several changes were made in the Image Size dialog and its options:

1. The Resample Image option is NOT checked by default when you first open the dialog;

2. Bicubic Smoother (for upscaling) and Bicubic Sharper (for downscaling) options have been added to the drop-down menu of resampling methods;

3. A Scale Styles option has been included to automatically adjust any styles present in the picture in proportion to any size changes made.

The results

In the example (on page 387), image skin tones and other areas of graduated color handled the upsizing operation the best. Sharp-edged elements evident in the lash areas of the eyes and the straight lines of the buildings tended to show the results of the interpolation more clearly. Though not unacceptable at normal viewing distances for big-sized prints, image-makers whose work contains a lot of hard-edged visual elements and who rely on ultimate sharpness in these areas for effect will need to 'test to see' if the results are suitable for their style of images. For portrait, landscape and general shooters upscaling using either of the two approaches listed here is bound to surprise and excite.

Image Size			CONSTRUCTION OF STATE	×		Image Size	and the state of the second second	
Pixel Dimens	re about: <u>Im</u> sions: 3.08M		0	OK Cancel		Learn more abo	67.6M (was 3.08M)	
Width: 2	048	pixels	-	Help		Width: 9600	pixels	
Height 5	25	pixels	•			Height: 2461	pixels	9.G
- Document S	ize:					- Document Size:		
Width: 6	.827	inches	~			Width: 32	inches	л.
Height: 1	.75	inches	~			Height: 8.203	inches	
Resolution: 3	00	pixels/inch	~		1	Resolution: 300	pixels/inch	J W
Scale Styles	oportions		0			Constrain Proport	ons	
Resample Im	Resample Image: Bicubic					Resample Image: Bicubic		~

Interpolation via Image Size >>> With Resample Image ticked and Bicubic selected input the new values into the Width or Height sections of the dialog. (a) Original file size. (b) Original pixel dimensions. (c) Original print size and resolution. (d) Resample Image option – tick to interpolate. (e) Select Bicubic (in version 4.0 pick Bicubic Smoother for upscaling and Bicubic Sharper for when reducing picture size) for quality. (f) Interpolated file size. (g) Interpolated pixel dimensions. (h) Interpolated print size and resolution.

I still cringe saying it, but it is now possible to break the 'I must never interpolate my images rule' in order to produce more print area for the pixels you have available.

I will provide some provisos though:

1. Images captured with the correct number of pixels for the required print job will always produce better results than those that have been interpolated.

2. The softening effect that results from high levels of interpolation is less noticeable in pictures with general content such as landscape or portrait images and more apparent in images with sharpedged elements.

3. The more detail and pixels in the original file the better the interpolated results will be, and a well-exposed sharply focused original file that is saved in a lossless format such as TIFF is the best candidate image for upsizing.

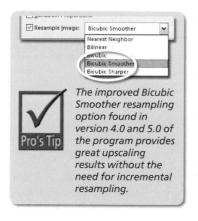

Step 1 >> With the image open in Elements select Image>Resize>Image Size.

Step 2 >> Tick Resample Image and choose the Bicubic (Bicubic Smoother for version 4.0 users) option. Input the new values into the width and height areas.

Step 1 >> For Stair Interpolation start the process by opening the Image Size feature.

mage Size			
V		t: <u>Image Size</u> .72M (was 3.08M)	
Width:	110	ercent	• ¬
Helgen		percent	~ _
- Document	t Size:		
Width:	19.07	cm	~
Height:	4.89	cm	~
Resolution:	300	pixels/inch	~
☑ Scale Style: ☑ Constrain F ☑ Resample I	roportion	ns Bicubic	

Step 3 >> Input a value of 110% into the Width box and click OK. Open the Image Size dialog again.

Learn more about: Image Size Pixel Dimensions: 3.08M Width: 100 percent Y 8 Height: 100 percent percer Document Size: pixels Width: 17.34 cm ~ Height: 4.45 cm ~ Resolution: 300 pixels/inch Y Scale Styles Constrain Proportions Resample Image: Bicubic

Step 2 >>> This time select the percent option for Width and Height. Tick Resample Image and choose Bicubic.

Learn m	nore about	: <u>Image Size</u>
1.51		
xel Dime	ineloso: 5	44M (was 4.51M)
Width:	110	percent
Height:	110.02	percent
ocument	t Size: —	
Width:	23.08	cm
Height:	5.92	cm
olution:	300	pixels/inch

Step 4 >> Input a value of 110% again and click OK. Continue this process until you reach your desired print size.

389

FINELY CRAFTED OUTPUT

Book resources at: www.adv-elements.com

14.13 Printing workflow

The key to producing good quality prints is knowing the characteristics of your printer. No printer is going to produce perfect results on all paper types with all images. Understanding the strengths and weaknesses of your machine will help you ensure predictable results more often. And the foundation of all such predication is a good color-management system.

D-

Recomm	nended F	Printing Wo	orkflow	
	Use 'canned' screen profile supplied with monitor	Calibrate screen using Adobe Gamma utility	Calibrate screen using ColorVision Spyder utility	
Color- Management Set up	Turn on Color Management in the Color Settings of Photoshop Elements and select between Screen or Print Optimized options			
	Activate camera color management			
	Activ	ate scanner color manage	ment	
	Perform Resolution test to determine optimum image resolution needed to maintain photo-quality output			
	Load 'canned' printer profile that came with print driver.	Use tone and color tests to modify 'canned' printer profile for all printer, ink and paper combinations.	Use ColorVision PrintFIX to create ICC profile for all printer, ink and paper combinations.	
	Select correct media or paper type			
Printer Set up	Choose paper size and orientation			
	Select Quality Print setting	Select same settings used for printer tests	Select same settings that were used for ICC profile creation	
	Check that 'canned' ICC profile is loaded Load PrintFIX profile			
	Adjust image tones and colors to suit			
Image	Set image resolution to optimum determined from the Resolution test			
Set up	Upscale small image if making big print (if necessary)			
		Apply Unsharp Mask filte	r	
Print Quality	Good	Better	Best	

It may be implemented using the built-in features contained in your camera, scanner and printer controls in conjunction with the color-management system in Photoshop Elements or it may take a more sophisticated form relying on customized profiles generated with specialist products from companies like ColorVision.

Either way the important thing to remember is that you need to start thinking about image management right from the time that you shoot or scan.

If you want to enjoy all the rewards of high quality output then it is critical that you employ a holistic approach to color management.

Just as is the case with factors like resolution and bit depth, decisions about color management need to be made at the point of capture, not left till it comes time to print.

390

FINELY CRAFTED OUTPUT

a	₩₩₩₩₩₩₩₩₩₩₩₩₩₩₩₩₩₩₩₩₩₩₩₩₩₩₩₩₩₩₩₩₩₩₩₩
Windows	Con
Ctrl + O	Shi
Shift + Ctrl + O	Co
Ctrl + W	C
Ctrl + S	-
Ctrl + Z	
Ctrl + Y	
Ctrl + T	
Shift + Ctrl + L	
Alt + Shift + Ctrl + L	
Shift + Ctrl + B	
Ctrl + U	
Ctrl + L	
Ctrl + A	
Ctrl + F	
Ctrl + R	
ctrl + H	
F1	
	D

Appendices

ADVANCED PHOTOSHOP ELEMENTS 5.0 FOR DIGITAL PHOTOGRAPHERS

Blend modes

The way that layers interact with other lavers in the stack is determined by the Blending mode of the upper layer.

By default the layer's mode is set to Normal, which causes the picture content on the upper layer to

obscure the picture parts beneath, but Photoshop Elements has many other ways (modes) to control how these pixels interact.

Called Blend modes, the different options provide a variety of ways to control the mixing, blending and general interaction of the layer content.

In the following Blend mode examples the picture has two layers - 'Top' (1) and 'Bottom' (2). In each example the Blend mode of the top layer has been changed to illustrate how the two layers blend together.

Multiplies the color of the bottom layer with the top layer producing an overall darker result. There is no image change where the top layer is white.

The pixels in the top layer are opague and therefore block the view of the bottom layer. Adjusting the opacity of the top layer will make it semitransparent causing it to blend with the top layer.

Combines the top layer with the Compares the color of the top bottom using a pattern of pixels. There is no effect if the top layer is at 100% opacity. Reduce the opacity to see the effect. The example is set to 80% opacity.

and bottom layers and blends the pixels where the top layer is darker than the bottom.

Darkens or 'burns' the image using the contents of the top layer. There is no image change where the top layer is white.

Uses the same approach as the Color Burn mode but produces a stronger darkening effect. There is no image change where the top layer is white.

Compares the color in the top and bottom layers and blends the pixels if the top layer is lighter than the bottom.

The opposite to the Multiply mode as it multiplies the inverse of the top layer with the bottom layer producing a much lighter image.

Makes the picture lighter using the top layer to dodge the bottom layer. There is no effect where the top layer is black.

Similar to the Screen mode but produces a much stronger lightening effect. There is no effect where the top layer is black.

Combines the effect of both the Multiply and Screen modes whilst blending the top layer with the bottom. There is no effect if the top layer is 50% gray.

The modes are grouped into several different categories based on the type of changes that they make (1).

The Layer Blend modes are located in the drop-down menu at the top left of the Layers palette (2). Blend modes can also be applied to the painting and drawing tools via a drop-down menu in the Tool's options bar (3).

Similar to the Overlay mode but produces a more subtle effect. There is no change where the top layer is 50% gray.

Uses the same approach as the Overlay mode but the change is more dramatic. Here the top layer is either Screened or Multiplied depending on its color. There is no effect where the top layer is 50% gray.

Combines the effects of both Color Burn and Color Dodge modes and applies the blend based on the color of the top layer. There is no effect where the top layer is 50% gray.

Similar to the Vivid Light mode but produces a more dramatic result. There is no effect where the top layer is 50% gray.

Blends the light colors in the top layer using the Lighten mode and blends the dark colors using the Darken mode. There is no effect where the top layer is 50% gray.

Creates a flat toned picture with limited colors and lots of posterization. The luminosity of the top layer is blended with the color of the bottom.

Displays the tonal difference between the contents of the two layers by subtracting the lighter pixels from either of the layers. This results in a dark and sometimes reversed image.

Similar to the Difference mode but produces less dramatic effects.

Combines the Hue (color) of the top layer with the Saturation (color vibrancy) and Luminance (tones) of the bottom layer.

Combines the Saturation (color vibrancy) of the top layer with the Hue (color) and Luminance (tones) of the bottom layer.

Combines the Hue (color) and Saturation (color vibrancy) of the top layer with the Luminance (tones) of the bottom layer.

Combines the Luminance (tones) of the top layer with the Saturation (color vibrancy) and Hue (color) of the bottom layer.

Faster Elements at no extra cost

Many dedicated Photoshop Elements users can get substantial speed gains from their existing, albeit modest, equipment by simply optimizing their computer and software so that it runs Elements more efficiently. So to make sure that you are getting the best from the bucks you have already spent, here is a collection of speed-enhancing tips for optimizing your machine.

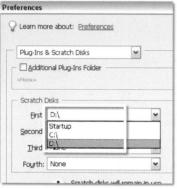

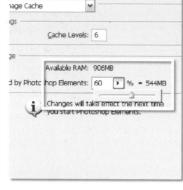

Ella Svistem :) NTF5 EM (C.) NTF5 (C.) FAT (C.) FAT kusage before defra,	Capacity 153 GB 553 GB 15 MB Intation:	Free Space 152 GB 17.13 GB 924 KB	% Free Space 99 % 22 % 5 %
::) NTFS EM (C:) NTFS D (Z:) FAT	153 GB 1.53 GB 15 MB	152 GB 17.13 GB	99 % 22 %
EM (C:) NTFS (C:) FAT	1.53 GB 15 M8	17.13 GB	22 %
0(2:) FAT	15 MB	100000000000000000000000000000000000000	
1		924 KB	5%
k usage before defra,	intation:		
usage after defragm	entation:		
Defragment	Pause	\$2	p Vie
100 mm			Defragment Pause Sc d files Contiguous files Unmovable files

Allocate a scratch disk >>

Photoshop Elements uses RAM memory to run itself, store picture information and to save undo and history state steps. Unless you are working with particularly small photo files it won't take too many editing changes before the RAM is completely used up. At this point Elements cleverly uses a portion of hard drive space as 'fake' RAM.

This is not a new idea. Most operating systems use the same approach (called Virtual Memory), to ensure that enough memory is available for running essential programs. Photoshop Elements calls this extra memory a 'Scratch Disk', and correctly setting up the disk will provide immediate speed and efficiency benefits.

To set your scratch disk, select Full Edit: Edit > Preferences > Plug-Ins & Scratch Disks. Then choose a drive that has the most free space from those listed in the pop-up menu. If you have other drives listed you can also allocate these as extra scratch drives.

Elements will make use of the drive listed first until it is full and then move to the next drive if even more memory is needed.

Most imaging professionals who regularly work with large files install a specific 'fast access' drive just to be used as a scratch disk by Photoshop Elements.

Set RAM percentage >>

Photoshop shares the RAM on your computer with the Operating System (Windows or OSX) and any other programs running at the same time. The percentage designated in the Photoshop Elements Memory & Image Cache preferences determines the upper amount of RAM memory that can be used by Elements. Most new users push this setting as high as possible, some as much as 90%, thinking that this will speed up the processing of their files.

Unfortunately if this allocation is set too high the operating system, as well as Elements, may need to move information from the fast RAM memory to the slower hard drive memory whilst processing. This action is called page swapping as the data is moved back and forth between the different memory spaces, and results in Photoshop Elements actually running slower.

If you experience slower performance when raising the percentage of RAM allocated to Elements, try reducing the total amount to 50–60% for systems with up to 2Gb, and 70% for computers with 4Gb of RAM.

Remember that you have to restart Photoshop Elements after making any memory changes to ensure that these alterations will take effect.

Defragment your drives >>

As images and files are saved and resaved to disk they tend to become fragmented. This means that rather than the whole file being saved in one continuous space on the hard drive the information is broken into pieces and stored in several locations (wherever there is empty disk space). Later when the file is reopened the document is reconstructed from each of the individual pieces. This file fragmentation slows down the opening and saving of files, as well as the running of programs such as Photoshop Elements, if they were fragmented when initially installed. You can overcome this problem by regularly defragmenting the drives you use to store your images and load your programs.

To defragment a drive in Windows XP:

Click Start > All Programs > Accessories > System Tools > Disk Defragmenter. Choose the drive to be defragmented and then select the Defragment button.

To defragment a drive in Mac OSX:

Despite the fact that the latest version of Mac OSX contains automatic defragmentation of files smaller than 20Mb most Apple users prefer to defrag their drives with third-party utilities.

Minimize History states >>

The Photoshop Elements Undo History palette is a great feature especially if you make mistakes as often as I do. Each successive edit is recorded as a step in the palette, enabling you to step back through the changes, gradually reversing your edits as you go. But such a great feature does come at a cost. Each step uses memory resources and, when you make complex changes to large files, you can imagine how much memory is used to store a collection of steps.

Thankfully Adobe provides a setting in the Edit > Preferences > General dialog that can be used to alter the number of History States (or undo steps) stored by your system.

By default it is set to 20, but if you find that Elements is running slowly after making a few editing changes then try reducing the number. Less History States does mean less opportunity to reverse editing changes, but this action frees up memory resources and can bring new life back to a slow running machine.

Multi-page documents >>

When working with large PSE or multi-page projects you can increase the speed of working by creating the project and then immediately saving and closing the file. After reopening, the images in the Photo Bin are thumbnail versions of each page, but only page 1 is fully open in the Editor. Other pages will open when you click the thumbnail or navigate to them. In this way you can limit the number of open pages when working on large books.

Levels: 6 Available RAM: 906MB coshop Elements: 60 > %

APPENDICES

Reduce the number of open files >>

It may seem like stating the obvious, but the more pictures you have open in Elements the more of the total resources of the machine is taken up, just maintaining each open file. When you add in the memory used to ensure undo or multiple History States for each file, it is not too hard to imagine that you will very quickly run out of RAM, forcing Photoshop Elements to use the much slower Scratch Disk space.

To speed up the processing, make sure that you only open (and keep open) files that are essential for your current editing task.

Scratch D	Disks	
Eirst:	D:\	~
Second:	Startup	
	D:1	
Fourth:	None	~

Scratch Disk versus Virtual Memory >>

Both Photoshop and the Windows XP operating system use hard drive space as extra 'fake' RAM. Adobe recommends that Photoshop Scratch Disks be positioned on a different drive to the one used by Windows for its Virtual Memory system. On most set ups the Windows swap file is stored on the start up or C drive.

To help with overall Photoshop and Windows performance, ensure that you don't position the Scratch Disk on the same drive. To set the location of your scratch disk select Full Edit: Edit > Preferences > Plug-Ins & Scratch Disks and choose the drive to use from the drop-down menu. Remember, don't select Startup or C drive unless you have no other choices. Alter the Image Cache setting >> Photoshop Elements uses a special image cache to help redraw highresolution images quickly. Instead of displaying all the information contained in these big files, Elements creates lower resolution versions of the photo that are then used to update the screen quickly.

You can elect to store from 1 – 8 cached versions of the photo. A value of 1 disables the caching. Higher values store multiple versions of the file, which in turn produces faster screen redraws. The default setting is 4, but inputting higher numbers will help speed up the redraw process.

When a high cache number is set, it will take longer to open files as Elements creates the low-resolution versions of the photo at this point. To alter the Image Cache setting select Full Edit: Edit > Preferences > Image Cache and enter a value from 1 to 8 in the Cache Levels text box.

Run Photoshop by itself >>

A simple measure to speed up Photoshop is to make sure that no other programs are running at the same time. Seemingly simple utilities such as iTunes, Outlook and Word all chew up memory and processor resources that could be used to drive Photoshop more efficiently.

The golden rule is that if the program is not essential for the editing task then close the software.

Before

Plug-ins

Since the first version of Elements Adobe provided the opportunity for third-party developers to create small pieces of specialist software that could plug into the program. These extra features extend the capabilities of the program and some of them have become so popular that they find themselves added into the program proper in the next release of the software.

Most plug-ins register themselves as extra options in the Filter menu, where they can be accessed just like any other Elements feature.

The Delta100 filter (1) from www. silveroxide.com is a great example of plug-in technology. Designed to reproduce the look of particular types of black and white film stock, the installed filter can be selected from the Silver Oxide group (2) of products in the Filter menu.

Plug-in options:

OS: Mac, Windows Cost: US\$179.00

e: www.autofx.com

396

Jargon buster

A>>

Aliasing The jaggy edges that appear in bitmap images with curves or lines at any angle other than multiples of 90°.

Anti-Aliasing This feature smooths out the sawtooth edges that appear on letters or shapes that have diagonal or circular sides. The anti-aliasing function in Elements softens around the edges of images to help make the problem less noticeable.

Aspect ratio This is usually found in dialog boxes concerned with changes of image size and refers to the relationship between width and height of a picture. The maintaining of an image's aspect ratio means that this relationship will remain the same even when the image is enlarged or reduced. Not maintaining the aspect ratio will result in the image being distorted – squished or stretched.

Automatically Tile Windows Automatically resizes open windows to fit the current work-space.

B>>

Background layer An image can only have one background layer. It is the bottom-most layer in the stack. No other layers can be moved or dragged beneath this layer. You cannot adjust this layer's opacity or its Blending mode.

Background printing A printing method that allows the user to continue working whilst an image or document is being printed.

Batch processing Refers to a function called Process Multiple Files. Batching applies a series of commands to several files at the one time. This function is useful for making the same changes to a folder full of images. In Elements this function is found under the File menu and is useful for converting groups of image files from one format to another.

Bit Stands for 'binary digit' and refers to the smallest part of information that makes up a digital file. It has a value of only 0 or 1. Eight of these bits make up one byte of data.

Bitmap or **'raster'** The form in which digital photographs are stored and is made up of a matrix of pixels.

Blend mode The way in which a color or a layer interacts with others. The most important after Normal are probably Multiply, which darkens everything, Screen, which adds to the colors to make everything lighter, Lighten, which lightens only colors darker than itself, and Darken, which darkens only colors lighter than itself. Both the latter therefore flatten contrast. Color maintains the shading of a color but alters the hue to the selected foreground color. Glows therefore are achieved using Screen mode, and Shadows using Multiply.

Brightness range The range of brightnesses between shadow and highlight areas of an image.

Burn tool Used to darken an image, can be targeted to affect just the Shadows, Mid tones or Highlights. Opposite of the Dodge tool. Part of the toning trio, which also includes the Sponge.

Byte The standard unit of digital storage. One byte is made up of 8 bits and can have any value between 0 and 255. 1024 bytes are equal to 1 kilobyte. 1024 kilobytes are equal to 1 megabyte. 1024 megabytes are equal to 1 gigabyte.

C>>

Canvas Elements makes a distinction between the canvas, upon which pictures and other content is placed, and the image content itself.

Caption Captions are another way to 'title' your photos beyond the standard file name and can be added using the Properties pane in Elements.

Catalog When you import pictures into the Photo Browser Elements creates a database of the images and their details. This database is called a catalog.

CCD or **Charge Coupled Device** Many of these devices placed in a grid format comprise the sensor of most modern digital cameras.

Clone Stamp or *Rubber Stamp tool* Allows a user to copy a part of an image to somewhere else. It is therefore ideal for repair work, e.g. unwanted spots or blemishes. Equivalent to Copy and Paste in a brush.

Collections A collection is another way that you can order and sort your photos in Elements.

Color mode The way that an image represents the colors that it contains. Different color modes include Bitmap, RGB and Grayscale.

Compression Refers to a process where digital files are made smaller to save on storage space or transmission time. Compression is available in two types – lossy, where parts of the original image are lost at the compression stage, and lossless, where the integrity of the file is maintained during the compression process. JPEG and GIF use lossy compression whereas TIFF is a lossless format.

D >>

Defringe The defringe command removes the contrasting edge pixels from picture parts that have been cut or extracted from their backgrounds.

Digitize This is the process by which analog images or signals are sampled and changed into

digital form.

Dodge tool For lightening areas in an image. See also Burn tool.

Downsample To reduce the size of a digital photo. Most methods for achieving this result remove unwanted pixels in the process.

DPI or **Dots per inch** A term used to indicate the resolution of a scanner or printer.

Dynamic range The measure of the range of brightness levels that can be recorded by a sensor.

E >>>

Enhancement A term that refers to changes in brightness, color and contrast that are designed to improve the overall look of an image.

Export The Export feature in the Photo Browser is designed to provide a quick easy automated way to create and save copies of multi-selected pictures from inside the workspace.

F>>

Feather The Feather command softens the transition between selected and non-selected areas of a photo.

File format The way that a digital image is stored. Different formats have different characteristics. Some are cross-platform, others have inbuilt compression capabilities or a limited color range.

Filter In digital terms a filter is a way of applying a set of image characteristics to the whole or part of an image. Most image editing programs contain a range of filters that can be used for creating special effects.

Front page Sometimes called the Home or Index page, refers to the initial screen that the viewer

sees when logging onto a website. Often the name and spelling of this page file is critical if it is to work on the web server. Consult your ISP staff for the precise name to be used with your site.

G >>

Gamma The contrast of the mid tone areas of a digital image.

Gamut The range of colors or hues that can be printed or displayed by particular devices.

Gaussian Blur When applied to an image or a selection, this filter softens or blurs the image.

GIF or **Graphic Interchange Format** This is an indexed color mode format that contains a maximum of 256 colors that can be mapped to any palette of actual colors. It is extensively used for web graphics, buttons and logos, and small animated images.

Grayscale A monochrome image containing just monochrome tones ranging from white through a range of grays to black.

Group You can group photos with similar content into a single Image Stack in the Photo Browser workspace.

Grow The Select > Grow feature increases the size of an existing selection by incorporating pixels of similar color and tone to those already in the selection.

H >>

Histogram A graph that represents the tonal distribution of pixels within a digital image.

History Adobe's form of Multiple Undo.

Hot linked This term refers to a piece of text, graphic or picture that has been designed to act

as a button on a web page. When the viewer clicks the hot linked item they are usually transported to another page or part of a website.

HTML The Hyper Text Mark Up language is the code used to create web pages. The characteristics of pages are stored in this language and when a page file is downloaded to your computer the machine lays out and displays the text, image and graphics according to what is stated in the HTML file.

Hue Refers to the color of the light and is separate from how light or dark it is.

|>>

Image layers Images in Elements can be made up of many layers. Each layer will contain part of the picture. When viewed together all layers appear to make up a single continuous image. Special effects and filters can be applied to layers individually.

Indexed color The Indexed Color mode can support up to 256 different colors and is the default Color mode for the GIF file format.

Interpolation This is the process used by image editing programs to increase the resolution of a digital image. Using fuzzy logic the program makes up the extra pixels that are placed between the original ones that were generated at the time of scanning.

ISP The Internet Service Provider is the company that hosts or stores web pages. If you access the web via a dial-up account then you will usually have a portion of free space allocated for use for your own site; others can obtain free (with a small banner advert attached) space from companies like www.tripod.com.

1>>

JPEG A file format designed by the Joint Photographic Experts Group that has inbuilt lossy compression that enables a massive reduction in file sizes for digital images. Used extensively on the web and by press professionals for transmitting images back to newsdesks worldwide.

JPEG2000 The newest version of JPEG is called JPEG2000 and uses wavelet technology to produce smaller (by up to 20%) sharper files with less artifacts than traditional JPEG.

L>>

Layer opacity The opacity or transparency of each layer can be changed independently. Depending on the level of opacity the parts of the layer beneath will become visible. You can change the opacity of each layer by moving the Opacity slider in the Layers palette.

LCD or *Liquid Crystal Display* A display screen type used in preview screens on the back of digital cameras, in laptop computers and more and more as replacement desktop screens.

Liquify A tool that uses brushes to perform distortions upon selections or the whole of an image.

M >>

Marquee A rectangular selection made by clickdragging to an opposite corner.

Maximize mode The Maximize mode is one of the many ways that open pictures can be viewed in Photoshop Elements. Selecting the option from the Window > Images menu switches the view from Auto Tiled mode to a single image surrounded by the gray work area background.

Megapixel One million pixels. Used to describe the resolution of digital camera sensors.

Metadata Metadata is a variety of non-image information about your picture that is attached to the photo file. Some of the detail is created at time of capture or creation and other parts are added as the file is edited or enhanced.

N >>

Navigator In Elements, a small scalable palette showing the entire image with the possibility of displaying a box representing the current image window frame. The frame's color can be altered; a new frame can be drawn (scaling the Image window with it) by holding the Command/Ctrl keys and making a new marquee. The frame can be dragged around the entire image with the Hand tool. The Zoom tools (Mountain icons) can be clicked, the slider can be dragged, or a figure can be entered as a percentage.

Noise Noise is the digital equivalent of the grain that appeared in photos taken with high ISO films. Noisy photos or those images that contain a lot of random speckled pixels instead of smooth tones generally result from long exposures times or the use of a high ISO or sensitivity setting. The Reduce Noise filter in Elements can be used to help correct this picture problem.

0>>

Optical resolution The resolution that a scanner uses to sample the original image. This is often different from the highest resolution quoted for the scanner as this is scaled up by interpolating the optically scanned file.

Optimization for Web The best way to optimize your photos for web use is via the Save for Web option. This feature provides before and after previews of the compression process as well as options for compression and reducing the dimensions of your pictures, all in the one dialog. APPENDICES

Options bar Long bar beneath the menu bar, which immediately displays the various settings for whichever tool is currently selected. Can be moved to other parts of the screen if preferred.

P>>

Palette A window that is used for the alteration of image characteristics: Options palette, Layers palette, Styles palette, Hints palette, File Browser, History, etc. These can be docked together vertically around the main image window or if used less frequently can be docked in the Palette Well at the top right of the screen (dark gray area).

Palette Bin The Palette Bin stores the Elements palettes and sits to the right of the main screen in the Editor workspace.

Photo Browser The Photo Browser or Organizer workspace is the main picture viewing, sorting and management area in Elements. Pictures can be imported into the Browser using the Get Photos command, viewed side by side with the Photo Compare command and seen as a slide show by selecting the Photo Review option.

Pixel Short for picture element, refers to the smallest image part of a digital photograph.

Q >>

Quantization Refers to the allocation of a numerical value to a sample of an analog image. Forms part of the digitizing process.

R >>

RGB All colors in the image are made up of a mixture of red, green and blue colors. This is the typical mode used for desktop scanners, painting programs and digital cameras.

S >>

Sponge tool Used for saturating or desaturating part of an image that is exaggerating or lessening the color component as opposed to the lightness or darkness.

Status bar Attached to the base of the window (Mac) or beneath the window (PC). Can be altered to display a series of items from Scratch Disk usage and file size to the time it took to carry out the last action or the name of the current tool.

Stock A printing term referring to the type of paper or card that the image or text is to be printed on.

Swatches In Elements, refers to a palette that can display and store specific individual colors for immediate or repeated use.

T >>

Thumbnail A low resolution preview version of larger image files used to check before opening the full version.

TIFF or **Tagged Image File Format** A file format that is widely used by imaging professionals. The format can be used across both Macintosh and PC platforms and has a lossless compression system built in.

W >>

Warp tool A means of creating differing distortions to pieces of text such as arcs and flag ripples.

Keyboard shortcuts

General >>

Action	Windows (ver. 5.0)	Macintosh (ver. 4.0)
Open a file	Ctrl + O	Command + O
Open file browser	Shift + Ctrl + O	Shift + Command + O
Close a file	Ctrl + W	Command + W
Save a file	Ctrl + S	Command + S
Step backward	Ctrl + Z	Command + Z
Step forward	Ctrl + Y	Command + Y
Free Transform	Ctrl + T	Command + T
Adjust Smart Fix	Shift + Ctrl + M	Command + Opt + M
Auto levels	Shift + Ctrl + L	Shift + Command + L
Auto contrast	Alt + Shift + Ctrl + L	Option + Shift + Command + I
Auto Color Correction	Shift + Ctrl + B	Shift + Command + B
Auto Red Eye Fix	Ctrl + R (ver. 4.0 only)	-
Auto Smart Fix	Alt + Ctrl + M	Command + Opt + M
Hue/Saturation	Ctrl + U	Command + U
Levels	Ctrl + L	Command + L
Remove Color	Shift + Ctrl + U	Shift + Command + U
Select All	Ctrl + A	Command + A
Apply last filter	Ctrl + F	Command + F
Show/Hide rulers	Shft + Ctrl + R	Command + R
Show/Hide selection	Ctrl + H	Command + H
Help	F1	Command + ?
Print Preview	Ctrl + P	Command + P
Exit Elements	Ctrl + Q	Command + Q
Deselect	Ctrl + D	Command + D
Feather a selection	Alt + Ctrl + D	Option + Command + D
<i>Convert to Black and White</i>	Alt + Ctrl + B	-

APPENDICES

Viewing >>

Action	Windows	Macintosh
Fit image on screen	Ctrl + 0	Command + 0
100% magnification	Alt + Ctrl + 0	Option + Command + 0
Zoom in	Ctrl + +	Command + +
Zoom out	Ctrl + -	Command + -
Scroll image with Hand tool	Spacebar + drag mouse pointer	Spacebar + drag mouse pointer
Scroll up or down 1 screen	Page Up or Page Down	Page Up or Page Down
Scroll 1 page to left	Ctrl + Page Up	Command + Page Up
Scroll 1 page to right	Ctrl + Page Down	Command + Page Down

Selection/Drawing tools >>

Action	Windows	Macintosh
Add to an existing selection	Shift + Selection tool	Shift + Selection tool
Subtract from an existing selection	Alt + Selection tool	Option + Selection tool
Constrain marquee to square or circle	Shift + drag Selection tool	Shift + drag Selection tool
Draw marquee from center	Alt + drag Selection tool	Option + drag Selection tool
Constrain Shape tool to square or circle	Shift + drag Shape tool	Shift + drag Shape tool
Draw Shape tool from center	Alt + drag Shape tool	Option + drag Shape tool
Exit Cropping tool	Esc	Esc
Enter Cropping tool selection	Enter	Return
Switch magnetic lasso to lasso	Alt + drag tool	Option + drag tool
Switch magnetic lasso to polygonal lasso	Alt + drag tool	Option + drag tool
Switch from Selection to Move tool	Ctrl (except Hand tool is selected)	Command

404

Painting	>>
----------	----

Action	Windows	Macintosh
Change to eyedropper	Alt + Painting or Shape tool	Option + Painting or Shape tool
Cycle through Blending modes	Shift + or -	Shift + or -
Set exposure or opacity for painting	Painting tool + Number key (%= number key × 10)	Painting tool + Number key (%= number key × 10)
Display Fill dialog box	Shift + Backspace	Shift + Delete
Perform Fill Layer with background color	Ctrl + Backspace	Command + Delete
Perform Fill with foreground color	Alt + Backspace/Delete	Option + Backspace/Delete

Type editing >>

Action	Windows	Macintosh	
Select word	Double-click	Double-click	
Select line	Triple-click	Triple-click	

Photo Browser (Organizer) workspace >>

Action	Windows (ver. 5.0)	Macintosh
Get Photos > From Camera	Ctrl + G	_ *
Get Photos > From Files and Folders	Shift + Ctrl + G	-
Go to Standard Editor	Ctrl + I	_
Display Color Settings dialog	Ctrl + G	-
View Photos in Full Screen	F11	atoria a Troffatoria
Compare photos side by side	F12	-

APPENDICES

Elements/Photoshop feature equivalents

	· ·	
Activity	Elements	Photoshop
Lighten shadow areas in an image	Fill Flash feature (ver. 1.0/2.0), Shadows/Highlights (ver. 5.0/4.0/3.0) Adjust Color Curves	<i>Curves and Shadow/ Highlight feature</i>
Darken highlight areas in an image	Backlighting feature (ver. 1.0/2.0), Shadows/Highlights (ver. 5.0/4.0/3.0) Adjust Color Curves	Curves and Shadow/ Highlight feature
Transformation	Image > Transform	Edit > Transform
Rotate layer	Image > Rotate > Layer 90° left	<i>Edit > Transform > Rotate 90° CCW</i>
Rotate canvas	Image > Rotate > 90° left	Image > Rotate Canvas > 90° CW
Resize image	Image > Resize > Image Size	Image > Image Size
Resize canvas	Image > Resize > Canvas Size	Image > Canvas Size
Batch dialog	File > Batch Processing or File > Process Multiple Files	File > Automate > Batch
Web Photo Gallery	<i>File > Create Photo Galleries or Create> Photo Galleries</i>	File > Automate > Web Photo Gallery
Contact Sheet	File > Print Multiple Photos > Contact Sheet or File > Process Multiple Files	File > Automate > Contact Sheet II
Picture Package	File > Print Mulitple Photos > Picture Package or File > Process Multiple Files	File > Automate > Picture Package
Auto Levels	Enhance > Auto Levels	Image > Adjustments > Auto Levels
Auto Contrast	Enhance > Auto Contrast	Image > Adjustments > Auto Contrast
Auto Color Correction	Enhance > Auto Color Correction	Image > Adjustments > Auto Color
Hue/Saturation	Enhance > Adjust Color > Hue/ Saturation	Image > Adjustments > Hue/Saturation
Color Variations	Enhance > Adjust Color > Color Variations	Image > Adjustments > Variations
Brightness/Contrast	Enhance > Adjust Brightness/Contrast > Brightness/Contrast	lmage > Adjustment > Brightness/Contrast
Levels	Enhance > Adjust Brightness/Contrast > Levels	Image > Adjustments > Levels

ctrl+0

Index

d Ctrl + Z Ctrl + Y Ctrl + T rm Shift + T Shift + T Alt + Sl rast Shift + T rast Shift + T Ctrl + TCtrl + T ADVANCED PHOTOSHOP ELEMENTS 5.0 FOR DIGITAL PHOTOGRAPHERS

12-bit capture, 19 16-bit mode, 21–2, 43 24-bit color (8 bits per channel), 19 48-bit color (16 bits per channel), 19

ACR see Adobe Camera Raw (ACR) Add Blank Page option, 316–18 Add graphics for Slide Show Editor, 333 Add Noise filter, 135, 147 Add Page Using Current Layout option, 316–18 Addition: lavers, 115 pages, 316-18 photos, 314-15 selections, 106 Adjust Color Curves control, 11-12, 186-8 Adjust Sharpness filter, 153-4, 162-3 Adjust Smart Fix command, 97 Adjustment layers, 114 Adjustment layers masks, 119-20 Adobe Camera Raw (ACR) interface, 64-7, 69-71, 76 Adobe Gamma, screen calibration, 368–9 Adobe Photo Downloader (APD), 61-3 Adobe/sRGB, 367 Advanced dialog for Adobe Photo Downloader, 62-3 Align option, 322 Alignment of text, 276 Angle controls, 270 Animated buttons, 260 Animated headings, 260-1 Animation in websites, 253 APD see Adobe Photo Downloader Apertures: depth of field panoramas, 227 digital shooting, 23-4 Arrange option, 323 Art paper, 380 Artworks and effects palette, 146, 318-21 Assembly of websites, 264-5 Assets protection, 88 Auto Color Correction command, 102, 240 Auto Contrast function, 8, 102 Auto dust removal, 47 Auto Face Tagging, 82 Auto fixes for exposure in panoramas, 237

INDEX

Auto Levels function, 8, 102 Auto photo stacking, 93–4 Auto Red Eye Fix command, 97 Auto Smart Fix command, 97 Auto stack whilst downloading, 93 Auto tonal control, 69 Auto white balance, 32 Automatic editing: Elements, 96, 98 Slide Show Editor, 333 Automatic white balance settings, 33

Backgrounds: free form photo layouts, 326-8 layers, 115 matting for websites, 262-3 Backup: Backup/Copy files command, 88 creation, 89-90 frequency, 90 glossary, 89–90 new features, 90 Barrel distortion, 198–9 Basic Dialog for Adobe Photo Downloader, 61 Bicubic Smoother resampling option, 389 Bits comparison, 19 Black and white: and color, 142-3 prints, 378 see also White balance Blemishes, 210–13 Blend modes, 117, 269, 392-3 Book publishing, 339-40 Borders: shapes as, 284 techniques, 143-9 Brightness: panoramas, 233-5 tonal adjustments, 68 Brown, Russell, 124 Brush: changing, 271-2 characteristics, 269-70 creation, 272-3 Bulk Red Eye fixing, 99

Burning-in: advanced techniques 127-8, 131 tools 123 Burning-in, 127-8, 131 Buttons on webpages, 253, 259-61 Calibration, printers, 373-7 Cameras: color-managed workflow, 363-4 defaults for Adobe Camera Raw interface, 65 exposure for RAW format capture, 60 noise, 48 positioning, 221-2 RAW files data, 37 raw-enabled, 57-8 support, 222-4 Canon workflow, 58 Captioning, 80 Capture workflows, RAW format, 59-60 Cataloged photos stacking, 94 CD jacket, 344 Change to old darkroom technique, 200-1 Clear Frame option, 313 Clear Photo option, 313 Clone Stamp tool, 195, 210, 212, 231 Collections: adding photos, 83 command, 81-2 groups, 84 Color: balance for panoramas, 238-40 black and white conversion feature, 121, 125-6 black and white two layer erase technique, 142-143 cast correction, 46 casts, 9, 31 consistency, 360-1 depth, 18, 43-4 depth for RAW format capture, 60 desaturation files, 122-3 discrete, 18 faded images restoration, 170-2 interpolation, 36 management, 362-7 noise reduction, 70

hand coloring, 174-6

Polaroid effect, 161 printers, 374-5 printing, 348-50 reduction, 296-7 regeneration, 49 saturation, 27-8 Variations command, 240 white light, 30 workflow management, 366 Color Curves function, 11-12 Color Vision Spyder, screen calibration, 370-1 ColorVision PrintFIX, 376–7 Combination of images, 191-3 Compare Photos Side by Side command, 85 Compression and images quality, 258-9 Contact sheets, 358 Contrast: control, 26-7, 45 RAW format capture, 60 tonal adjustments, 68 Unsharp Mask filter, 162–3 Conversion process, Raw files, 72–5 Convert then Edit approach, 56–76 Converted files outputting, Raw files, 70-2 Cropping, 7-8 Cross-processing effects, 172-3 Curves feature, 186 Customization: Adobe Camera Raw interface, 65 of shapes, 280-1, 285 Date View command, 4, 85 Defragmentation, 394 Deletion of pages, 316-18 Depth of field (DOF): darkroom techniques on desktop, 176-80 panoramas, 226-7, 236 Desaturation: color file, 122-3 darkroom techniques on desktop, 168-9 Polaroid effect, 160 Diffuse glow filter, 206, 208 Diffusion printing, 156-7 Digital technologies: camera workflows, 40

ICE technology, 47 ROC cameras, 49 shooting techniques, 22–4 Discrete colors (levels), 18 Distance from subject for DOF in panoramas, 227 Distortion: free form photo layouts, 314 lens, 198-9 perspective, 167 Distribute option, 323 Dodging, 123, 127-8, 131 DOF see Depth of field Dots in printing, 349-50 'Dots Per Inch' (dpi), 15 Downloading organization, 78-9 Dpi see 'Dots Per Inch' Drawing tools, 268 Drawn symbols, 294 Dreamy effect, 208-9 Drop Shadow options, 180-4 Dropped Shadow text box, 305-6 Duplicate files storage, 90 Dust, 47, 189-90 DVD: jacket, 344 VCD/DVD with menu project, 335-6 Dye sublimation printers, 352-3 Editing: automatic, 96-9 manual, 103-4 multiple files, 99 non-destructive, 124 pages 316-18 photos 314-16 semi-automatic 100-2 versioning, 91 Elements: faster running programs, 394-5 Photo Galleries tool, 253-6 Photoshop feature equivalents, 406 printing, 355-7 Enhance command, 123 Enhancement of poorly exposed images, 132

409

INDEX

Eraser tool, 157 Erasure in tonal layers, 129–30 Exposure: compensation, 24–5 control, 23–4 digital shooting, 22 panoramas, 225, 237–40 poorly exposed pictures, 134 tonal adjustments, 68 Eyes, 207, 214 see also Red Eye fixing

Fade settings, 270 Fade to white in presentation backgrounds, 304 Faded images restoration, 170-2 Faster running for Elements, 394-5 Feather tool, 179, 232 Files, location, 86–7 Fill flash effects, 188 Fill layers: description, 114 masks, 119-20 Film scanners, 41-2 Find option in collections, 87 Fit Frame to Photo option, 313 Flat pictures in spinning movies conversion, 244–7 Flipbooks, 345 Focal length in depth of field in panoramas, 227 Focus in panoramas, 226 Font families and styles, 276 Frames: alignment, arrangement and distribution, 322-3 frame-by-frame control, 25-6 layers, 115, 145-6, 308 in Polaroid effect, 161 Freckles, 209 Free Rotate Layer option, 314 Free Transform tool, 111, 314 Frequency of backup, 90 Full Edit workspace, 101, 103 Full Editor, 5

Gaussian Blur filter, 157, 176, 179 General purpose paper, 380 Get Photos command, 4

GIF (Graphics Interchange Format) format, 258 Global enhancement, 20 Glossary, 89-90, 398-402 Glossy photographic paper, 380 Gradient Editor, 293 Gradient maps, 142, 197 Grain filter, 148 Graphics, 326-8 Graphics, tablets, 294 Grayscale masks, 121-2, 124-5, 144-5 Greetings card project, 343 Grouping of photos, 83 'Groups with previous' masks, 120 Hand coloring, digital, 174-6 Hardness settings, 270 Headings for websites, 253, 260-3 Healing Brush tool, 210, 213 High bit mode, 20-2 High-key pictures, 196-7 High-resolution mosaics, 241 Highlights: adjustment, 44 capture, 45-6 poorly exposed photos, 135-6 Histograms: Adobe Camera Raw interface, 64 tones, 27

History (faster running of Elements), 395 Hue Jitter controls, 270 Hue/Saturation control, 136–7 Images:

Adobe Camera Raw interface settings, 65 cache settings, 395 capture, 15–16 combination, 191–3 compression and quality, 258–9 data for RAW files, 37 editing program, color-managed workflow, 365–6 Elements Photo Galleries tool, 253 layers, 114 layers screening, 132–4 professional outsourcing, 385–6

guality and compression, 258-9 Raw files, 37 resolution/printer resolution, 354-5 sharpness, 27-8 stacks, 92-4 in text, 286-7, 288-90 websites, 253 Importing: multi-selections, 63 photos, 6-7 In-camera picture details, 78 Inks: for black and white prints, 378-81 mottling in Polaroid effect, 160-1 Inkjet printers, 350-1 Input resolution, 15 Interactive website styles, 254 Interpolation: color, 36 shoot small print big, 387 ISO RAW format capture, 60

'Jaggies', 275 Jargon buster, 398–402 Java Applet viewer, 247 JPEG (Joint Photographic Experts Group) format, 36, 258 Justification of text, 276

Kaleidoscopic images, 300–2 Keyboard shortcuts, 403–5 Kodak Gallery, 340–1 Kodak Photo book, 325

Large preview of Adobe Camera Raw interface, 66 Laser printers, 352 Lasso tool, 168 Layers: black and white and color, 142 image changes, 114–17 masks, 119–20 Layouts: editing, 309–14 printing, 324–5 Leading text, 277 Lens Flare filter, 196 Lens problems, 198–9 Levels adjustments, 11 Life expectancy, prints, 382-4 Light sources: color casts, 31 white balance settings, 32-3 Lightening soft-edges for presentation backgrounds, 304 Lighting adjustment function, 11 Lith printing, 164–6 Loading selections, 109 Local enhancement, 21 Location: files. 86-7 metadata, 87-8 Logos 294-5 Luminance smoothing, 70

Magic Selection Brush command, 108-9 Magic Wand tool, 140 Magical selections, 108-9 Magnetic tool, 168 Manipulation of layers, 116 Manual editing, 103-4 Map View, 4 Marquee option, 113 Mask mode Selection Brush command, 107 Masking techniques, 118-26 Matt/satin paper, 380 Metadata location, 87-8 Modification of selections, 110 Monitors for color-managed workflow, 364-5 Monochrome inks, 79-80, 380-1 Monochromes, tinted, 136 Montages: darkroom techniques on desktop, 193-6 text, 291-3 Month by month project, 346 More options palette, 270 Motion Blur option, 154 Moving of pages, 316–18 Multi-page documents, 395 Multi-reflection images, 300 Multi-sampling, 44–5

411

INDEX

Multi-selections: editing, 99 importing, 63 Multimedia slide shows, 333 Multiple files processing, 98 Multiple prints, 359 Music and narration for Slide Show Editor, 334 Mypublisher, 342

Naming, 80–1 Neutral grays, 379 Nikon workflow, 58 Noise: cameras, 48 RAW format capture, 60 reduction, 48 Non-destructive techniques: editing, 124 retouching, 216 textures, 149

Offset lithography, 353 Old look, change to, 200–1 On-line publishing, 340–2 Open files, 395 Organization: downloading, 78–9 Photo Browser, 78–9 photos, 78 Organizer function, 4 Orientation, 6–7

Pages: adding, moving and deleting 316–8 printing and publishing, 336–8 Painterly photos, 202–4 Painting tools, 268 Pan and Zoom, Slide Show Editor, 333 Pano2Exe utility, 246 Panoramas: movies, 244–7 printing, 242–3 tripod heads, 223 workflow, 248 zoom, 226

Paper: black and white prints, 378-81 Polaroid effect, 161 Paragraph text, 275 Permanence in printing, 381–5 Perspective, 166-7, 314 Photo books, 337-8 Photo Browser view command, 84 Photo Creations: access, 331 command, 5 options, 331 projects, 308, 333-46 Photo Downloader, 6–7 Photo Galleries option, 254 Photo Layout feature, 308, 309-14 Photomerae, 218-20, 244 Photoshop, Elements feature equivalents, 406 Photoworks, 341-2 Pictrography, 353 Pictures: addition to shapes, 282-3 month by month project, 346 text, 286 Pincushion distortion, 198–9 Pixels, 14, 16-17 Plug-in options, 396-7 Polaroid transfer effect, 158-61 Poorly exposed images enhancement, 132 Pop art posters, 203-4 Position Photo in Frame option, 313 Positioning, camera, 221-2 Posterized pictures, 298-9 Posters of pop art, 203-4 Powerpoint slides, 305-6 Precision control of selection size, 113 Presentation backgrounds, 303-6 Preview, websites, 256 Previous conversion of Adobe Camera Raw interface, 65 Print function, 5 Print preview dialog, 356-7 Printer resolution/images resolution, 354-5 Printing: basics, 348-51

412

color management, 362 diffusion printing 156-7 Elements, 355-7 layouts, 324-5 panoramas, 242-3 printers, calibration, 373-7 publishing, 336-8 sRGB/Adobe RGB, 367 workflow, 390 Prints, life expectancy, 382-4 Professional outsourcing of images, 385-6 Protection of assets, 88 Publishing books, 339-40 online, 340-2 printing, 336-8

Quick Fix Editor, 5, 100, 101 Quick reorder, Slide Show Editor, 334 Quicktime movie format, 245

RAM percentages, 394 RAW format: advantages, 39 control, 35 dialog, 38 processing, 36-8, 56-76 Raw files: Adobe Photo Downloader, 61 camera/card reader, 61-2 conversion process, 72-5 description, 37 existing archive/disk/drive, 63 outputting converted files, 70-2 plugins, 76 raw-enabled cameras, 57-8 Red eye fixing see Auto Red Eye Fix command Reduction of color, 296–7 Removal of photos, 314-15 Renaming, 80-1 Replace Photo option, 313 Replacement of photos, 313, 314-15 Resolution: basics, 14-16 printers, 374

Raw format capture, 59 scanners, 42–3 Retouching, non-destructive, 216 Ring flash shadow, 184, 185 'Rollovers' (animated buttons), 260 Rotate 90° Right or Left option, 313 Roundness settings, 270 Rule of thirds, 221

Saturation: RAW format capture, 60 tonal adjustments, 69 Saturation adjustment, 28 Saving, 10, 109 Scale to Fit option, 356 Scale options: to fit. 356 proportionately, 314 Scanners: color-managed workflow, 363-4 description, 41-3 scanning workflow, 50 Scatter settings, 270 Scrapbooks, 336-8 Scratch disk, 394, 395 Scratches, 47, 189-90 Screens: calibration with Adobe Gamma, 368-9 calibration with Color Vision Spyder, 370-1 color-managed workflow, 364-5 Select and Tone, 139-40 Selection Brush tool, 106-7, 118 Selections: layer masks, 120 loading, 109 modification, 110 saving, 109 Selection Brush command, 106–7 size precision control, 113 tone, 127-8 Semi-auto full edit features, 101 Semi-automatic editing, 100 Sepia effect, 137, 200 Shadows:

adjustment, 44

Shadows (continued) capture, 45-6 poorly exposed pictures, 135-6 shadow/highlights feature, 188 tonal adjustments, 68 Shape layers, 115 Shapes, 280-5 Sharedink, 341 Sharing of websites, 254 Sharpening: Adobe camera Raw interface, 70 basics, 9-10, 150-1 capture workflow for Raw files, 60 image changes, 150-1 sharpness adjustment, 29 sharpness of printers, 375-6 Shoot small print big, 387-9 Shooting problems, 51-2 Shortcuts using keyboard, 403-5 Shutters, 23-4 Simple borders, 143 Simple type, 274 Simulated tones in printing, 351 Size of selections, 113 Skew option, 314 Skin: retouching, 215 tones, 207 Slide Show Editor, 332–4 Slide shows for websites, 263-4 Snapfish, 342 Speciality paper, 380 Spinning movies conversion of flat pictures, 244–7 Spinning panoramas movies, 244-7 Split toning, 139-40 Spot healing brush, 211 SRGB/Adobe RGB, 367 Stacking cataloged photos, 94 Storage of duplicate files, 90 Straightening, 7-8 Styles: layers, 116 styled text, 333 text layers, 277-9 Subtraction of selection, 106 Support for cameras, 222-4

Symbols, 294 Tagging, 81 Tags command, 81 Temperature (color selection), 66 Text: alignment, 276 changes, 275 graphics, 274-6 images, 286-7, 288-90 justification, 276 layers, 114 layers styles, 277-9 leading, 277 montages, 291-3 pictures, 286 websites, 253 Textures, 147, 149 Themes system, 308 Thermal wax transfer printing, 353 Threshold command, 294 TIFF format, 36 Timing of panoramas, 229 Tints: Adobe camera Raw interface, 67 hue/saturation control, 138 monochromes, 136 Tonal adjustments, raw files, 68-9 Tones: basics, 8-9, 11-12 enhancement, 132-4 layers erasure, 129-30 printers, 373-4 printing, 348-50 selections, 127-8 techniques, 137 Transformation selections, 111-12 Transitions in Slide Show Editor, 333 Tripod heads, 223, 230 Two-layer erase technique, 141 Type tools controls, 274

Unsharp Mask (USM) filter, contrast, 162–3 Unsharp masking, 151–2 Uploading of websites, 266 Upscaling techniques, 388 USM *see* Unsharp Mask

414

VCD/DVD with Menu project, 335-6, 345 Version Set Photos command, 92 Versioning: edits, 91 Photoshop Elements, 91-2 Vertical panoramas, 240 View changing, 84-5 View Photos in Full Screen command, 85 Viewing, layers, 116 Virtual memory, 395 Virtual reality (VR) tripod heads, 223, 230 Visual surgery, 207 VR see Virtual reality Warhol, Andy, 298 Watercolour painting, 203-4 Web galleries, 254 Web pages: button creation, 253, 259-61 creation, 252 Java Applet viewer, 247 Websites: animation, 254 assembly 264-5 assets, 253 for book, 3 building, 251-2 headings 253, 260-3 interactive, 254 photo optimization, 257-8 saving options 254 settings, 256 sharing options, 254 slide shows, 263-4 styles, 250, 253-5 web galleries, 254 White balance: Adobe Camera Raw interface, 66-7 automatic, 33 control, 19-30 customization, 34 light sources, 32–3 panoramas, 228 RAW format capture, 60 White Balancing Bracketing option, 33

WIR (Wilhelm Imaging Research) certification program, 384–5 Workflows: Basic Elements, 10–11 Canon cameras, 58 digital camera, 40 Panoramas, 248 printing, 390 RAW format capture, 59–60 scanning, 50

Zoom for panoramas, 226

415

Love Photoshop Elements?

Do you need more information on the latest and greatest changes in Photoshop Elements? Do you crave extra tips and techniques? Do you want all these things but presented in a no nonsense understandable format?

Philip Andrews is one of the world's most published photography and imaging authors and with the following titles he can extend your skills and understanding even further.

Adobe[®] Photoshop[®] Elements 5.0 A-Tools and features illustrated ready reference

'...with Adobe Photoshop Elements A–Z at your side you will be up to speed in no time.' Don Day, Photoshop Elements QE, Adobe Systems Inc.

- Discover and master the tools and features in Photoshop Elements 5.0 with this comprehensive, beautifully illustrated full color guide
- Save valuable time when trying to understand a function or tool simply dip in and find the listing in this easy-to-use A–Z format
- Learn tool and feature tips and best practice from a professional photographer and Elements guru!
- Dedicated website full of resources and video tutorials www.elementsa-z.com ISBN: 0 240 520610 – \$29.95/ £17.99 – Paperback – 256pp

Adobe[®] Photoshop[®] Elements 5.0 A visual introduction to digital imaging

'...an unrivalled introduction to the budget imaging package, and an excellent overview of digital imaging.' What Digital Camera magazine, UK

- Save valuable time with this successful, jargon-free introduction to digital imaging
- Real-life examples
- Fully updated to cover all the new Elements 5.0 features
- All new section on file management with the Photo Browser
- Clearly shows you how to put each technique into practice
- Full color, high quality illustrations visualize what can be achieved with this successful package
- Dedicated website full of resources and video tutorials www.guide2elements.com

ISBN: 0 2405 20491 - \$34.95/ £19.99 - Paperback - 424pp

To order visit: www.focalpress.com or your favorite online bookseller